THE IMPRESSIONISTS

WILLIAM GAUNT

THE IMPRESSIONISTS

with 108 plates in full colour

Thames and Hudson · London

Printed and bound in Italy by Alfieri and Lacroix, Milan.

I S B N 0 500 23134 6

CONTENTS

1 THE BACKGROUND

Impressionism adds a singularly beautiful history to the annals of European art. It is a story of effort heroically maintained in spite of discouragement and hardship, of aesthetic aims pursued with unswerving integrity and entrancing result, of eventual triumph and fruitful sequel. Like other great movements in art it was as complex in origin as it was far-reaching in effect.

A mocking critic, Louis Leroy, coined the term in 1874 on seeing *Impression: Sunrise (pl. 18)* (Musée Marmottan, Paris) by Claude Monet in an exhibition in Paris—untitled except as the co-operative venture of a group of artists. But this, the first of the eight Impressionist exhibitions held between 1874 and 1886, was far from denoting the start of the movement. The period these exhibitions define was one of matured achievement. The French painters who then defied criticism by adopting for themselves the name intended to deride, had long before determined their intentions and methods.

They can be viewed now as being in the main current of development in France, bound by many links to earlier great painters of the nineteenth century and to contemporaries of an older generation. It is possible to go much farther back in the search for historical antecedents. There are suggestions of Impressionist technique to be found in certain Old Masters. As a way of indicating how light falls on an object or figure by touches of broken colour that model form without recourse to definite outline, it has example in the work of Velasquez, and an Impressionist element may likewise be discovered in Guardi, Watteau and Goya. The Old Master paintings brought out some of the potentialities, still latent in the oil medium, which were to lend themselves so well to Impressionist purposes, though the likeness to Impressionism is distant.

The study of origins must also refer to the changed order of things in the nineteenth century; the place of the artist in society after the Revolutionary and Napoleonic periods; a new definition of reality and feeling for nature; the special cultivation of landscape and open-air painting; and an approach that was scientific in direction even if intuitively made to the related properties of light and colour.

In several of these respects English art had a pioneer role and influence, most clearly represented by John Constable. The analogy between his landscapes and those of the French Impressionists is close. To render natural light was his aim—'light —dews—breezes—bloom—and freshness'. A remarkably original statement for his time appears in one of his lectures: 'Painting is a science and should be pursued as an inquiry into the laws of nature. Why then may not landscape painting be considered as a branch of natural philosophy of which pictures are but the experiments?'

From such an unlikely source as Benjamin West he had learned early on the lesson that 'light and shadow never stand still'. The tones of both were infinitely varied according to circumstances.

'Reflection and refraction' he observed, 'change more or less every colour' and shadow could never be colourless. The observations contained in Constable's lectures on landscape show how much conscious thought he gave to questions of a first importance from an Impressionist standpoint. His practice was a brilliant demonstration in two somewhat different ways. Small oil sketches, swiftly made in the open air, vividly caught transient effects of light and atmosphere. Larger studies for finished exhibition pictures were painted in the studio with the broken colour and distribution of light gleams that gave the effect of the sky's luminosity throughout the painted scene.

In the finished picture Constable sought to combine the freshness and directness of the sketch with the sparkle and vigour of technique in the more elaborate study, though both were modified to a certain extent in the process. This may be appreciated by a comparison of the magnificent sketch for *The Haywain (pl. 2)* in the Victoria and Albert Museum with the finished work. Yet in the latter, toned down as it was, the different depths of cloud, the gleam of sun on distant meadows, the ripples and reflections of the water, the varied substance of foliage, are enough to explain the deep impression the picture made when exhibited in France at the Salon of 1824. Delacroix went so far as to term Constable, 'the father of our school', and it is well known that he retouched his *Massacre at Chios* (Louvre) before the Salon opened, after seeing *The Haywain* first in the window of the dealer John Arrowsmith's shop in Paris. How far this retouching went cannot exactly be known, but there is a strong presumption that the animation of surface Delacroix finally produced by small touches of bright and varied colour, especially on figures and foreground, conveys its extent.

In a less well defined fashion it seems probable that Bonington, the friend of Delacroix and an English artist consistently admired in France, also had some influence on French landscape by his watercolours and his fresh and spacious paintings of the Normandy coast. English watercolour in the famous Salon of 1824 may have suggested to French painters the value of a higher key of colour than was customary then in the oil picture. But apart from the interest and even enthusiasm aroused by the initial encounter with English landscape it is not easy to trace a continuing influence in France. Its effect has been much misrepresented or based on mere assumption. Camille Pissarro, in considering what the Impressionists might have derived from English artists and referring appreciatively to their kinship in *plein-air* painting, was at pains to point out that neither Constable nor Turner displayed any understanding of the *analysis of shadow* so important in the Impressionist development.

Turner has certainly been incorrectly described as an Impressionist precursor. The beautiful oil sketches of the Thames *(pl. 1)*, made from nature between 1805 and 1810, give a parallel, exceptional in his work, to that of Constable. They might have been influential if they had been publicly seen, as instances of the quality appertaining to painting in the open air, but they were part of the great private output of which it has only been possible to get a proper idea in comparatively recent years in the present century. Turner's giant powers, generally speaking, were applied to ends that were outside Impressionist scope or sympathy. In the frequent references of his exhibited works to the decline of civilizations and the helplessness of man in the face of fire, storm and flood, Claude Monet seems only to have found an intolerable romanticism. Turner was capable of violence and discord in colour of a kind that would nowadays be called Expressionist rather than Impressionist, for which Auguste Renoir expressed considerable repugnance. The Impressionists were set on a course of their own before, in all probability, they had seen any Turners at all. He was a new experience to Monet and Pissarro during their stay in London in 1870 and 1871 but it was impossible for them

to see anything like the range of his work that in this century has been made available to the visitor in the Tate Gallery. It was by a different route that Monet was to arrive at the poetic abstraction of his later works in which an affinity with Turner's final phase at last appears.

The influence of Constable's landscape in France might be compared to the effect of a spring shower quickly absorbed in the ground but contributing as an invisible source of nourishment to the new blooms of a spring season. The powerful immediate impression made on Delacroix by *The Haywain* left behind only the most general trace on his work and thought in the form of an inquiry into the properties of colour in itself, quite apart from subject. Yet it was through his new sense of the life in colour, gained from Rubens also, that Delacroix claimed the respectful attention of the masters who came after him.

It seems likely that apart from exhibition pictures, not seen for long in public (*The Haywain* itself, after some years in a private French collection, was sold back to England in 1838), the mass of English topographical prints and illustrated books had an effect on the direction of French art. English draughtsmen who had made what may be called in a visual sense the 'discovery of England' crossed the Channel in increasing numbers as the insular taste for foreign travel grew. They celebrated in their own way the attractions of French town and country. Turner, Cotman, Samuel Prout and others delighted in the aspects of the Seine and regions of Normandy that were to be the favoured subjects of the Impressionists.

The example can scarcely have been lost on French painters though what may be thought of as their discovery of France can be seen against the more grandiose background of Classicism and Romanticism. A reaction against the 'classical' landscape that had had its great French exponents in Poussin and Claude and its sequel of Italian scenes in the work of Fragonard and Hubert Robert, turned artists of the early nineteenth century away from the formal composition, the ancient ruins, Italian gardens, lakes and shores.

Romanticism in one of its several aspects was a new feeling of intimacy with nature and as it grew in England with a local affection, for East Anglia in particular, so it was bound up with the realization by artists in France of what its northern regions offered. As a model for a genre that required no exotic scenery or awesome spectacle for its effect, artists in both countries could—and did—refer to the landscape paintings of seventeenth-century Holland.

The sense of space, the panorama of cloud above land stretching away to a far horizon, diversified by the picturesque silhouette of a windmill or ancient tree, appear in the works of the pioneer of nineteenth-century French landscape, Georges Michel. He looked at the country in the neighbourhood of Paris, especially the still-rural Montmartre, through the eyes of the Dutch masters with whose work he was familiar as a picture restorer. An artist, in Michel's estimation, should be well able to find all he required within a radius of four miles from where he lived.

Paul Huet was another pioneer, an admirer of Constable though representative of the more tempestuous phase of Romantic feeling. The belief implicit in the work of both, that the visit to Italy as the classical training ground was no longer essential, that France had all a painter could wish for, was a strength of the Barbizon school—close-knit by many filaments with the nascence of Impressionism.

Here indeed was the 'return to nature', initially propounded as a philosophy by Jean-Jacques Rousseau, invested with poetry by Wordsworth in England and Lamartine in France, a retreat from the world 'too much with us'. The little village of Barbizon, some twenty miles to the south-east of Paris, offered a refuge where the poverty-stricken painter could live for very little. It was on the fringe of the almost primeval forest of Fontainebleau, its depths still uncrossed by pathways, its silence a solace to the solitary mind.

9

The Background It could be guessed that the initial retirement was prompted by the mood of Romantic melancholy that required a hermit-like seclusion as the proper atmosphere of self-expression. Something of an earnest and sombre temperament appears in the landscapes of Théodore Rousseau *(pl. 4)* and peasant themes of Jean-François Millet. But another element makes its appearance—an objective interest in what is seen, an observation of the times of day from dawn to dusk and their differences of light in its impingement either on the open plain or in some forest glade. What was seen in reality —the reality of light as much as of the objects it surrounds—became of more concern than a purely egotistical sensation. The painters associated with Barbizon thus in their own fashion opened a road for the Impressionists to follow. Some of them, Corot being a great example, exercised a personal influence and lived long enough to witness the Impressionist movement in full career in the second half of the nineteenth century.

2 CHANNELS OF COMMUNICATION

The early history of the Impressionists may be defined as a casually connected chain of circumstances in which, nevertheless, an inevitable pattern seems to take shape. It leads first to Le Havre, at the mouth of the Seine, in mid-nineteenth century or shortly thereafter. In its breezy, coastal atmosphere Claude-Oscar Monet, who was to be the very heart and soul of the movement, spent his boyhood and made his first essays in art.

At the age of fifteen he had gained a local reputation as a caricaturist. His clever sketches of individuals with large head set on diminutive body in the caricature style of the time were exhibited in the window of the frame-maker's shop in the rue de la Communauté that Eugène Boudin had started in 1844. It was there that Boudin, by then working independently as a painter, saw Monet's drawings in 1858. By advice and example the painter of thirty-four induced the talented youth of eighteen to abandon his facile comic draughtsmanship and to take to painting from nature.

If only because he made Monet a painter, Boudin merits a place of honour in the history of Impressionism though the lessons he had absorbed from others and the nature of his ideas placed his own work within its sphere. He had met some of the Barbizon painters who came to his shop to have pictures framed, was encouraged by them to paint and for a while was assistant to the painter of cattle and pasture, Constant Troyon. But the main lesson he derived from Barbizon example was, perhaps, that painting could best be carried on in a region well and intimately known. A native of Honfleur and the son of a ship's captain, Boudin was naturally inclined to specialize in the marine subjects of the native region he held in great affection. Yet it was not picturesque detail that engaged his eye but light and space, the restless motion of the elements, variable skies, transient gleams of light, dancing waves (pl. 6). He became, as Corot described him, 'the king of the skies' and, as Baudelaire thought, one destined to display 'the prodigious wonders of air and water' by virtue of painting in the open air. By the 1850s this was not without precedent in France but no one was more emphatic than Boudin in the conviction that (to use his own words), 'Everything painted directly and on the spot has a strength, vigour and vivacity of touch that can never be attained in the studio; three brush strokes from nature are worth more than two days studio work at the easel'.

What was to be a cardinal point of Impressionism, pursued by Monet with a lifelong consistency, was thus a direction given by Boudin. It was already a solution for the problems of a youth still in his teens. Though Monet at nineteen invested his small savings in going to Paris for more formal art training, he was by nature a determined rebel and was to gain little advantage even from the free academies he went to except (which was to be very important) the friendship

of fellow students who were to become fellow Impressionists.

At the Académie Suisse, where he elected to study first in 1859, he met Camille Pissarro. Pissarro was born in 1830 on the little island of St Thomas in the curve of the Lesser Antilles which separate the Caribbean Sea from the Atlantic. Acquired since by the United States, it was then a Danish island, colonized almost entirely by Jews. Camille's father was a French Jew of Sephardic ancestry, his mother a Creole. The boy was intended to enter the family ironmonger's business though he showed an unaccountable taste for drawing which sending him to school in France—at Passy—when he was twelve did nothing to cure. He returned to St Thomas in 1847, and for some years went through the motions of being a clerk in the store, drawing, as opportunity allowed, palm trees and seashore and the bustle of negro dockers at the port of Charlotte Amalia.

Pissarro seems almost a Gauguin in reverse, starting out with exotic adventure and ending his career in the quiet of rural France. He adventured to the mainland of South America and painted at Caracas in the company of a Danish painter, Fritz Melbye. If he had to be an artist, his father intelligently concluded, Paris was the place for him and not Venezuela. With some parental aid Pissarro came once more to Paris in 1855. It was the year of the great Exposition Universelle to which he made his way without delay. In the six landscapes by Corot shown in the Fine Arts section he found as wonderful a relevation as Monet in his introduction to *plein-air* with Boudin.

Jean-Baptiste Camille Corot was one to be regarded as a patron saint of the Impressionists, indeed of art in general in nineteenth-century France. His great gifts and his simplicity and goodness of heart alike claimed devotion. He appears at intervals in the course of the Impressionist history to give wise counsel (though holding always, as he told Berthe Morisot, that

'nature is the best of counsellors') and on occasion, support. Boudin, Monet, Renoir, Berthe Morisot, Pissarro were all encouraged by his example. Pissarro was made welcome at Corot's studio, 59 rue Paradis Poissonnière. Corot, then over sixty, perhaps took the more interest in his colonial visitor from some points of likeness in their personal history. Corot also had struggled when young in the toils of a family business, not being able to extricate himself and paint in earnest before the age of twenty-six.

Pissarro had lessons also from Anton Melbye, the brother of his Danish friend, who was a painter in Paris. When two pictures were accepted by the Salon in 1864 he proudly described himself as 'pupil of Anton Melbye and Corot'. Meanwhile he had put in an occasional appearance at the Académie Suisse on the Quai des Orfèvres and there had made the acquaintance of Monet and Cézanne, though it was not until later in the decade that they became allies.

In 1862 Monet had returned home after a brief period of military service in Algeria and begun painting again at Le Havre. The pattern of aesthetic communication was again extended. An Englishman, it is recorded, (unusually forthcoming for one of his race) asked the young painter if he knew Jongkind and volunteered an introduction. Meeting the tall, bearded, blue-eyed Dutch painter Johan-Barthold Jongkind was a second revelation after that of Boudin, and a revelation even for Boudin himself. Jongkind is one of the several artists who have qualified for the title of 'the first Impressionist' in the eyes of critics. So, without hesitation, he was described by Paul Signac. His work conveyed not only the value of the vivid sketch but also the use of touches of pure colour to express the play of light and atmosphere *(pl. 7)*. Perhaps more in watercolours than oil paintings he anticipated what was to become a characteristic Impressionist method.

Jongkind was forty-one when he and Monet met. Like his fellow-countryman, Vincent van Gogh,

12

whom he resembles in intensity of feeling and tragic destiny, he had led a wandering life. He painted many picturesque byways in Paris but found a particular pleasure in the region of Le Havre, Harfleur and Trouville, varied now and then by return to pictures of the canals, windmills and polders of his native Holland. He was unknown to the public, regularly refused at the Salon, and often reduced to the depth of poverty from which Corot and the Barbizon painters were wont to give him a helping hand.

Eccentricity turned into the mental disorder of his later years when he brooded over the imaginary wrongs done him by the Prince of Orange and withheld his hand from visitors, believing it would transmit the poison with which his enemies had infected it. In that period Monet was sadly to record, 'he is quite mad . . . and yet the best marine painter we had'. The malady was undeclared when Monet introduced Jongkind to Boudin and the three of them painted in the open air together. The modest Boudin was to declare that he 'went in through the door Jongkind had opened'. Monet has left his testimony that Jongkind 'added the crowning touch to the encouragement Boudin had already given me'. His 'true master' from then on, he said, was Jongkind to whom he owed the education of his eye. Though continuing for many years after to produce works that might be termed Impressionist in spirit and atmosphere, Jongkind remained apart. It was not until 1891 that he died in an asylum at Grenoble, though by 1875 the signs of mental and physical decay were plain to see and his ghost-like appearance and wild speech shocked the other mourners at Corot's funeral in that year.

After their first encounter, Monet felt the need to go to Paris once more and again submit himself to the academic training for which he seemed so little adapted. His choice this time was the atelier of Gabriel-Charles Gleyre, a compromise between the personal studio and the art school, being in the latter respect a subsidiary of the Ecole des Beaux-Arts. The grubbiness and unruliness of the place as it was some years earlier, at the time when Whistler was a student there, has been described by George du Maurier in *Trilby*. Gleyre himself, a Swiss follower of Ingres, was in every way the antithesis of an Impressionist, suspecting colour as an evil indulgence and judging figure drawing by its conformity to 'the antique'. Monet, the natural rebel, and one already instructed on quite contradictory lines was prompt to react against these criteria. But there were two advantages about an atelier of this kind. The teacher, apart from inciting disagreement with what he said, interfered little with what the students did. There was also the chance of falling in with kindred spirits among the other students and so it happened with Monet—to his and their subsequent benefit. It was in Gleyre's classroom that he came to know and ally himself with three others, forming a group which shared certain traits and ideas. Like Monet the grocer's son his new friends belonged to the urban middle-class at various social and financial levels. Each had exercised independence in breaking away from the occupations planned for them and had taken, through sheer love of painting, to work that promised no security or likelihood of being wanted in a philistine world. They were all about the same age.

Frédéric Bazille, for whom his friends foretold a brilliant future but who was killed in 1870 in the Franco-Prussian war, was born at Montpellier into a bourgeois family whose ambition was to make him a doctor. On coming to Paris in 1862 he contrived to divide his time between medical studies and the atelier life-class.

Alfred Sisley was born in Paris, the son of an English business man with a prospering import-export agency who destined him for commerce. He was sent at an early age to England to learn both trade and language but soon came back to Paris and attended Gleyre's atelier as an amateur under no compulsion to be anything more.

Pierre Auguste Renoir was the son of a jobbing

tailor who had come from Limoges to look for more opportunity in Paris. Auguste as a boy was apprenticed to a china manufacturer but machine production had thrown him out of work. From several kinds of hackwork—decorating fans and painting blinds—he had saved enough to get into training, at a recognized school, to become a 'real painter'.

They worked under and without regard to Gleyre probably until he closed the studio in 1863, and certainly during the winter of 1862. Monet, with the advantage of contact with such masters as Boudin and Jongkind, the most mature in outlook and in character the most forceful and most determinedly bent on beating out a new path, imparted to the others his enthusiasm for painting landscape. He enlisted his friends in the enterprise of painting in the forest of Fontainebleau as the men of Barbizon had done—and still did after many years.

The region had changed to the extent of becoming a popular painting ground since Corot and Théodore Rousseau had first painted there. That was thirty years before Monet and his friends, in the 1860s, worked in the open at Chailly-en-Bière and Marlotte on the skirts of the forest. Its glades were by now well-trodden by the feet of many artists. If Corot chanced once again to set up his easel there in the course of his extensive travels he would be surrounded by a swarm of admirers or 'circle of idiots' as Renoir put it. Veterans now of Barbizon were Jean-François Millet who kept himself somewhat aloof; Rousseau, in his later years melancholy and agonized by the insanity of his wife; Jules Dupré, noted for his skies, and Diaz de la Peña, painter of gnarled clusters of Ruisdael-like oaks.

Painting forest subjects of a similar kind, the work of the young men took on some of the weightiness and claustrophobic density that the earlier generation had extracted from the ancient trees, the rocky pools and solemn avenues. For Monet they provided a great contrast with the vivacity and openness of nature as observed at Le Havre, though both contributed something of value to his paintings in the 1860s. But neither his work nor that of his friends can be summed up exclusively in terms of a local development of landscape. A wider pattern of communications relates them to Gustave Courbet and Edouard Manet and the controversial issues that beset the world of art in this decade.

14

3 FORMATIVE YEARS

The nineteenth-century movements in art with titles having the suffix -'ism' bear witness by that appendage to the growing independence of artists in thought and aim. To speak of baroque and rococo in the pre-Revolutionary era is to recall not only the development of style but of patronage and its requirements. But the classicism and romanticism of the early nineteenth century were matters primarily of how artists felt and not of what a public wanted. Here was the opening of a gulf that grew wider as time went on.

The conflict of ideas in the 1830s was between artists who took the Classic or Romantic side, for or against Ingres or Delacroix. By 1850 it was a conflict between the original artist and public opinion, developing into a contest still more prejudicial to originality in which official opposition was added to outside criticism.

Gustave Courbet was the first of a number of great artists to be subjected to this ordeal. The Realism he stood for was the cause of a violent storm. The title of *realist*, he said in 1855, was one that had been imposed upon him, just as the men of 1830 had been dubbed *romantics*. But his definition of what he was personally after, 'to interpret the manners, ideas and appearance of my own time, according to my own view and assessment; to be not only a painter but also a man, producing a living art' had a more general application. Classicism and Romanticism had shared a leaning towards the past whether in antique or medieval guise. The growth of a

scientific attitude and reaction against this nostalgic sentiment made a present reality the necessary substitute for a decayed idealism.

After the reigns of Charles X and Louis Philippe, brusquely terminated by the revolutions of 1830 and 1848, the Second Republic showed for a while a reforming and progressive spirit that welcomed the social comment of realism in painting. The Salon of 1848 was open to all who submitted their pictures. Jean-François Millet showed *The Winnower* (Louvre), the first of the peasant subjects for which he was to become famous during his life at Barbizon. Courbet had six works to show. Millet's *The Sower* (Louvre) and Courbet's funeral scene truthfully depicting the types of his native place—*Burial at Ornans* (Louvre)—were prominent in the Salon of 1850. Though Courbet was politically a socialist his paintings were free of propaganda or that sermonizing undercurrent that somewhat troubled Baudelaire in the work of Millet. Yet for various reasons he now became the object of attack. His choice of subject and rough strength of style upset those who looked for the comfort of artificiality—not only a philistine lay public, but the conventional painters and officials who sought to rule the Salon.

Officialdom became securely entrenched and the more intolerant of anything that smacked of republicanism when the manoeuvres of Louis Napoleon, the chosen President of the Republic in 1848, resulted in his being declared Emperor

in 1852. Courbet's position as outlaw was defiantly proclaimed when in 1855 his extraordinary masterpiece, *The Studio—allegory of real life* (Louvre)—and *Burial at Ornans* were refused by the jury of the Exposition Universelle. His 'personal Louvre' as it was termed, the pavilion he built facing the exhibition buildings to contain his own independent exhibition with a catalogue that printed his statement on Realism, placed him in the full blaze of notoriety. There followed years of triumph which Count Nieuwerkerke, the Superintendent of the Beaux-Arts, and other enemies in the Salon were powerless to resist. In the 1860s Courbet was the acknowledged leader of a young generation among whom were the Impressionists-to-be. From Courbet they could learn that Realism was a term of wide application, that commonplace or even ugly subject matter in no way detracted from the quality of sincere painting. In landscape indeed the ready-made beauty of the 'beauty spot' was a positive hindrance. The absence of any remarkable feature in the little vale of the 'Communal' at Ornans made it none the less attractive to Courbet as the background of his *Les Demoiselles de Village* (Metropolitan Museum of Art, New York). What some lamented as the ugliness of contemporary dress in the period of the crinoline and the frockcoat, the Realist was able to turn to good account.

The example of Courbet as a figure painter was especially inspiring to the young Renoir. When painting at Marlotte with Sisley he turned from forest scenery to paint the Courbet-like group of the *Cabaret de la Mère Antoine* (National Museum, Stockholm), solidly veracious in portraiture and dress with a wall in the background scrupulously detailing the playful scrawls of many artist hands including a caricature of Henri Murger by Renoir himself. The crinoline of the 'sixties and the awkward cut of masculine attire take on charm in Renoir's portrait of Sisley and his wife *(pl. 68)*. In such a sturdy nude as *La Baigneuse au Griffon* (Museu de Arte, São Paulo) there is a reminiscence of a work by Courbet that

the Emperor in 1853 was with difficulty restrained from slashing with his stick.

Monet was certainly attracted by the rebel in Courbet and the fearless expression of his beliefs. They became personally acquainted in Paris and again met on Monet and Boudin's home ground at Trouville where Courbet was painting coastal scenes in 1865 in company with his young friend, James McNeill Whistler. To be bold in statement and to use a large canvas and treat it largely were lessons that Monet imbibed.

Yet it needed a further crisis and still another master at odds with the forces of reaction to give young painters in the realist line of development some cohesion among themselves and some militant unanimity of thought. The occasion was the Salon des Refusés of 1863; the much maligned and hotly championed master: Edouard Manet. The Salon des Refusés was the climax of the years of growing partiality and prejudice that had followed the first generous gestures of the now-superseded republic. The number and nature of the rejected entries for the official Salon in 1863 caused a wave of protest that came to the notice of the Emperor.

It may be doubted whether Napoleon III was of a less conservative mind than the selection committee. But his popularity was on the wane. His unsuccessful attempts to extend the power and prestige of France abroad were doing him no good. He may have calculated that a display of liberalism would bring back some measure of popularity and at all events avert a controversy in which the government might be uncomfortably involved. He gave instructions that all 781 rejects should be exhibited in a separate compartment of the Palais de l'Industrie.

The refused included, besides Manet, Jongkind, Harpignies, Fantin-Latour, Alphonse Legros, Camille Pissarro and Whistler (delighted thus to figure in what he saw as the battle of art against ignorance). But the great scandal and also triumph of the show was Manet's *Le Bain* afterwards known as *Le Déjeuner sur l'Herbe* (Louvre) *(pl. 11)*.

16

It is hardly possible to imagine a more ironical situation than was thus produced. Manet, whose father held high legal office, whose mother was the daughter of one of the first Emperor's diplomats, belonged to the upper level of Parisian society and wished for nothing more than a conventional and respectable place in the world and in the Salon, alongside Meissonier and the others who threw his work out. His genius denied him what his respectability craved. The sight of bathers in the Seine first suggested the picture to him—to that extent, and more especially in the smaller of the two versions Manet made, it was a study of *plein-air* effect. But the *Concert Champêtre* in the Louvre, attributed to Giorgione, gave a precedent for a composition in which nude female and clothed male figures appeared. The combination gave rise to an outburst of prudish dismay and anger that was to be followed by still more ferocious explosions.

It was ironical that a motif causing no offence in an Old Master work should do so in a modern version. It was observed that Napoleon and the Empress Eugénie studiously averted their gaze from the naked model among the men picnickers. Yet if one had passed through the narrow doorway in the Palais de l'Industrie between the array of rejects and the official Salon where, to quote a critic of the time, 'Venus reigned', it would have been to find in what was generally voted the picture of the year, the *Birth of Venus* by Alexandre Cabanel, a work with an artful eroticism the *Déjeuner* did not possess—and an eroticism received with general complacence.

The experiment of the Salon des Refusés was never repeated. Perhaps it was felt that there was danger of its eclipsing the official Salon by its very notoriety. The request for its revival made by Cézanne in 1866 was curtly refused. But in the official Salon Manet continued to be controversial in spite of himself. The *Olympia* (Louvre) *(pl. 9)* shown there in 1865 like the *Déjeuner* was designed to bring an Old Master theme up-to-date—this time in an adaptation of Titian's *Venus of Urbino*, though the charge of indecency previously made was repeated with still more insistence and insult.

Excluded from the Exposition Universelle of 1867, Manet was goaded into a gesture of defiance like that of Courbet in 1855. At his own cost he built a hutment on a small grass-plot at the corner of the avenue Montaigne and the avenue de l'Alma and there showed the whole series of the works at which opprobrium had been hurled. There was the portrait of a tramp, called *The Absinthe Drinker*, 1859, of which Manet's own master, Couture, had said 'There is only one drinker of absinthe here—the painter who has produced this piece of absurdity' (Ny Carlsberg Glyptothek). The *La Musique aux Tuileries* of 1862 (National Gallery, London) *(pl. 57)*, so full of light, movement and Second Empire gaiety, was an exhibit—a picture jeered at as a 'caricature of colour'. The *Le Déjeuner sur l'Herbe,* which recalled the 'Salon of the Pariahs' as Parisian wits had labelled the exhibition of 1863 and its main sensation. The *Olympia* also—described with a curious lack of any appropriateness by one critic as a 'female gorilla'—and *The Fifer* (Louvre) *(pl. 10)*, surprisingly, in view of its uncontroversial charm, a reject from the Salon of 1866, were included in this constellation of much abused masterpieces.

Courbet, as in 1855, again had his own pavilion near by where he showed more than a hundred paintings. It was better received than Manet's though the brothers de Goncourt condemned it for 'a bourgeois ugliness without the special beauty ugliness can possess'. Courbet's massive shoulders had also borne many insults, it had been said of him that he was 'the anti-Christ of physical and moral beauty', yet the hate and derision that assailed Manet's one-man show went farther— 'never', said Antonin Proust, 'was there so revolting a spectacle of injustice'.

The gulf now yawned wide indeed between artist and public—and also between the original artist and the professional purveyors of pictures

acceptable to tastes less enlightened than those of the pre-Revolutionary connoisseur. The fury aroused in those who were under no compulsion to acquire or even to look at the works that caused it still seems to call for psychological explanation. Subject matter seems an insufficient reason. A novel style of painting such as Manet pursued perhaps caused a certain fear and consequently anger as being in some obscure fashion a threat to settled ways and beliefs. There may have been a physical, an optical difficulty in adjusting the vision to unfamiliar conceptions of form and colour. There was perhaps an undercurrent of jealousy felt for the exceptional individual. If Courbet fared better than Manet it could have been on account of the distinction that Renoir made between them. 'Courbet', he said, 'was still tradition, Manet was a whole new era of painting'. Picture-buyers were more easily reconciled to new departures in subject treated in a familiar manner than to new departures in style. *Contemporanéité*—Manet's aim—might appear substantially the same as Courbet's realism. It advanced into a different dimension in implying that method might be contemporaneous as well as theme. Only artists—and in particular younger artists—appreciated this original mode of expression. Execrated though he was by public and critics, Manet in the 1860s was the hero of a circle, and in championing him its members found a growing clarity in their own ideas.

The importance of the Parisian café as a meeting place of painters and writers where they could exchange thoughts and concert plans is illustrated by the Café Guerbois where Manet reigned and the nucleus of the Impressionist group gathered round him from 1866 to 1870. It was near the house in the rue St Petersbourg where Manet lived with his wife and mother, at the beginning of what was later the avenue de Clichy. Monet, Sisley, Pissarro and Renoir were among the frequenters. Edgar Degas, the friend of Manet, came at intervals and Fantin-Latour who was to make his demonstration in favour of Manet in

pictorial form in *The Studio at the Batignolles* (Louvre). Fantin pictured the great man at his easel, handsome and elegant in attire, even when dealing with oil paint, watched by some of the Guerbois devotees. He is seen at work painting the portrait of the poet and sculptor, Zacharie Astruc, while Renoir in the rear contemplates the progress of the work. Beside him is Zola who, prompted by Cézanne, had written in Manet's defence and next to Edmond Maître is the unusually tall figure of Bazille. Monet at the extreme right unobtrusively completes the group. In spite of arguments and squabbles, the differences of class that distinguished the representatives of the wealthy and superior bourgeoisie—Manet, Degas, Bazille, from the poverty-stricken and skimpily-educated Monet and Renoir; the differences of temperament and tastes that made each individual in painting; the contrast between the Parisians and the rough provincial, Cézanne, the meetings at the Café Guerbois made a lasting link between its variously gifted patrons.

Monet was later to speak warmly of the advantage gained from the thrashing out of problems in company, though at that time Manet was little responsive to the enthusiasm of the younger man for painting in the open air. Neither then nor at any other time was Degas interested in the idea or in landscape as a theme. If Manet would be wrongly described as the founder of Impressionism or as 'the first Impressionist' he may well be called the pacemaker of the movement not only in encouraging a determined stand against officialdom but in his use of colour. The juxtaposition of flat areas of different colour to stand for the transition from shadow to light was a way of painting by which he attained the fresh and spontaneous effect of a sketch. Daumier noticing this flatness in Manet's *The Fifer (pl. 10)* remarked that the picture was like a playing-card, though it was none the less full of life. In this technique, Manet's admirer, Antonin Proust, was acute in observing that 'from his short stay in sunny countries Manet had acquired a vision of supreme

18

simplicity . . .' Proust referred to the artist's early visit as a ship's apprentice to Rio de Janeiro. He had soon given up the project of a seafaring career but the impression of strong light gained in South America could reasonably be supposed to have remained with him and to appear in the crisp simplification that dispensed with the soft gradations of 'tone', considered as a gamut of greys between black and white. Though contrary to the fully developed Impressionistic practice, Manet attached importance to black as an accent and in a sense an extra colour.

Painting was coming into the light of day. The shadowy depths, the browns, ochres and mellowing varnish which to many eyes had spelt warmth and comfort were black-out curtains pulled aside. This was one facet of realism, which had several forms in painting as in literature. In his pictures of peasants at Barbizon, Millet was an early 'social realist', not content, as Baudelaire pointed out, with the simple poetry of his subject but, as in the *Angélus* (Louvre) of 1859 with a possible sermon up his sleeve on the dignity, martyrdom or devotion of labour.

'Truth to Nature' was not complicated as it was for the contemporary Pre-Raphaelites in England who had begun as realists but whose work was still overlaid by the romantic nostalgia for the past. Social significance however was a certain complication in France. Daumier in the 'sixties was making those paintings and drawings of the street performers, proletarian workers and mournful third-class carriages that were a new examination of the social structure in the city, parallel with that of Millet in the countryside.

The preferred reality of Manet and Degas was that of Paris at a more luxurious level, the new Paris of the boulevards which Baron Haussman at enormous expense had driven through the populous streets and remnants of the medieval city. It was the Paris of the Opera, adorned by Carpeaux in 1869 with the ecstatic figures of his sculptural masterpiece, *The Dance*; the Paris of sophisticated entertainment.

The younger members of the 'group of the Batignolles', as the frequenters of the Café Guerbois were known, show less of this interest in human society. The scientific study of human life as proposed by the 'naturalism' of the French novel and the literary criticism of Hippolyte Taine, was replaced by the scientific study of means. It was the use of colour that came to concern them primarily, though to follow their development up to 1870 it is necessary to trace a complex process of assimilation.

The publication in 1865 of Delacroix's notes on colour was probably not without effect. These asserted the universal validity of the 'three' (or primary) colours, that every shadow cast on the ground was violet, that the only true colour of flesh was to be perceived in the open air, with other dicta that correspond to Impressionist practice. A more immediate inspiration was Manet's replacement of tone by colour. But due weight is to be given to the actual practice of painting in the open. This obviously dispensed with the calculated preparations of the studio composition, the 'dead painting' in which the whole was laboriously worked out in monochrome, the leisurely Old Master system of completion by glazes of colour. It called for swiftly improvised apprehensions of light and its translation into colour. This must inevitably have directed the painters to the primary or spectrum colours, the actual components of light, with particular regard to blue, the atmospheric colour *par excellence* of sky and distance as well as a main component of cast shadow. The suppression of the earth colours logically followed. The ochres and browns had no part in the make-up and transmission of light; on the contrary, serviceable though they had always been in other ways, they obscured luminous effect.

Figure compositions did not lend themselves as did landscape to the technique that sought to catch the fleeting moment. This is a reason why Claude Monet eventually came to give the figure a small and incidental part only—if any part at

all—in his paintings of either town or country. Yet in the paintings executed before he was thirty he showed that it was through no want of ability that he later relegated the figure to a minor place. What good use he made of the lessons to be derived from older contemporaries can be seen in these early works. He added to Courbet's interest in contemporary dress a faculty for investing the heavy women's clothes of the 'sixties with elegance and charm that made them seem like butterflies fluttering through summer gardens. He took Manet's subject *Le Déjeuner sur l'Herbe* but gave his version (Moscow) more of circumstantial reality in the forest setting with trees such as Diaz loved to paint and conveyed the omnipresence of sunlight among the trees and round the picnic group in a way that Manet had not attempted.

There is an echo of Courbet in pose and manner in the portrait of Camille Doncieux, the girl who was to become his first wife, painted for the Salon of 1866 but reminiscences of Manet are more frequent for some time, appearing in the *Terrasse à Sainte-Adresse* of 1866 (Metropolitan Museum of Art, New York) in the vivacity of maritime detail and the broad divisions of colour in light and shadow and in the boldly treated beach scenes of 1870 at Trouville *(pl. 87)*. Monet as an artist was advancing by leaps and bounds in the three years before the Franco-Prussian war made interruption. It is surprising to think that works so delightful were produced while he was in the direst need and a black despair from which only his unusual strength of will and conviction rescued him.

In 1866 he had to leave the house at Ville d'Avray where he painted his *Women in the Garden* (Louvre) *(pl. 86)*, to escape his creditors. In disgrace with his family because of his association with Camille who bore him a son in 1867, he spent a penniless summer with his aunt Madame Lecadre at Sainte-Adresse. In 1868 canvases were seized by creditors and he and Camille were thrown out of the inn at Fécamp where they

were lodging. By that time he had come to the point of contemplating suicide.

Only the occasional purchase of a picture or loan from Bazille had so far given him temporary relief. In 1868 M. Gaudibert of Le Havre came to his rescue with a commission to paint Mme Gaudibert *(pl. 69)* and purchased other works. Money supplied by the Gaudiberts enabled him, in 1869, to take a house near Bougival, where Renoir was a neighbour but it was not enough to keep him in food for long. Only the bread that Renoir brought him—bread from his own family's table—saved Monet from starvation. Renoir was little better off. He had known the same routine of flitting from one miserable lodging to another, quartering himself in periodic crises on painter friends and retreating from time to time to stay with his far from affluent parents. During these pre-war years he was also advancing rapidly as a painter in a direction parallel with that taken by Monet. The influence of Courbet lingered in his portrait of his model Lise in 1868 against a forest background, painted in the open air, the sunlight playing on her full white dress. In the same year he painted the skaters in the Bois de Boulogne in a style that recalled Manet's sketchy panorama of the 1867 World Fair.

A stage in the development of Impressionist technique that went beyond the influences that first inspired it was reached by Monet and Renoir when from 1868 to 1869 they worked together on the bank of the Seine at Bougival. They painted the same subject, *La Grenouillère (pl. 59)*, a popular resort with a restaurant near by, offering to the eye the varied attractions of trees, water, boats and lively groups of bathers and other holiday-makers. It is significant of the difference between the naturalism of the writer and that of the painter that, as a concourse of human beings, de Maupassant could describe it as a scene of crude vulgarity while to the painter it was visually an idyll with nothing to mar its perfection.

The gentle ripple of river water was more conducive to the open-air study of colour than the

Channel waves dashing up against the jetty at Le Havre that Monet had painted a little earlier. The latter picture is a rarity in his work which in general avoids the forceful movement Turner could give to the sea as well as the sculptural weight that Courbet found in the breakers on the shore. A calm made apparent all the gleams and reflections that vanished from the ruffled surface. The nature of the ripples on the Seine forming small horizontal patches of different colours, suggests—as the artists rendered them— the mature Impressionism that made use of such broken colour as a translation of nature in general; a subtler technical instrument of more extended application than the simple opposition of flat colours that Manet had so far favoured.

Camille Pissarro meanwhile had led a life more consistently rural, domestic and with fewer vicissitudes than his younger confrères. He was married in 1861 and his first son, Lucien, who was later to have a modest celebrity as a painter and decorative book-illustrator in England, was born in 1863. Camille was finding his own way and the sober greys and greens of the early landscapes painted at Montmorency, La Roche-Guyon and La Varenne were giving way to a heightened sense of colour and a more personal style, though with a consistent devotion to open-air painting, during the period spent first at Pontoise and from 1868 at Louveciennes. The small allowance had not yet ceased to come from the Caribbean. He was also able to sell pictures for small sums— twenty to forty francs—to one of the few tradesmen and other buyers who were willing to give providential aid to artists struggling and unknown. One of these was P. F. *(le père)* Martin who had also helped Corot and Jongkind and whose collection, when he died in 1892, included works by Courbet, Corot, Monet and Sisley.

There is little to tell of Alfred Sisley in these prewar years, though in the portraits by his friends he comes clearly into view. He was married while still in his twenties and inclines with courteous affection towards his wife in the charming picture *(pl. 68)* Renoir painted of the two in 1868. Bazille portrayed him with a quietly reflective air about the same period and he is again seen, gravely handsome and by then somewhat careworn, in Renoir's portrait of 1874.

A gentle, modest character, he seemed more retiring than his friends and slower to change. He was consistent in his loyalty to Corot but painting in the open as he did with his friends on the Normandy coast, as well as in the forest of Fontainebleau, his style became harmonious with theirs, complementary in particular to that of Monet. In the 'sixties he had what was either the good fortune or misfortune not to need to earn his living by his brush. In this amateur position he escaped the difficulties that beset Renoir and Monet but was not conditioned as they were to a precarious dependence on painting though this was eventually to be his destiny.

Greater contrast could scarcely be imagined in character or style of work than between Sisley and that occasional participant in the symposia of the group of the Batignolles, Paul Cézanne. With his densely black beard and dark piercing eyes beneath frowning brows, he exuded an air of gloomy intensity. In painting, the passion that seemed bottled up in him found vent in a riot of imagination, thick layers of colour heaped on the canvas with a palette-knife, aggressive contours. It was not the work of a tentative or clumsy beginner but of one imbued with a Romantic spirit of violence.

At this time Cézanne was out of accord with the trend towards Impressionist realism. His repressions were sublimated in the scenes of terror and lust which he painted with reckless zest. In this respect he was a belated representative of the morbid side of the Romantic movement. His colour was manifestly not intended to convey natural effect but to heighten the pitch of excitement and express the painter's own tumult of feeling. From a present-day point of view he was a forerunner—by reason of his uninhibited use of vermilion, emerald and ultramarine—of painters

21

to follow and could share with his friend and fellow-southerner Adolphe Monticelli, the fashioner of rich jewels of paint, the description of 'the first Fauve'.

If Henri Matisse and his friends were indignantly condemned as wild beasts of art by the word *fauve* in the early years of this century, Cézanne could arouse much greater animosity in the 'sixties by his anticipation of their freedom of colour. Worse even than a wild beast, he was dreaded as an ogre. Mobs formed in the street when a dealer in Marseilles in 1867 exhibited one of Cézanne's paintings in his window. Ominous signs that their fury would lead to its destruction caused the painting to be withdrawn.

Cézanne in his twenties was more hampered in one way than such other young painters of his generation as Monet and Renoir. A long-drawn battle of wills continued between him and his father, the provincial banker, who had consistently opposed his ambition to paint. Paul had so far won as to come to Paris but was given a niggardly allowance on which he was scarcely able to support life. His works were rejected by Salon after Salon even though Corot and Daubigny, who became members of the Jury of the Salon in 1866, gave him their support.

On the whole, for the Impressionists (not yet so called) the 1860 decade was a period of hard struggle but of growing purpose and of brilliant productions in which the Impressionist idea was already crystallizing. An interlude was to follow with the outbreak of the Franco-Prussian war in 1870. The efforts of Napoleon III to extend the power and influence of France in military and political imitation of his uncle had failed one by one. Manet commemorated the fiasco of intervention in Mexico in his painting of *The Execution of the Emperor Maximilian* (Städtische Kunsthalle, Mannheim) though debarred from showing the work publicly in his exhibition of 1867, as it conveyed all too plainly and painfully the result of Napoleon's meddling and of his withdrawal of French support. The empty challenge to Prussia in 1870 so speedily followed by the German invasion of France and the collapse of the Second Empire brought an element of extraneous drama into the Impressionist story.

4 WARTIME INTERLUDE

The outbreak of war in July 1870 when the boulevards of Paris rang to the cries of '*A Berlin! A Berlin!*' caused a wholesale dispersal of artists. Manet became a staff-officer in the National Guard, ironically enough under the command of the academic *peintre de l'histoire*, Meissonier, with whom of all painters he must have had least sympathy. Degas was assigned to a battery of artillery though the imperfection of his sight was already observed. So swiftly came the military débâcle that by then the Second Empire was at an end. By September the battle of Sedan had been fought and lost and Napoleon III had surrendered.

The German advance was so swift that Pissarro suddenly found his house at Louveciennes was within range of the guns. He was forced to de-camp with his family, leaving behind some 1500 canvases painted since 1855, together with others he had stored for Monet. The Prussians turned his studio into a butchery and used his canvases as aprons—which were soiled with the blood of slaughtered animals. Some paintings, however, were taken away to Berlin and reappeared in sales during the 1920s.

Bazille, whose last big painting in 1870 was of his spacious studio in the rue Condamine in which he painted portraits of Astruc, Manet, Monet, Sisley and himself, enlisted in a Zouave regiment in August. His death in action at Beaune-la-Rolande in November cut short what might have been an outstanding Impressionist career. Renoir joined a cavalry regiment but saw no fighting, serving out his time at Bordeaux and later at Tarbes in the Pyrenees.

Sisley, who was not a naturalized Frenchman though he never wished to live elsewhere for long, visited England either towards the end of the war or just after it in 1871 at the time of the Commune. Cézanne went back to Provence and settled at l'Estaque, not far from Aix, with the young woman he was to marry, Hortense Fiquet. No strenuous effort seems to have been made to draft him in the army, perhaps because his immersion in a world of his own seemed total and beyond reclaim. When asked what he did during the war he was able to say that he busied himself with the *motif*.

The most interesting results directly attributable to the wartime changes of scene were the pictures painted abroad by Monet and Pissarro. They came together in England. Pissarro after the flight from Louveciennes and a brief stay with his friend the painter Ludovic Piette in Brittany, took his family across the Channel to stay with a married sister in south London. Monet was painting in the region of Le Havre when the war began. The picture of shipping, *L'Entrée du port de Honfleur* which owes something to the spirited treatment of Manet's *Combat of the Kearsarge and the Alabama* (as seen from the coast at Cherbourg), is dated 1870 (Johnson Collection, Philadelphia). Besides sharing the republican (i.e. anti-Second Empire) feeling of many other French artists Monet had

the impatience, not uncommon in them also, with war as an intrusion and waste of a painter's valuable time. In the autumn he too made up his mind to go to England to avoid being drafted into the army. By then married to Camille Doncieux, he was assured that she and their small son would be safe under Boudin's protection. According to Michel Monet's account she joined him in London later. The records of the stay are vague enough, though specific addresses are given. They were conveniently near to the subjects he painted: Arundel Street, close to the river and the Houses of Parliament and Kensington, convenient for the park.

Pissarro at South Norwood was prepared to demonstrate that light could invest the unspectacular suburban scene of Sydenham Road and the neighbourhood of the Crystal Palace with its own beauty, though something of architectural primness peculiar to the Victorian period is inevitably apparent in the Gothic Revival church, the heavily gabled villa, the neat fencing and other insular features he did not hesitate to include. But there was a clarity and truthfulness in his vision that added its own pictorial virtue *(pl. 14)*.

In the heavier air of central, riverside London, smoke-laden and chromatic, Monet found an effect of atmosphere new to him, inspiring a magnificent view of the Gothic towers of Parliament, reduced to a blue silhouette, delicate against the contrasting sharpness of a jetty. One might look in such a picture for a sign of the influence of Turner, whose work the two French painters studied in the National Gallery, but in fact of Turner there is no trace whatever. The only painter with whom Monet might be compared in his *Westminster Bridge* (Lord Astor of Hever, London) of 1871 *(pl. 17)*, is J. McNeill Whistler. The *Nocturne in Blue and Green* that Whistler painted in the same year is like the Monet in silhouette, unified tone and the careful placing that suggests a lesson imparted by Japanese prints, but there is no evidence of any special

contact between the two artists at this date. The atmosphere of London may be credited with inspiring this similarity of result.

It was fortunate for Monet and Pissarro that other compatriots were in London, in particular Charles-François Daubigny. Daubigny, a successful landscape painter, fifty-three years of age in 1871, had been one of the early visitors to Fontainebleau and to that extent is to be regarded as belonging to the Barbizon School though most of his work had been done elsewhere, on quiet stretches of the Northern French rivers, at Villerville on the coast near Honfleur and Auvers, where he had his house.

Daubigny was no stranger either to London or to Monet and Pissarro. British taste in the High Victorian age extended as far as Corot and the Barbizon School and there were British admirers of Daubigny, among them Sir Frederic Leighton who had one of his works in his personal collection as well as a Corot. In a public or Royal Academic capacity Leighton was instrumental in inviting Daubigny to London in 1866. He had come, had painted views of the Thames and had a picture shown in the Royal Academy, an *Effet de Lune*. He exhibited a second time at the Academy in 1869 when Corot was also represented.

Daubigny in France had been an enlightened supporter of the Batignolles group and as a member of the Salon jury had supported Renoir and Cézanne in 1866, had exerted his influence on behalf of Monet, Manet and Pissarro in 1868, and, along with Corot, resigned from the Salon jury in 1870 because Monet was not accepted by their fellow-members. One of the first French painters to complete pictures in the open air he had long been admired by Monet and his friends. His admiration in turn was extended to their efforts which were not without influence on his own work. He had the Impressionist feeling that space and light could touch any painted scene whatever with magic *(pl. 5)*.

It was fortunate for Monet that he should meet in London one so well acquainted with his career

to that date and so sympathetic with his aims. Monet's financial predicament was relieved by Daubigny's introducing him to the dealer, Paul Durand-Ruel, who in the prevailing confusion of war had thought it an opportune moment to establish a gallery in Bond Street. His purchases relieved a situation that was little short of desperate.

In Victorian England Monet and Pissarro were completely out of their element. The Academy into which Corot and Daubigny had been admitted was little disposed to give its countenance to more and more unconventional forms of foreign painting. The works submitted by Monet and Pissarro were turned down. What the Academicians painted and approved of were pictures that told a story, whether in antique guise like those of Alma-Tadema or in contemporary dress like those of Frith, and the story as the British painter knew how to tell it was what the picture-buying public liked best.

Impressionism was to remain a blind spot of the insular connoisseur. Durand-Ruel could make no headway in Bond Street nor did the French exiles find common ground with painters in London.

If France had her Alma-Tadema and Frith in the persons of such Salon men as Léon Gérôme and Meissonier there were by way of compensation rallying points of opposition such as the Café Guerbois had been. But in London Monet and Pissarro were unable to discover any similar meeting point of kindred spirits. Pissarro wrote bitterly to Théodore Duret, who had been one of the Guerbois habitués and was later to be an historian of Impressionism, of the jealousy and mistrust he encountered among confrères. 'Here there is no such thing as art; everything is treated as a matter of business'.

In view of their cold reception it is not surprising that they wished to return as soon as Paris was herself again. Their disappointment however was not so keen as to determine them never to set foot in England again. In later life both visited London once more. There is a curious consistency in the fact that after an interval of over twenty years each went back to the same type of subject as had engaged them at first; Pissarro to the suburban scene at Bedford Park and Kew, and Monet to the bridges of the Thames and the foggy grandeurs of Westminster.

25

5 THE HEROIC DECADE

Both were back in France by the end of 1871. Monet went by way of Holland, probably in company with Daubigny who bought one of his pictures of the waterways and windmills of Zaandam. A kindred outlook appears in the sense of space that both gave to their paintings of Dutch landscape. Pissarro arrived in Paris before Monet, in June, the month after the Commune, the exasperated move that followed the ignominy of defeat, had been put down by the forces of the acting government at Versailles.

Now that the upheavals of war, including civil war, were past Monet and Pissarro seem to have looked to the future with calm and optimism. There were artists roused to indignation by the suppression of the Commune. Manet produced two lithographs of protest, *Civil War* and *The Barricade*. One of Daumier's last drawings before his sight failed was of *Peace* as a piping skeleton and a stern figure of Paris pointing to a grave-yard and crying 'Enough!' Yet the landscape painter, absorbed in the study of non-human nature in the open air, was less capable of strong political feeling than these townsmen—or than Courbet whose active part as a Communard and supposed responsibility for pulling down the Vendôme column led to his imprisonment—and long subsequent persecution. With characteristic loyalty to an artist he admired, Monet, together with Boudin, paid him a visit of sympathy after Courbet's incarceration at Ste Pélagie.

But the country, free of social and political complications, again promised more attraction than the city. The official climate was less propi-tious than ever to the radical flavour of 'social realism'. Manet's offer to decorate the new Hôtel de Ville, replacing the building that was burnt down in the rising, with wall paintings of 'the public and commercial life of our time', true as it was to the spirit of *contemporanéité*, was treated with contempt and not given the courtesy of an answer. Neither Monet nor Pissarro was averse on principle from painting city views, as many beautiful pictures of the boulevards were still to show but their concern with light gave a secondary place to topography, human character or social implications. There were other reasons for betaking themselves as they did to rural retreats, considerations of economy being as pressing in the 1870s as they had been long before for the first painter-settlers at Barbizon.

Monet rented a small house at Argenteuil in December 1871. He remained in what was then a pleasant village on the Seine, not yet an indus-trial suburb of Paris, until 1878 when he moved farther away from the capital in the direction of Rouen to the village of Vétheuil, also on the Seine. Pissarro, after a rueful look at his house at Louve-ciennes which the Prussians had pillaged, decided to move to Pontoise where most of his work was done in the following ten years.

This was the heroic decade when Impressionism gained its name, when the Impressionist exhibi-tions were the centre of controversy and in the long run, though only after a gruelling struggle, success came to the painters concerned. Monet was now clearly a leader, in force of character, originality of style and desire for group action.

Pissarro was the Nestor of the movement full of wise counsel and unselfishly ready to place his experience at the service of others. It is only necessary to look back at their history hitherto to see how little they directly owed to the English masters of landscape and to realise that no sudden flash of revelation came from the Turners and Constables in the National Gallery and the South Kensington Museum. But this would be far from saying that they derived no encouragement from the sight of these works; encouragement in the signs of likeness of aim and no doubt also some satisfaction in those respects in which they prided themselves on original departure. The analysis of shadow referred to by Pissarro is an instance in which they could maintain that they had gone farther than Turner (or done something he did not attempt). The Impressionist technique was now fully developed and confidently applied. Blacks and browns were banished utterly. Differences of light and shade were not degrees of light and darkness but of nuances of colour applied in small separate strokes. The light of day was rendered as never before; the rays of the sun permeated every inch of the painter's canvas. At Argenteuil there came about one of those rare and splendid occasions when enthusiasm brought a whole group of artists into close harmony of style and feeling.

The place itself fostered their mood; geography here as in other aspects having its correspondence with the spirit of an art. It is strongly characteristic of Impressionism that it flourished in an essentially temperate and placid zone. The painters eschewed effects of violence and mystery. They did not repair to the mountains to savour, like the Romantic, the grandeur of heights and depths, the impressiveness of Alpine storm. They wished for little incident in their skies—a little train of woolpack clouds would usually content them. The rarer phenomena of nature interested them hardly at all. Only in his early painting of the jetty at Honfleur did Monet introduce a rainbow.

Lightning never flickers in his landscapes or those of his confrères nor was the poetry of moonlight much to their taste.

Normandy, the Ile de France and Brie were the Impressionist domain. The fertile, well-watered plain with its equability of climate, neither too hot nor too cold, was entirely suited to their aims. In its tranquillity the region offered, as it were, a still-life to the *plein-air* painters. The Channel could be rough when they chose to paint on the Normandy coast but they were under no obligation to paint such heaving mountains of salt water as Turner in his *Calais Pier* (National Gallery, London), they could wait for the day when the slighter breeze produced only the moderate choppiness that had delighted Boudin. The rivers provided most of what they sought, the reflection of sky, the changing colours of an almost imperceptibly moving surface. The Seine, the Oise and the Marne, the tributaries and their environs quiet and unaffected by the passage of time, were ideal for the Impressionist purpose. Paintings with these themes in summer were frequent enough to give the feeling that Impressionism was the celebration of an Elysian and protracted day of sunshine. As a painter Renoir would have wished it always to be so, though his friends took pleasure in the differences of season, painting landscapes under the snow that Renoir grumbled at as 'the leprosy of nature'. Monet, Pissarro and Sisley in their winter scenes followed Courbet who had so often painted forest trees with snow-laden branches. But Courbet's effects were grey and white. It was in keeping with the Impressionist vision to show with how much of the spectrum the virginal whiteness was composed. Among the most beautiful Impressionist paintings are those *Effets de Neige*, especially under a winter sun where the scene is made at once brilliant and extraordinarily realistic by the blue shadows and tints of pink and yellow that sparkle on the snow. Argenteuil had much to commend it as painter's ground. It was part of that panorama of the Seine that furnished the Impressionists with a wealth of

motifs. There were fine trees in the wooded way by the river and the river was a delight in itself with its multitude of skiffs and yachts, their white sails making cheerful patterns as they glided past the Ile Marante. That the architecture of the place was undistinguished was no drawback to painters confident of their ability to enliven any scene by the light with which they invested it.

There was a practical advantage in addition, which painters had earlier found in Barbizon and the Impressionists valued in their various places of work along the Seine. Though as yet just outside the suburban zone, Argenteuil was close enough to the capital to enable the poverty-stricken painter in extreme need to seek some modicum of subsistence there and sell a picture or two for some small but badly wanted sum. Hardships in plenty were still to be faced in the 1870s, by Monet especially, calling for such expeditions. Yet the masterpieces he now painted —and the Argenteuil period is rich in paintings that can certainly be so described—convey only a singular buoyancy of spirit.

More determinedly than ever he painted in the open. Following the example of Daubigny, who had turned a river craft into a floating studio, *le botin*, in which he made leisurely cruises along the Oise, painting as he went, Monet adapted a small boat to the same purpose. Manet's oil sketch of 1874 shows him painting under its canvas awning with Mme Monet behind in the green-painted cabin he built onto it, big enough both to store his gear and to sleep in.

Though Manet had been the hero of the group of the Batignolles and had encouraged by his example a direct manner of painting, he had not sought to countenance novel theory. He had no urge to paint in the open air. He had no more objection to black or a dark area if a composition should seem to require it than the Spanish Old Masters he so much admired. It is to that extent surprising to find him for a summer at Argenteuil, not as the monarch of the Café Guerbois receiving the homage of his subjects, but as a companion on

an equal footing, taking to the *plein-air* practice of the younger men, so far acknowledging the leadership of Monet as to follow him in certain points of style *(pl. 25)*.

That the Manets had some family property in the neighbourhood would partly explain his coming to Argenteuil for a while, but painting in the open, and with the division of colour Monet used, represents a conversion to which he was persuaded by another artist, the gifted woman, Berthe Morisot. A member of a cultivated but conservative bourgeois household, she had been allowed to take lessons in painting as a girl and had quickly shown an independence of character and instinctive sense of what was currently best in art. Contrary to the advice of her conventional art master, Joseph Guichard, she formed an idea for herself of the value of open-air painting when she was nineteen, and during the 1860s had the advantage of working with Corot out of doors at Ville d'Avray. She began to exhibit at the Salon in that decade, in 1867 sending a *View of Paris from the Trocadéro* (Private Collection, Florida) which attracted Manet's attention and seems to have influenced the panoramic treatment of his own picture of the World Fair. The two families, the Manets and Morisots, came to be on very friendly terms. Berthe in 1868 posed for one of the figures in Manet's *The Balcony* (Louvre) and in 1874 married his younger brother Eugène. Her independence of judgment and method drew her towards Monet, Pissarro, Renoir and Sisley. In spite of her admiration for the painting of Edouard Manet she was not uncritical of his more pronouncedly 'Old Master' moods, as for instance in the portrait of his pupil Eva Gonzalès (National Gallery, London). There is reason to suppose that her defence of what could already be termed Impressionist painting added its weight to the example of Monet and his friends at Argenteuil. He was still primarily a painter of human beings—of the gay holidaymakers in their boats, yet the key of colour was generally lighter, sunlight was diffused in the Impressionist

style so as to envelop both landscape and figures. The sympathetic likeness between the paintings of *La Grenouillère (pl. 59)* by Monet and Renoir before the war, became an even closer relation in the work of the two at Argenteuil. In scenes of regatta *(pl. 27)*, vibrant with atmospheric blue, drenched in light, they arrived at times at an almost identical point. Argenteuil, where Sisley made an occasional appearance, was balanced as a centre by Pontoise where Pissarro had settled. Pissarro took pleasure not only in the undulating country around but in the spectacle of peasant life. Millet gave him an example—though in some respects an example not to follow as Baudelaire had acutely remarked. The suggestion of unspoken words on the pathos, hardships and humble faith of the peasantry was alien to Pissarro. Realism that diverged into emotional comment revived a romantic heresy from his point of view and that of his friends. Closely as he studied the farmworkers, male and female, of the region, with more feeling for rustic life than Monet, he strictly confined himself to externals. The primary importance of light remained as the unifying element between landscape and the hard-working population by which it was inhabited.

Calm, objective, restrained with the restraint he had first derived from Corot and, in the 1870s, also some of the mature perspective of middle-age, Pissarro was perhaps the only mentor whom at this time the passionate and difficult Cézanne would have willingly accepted. That he did accept it is shown by the change of his work when, escaping from family oppression, he came to Pontoise with his wife. The southern temperament was subdued to that of the north. The fire of wild imagination was banked down by Pissarro's reasoning. It was a chastened Cézanne who in 1873 produced the landscape, *The Suicide's House* (Louvre) *(pl. 19)*. That a man had committed suicide in the house shown in this picture was irrelevant to its character and Cézanne's sense of the dark and mysterious was not involved. Albeit still with rough thicknesses of paint, in this work he began seriously to examine the visible world and to pay heed to Impressionist method.

In spite of these networks of relationship and fruitful interchanges of thought, Monet, Sisley and Pissarro in 1874, as far as they were known at all, would have seemed to the outside view not so much the nucleus of a brilliant group as struggling individuals, penurious, unimportant and obscure. They went from one financial crisis to another, were reduced to desperate shifts, which indeed prompted the thought of a group exhibition to bring their work directly to the notice of buyers. A brief boom after the war was followed by a slump which badly hit Durand-Ruel who had been one of their standbys. With a gallery full of unsold pictures and with clients many of whom looked askance at his recent acquisitions, the dealer was unable, for the time being at least, to help.

The artists consulted were mostly in favour of the group exhibition, though Manet, still clinging to the idea that the Salon was the only proper place in which to exhibit, refused to join in. Degas was anxious that it should not be a second Salon des Refusés, bringing them, as he had sarcastically remarked of Manet in 1863, 'the celebrity of Garibaldi'. He suggested therefore that a number of respectable and more conventional painters should be invited in addition to the inner circle of intransigeants. That this was done accounts for the number of contributors who have otherwise little claim to figure in Impressionist history. Whether the exhibition should have a specific title was also a matter of debate. Renoir who was essentially of conservative disposition and not at all desirous of being labelled a revolutionary firebrand, was against a name that would suggest a new 'school'. Accordingly the exhibition which opened on 15 April 1874, two weeks before the Salon, at 35 Boulevard des Capucines, in premises previously occupied by the photographer Nadar, was styled simply as a cooperative venture—a *Société anonyme* —of painters, sculptors and engravers.

If the experimental treatment of light and colour be regarded as the criterion, a good half of the exhibitors had no necessary part in the show. Nor was there unanimity in the selection. Pissarro had to fight hard for the inclusion of his friends of student days, Armand Guillaumin and Cézanne, in whom he saw great powers still to develop, an estimate that Degas was far from sharing. But the critics of the press had no difficulty in picking out the original works and making them their butt. The badinage of Louis Leroy in *Le Charivari* was as unerring in its choice of victims as it was uniformly silly in comment. He wasted no time on such mild productions as those of Lépine and Ottin, but singled out Renoir, Monet, Sisley, Pissarro, Degas, Berthe Morisot and of course Cézanne, who exhibited so little Impressionist a work as his *A Modern Olympia* (Louvre). How this jeering critic came to invent the name, Impressionist, from the picture by Monet catalogued as *Impression: Sunrise (pl. 18)*, which depicted a red sun seen through mist over the water at Le Havre, is well known.

It is a paradox of ignorant attacks on works of merit that they often do more good than harm, giving a sort of jet impulsion to what they aim to destroy. So it was in this instance. At the time it may have looked as if the destructive aim had been achieved. The exhibition was a failure financially and the group promoting it an object of ridicule. Yet what a gain it was to have a name to appropriate and boldly flaunt like a banner of defiance. And more than a name, how clearly did the term 'Impressionist' convey that the unity of the group was not one of personal acquaintance simply but of a cause.

If the official world and the wealthy connoisseurs turned stony faces to the newly-named Impressionists, the latter had fortunately a few supporters who believed in their painting and would buy examples, though at what now seem pathetically small prices. There were the amateur painters who identified themselves with the group, followed the example of its leaders and in the role of patrons were of material assistance. Gustave Caillebotte, the shipbuilder who made the acquaintance of Monet at Argenteuil and contributed to several of the Impressionist exhibitions, brought together in this way the great collection he bequeathed to the French state in 1893. Henri Rouart, the engineer friend of Degas, also a regular contributor to the Impressionist exhibitions, bought numerous works by Manet, Monet, Pissarro, Renoir and Cézanne.

Other patrons were an oddly assorted company: the confectioner Eugène Murer; the Rumanian doctor de Bellio, who tided Pissarro over various difficulties; the singer Faure; the artists' colourman Julien Tanguy, who would take a painting in exchange for paints and other materials. A minor civil servant with unusual discrimination and the especial champion of Renoir and Cézanne was Victor Chocquet, whose sensitive features have been immortalized by both. For a time Monet had the support of the financier Ernest Hoschedé until the latter's ruin in 1878.

Selling a picture occasionally for a small sum was far from being a dependable livelihood and the regard of the few was offset by the general disapproval of critics and public which continued long after the exhibition in the Boulevard des Capucines. The auction at the Hôtel Drouot in the following year was an equal fiasco. At the second Impressionist exhibition held in 1876 at Durand-Ruel's gallery in the rue Le Peletier, the number of exhibitors was reduced from thirty to nineteen by the defection of those who feared the adverse publicity or had decided that Impressionist aims were not theirs. Monet, Pissarro, Renoir, Sisley, Degas and Berthe Morisot were all well represented, though new critical bugbears appeared such as Albert Wolff who observed, 'After the fire at the Opera here is a fresh disaster that has overtaken the quarter.'

It says much for the determination of the group that the exhibitions continued. Sheer pertinacity helped to turn the tide in their favour. Though the

size and composition of the eight exhibitions held from 1874 to 1886 varied considerably, Pissarro, Degas and Berthe Morisot were steadfast from first to last. The sixth exhibition was greeted with enough approval for Huysmans to say that 'Messrs Pissarro and Monet have at last emerged victorious from the terrible conflict'. Durand-Ruel was at last finding a market for works that had been piling up in his galleries and absorbing much of his capital. The eighth and last of the Impressionist exhibitions in 1886 coincided with the Durand-Ruel exhibition in New York that placed a final seal of international success on the movement as a whole.

How the artists had developed during these heroic years of struggle can only be estimated by considering the work of each individually for there is no criterion by which Impressionism may be judged apart from the different forms it took according to the artist concerned. Claude Monet seems so much the centre of the movement that there is a tendency to regard him as the one perfect Impressionist with others admissible only in so far as they adopted his practice of painting in the open directly from nature, with the substitution of clear colour in place of the traditional chiaroscuro. But anxiety for clear definition can make for too great exclusiveness. Théodore Duret in his *Histoire des Peintres Impressionnistes* chose deliberately to omit Degas, even though he contributed to all but one of the eight Impressionist exhibitions. Degas, said Duret, belonged to an earlier generation, for one thing (he skimmed over the fact that Pissarro was four years older than Degas!) But he was mainly disqualified as one who never deviated from the technique he first acquired (a statement that overlooks the technical audacities of Degas in pastel) and remained a draughtsman on classic-academic lines. The critic arrived at a definition that applied primarily to landscape. It ruled out the painting of life and action as opposed to inanimate nature, though it would be hard to maintain that the representation of any scene as immediately glimpsed in totality or recalling the immediate impression was anything other than Impressionist. Manet, Degas and Renoir may be grouped together in giving such vivid impressions of contemporary life. It is sometimes overlooked that every theme of the painter—portraiture, genre, still-life, the town view, the rural scene—has its Impressionist interpretation. A point has been made in this visual history of an arrangement that brings together and illustrates the nature of each genre.

There is Impressionism in the informality of the portrait as practised by Manet and Degas, in which the sitter is as it were taken unawares in the least conventional of attitudes and the most casual assortment of accessories. This is how Manet saw Mallarmé, when the poet reclined at his ease, one hand tucked in the pocket of his coat, the other turning the page of his book. In the painting now in the Louvre he heightened the instantaneous effect by the varied sharp notes of colour against the general simplicity and even by the ascending smoke of Mallarmé's cigar.

With a similar feeling of introduction to a personality both immediate and intimate one may view Degas's portraits—made in 1879—of Diego Martelli (National Gallery of Scotland) *(pl. 73)* and Edmond Duranty (Glasgow), these two critics and supporters of the Impressionists being surrounded by the homely confusion of implements of their literary trade. They seem the more taken unawares by the fact that Degas has portrayed them not at eye level but as seen from above.

The intimate group portrait was another of the Impressionist achievements. Its progress might be traced as a part of open-air study from a family group painted by Bazille in 1867 by way of the work of Manet and Renoir at Argenteuil as far as the informal open-air groups of Bonnard, though Bazille's *Family Reunion* on a terrace near Montpellier was still rigidly posed; the members had the air of stiffening as if a photograph was being taken. Bazille, in fact, made no secret of

using photography from time to time, nor indeed did the Impressionists generally show hostility to the camera. But in Monet's garden at Argenteuil in 1874, Manet and Renoir showed the vivid effect to be gained by swift, direct painting in the portraits they executed together of Mme Monet and her son, each combining the naturalness of light with an unaffected ease of attitude. The many beautiful portraits of women painted by Renoir in the 1870s showed to what extent the vibration of pure colour could be used to convey feminine charm.

Surprising in Renoir is the speed with which he absorbed the Impressionist aims, the release of colour, the new sense of light, and was able to turn them to varied employment in portraiture, landscape and scenes of popular life. His first great picture of contemporary life, *La Loge* (Courtauld Institute, London) *(pl. 71)*, exhibited at Nadar's in 1874, was composed in the conventional manner in the studio, the artist's brother and a professional model sitting separately for the figures. Renoir made little attempt to convey the atmosphere of the theatre but the picture he began in the following year, *La Première Sortie* (Tate Gallery, London) *(pl. 74)* shows him to be grappling with essentially Impressionist problems of vision.

In addition to the problem of translating the incidence of light into colour, there was that of rendering what the eye was capable of seeing at any given moment. The objects on which it was mainly focussed would be sharply distinct. Others outside the eye's immediate range, which in some mysterious way were also present to the vision, could be plausibly represented in blurred fashion. So Renoir, having focussed attention on a charming young girl in the theatre box, gives a confused glimpse of the audience in the background and by this means also conveys something of the excitement of the occasion.

A similar effect is given by the mirrored audience in Manet's masterpiece of 1882, *Un Bar aux Folies-Bergère* (Courtauld Institute, London). But

Manet, like Degas and Renoir, was one who pursued a complex course. Manet, as he said in the apologia of his catalogue in 1867, had never attempted to do away with an old system of painting, nor did he 'want to create a new one'. He had 'simply sought to be himself and no one else'. Sometimes he veered towards the course followed by the Impressionists, sometimes away from it. There is a striking contrast, for example, between the two pictures he painted in 1868, *Le Balcon* (Louvre), the group portrait of the painter, Antoine Guillemet with Berthe Morisot and the violinist, Jenny Claus, and *La Lecture* (Louvre), the portrait of Manet's wife with her son who is reading aloud. The balcony group, with the figures set against a deeply-shadowed interior suggests that Manet was inspired by Goya's treatment of a like subject. *La Lecture* was painted in a quite different style, in a lighter key and with the indication of daylight falling on the seated figure from the curtained window. It seems possible that Berthe Morisot had by then improved upon their acquaintance to speak enthusiastically of such painting as had light and sun in it, and that Manet took notice of these remarks. There is even a hint of Berthe Morisot's own style of portraiture, which added the charm of light to that of feminine personality, in the portrayal of Mme Manet.

At all events here is Manet in two aspects, the traditionalist and the innovator in spite of himself and his hankering for respectability. Again in 1873, after a visit to Holland, Frans Hals was very much in his thoughts and the aroma of good living and humorous character was so strongly reminiscent of the old type of genre portrait in his painting of the engraver Bellot—*Le Bon-Bock* (Private collection, Philadelphia)—that a philistine public showed approval of Manet for the first time and those who had admired him as the leader of an avant-garde were correspondingly disappointed in him. Yet in the year following he entered so far into the spirit of Monet's work at Argenteuil that one might think his conversion

to Impressionism complete. That this was not so is indicated by his refusal to join in the exhibition of 1874 and he was gravely concerned by the wilfulness of Berthe Morisot as his pupil in siding with Monet and his friends of the Boulevard des Capucines.

In the paintings of the contemporary scene by both Manet and Degas there was an original quality of vision rather than a scientific preoccupation with the properties of the spectrum. They were fascinated as Parisians by the spectacle of the cafés, boulevards and theatres.

Between 1860 and 1870 Degas gave up the 'history' painting to which he was first drawn by the example of Ingres—such classical themes, as the *Young Spartans Exercising*, of which he painted three versions in about 1860. He embarked instead on a course in keeping with the contemporary spirit of realism, though he remained firmly opposed to the practice of painting in the open air, had little or no interest in landscape and attached all that importance to drawing that the rules of the classicist demanded. A beach scene, *La Plage* (National Gallery, London), *c.* 1876, has nothing of the breezy atmosphere of a Boudin or the sunlight Monet captured on the Normandy coast. Instead, Degas made an arrangement of forms as studied as in Whistler's 'arrangements' of the same decade, indicating similarly with what care he had considered the nature of design in Japanese prints. More congenial subjects than the seaside were firstly the race-meeting, then the opera and thirdly the ballet, which inspired the exquisite productions that are among the most famous works of his century. Degas's innovations in composition show one facet of his originality. They were evolved from two different sources—the Japanese print and the photograph. Unrelated as these sources of inspiration might appear, they tended towards a similar conclusion. A whole new range of design was implicit in the abandonment of the old centrally-focussed style of pictorial composition, with its symmetrical balance, and the use instead of asymmetry. The unconventional placing of objects to one or other side or corner of the canvas after the manner of the Japanese *ukiyo-e* school made available an amount of free space that could be turned to dramatic effect. Thus Degas could suggest the movement of his ballerinas as much by the empty area of stage on which they had yet to advance as by their own poise and gesture.

The camera in the 1870s had reached a stage of development parallel with that of realism in painting, in the form of instantaneous photography. The arbitrary slice of life cut out by the lens was natural in a way that the posed photograph demanding a period of painful stillness could not be. This quasi-photographic effect is seen in Degas's *Carriage at the Races* (Boston) one of the exhibits at Nadar's in 1874. Just as the camera might have done, the artist cuts off the carriage wheels and one of the horses in bringing the equipage into foreground prominence.

In 1870 however, Muybridge had not yet produced the studies of 'animal locomotion' which truthfully showed the action of a galloping horse. Degas painted the racing horses in the distance of his *Carriage* pictures according to the old convention with all four legs outstretched and off the ground. It is possibly significant that when, towards the end of the decade, Muybridge's series photographs of motion gained much publicity and discussion, Degas gave far more attention to unconventional movement. Without attempting to convey the impression of the gallop he depicted the varieties of motion of horses brought up to the starting point which his own photographic accuracy of vision recorded. He observed human movement as keenly, though the sharpness of eye that gave as unemotionally objective a view of the dancing lesson as that of *The Dance Foyer at the Opera* (Louvre) *(pl. 82)* in 1872 was supplemented after the passage of some years with a perception of the ecstatic illusion into which the drill of rehearsal was finally transformed. A poetry beyond the capacity of the camera to achieve is to be found in the marvellous

33

pastel of 1878 in which a dancer with a bouquet makes her bow in a triumphant shimmer of artificial light (Louvre) (pl. 84).

Artificial light introduced complications different from the diffused light of day favoured by the landscapists, but in an interior at night it made for just as much an 'Impression'. Even so open-air a man as Monet could apply himself to the lamp-lit scene of The Evening Meal with the Sisley family at table, probably just before the Franco-Prussian war (Bührle Collection, Zurich). It is a picture that sympathetically foreshadows the intimate interiors that Bonnard and Vuillard were later to paint, though exceptional in Monet's own work and—in making for a return to the old contrasts of chiaroscuro—uncongenial to his way of thought.

In the place of entertainment there was less of the placid depth of shadow. Light ricocheted unpredictably from one point to another, reflected false jewels of colour, entangled human beings in an intricate and insubstantial network. Manet, fascinated like Degas by the glittering spectacle of the theatre and the café-concert, produced the masterpiece of Impressionist genre, La Serveuse de Bocks (Louvre) (pl. 72) and, two years before he died at the age of fifty-one, that extraordinary combination of portrait, still-life and glamorous sensation, Un Bar aux Folies-Bergère (Courtauld Institute, London). Yet Manet, restless in temperament, was not a consistent devotee of the place of entertainment as Degas was. In the last three years of his life he returned to painting pictures completely in the open air. His paintings of the garden at Bellevue, where he stayed in 1880 for medical treatment, were brilliant in their splashes of light and dark colour though with more of descriptive local colour than the out-and-out practitioner of Impressionist method would allow (pl. 93).

Renoir shared with Manet and Degas a love of the town, though at a more popular level. In a Montmartre where the working windmills that Georges Michel had painted had been turned into

dance-halls patronized by the commonalty of the region, but were not yet the resort of tourists or flashy with the febrile sophistication of the 'nineties, he found subjects that suited him perfectly. The Moulin de la Galette (Louvre) (pl. 60) was one such place, still rural in atmosphere, decorous in working-class gaiety, that provided the theme of a masterpiece in 1876. The feeling, always strong in Renoir, of a link with the past, appears later in his paintings of holiday-making Parisians. The cheerful vulgarity of the Luncheon of the Boating Party at Bougival (Phillips Memorial Gallery, Washington) (pl. 94) is refined by his touch into a memory of the aristocratic fête champêtre.

The impression of the street was a theme to which Manet, Degas, Renoir and Monet all applied themselves. They did not search for such ancient and picturesque aspects of the city as remained. The new boulevards unlike those medieval alleys that resisted the sun, sparkled with light. Whether or not they had been intended by the wish of the Emperor as broad ways making it hard to barricade and easy to shoot down insurrection, they permitted a flow of humanity that delighted the painter's eye. No one perhaps has better expressed the sense of sheer delight, of joyful promise in the Parisian boulevards in spring, than Renoir. How gay too was his Pont Neuf of 1872 (Marshall Field Collection, New York), with its flocculent clouds sailing leisurely past and the noon sun throwing short violet shadows from the pedestrians, horse-buses and carriages. Manet in his picture of the Roadmenders in the Rue de Berne (Lord Butler) (pl. 32), in 1878 painted a street scene that was a masterpiece. Impressionist in its light key and blue shadows, but typically achieving the effect of light by a sketch-like spontaneity. The moving panorama of the boulevards incited both Monet and Degas to draw suggestions from the photography of the time or to produce a comparable effect. In Monet's picture of the Boulevard des Capucines in 1873 the figures seen from above and at a distance are

blurred in a fashion that resembles some of the still imperfect efforts to capture movement with a camera. They aroused the ire of M. Leroy's imaginary painter in the critical dialogue about the first Impressionist exhibition that appeared in *Le Charivari*. He asks, 'Be so good as to tell me what those innumerable black tongue-lickings in the lower part of the picture represent?' and is convinced that he is being made fun of, when told they are people walking along. From a present day point of view the total effect is uncannily that presented by a casual crowd.

Renoir, as in the painting of the Place Pigalle about 1880 *(pl. 92)* arrived at instantaneousness in combining the figure distinctly seen at close quarters with the vague movement of figures behind. Degas indicated the movement of strollers in the Place de la Concorde by adding to his portrait group of the Vicomte Lepic and his daughters a boulevardier behind them who is only half in the picture. Dr Aaron Scharf in his fascinating book, *Art and Photography*, aptly compares the Degas with an instantaneous photograph of Borough High Street, London taken in 1887, in which movement is arrested at a similar point. In various ways Impressionism made for a new approach to traditional themes not excluding still-life which through the example of Courbet and Manet *(pl. 54)* was revived as an exercise in pure painting and the study of light. Flowers were no longer necessarily identifiable by exact botanical shape but were of value to the painter as interceptions of light. Fruits and other edible elements of still-life were no longer simply a tempting array of good things but forms that displayed many modulations of colour.

That Impressionism was solely a vision of unspoiled landscape would evidently be a misapprehension, though many beautiful paintings by Sisley and Pissarro in the heroic decade could be so described. Sisley of all the Impressionists was one for whom the local ties of landscape were strongest. The earthly paradise for him was located in the valley of the Seine and the Ile de France and such river villages as Moret-sur-Loing where he finally settled. On his few visits to England he looked only for an equivalent of the Seine in the Thames at Hampton Court *(pl. 23)*. He was, it is said, the most harmonious and least venturesome of the group in his work but the harmony was not a quality to be underestimated. It was the product of the sensitive response to nature that made him at one with the scenes he depicted and for which he had an intimate affection. 'In any picture', he remarked, 'there should always be some beloved nook—it is one of the charms of Corot and of Jongkind too'. A footpath wandering irregularly by the shore of the Seine or the Oise, a cluster of quiet houses reflected in the rippling waters of river, canal or flooded meadows sufficed for those paintings of the 1870s among which many of his best works are to be found.

The feeling of serenity, rarely missing from Impressionist paintings even when the artists were in greatest want and material misery, is especially remarkable in Sisley, whom the collapse of the prosperous family business in the war of 1870 had turned from a wealthy amateur into a struggling professional. In 1878 he made the despairing proposal to paint thirty pictures for a collector at a hundred francs apiece. From this bleakness he could turn to the blissful calm and serene cloud-dapple of the skies which, like Constable, he looked on as of key importance in any landscape painting *(pl. 34)*.

Idyllic also are the landscapes which Pissarro (in equally desperate plight financially) was producing in his wanderings about the Pontoise country *(pls. 29, 30)*. By some alchemy of his own he could even turn a factory chimney on the banks of the Oise at Pontoise into an adjunct of the rural scene. Monet and Renoir had conveyed something of this happiness of feeling in their landscapes at Argenteuil but their range was far more extensive.

Neither Monet nor Renoir evinces quite the same affection for the countryside as Sisley and Pissarro.

Renoir was magnetically attracted towards humanity as a subject and especially the charm of the young. Monet was so little concerned with subject basically that it would be paradoxical, though not inappropriately so, to say that he could take on with equanimity the greatest variety of subjects. For this reason he was often unexpected, as in his painting of *Men Unloading Coal*, 1872 (Durand-Ruel Collection). The men coming and going from the barges with their dark loads almost suggest that for once he intended social comment, like Gustave Doré with his procession of workmen along the grim balconies of Thameside warehouses—though nothing more may have been in his mind than the pattern their movements formed. Monet had no objection to such ugliness as that of the iron railway bridge at Argenteuil, which he painted in 1873, its bulk providing a bulwark to the composition (as so often he and his friends made bridges do). Nor was he to be deterred by the spectacle of locomotives in a railway station. Pissarro may have been first to tackle the subject in his picture in 1871 of a quaint little engine at suburban *Penge Station* in England (Courtauld Institute, London) but Monet gave to steam all its metropolitan importance.

The series of the *Gare Saint-Lazare* (Louvre) *(pl. 31)* in 1877, the first of the several series he painted of the same subject at different times of day, was triumphant in making the industrial scene tributary to aesthetic purpose. In these combinations of light and smoke he may possibly have had some passing thought of Turner's *Rain, Steam and Speed*, remembered from the National Gallery, though the effect is very different. Nor is it merely vaporous. Monet was stronger and more varied in composition than might be assumed from his concern with atmosphere. In the versions of Saint-Lazare that show the station's glass roof from within, its V-shaped pitch and elements of structure give a decided framework to the puffing engines.

Yet in the 1870s he could produce in contrast not only the river views of Argenteuil but sunlit stretches of country, flawlessly serene, with small figures that suggest Arcadian pleasure. He startles in 1876 with *La Japonaise* (Museum of Fine Arts, Boston), a full-length figure for which his wife provided the pose, wearing a heavily-ornamented kimono and waving a fan. It is possible to demur from those who have seen the influence of Japanese art in its execution. Nothing really could be more western, and for once academically so, than the way the garment is painted, while the fans on the wall behind are strewn about with so little of the oriental sense of placing that he might almost have intended a satirical comment on the vogue of the time (and indeed his own liking) for things Japanese.

This however was an isolated experiment. An unusual work of another kind was the near-abstraction of *The Rue Montorgueil Decked out with Flags* (Musée des Beaux-Arts, Rouen) painted on the occasion of the Fête Nationale in 1878, in which he took full advantage of the bright patterns created by the array of flags with their varied splashes of red, white and blue. By then he had taken a house at Vétheuil, farther away than Argenteuil from the advancing metropolis, and a hard winter there was to find him once again immersed in the problems of interpreting wintry atmosphere, during the exceptionally severe seasons of 1878 and 1879 *(pl. 33)*. Monet during his four years at Vétheuil from 1878 to 1881 reached the nadir of misery. After the birth of their second son, Michel, his wife, weakened by many hardships, died in 1879. The human being sorrowed but the dedicated artist, a being apart, could study the changes of colour in her face as she died. Ruined by speculation, his patron Hoschedé was sold up in 1878 and Monet gave shelter to Hoschedé's wife and six children at Vétheuil. Once again he had to pawn belongings to live. In these circumstances it is not surprising that his winter landscapes should convey—as they did to J. K. Huysmans—'an intense melancholy' the product of personal feeling as well as a melan-

choly inherent in the scene. At the same time, no English Pre-Raphaelite in the first enthusiasm of 'truth to nature' could have been more objective in approach. His easel and stool were planted in holes made in the ice. As he painted the floes in the Seine and their variations of colour, hot water bottles were brought him to restore circulation to his numbed fingers. With the thaw and the reappearance of the gentle blue sky that most pleased him, his paintings shed their sadness. In spring sunshine, Vétheuil as he painted the village and its environs from the Ile Saint-Martin suggests only an uplifting of the spirit at the mild and beneficent light that gives cheerful colour to the fields, hedgerows and distant slopes.

In some respects the work of Renoir in the 1870s is closely parallel to that of Monet, especially when, as at Argenteuil, they painted the same subject together. In painting the river and its craft as a haze and impression of light Renoir at times went even farther in audacity than his companion. He also had the secret of investing landscape in its least organized, its most formless, aspect—the rambling pathway through fields or the field simply as an area of tall grass—with a miraculous fulness of colour and visual meaning. He could make the spectator feel he was actually breathing the intoxicating air of Paris in spring by the magic of his painted boulevard scene and apply to a flower-piece a luxuriance of paint akin to that of Manet. Yet viewing the work of this period as a whole brings out the primary importance that humanity held for him. The beauty of women and children was a necessary factor in his art, whereas Monet was able virtually to dispense with it altogether. In appreciating their charm Renoir felt himself in no way distant from Boucher and Fragonard. One of his contributions to the first Impressionist exhibition was *The Little Dancer* (National Gallery, Washington) in whom the naive personality is more striking than the professional graces of limb on which Degas would have concentrated. The group pictures of dancers and canotiers alternated with this type of genre-portrait in which he excelled. It was due to this sense of charm that he was first among the Impressionists to make a favourable impact on the public and to escape from the financial quagmire in which they all struggled. Georges Charpentier, the equivalent in book-publishing (as the champion of the 'naturalists') of Durand-Ruel in painting, was attracted by Renoir's work to the extent of commissioning several portraits of the Charpentier family. The great success was the group portrait of *Mme Charpentier and her Children* (Metropolitan Museum, New York) which attracted much notice when exhibited at the Salon in 1879. Delightful children, handsome mother, pleasantly grouped in a fashionable interior including such voguish details as bamboo furniture and japonaiserie (little to Renoir's own taste), made up a composition that assured him other patrons. He was introduced to the Foreign Office official, Paul Bérard, members of whose family he painted on frequent visits to the Bérard chateau at Wargemont near the Normandy coast.

For the other Impressionists—except poor Sisley who was never out of financial difficulty to the end of his life—the 1880s brought some amelioration of their lot. Durand-Ruel who had supported them bravely, though hindered by his own ups and downs of fortune, was at last able to assure them sales. The change of fortune was sealed by the success of Durand-Ruel's Impressionist exhibition in New York in 1886. Their own dogged persistence had brought them through the ordeal without concession to philistine taste, in a way altogether admirable. But now they had also time to breathe, to give more considered reflection to what they were doing and what in the future they might wish to do. What made each personally distinct as an artist became clearer in the process. The ideas behind Impressionism were subjected to a scrutiny that led to disagreements and partings of ways, though these were still part of its history, the fulfilment of which had yet to extend into the twentieth century.

6 TURNING POINTS

The success of Renoir's portraits enabled him for the first time to travel outside France with a consequent revision of some of his ideas. He visited Algiers and, like Delacroix before him, was excited by the colour and bravura of Arab life. After his marriage in 1881 to Alice Charigat (whose round face, wide-set eyes and small well-formed features appear in so many of his paintings) they holidayed in Florence, Venice, Rome and Naples. It does not seem that Renoir was greatly interested in foreign places but what impressed him deeply were the frescoes of Raphael in the Vatican and the Pompeian paintings in the Naples Museum. They made him discontented with Impressionism and the contribution he had made to its development. Admiring Raphael's 'simplicity and grandeur', he remarked that Raphael did not need to work out of doors to fill his frescoes with sunlight. The Greco-Roman painters had not required the colours of the spectrum but gained the effect they wished with a palette limited to black, white, and red and yellow ochre. He had often been warned against the use of black since the day at Fontainebleau when the friendly Diaz, with implied criticism, asked him why he used so much of it. Yet, argued Renoir, had not Tintoretto called it the 'queen of colours'?

Reading a translation of Cennino Cennini's treatise on painting added to his belief that painting was a handicraft with an unchanging set of rules whatever the century in which it was practised. Sensuous rather than intellectual, he was not one of those who enjoyed the theoretic debates of the Café de la Nouvelle-Athènes that had now replaced the Café Guerbois; he had more to learn from the company of Cézanne whom he visited in the south of France on his way back from Italy.

By then Cézanne had assimilated all that he could from Impressionism as Pissarro had expounded it. It was both a sedative and a discipline, in either aspect making for a reversal of his first violence of expression. The ferocious drama was abandoned and was never to reappear. Colour was used more sparingly and with consideration of its accurate reference to nature. In gratitude for the help he had been given when working in Pontoise and Auvers, Cézanne was to sign himself, 'pupil of Camille Pissarro'.

The energy at first expended in riotous colour and theme was now concentrated in the effort to carry Impressionism a stage farther than the realistic imitation of transient atmospheric effect; to make of it, as he said himself 'something solid and permanent like the art of the museums'. Forms in which structure was apparent and colour that represented structure were the means by which he sought to attain this end. In landscape it was better achieved in the south with its sharper and less changeable light, its lesser floridity of vegetation, its hillsides pared to the bone, than in northern France. The bare trunks

and branches of trees served his purpose even better than the foliage of summer.

A criticism of *plein-air* painting was implicit in the increasing extent to which he practised still-life. There form and colour could be studied in immunity from movement or variations of light. Renoir must have found in Cézanne much to confirm the reaction he himself had experienced, though there were many temperamental differences between them. Cézanne, for many years repressed, could never attain that warmth and ease with which Renoir painted the beautiful bodies of women. Misunderstood, even by the close friend of his schoolboy days, Zola; ridiculed every time one of his works was publicly seen, he was driven to a hermit-like existence, shutting out life from view and finding comfort of a kind in the abstract analysis of the visible world.

Neither by type of intelligence nor instinct was Renoir fitted to share entirely in Cézanne's attitude although personally they got on together unusually well. He was more interested in the living organism than the geometrical figures that Cézanne divined behind form of any kind. But they had common ground in the respect for tradition that made Cézanne refer to the classic art of Poussin as something that might be done-over 'after nature' and caused Renoir to think as admiringly of Boucher as if no French Revolution had intervened between them. Cézanne's austerity was a reproof to the empty slickness of Salon painting. This, as Renoir realized, was a temptation to be steadfastly shunned by one with his own facility of execution. He became more formal, more consciously decorative in the paintings of the 1880s. *The Dance at Bougival* of 1883 (Boston) is a contrast in this respect with the *Moulin de la Galette (pl. 60)* of 1876. A deliberately contrived design, very beautiful in itself but with little trace of *plein-air* immediacy is *Les Parapluies* of 1884 (National Gallery, London) *(pl. 62)*. This phase of Renoir's art, known as his *manière aigre*, had its most highly-wrought example in *Les Grandes Baigneuses* of 1887 (Philadelphia

Museum of Art) *(pl. 65)* in which the softness of flesh gave way to a sculptural hardness and a sharpness of outline recalling the inspiration of the work, a relief of bathers at Versailles by the seventeenth-century sculptor, François Girardon. The hardness of manner was later to be put aside, the figure was to regain in Renoir's work the colour and substance of life but in the 1880s the Impressionist phase of his art had come to a halt.

Travel in the same period was not without its influence on Monet. His restless excursions from Paris and along the Seine and to the Normandy coast produced paintings with considerable variety of theme and composition but with the same atmospheric veil of the mild northern climate. The Riviera, which he visited briefly for the first time in 1883 with Renoir and subsequently by himself, opened his eyes to a vivid warmth of colour he had not previously conceived of. With a chameleon faculty of response to its stimulus he heightened the pitch of warm hues in paintings of Bordighera, Menton, Juan-les-Pins and Antibes to an extent that strongly contrasted with the subtle harmonies he had found not long before in the chalk cliffs of Etretat and their famous *roche percée*.

The pictures of the warm south were, however, an interlude rather than a real turning-point in his art. It was not as some supposed that he exaggerated the colour of the Riviera but that harmony tended to be lost in an effort that strained too much after realism in exotic application. Where Cézanne was at home Monet was an alien; and in so far as Monet is the essence and touchstone of Impressionism, in the south of France the movement was alien also. It was at Giverny, half-way between Paris and Rouen on the banks of the Epte, that his painting was to flower afresh. He rented a house there in 1883 but it was not until after 1886 and Durand-Ruel's success in the United States that he could feel securely placed. He then acquired a settled establishment in buying the house and marrying

39

Mme Hoschedé and except for rare expeditions remained there for the rest of his life. The season of the year and the time of day had always been his special study, locale was of minor account. His habit of painting the same subject over and over with such changes as the season and the hour dictated now became a settled practice and simple or simplified subjects became the vehicle of what was really an abstract pursuit.

The poplars on the Epte *(pl. 46)*, sometimes tremulous in early morning light, or verticals rigidly distinct in evening mellowness; the haystack with its blue shadow in snow, its gilding by the summer sun, and—splendidly transformed from its splendid self—Rouen Cathedral as an object battered by light rays, not an identity of Gothic form but some strangely encrusted cliff giving back with an extra measure of vibration the light it had received at hours that produced a mottled rugousness of blue, buff, pink or grey *(pl. 47)*; these were the preoccupations of Monet in the 'nineties.

There is a likeness as well as a difference in Degas's contemporaneous devotion to a series of works with the same subject, though Degas was a man to whom a haystack was supremely uninteresting and who must be inspired by the spectacle of Parisian life, and, like Renoir, by the form of woman.

Women at work were a subject of the 'eighties in paintings so carefully casual in composition that they seemed to arrest an accidental or momentary gesture like a snapshot. Thus he depicted a modiste trimming a hat, a laundress yawning over the ironing-board *(pls. 95, 100)*. He was a devotee, as ever, of the ballet but the exquisite precision and near-photographic delicacies of the ballet scenes of the 'seventies gave place to a bolder style, more brilliant colour.

Degas's weakening sight made for a broader treatment and the increasing use of pastel instead of the oil medium, as being less exacting, encouraged him to forceful juxtapositions of pink and green, of blue and yellow. With his coloured crayons he could at one and the same time paint and draw. In keeping the touches of colour largely intact and distinct without the rubbing down into tone that was the old practice of pastellists, he preserved the vibrating life of the pure colour in a way that was truly Impressionist.

From studying the disciplined grace of the dancers he turned to the more intimate record of the unself-conscious postures of the figure in domestic privacy. Tradition required that the nude should appear in painting in some mythological or ideal guise but this was precisely what Courbet had denounced and the realistic tendencies of the age had avoided. After his *Young Spartans Exercising* Degas had given up the subject matter taken from an imagined antiquity. But *le tub* was a contemporary institution that might reasonably engage the attention of the realistic painter. Getting into or out of it, washing or drying, at various stages of her toilet the female model provided Degas with that original repertoire of form in movement that is one of his great achievements *(pls. 67, 99)*.

The loyal attachment of Degas to the Impressionist exhibitions, in spite of his disapproval of the *plein-air* factor is an agreeable trait of his character. He contributed to seven out of the eight and was one of the seventeen participants in the last exhibition held in the rue Laffitte in 1886, after which date he no longer showed his work in public. In other ways the year was a turning-point. Durand-Ruel's success in America gave the promise of prosperity. The last Impressionist exhibition, which might seem to ring down the curtain, was instead one in which the curtain rose on another scene, a new stage of development.

As far as immediate questions of criterion and acceptance were concerned, the event looked one of disarray and disagreement. The exhibitions had never been especially consistent in whom and what they represented but prejudice now very seriously asserted itself. Monet and Renoir refused to exhibit, possibly because Berthe Morisot and her husband, Eugène Manet, who had much to do with the arrangements, admitted Paul Gauguin

and his friend Schuffenecker but possibly also because of the inclusion of two newcomers, Paul Seurat and Paul Signac.

Gauguin, after all, had been an exhibitor with the Impressionists since 1880 in the three previous exhibitions. The sailor turned stockbroker had become an enthusiastic amateur painter and a collector of Impressionist paintings. His god-father, Gustave Arosa, one of Pissarro's few patrons, had introduced the tiro to the master and Pissarro in his kindly way had given him much good advice. They had painted together in 1877 at Pontoise along with Cézanne—who had a special place in Gauguin's regard and collection. Yet he had not heeded Pissarro's well-meant but grim warning as to what a would-be professional painter might expect. In 1886, a man of thirty-eight, penniless and for some time separated from his Danish wife who had retired with their five children to Copenhagen, he had yet to become the hero of a circle and the propagator of new doctrine at Pont-Aven in Brittany.

It was not Gauguin's still mildly Impressionist pictures of Normandy and some souvenirs of his brief effort to live in Denmark that were upsetting to the orthodoxy of the movement but the ideas worked out by Seurat and Signac. A magnificent outcome was Seurat's masterpiece at the eighth exhibition, *A Sunday Afternoon at the Grande Jatte* (Art Institute of Chicago) *(pl. 63)*. The ideas were based on science and recall the extent to which science had assumed the position of court of appeal for the arts. It was the essence of literary criticism and history to Hippolyte Taine—'the problem', he said, 'is purely mechanical and the resultant is determined by the amount and direction of the forces producing it'. It was the essence of the novel to Emile Zola which he termed, 'the study of the natural man—the resultant of physio-chemical laws, joined to the influence of surroundings'. The conclusion was parallel that optical laws determined, or should determine, the study of colour.

Several nineteenth-century scientists had inquired into the question of colour sensation, probably most influential among them being the chemist Michel-Eugène Chevreul whose treatise, *Of the Law of the Simultaneous Contrast of Colours* was published in 1839. The work was primarily intended to assist industrial designers and workers at the Gobelins tapestry factory. Possibly Delacroix had derived from it an idea of reciprocal action between the colours of the spectrum though it seems unlikely that it contributed anything to the practice of Monet as a leader in Impressionist technique. Instinctively he and his confrères had got rid of black (as the total absence of light) and of earth colours as being non-transmissive of light. But the combinations of colour had been empirical and so little reduced to a system that Monet varied between colours blended into one another and those applied in separate patches, sometimes using both methods on the same canvas.

The revived influence of Chevreul's treatise in the 'eighties was to some extent due to the publicity attending his extreme old age. He was a hundred in 1886 and there were national celebrations in his honour. Seurat for some time previously had shown himself to be an artist fascinated by theories and systems. The colour diagrams that Chevreul had devised (without thought of their application to picture painting) suggested to Seurat the systematic use of the spectrum range. Applied in small separate dots or patches of red, blue, yellow and green and their intermediate shades they merged at a distance into the required tones though with a vibration that colours mixed on the palette in advance did not possess.

The method which Seurat preferred to call divisionism (though it was to become popularly known as pointillism) was in one aspect Impressionist practice codified. As such it appealed to Pissarro, always the most methodical of the group. He saw in it also a means of further advance. Introduced to Seurat by Signac in 1885 he quickly came to the conclusion that the former

41

had 'something new to contribute'. He insisted that his two young friends should be represented in the 1886 exhibition. He was personally convinced, he said, of the progressive character of Seurat's art and certain that in time it would yield extraordinary results.

The *Grande Jatte (pl. 63)* was already an extraordinary result for an artist of twenty-seven. Seurat had so far followed Impressionist example as to divide his time between those suburban reaches of the Seine that were beginning to be industrialized—but still had attractions for the Parisian on an outing—and the Normandy coast. Asnières, four kilometres from the Argenteuil of Monet and Renoir, was his chosen suburb where he painted undeterred by the nearness of factory chimney and gasworks. In the Impressionist manner he made numerous small sketches in oils on the spot but his first big picture, *Une Baignade* (National Gallery, London) *(pl. 98)*, was executed from such sketches in the studio, 1883–84, and added to the sunny effect of light a monumental stability of composition.

The *Baignade* was rejected at the Salon of 1884 and as in the old Café Guerbois days, the rejection brought a rebellious and argumentative group together. They launched their own Salon (des Indépendants) in 1884. Exhibitors were Seurat, Signac, Charles Angrand, Henri-Edmond Cross and others whom the official Salon jury had rejected. Seurat's study of Chevreul (whom he and Angrand visited to question about his theories) now bore fruit in landscapes painted at Grandcamp and in preparations for a second large picture, of promenading Parisians in their Sunday best at the Ile de la Grande Jatte at Asnières, the islet that had already figured in the background of his picture of the bathing-place.

Pissarro became so enthusiastic that he himself, the patriarch of Impressionism, *le père* Pissarro, adopted their divisionist method, greatly to the annoyance of Monet and arousing the irony of Renoir who addressed Pissarro with the words, 'Bonjour, M. Seurat'. Félix Fénéon, champion of

Seurat and Signac, gave equal credit to Pissarro as an innovator in his pamphlet, *Les Impressionnistes*. 'Transforming his manner,' he said of Pissarro, 'he brings to Neo-Impressionism his mathematical rigour of analysis and the authority of his name . . .'

'Neo-Impressionism' was not, in one sense, an unsuitable title for the method. It could be argued that it carried the Impressionist method to its logical conclusion. Yet clearly enough the systematic coverage of an area with small dots or lozenges of paint was a laborious process unfitted for painting in the open air to which the flexible brushwork of the earlier years had been well adapted. Like the *Baignade (pl. 98)*, Seurat's *Grande Jatte (pl. 63)* was preceded by oil studies that could be regarded without qualification as Impressionist. But the finished work was an artificial structure rather than an impression of a sunny afternoon.

There was an ambiguity also in the suggestions received from Chevreul. The colours might resolve into tone quietly and unobtrusively as in the mechanical three-colour process of reproduction. This is the effect of Seurat's beautiful paintings of harbours and coastal incident, secondary to the structural simplicity of design *(pls. 39, 45)*. But there was also the possibility of intensifying the values of the primary colours in combination to a new pitch of brilliance that went beyond equivalence to tone in nature. Impressionism had been the outcome of Realism, a realistic art in its effort to convey truth to atmosphere. But it could now at the end of the 'eighties be felt that realism approached its end, that a conflict or at least an incongruity was appearing between colour devised to be plausibly objective and that which had other capacities of expression. Seurat in the later works of his too-short life (he died at thirty-one) shows the tendency to make colour part of the emotional as well as material atmosphere of a theme. The reds and yellows, the blues, violet and green of *Le Chahut* (Rijksmuseum Kröller-Müller), for example, make for a feeling

of gaiety but not in the illusory fashion that Degas or Manet would have given to the glitter of the stage.

For Paul Signac the science of colour was the great revelation of the century, a continuous development as he expounded it in his book *D'Eugène Delacroix au Néo-Impressionnisme* (1899). The Neo-Impressionists, he said, had adopted the title as a mark of homage to their elders. The difference was that they relied on instinct and instantaneity; 'We have turned to what has been carefully thought out and built to last'. Settled at Eragny near Gisors, farther from Paris than before, Pissarro displayed a restless desire not to become too fixed in his ways, experimenting with watercolour and pastel and gathering fresh material in the study of market types at Rouen and Gisors. This avidity for new methods and ideas made him an enthusiastic *divisionniste*. For two years he exhibited nothing but works conceived in this spirit. Yet though they included greatly distinguished paintings, the continuity so apparent to Signac was less so to picture buyers distrustful of change. Nor did he find it led him towards altogether congenial ends. Divisionism was an incident in his later years rather than a turning-point. It was in views of the city and its crowds

that his art was to attain a splendid level of late maturity. Arriving at financial ease after two successful exhibitions, at Boussod et Valadon's, where Theo van Gogh was manager, in 1890 and at Durand-Ruel's in 1892, he began to travel a good deal; to Belgium, to England (renewing old acquaintance), to various regions of France. But Paris now gained most of his attention as if he wished to compensate for those long stretches of country life lived in poverty by the taste of metropolitan luxury.

Like Monet he worked in series, painting the same subject at different hours and seasons. From an hotel window in 1897 he painted the Boulevard Montmartre and the constant movement of its traffic and pedestrians by day and night. From other vantage points he painted the Place du Théâtre Français, with its intricate pattern of people and horse-drawn buses and carts; the ordered expanse of the Jardin des Tuileries; the Pont Neuf as seen from the old house at one corner *(pls. 48, 50)*.

Systematic divisionism was not adapted to convey the sense of direct impact, the accidental effect of movement, or even the seasonal atmosphere in which these late paintings by Pissarro revealed the true Impressionist.

7 THE VARIED FOLLOWING

The success of Impressionism towards the end of the nineteenth century may be judged in two sharply contrasting ways; by the following the movement had acquired among painters and by the impatience of a younger generation in France to break new ground. There had been some hostile painters who were not above imitating when imitation might be a source of profit. Degas sarcastically remarked, 'They want to assassinate us and pick our pockets too!' But this would be unfair to a number of well-disposed and worthy men who had some relation with Impressionism in superficial features of style and perhaps some contact also with its leaders.

One who was in at the beginning and a contributor to six of the Impressionist exhibitions—but much overshadowed by his greater colleagues— was Armand Guillaumin. He was a student at the Académie Suisse with Pissarro and Cézanne, an admirer of Monet and a sharer of Bohemian hardships until driven back to regular employment by sheer necessity. He painted able views of Paris in his spare time until the good fortune of winning 100,000 francs in a state lottery enabled him to devote all his energies to painting vigorous landscapes in various regions, freely at his choice.

The curious list of 'Secondary Impressionists' drawn up by Camille Mauclair in his account of the movement includes even such outstanding personalities as Pissarro, Sisley, Morisot and Cézanne in addition to Gustave Caillebotte and Albert Lebourg, who answer more nearly to the description. Caillebotte is still mainly known as the rich amateur who left a magnificent legacy of Impressionist paintings to the state but his own pictures of his native Gennevilliers and those he made at Argenteuil in Monet's company show a talent he deprecated with too much modesty. Albert Lebourg who exhibited twice with the Impressionists, in 1879 and 1880, had a robust feeling for light and colour. Gustave Loiseau was not without a touch of Sisley's poetic feeling for river landscape. Henry Moret and Maxime Maufra carried on the Impressionist practice of painting in the open air in Brittany. Albert André, the friend of Monet and Renoir, was a painter of figures, landscape and still-life who made some moving portraits of Renoir at work in old age.

A longer list could be made of landscape painters who arrived at an acceptable compromise between Salon and Impressionist standards but it was not in them that the true legacy of Impressionism is to be found but rather in the speculations and divergent paths it opened, even when they seemed opposed to its nature in some respect. On several counts an intellectually active younger generation in the 'eighties and 'nineties was tiring of the objective and materialist conception of the world in art. The alternatives were some kind of religious or mystical inquiry that was not satisfied with the external and the obvious, some clearer distinction between the thing seen and the aesthetic beauty of a work of art, and some more definite

44

expression of the painter's own emotions in what he did.

The trend is variously represented by Gauguin and the circle that formed round him in Brittany; by the advent on the French scene of Vincent van Gogh; by the group that called themselves the Nabis (a Hebraism implying 'divinely inspired') and the Salons of the Rose+Croix organized by the eccentric character, Joseph Peladan whose object it was to 'ruin realism', boycott landscape and still-life and revive a school of ideal art. Brittany with its wilder coast and rocks of bare granite was not geographically so amenable to the Impressionist vision as Normandy, though Monet painted the starkness of Belle-Ile in 1886, the year of Gauguin's first stay at the village of Pont-Aven. Gauguin appreciated the austerity, was influenced even more by the primitive dignity of Breton life and the character of its crude religious sculpture with its distant memories of old Celtic design. But as influential were the ideas and enthusiasm of other and younger artist visitors to what was already a sketching ground and tourist resort.

The season in which Gauguin worked together with the young enthusiast Emile Bernard saw the evolution of his work from quiet exercises in Pissarro's manner to the imaginative splendour of his *Jacob Wrestling with an Angel* (National Gallery of Scotland) *(pl. 102)*. The disciple of Pissarro seems suddenly transformed into the Symbolist with an aim of evocation to some extent like that of Mallarmé and the Symbolist poets; the Synthesist who reassembled form in large areas of flat colour; the Cloisonnist who enclosed the brilliance of such areas in strongly emphasized contours. These were theoretic moves not necessarily his own (Bernard was angrily to feel that his thunder had been stolen) but of which he was able to make a creative use beyond the power of lesser artists.

The young men looked not only to him but to Cézanne, settled now at Aix, a wealthy man since the death of his father and seemingly as far distant from his old Impressionist associations as if he had passed through some extraordinary metamorphosis and become a mythical sage or saint to be sought out in a Provençal thebaid.

In this transformation the contrasting elements in Cézanne's character and mode of operation were strangely allied. It required no more than a twist of the same thought to turn from the solidity and permanence of Poussin to the conception of geometric forms underlying all nature; from the conservatism of the classicist to a supposition with the most radical possibilities. It remained his Impressionist habit to paint landscape on the spot out of doors, though logic might have persuaded him that the externals did not reveal the structure he conceived of behind them.

There had always been obvious difficulties in exactly painting natural effect. So changeable is light that even to paint for an hour in front of a scene with a view to its truthful rendering involved a feat of memory; but to paint on a second day from nature at a given place on the assumption that at the same hour and under the same atmospheric conditions as before the effect would be identical was to court disappointment. The degree of heat or humidity, the subtle processes of natural growth or decay, the quality of sunlight might all vary. Had the Impressionists then deceived themselves in their search for truth; was Cézanne doing likewise? If so they had deceived themselves to the extent of producing superb works. The Impressionist effort to produce a picture at a sitting with its consequent exclusion of detail gave the unity that the highly-wrought works of the studio had often lacked. It could be said that shadows in nature were not so full of colour as the Impressionists painted them. Yet the recurrent blue of shadow contributed to the harmony of a scheme that had its inception in the artist's eye.

Art, said Gauguin, was an abstraction to be dreamed of in the presence of nature. What the study of nature revealed was the temperament

45

through which it was seen. There could be no more striking illustration of this than the third of these Post-Impressionist masters, Vincent van Gogh. His arrival in Paris in 1886, the sight of Impressionist canvases collected by his brother Theo at the gallery of Messrs Boussod et Valadon and of the divisionist works of Seurat and Signac in the last Impressionist exhibition had as pronounced an effect on him as if he had been brought up in the same atmosphere instead of on recollections of the old Dutch masters and the dusky wood-engravings of contemporary English illustrators.

As Seurat made a scientific extension of Impressionist method, so Van Gogh made an emotional extension of Neo-Impressionism, violently enlarging the pieces of colour mosaic and loading on the primary brilliance of colour until it was surcharged with his own feeling. His greater force of colour must have had a powerful influence on Gauguin's style at the time of their ill-fated encounter at Arles in 1888, adding emphasis to those injunctions Gauguin imparted to Paul Sérusier and others to raise each red, yellow or green perceived in nature to the greatest possible intensity of pitch. The painting on a cigar-box lid that Sérusier carried out to Gauguin's instructions and bore back triumphantly to his friends in Paris—Maurice Denis and the circle, including Maillol, Bonnard and Ranson, that was to form the Nabi group of the 1890s—was like the ark of a new covenant, arousing the keenest interest there.

'Post-Impressionism' is a not altogether satisfactory term to describe jointly artists so distinct in style and thought as Cézanne, Gauguin and Van Gogh. Cézanne was concerned with essential structure, Gauguin with decorative effect not unmixed with philosophic reflection on the mysteries of life, Van Gogh with the fervour of emotional expression. Cézanne was disdainfully conscious of the differences between them, dismissing Gauguin as a mere maker of silhouettes and Van Gogh as a madman.

History has linked them together in the isolation of their struggles and yet as a trio that gave a fresh start to painting. In the first respect they are only distinct from the Impressionists in the intensified drama of the same encounter with indifference or dislike. It is manifest that they had a decisive part to play in giving shape to the art of the twentieth century. The signal fact remains that the release of colour so vital in the work of each stemmed from the Impressionist evolution. To ignore the filaments that connect them with that preceding phase of French art is to impart a false compartmentation to art history. Convenient as the term 'Post-Impressionism' may be it should not imply a complete lack of connection with what had gone before. The transition from the nineteenth to the twentieth century is better viewed as a continuous expansion. As Cézanne remarked in a letter to the critic Roger Marx, 'one should not substitute oneself for the past, one has merely to add a new link'.

From this standpoint Henri de Toulouse-Lautrec has a place in Impressionist history as one who added a link with Degas. Though entirely without interest in theory and so lacking the partisanship of someone like Emile Bernard as to have a good word for the much derided Meissonier, he seems at an early stage, after his first essays as a painter of sporting subjects, to have profited by the example of Berthe Morisot and perhaps even Seurat in a certain unobtrusive and tentative division of colour in portraits such as the one of his mother (pl. 77) painted at Malromé in 1887 (when he was twenty-three). In his frequent use of a quick-drying spirit medium he attained that effect of vivid and instantaneous impression that Degas derived from pastel. Where he was beyond the Impressionist frontier was in the fin-de-siècle mood of intimacy with all that was hectic or degraded in what has been called the civilization de minuit. It is a difference from Degas, in which Degas seems the more Impressionist, that Lautrec gives individuality and personality to the inhabitants of the maison close whereas Degas,

picturing the same kind of scene in a series of monotypes, evinces not the slightest social sense or any feeling other than appreciation of gesture and composition.

Until the 1880s Impressionism seems almost entirely a product of French genius in art and its following is found mainly among French painters. The two Dutch painters, Jongkind and Van Gogh, like the Englishman, Sisley, seem so closely identified and in sympathy with the French aims that one can only think of them as painters in this context. Though in Holland itself there was a revival of landscape in the nineteenth century, a parallel in some ways to that of Barbizon, the delicate greys of a Jacob Maris or an Anton Mauve lacked the realistic impulsion and the colour secret of the Impressionists. But some influence on painters of other nationalities is to be observed towards the end of the century.

Of the three outstanding American expatriates, Mary Cassatt, John Singer Sargent and James McNeill Whistler, Mary Cassatt may be accounted the nearest to the Impressionists, as much by support and the influence she exerted on their behalf as by her own work. A wealthy woman, the daughter of a Philadelphia banker (as Francophile as the descendant of French émigrés in the seventeenth century might be expected to be) she had roamed about Europe studying painting. Her contribution to the Salon of 1874 caught the eye of Degas and through him she was invited to participate in the Impressionist exhibitions and sent to four of them between 1879 and 1886.

Like Berthe Morisot she was mainly interested in portraying young women and children though this makes only for a superficial resemblance in their painting. Berthe Morisot was much the more deeply involved in the Impressionist study of light, with which Mary Cassatt's tidy precision of drawing did not altogether tally. (Degas, however, admired it and would appear to have intended a compliment in remarking that she painted a picture as a milliner would make a hat.) Neither Whistler nor Sargent fits with ease into a category, though both had friends among the French Impressionists. Whistler painted with Courbet but later renounced any association with Courbet's realistic aims. In the great decade of Impressionism he reached his own zenith of landscape in the beautiful Nocturnes which were atmospheric in their evocation of twilight. But they were remote from Impressionism in the artist's avoidance of direct contact with nature and a reliance on considered arrangements of form and colour that had more in common with Hiroshige than any European master. It was indeed the lone eminence of Whistler in the late nineteenth century to be the first of abstract painters.

Sargent was trained in Paris but like Whistler chose London as his base of operations. He had an interest in the effect of light that creates some resemblance to Impressionist aims in the water-colours that were a relaxation from the discipline of portraiture. Yet his skill and observation were fundamentally of another and academic kind. It is as the historian of a social order in Edwardian England and the United States that he has his surest claim to celebrity. Impressionism gained an unobtrusive footing in America through painters who took home some experience of method and aim from visits to, and study in, Paris. They included John H. Twachtman and J. Alden Weir, leading spirits in the American Group of Ten who first exhibited together in 1898. William Glackens, who followed Renoir in style and Maurice Prendergast, who made a personal adaptation of lessons learned in Paris, c. 1886–91, give somewhat later examples.

Impressionism had only a limited influence in England. Outdoor painting and 'truth to nature' were prescriptions of the Pre-Raphaelite Brotherhood at about the same time as realism became an objective in France but were overwhelmed in the romantic complexities of the movement. After a certain interest had manifested itself in the Barbizon School there was a prolonged pause in foreign picture-buying in England and a

47

corresponding lack of concern with, or even comprehension of, foreign ideas among insular painters. The art of Manet was crazy and incredible in the view of Dante Gabriel Rossetti, and, as has already been noted, Durand-Ruel's exhibitions in Bond Street between 1870 and 1875 made little headway with either connoisseurs or artists.

The impression that French art was immoral had its absurd outcome in 1893, when Degas's *Au Café* was exhibited in London under the title of *L'Absinthe* (Louvre) *(pl. 88)*. The actress Ellen Andrée and the engraver Marcellin Desboutin quietly seated on the terrace of the Café de la Nouvelle-Athènes (he with nothing more alarming than black coffee before him) seemed to Walter Crane 'a study in degradation, male and female' and to Sir William Blake Richmond a reflection of 'the deplorable side of modern life'. Even George Moore, a frequenter of the Nouvelle-Athènes and a self-appointed compère of the great men who frequented it, though he wrote in championship of Degas, was so far a prey to moral self-hypnosis as to speak of the contemplative actress and model as 'a slut', with features marked by a lifetime of vice and of the picture in general (no High Victorian could have done it more sanctimoniously) as 'a lesson'.

Yet the New English Art Club, founded in 1886, the year of the last Impressionist exhibition, was a fraternal gesture of English artists towards the French Impressionists. Its leading members had special links with Paris. Walter Richard Sickert, a pupil of Whistler in London, perhaps owed more and certainly as much to Degas, whom he met in Paris in 1883. In the cultivation of memory rather than working from nature direct he followed both masters but in the apparent improvisation (carefully prepared) Degas was his model.

Philip Wilson Steer studied in Paris between 1882 and 1884. A splendid flash of early brilliance in paintings of the shore at Boulogne and Walberswick in Suffolk *(pl. 104)*, around 1890,

shows a profit from and a sympathy with Divisionism as practised by Seurat and Signac for which Steer's biographer D. S. MacColl gave too little credit to the Neo-Impressionist influence. The freshness and vivacity of these works were displayed in a style he was shortly to abandon in favour of a more conservative and insular approach. In general, there was a lack of understanding in England of colour's vital place in French Impressionist painting. Camille Pissarro deplored the want of a critical sense in English art that led some to imitate the sentimental pictures of the peasantry by Bastien Lepage. He looked with dismay at the English world of taste and the liking for archaic crafts and romantic sentiment that in his view was painfully divorced from reality. He did his best to dissuade his son Lucien from committing himself to the strange milieu across the Channel though Lucien, coming from the seat of creative activity and bearing his father's distinguished name was received in London by Sickert and his circle almost with awe as the possessor of superior knowledge and faculties.

Germany and Austria were much more affected by the decorative and extravagant aspects of *art nouveau* than by Impressionist example. Contact with Paris, however, served to lighten the palette of Max Liebermann in figure subjects— peasant and proletarian—in which he modelled himself on Millet and Josef Israels. Lovis Corinth was able to introduce an open-air sparkle into his landscapes of mountain and lake, and Max Slevogt worked with something of Impressionist spontaneity. But on the whole, northern Europe was not deeply stirred any more than England. The influence on the southern countries of Europe was almost negligible. The force of Impressionism was concentrated in France. It was not until the transition to a more dominant form of expression had been effected that the School of Paris began to exert a powerful international influence.

8 THE MASTERS IN THEIR LATER YEARS

So dramatic and singular were the fortunes of the artists known as Post-Impressionists, so far have they seemed the 'primitives' of a school intent upon making a fresh start, that the later work of the leading Impressionists, if not obscured, has been less considered as a development than their work of the 'seventies. Some might assume that the movement was over and done with by 1886. The fact remains that Pissarro, Monet, Renoir and Degas lived on into the twentieth century and except for Pissarro who died in the same year as Gauguin, outlived those who in aim and style are described as coming after them. Seurat died in 1891. Van Gogh committed suicide in 1890. Monet, painting to the end, in 1926 reached the age of eighty-six.

Alfred Sisley and Berthe Morisot did not live as long nor were they so wide in range. Sisley remained quietly in the background. His short visits to Hampton Court, the Welsh coast and the Isle of Wight were the only breaks in a stay-at-home existence faithfully confined to the Seine and Parisian suburbs and to Moret-sur-Loing in the Fontainebleau region he had always favoured. Settled at Moret in 1879 he spent his remaining twenty years there, living with his wife and daughter in a small house near the church that has been described as like the abode of some penurious curate. He made the place so much his own by his paintings on the banks of the Loing that after his death the people of Moret put up their memorial to him near the bridge he had depicted so often.

If there was any variation in his work it was a declension when he tried too hard for the place in the Salon that might gain him more sales and better prices. His tendency then was to force his colour and to produce a certain hardness of effect that was uncharacteristic. But in general he retained the sensitive quality that makes his evocation of placid streams and cloud-dappled skies a lyrical delight—with the Mozartian effect that though the purport is always much the same, they never cease to come with an appearance of freshness to the eye. It is sadly ironic that soon after his death in 1899, but not until then, his paintings gained a sudden access of popularity and were sold at prices he had never dreamed of.

Berthe Morisot, like Sisley, remained in the background, though Impressionism had no more convinced or loyal adherent. Strong-willed and intelligent she was also greatly gifted (as it would perhaps be natural to assume of the great-granddaughter of Fragonard) and gifted in a way different from the other Impressionists. While they had an alternative and abstract existence in the pursuit of their aims, she as Paul Valéry has so admirably said, 'lived her painting and painted her life'. The element of pictorial autobiography makes it relevant to draw some distinction between male and female. Her work could be viewed as 'the diary of a woman who uses colour and line as her means of expression'.

From the time of her marriage to Eugène Manet in 1874, her early interest in landscape lessened. Though she never entirely abandoned it, her domestic interests were now mirrored in her art and the more constantly after the birth of her daughter, Julie, in 1878. Eugène, the only man she painted, appears several time in her pictures;

by a window looking out to sea on their honeymoon visit to the Isle of Wight; with their small daughter in the garden at Bougival in 1881; in other pictures of the 1880s, reading to her or giving her a lesson in the same surroundings. She portrayed Julie at various ages; a little girl of four in 1882, making sand castles; at seven listening to the maid Pasie read (in the picture for which Mallarmé chose the title, *La Fable*); at eight feeding the swans in the Bois de Boulogne; and as a young woman of fifteen in 1893 practising on the violin. Though the death of Eugène Manet in 1891 clouded her last years with melancholy, she worked the more assiduously, never failing to impart to her portrayal of youth the ambience of light.

Her first one man show, which gave great satisfaction to her friends, Monet, Renoir and Degas, was held at Boussod et Valadon's gallery in 1892. These friends were in her mind just before she died and the affectionate letter she wrote to her daughter in 1895 contained instructions as to souvenirs for Monet and Renoir and the request that Julie should 'Tell M. Degas that if he founds a museum he should select a Manet'. Mallarmé's preface to the retrospective exhibition of 1896 well described her as 'the magician' whose works could bear comparison with any produced in an epoch-making phase of art.

How different from either of these gentle souls was Cézanne, withdrawn from life, absorbed in the search for 'some indefinable dream of solidity', at once inseparable from Impressionist history and yet so fiercely independent. It is a mark of the truly great artist to be like no other and in this sense he stands alone. It was not his achievement either to conform to or to throw overboard Impressionist tenets but to make the technique in which Pissarro had instructed him do what he wanted. The later works in which his genius was fully revealed were Impressionist in method to the extent that they consisted of thinly laid touches of pure colour but his aim was more comprehensive, his attention fixed on what was permanent in form rather than the fleeting effects of atmosphere. In representing the planes that defined the surface of a three-dimensional object by different nuances of colour he used the Impressionist method to another end. The celebrated words of advice he gave to Emile Bernard, personally at Aix and also by letter, 'to treat nature in terms of the sphere, cone and cylinder' (though the cube was not mentioned its inclusion might be assumed) made him the forerunner—almost the unwitting promoter—of Cubism.

His observation—that the fulness of form was to be found in the fulness of colour—was another precept that reinforced the stimulus given to such younger artists as Henri Matisse by his painting. It is possible however for these pregnant phrases to occupy too large a space in exposition of Cézanne's art. To give the paintings of the later years their full due and to account for their immense effect it is necessary to have in mind the grandeur that like Chardin he could give to a few simple objects of still-life; the beauty of his colour as well as its definition of solidity; the sense of essential peasant character that comes out, even if unsought, in his paintings of rustic cardplayers and other country types; the look of a precious stone he could impart to *Mont Sainte-Victoire* (Courtauld Institute, London) *(pl. 36)*; the drama of his *Mardi Gras* (Pushkin Museum, Moscow); the baroque impulse of his *Bathers*, especially in the versions in the Philadelphia Museum of Art and the National Gallery, London. There is the supreme instance of development from the Impressionist matrix in this remarkable career, the products of which, in the exhibition organized by Ambroise Vollard in 1895, the display of his work at the Salon d'Automne of 1904 and the memorial exhibition of 1907, the year after his death, came as a revelation to the many who knew little of his history.

In the same way that one may recognize both an Impressionist and an anti-Impressionist in Cézanne, something of this dual character is to be found in Gauguin and Van Gogh. Pissarro's

tuition was not wasted on Gauguin though the Impressionist master, firm in devotion to the realist aesthetic, disapproved of any symbolic or mystical tendency. There is still a memory of Impressionist colour harmony in the paintings of native life and landscape in the South Seas that Gauguin produced between 1895 and 1903, the year of his death at Atoana in the Marquesas Islands. Yet into the fabric of ideas and images there are curiously woven decorative elements owing something to Puvis de Chavannes, and not unaffected by the contagion of *art nouveau*, references to Polynesian folk lore and superstition in the form of symbols, and philosophy distilled in picture titles. There was sufficient of heresy here, from the viewpoint of one such as Pissarro, to show how far Gauguin had departed from the Impressionist true faith, although he unified a diversity of elements in a uniquely graceful and dignified whole.

In the period of Van Gogh's impassioned creativeness between 1886 and 1890 he can be imagined first on his arrival in Paris as making the acquaintance of Toulouse-Lautrec and Emile Bernard at the Atelier Cormon, bowled over by the work of Monet and others in Theo's gallery and faced with a choice of paths between the intensities of colour projected by Emile Bernard and Gauguin and the Neo-Impressionism of Seurat and Signac. The Impressionist or Paris phase of Van Gogh's life is unfortunately the most obscure. Since he was lodging in his brother's apartment he naturally stopped writing Theo those long descriptive letters which are the prime source of information about his thought and work. At the industrial suburb of Paris, Asnières, where Seurat had painted his *Baignade (pl. 98)* some years earlier, Van Gogh worked along with Bernard and Signac, deriving from the latter the divisionist method to which he was later to add a tempestuous violence. There was a reminiscence of Monet in his paintings of the river.

In the two immensely productive years that began in 1888 with his stay at Arles and ended at Auvers in 1890, he threw off the moderation that Impressionism and even Neo-Impressionism counselled. For this man from the north all nature under the southern sky took on an amazing brilliance. The limpid air vibrated in a way that put him in mind of a flowerpiece by the Provençal painter, Monticelli, rather than of Monet. Of Impressionism he retained only the practice of painting several different versions of the same subject, like the five large sunflower pictures he completed out of a projected six.

The rapture that turned to sadness in the last fateful year; the famous quarrel with Gauguin; Van Gogh's mutilation of his ear and his subsequent stay in the hospital at Saint-Rémy; his final agony at Auvers, created an emotional intensity destined to have a powerful influence on all that may be called Expressionist in twentieth-century art. But his mind went back to the pre-Impressionist artists, as is evidenced by the copies he made in his illness; a *Pietà* by Delacroix which brought him a measure of religious consolation and Millet's *The Sower* consolation of some kind. His admiration for Daubigny is reflected in the several paintings of Daubigny's garden at Auvers and in the composition of *Wheatfield with Crows* (Stedelijk Museum, Amsterdam), painted only a week or two before the final tragedy. The Impressionists and Neo-Impressionists had given him a new orientation as an artist but his leaning to those who had a message or moral lesson to impart remained to the end.

Renoir, one of the original Impressionists who for a while vied with Monet in the rendering of natural light and atmosphere, reached a point when he became severely critical of the whole idea of Impressionism. He had a sense of tradition leading to the belief that painting was always painting, whatever changes might affect the character and function of the painter. His fellow-feeling for Boucher was unprejudiced by the difference between the France of Louis XV and that of the Third Republic. In the period spent in travel after his great successes as a portrait

painter, visits to museums tended to increase his conservatism. At Naples he observed the excellence of Pompeian paintings obtained perhaps with black, white and two earth colours. Why then insist on the colours of the spectrum? Other awkward questions occurred to him in middle-age. Was not Impressionist painting becoming formless, needing that greater solidity at which he saw Cézanne aiming? Was it not obvious that *plein-air* painting was incompatible with a carefully thought out composition?

The conclusions he arrived at are apparent in the novel sharpness of outline and artifice of composition in paintings of the 1880s, the greatest example being *Les Grandes Baigneuses* of 1885. His search for classical quality increased his distaste for a 'new art' as propagated by Gauguin and Bernard in Brittany. But Renoir's *manière aigre*, with all that it suggests of acridity and hardness in style, was a transient stage prior to the series of portraits and paintings of the nude to which he devoted himself from the 1890s to 1919, the year in which he died.

Up to a point he had turned Impressionist again, in that colour once more had a principal part, dispensing with outline, though the atmospheric blues and delicacies of tone in earlier paintings were replaced by a prevailing warmth. Settled in the south of France in an effort to counter advancing arthritis, like Berthe Morisot he painted a family biography in portraits of his wife and children and the servant, Gabrielle, devising also a golden age of his own in roseate pictures of the figure. Something of sensitivity was bound to be lost when his crippling affliction made it necessary for his brush to be tied to his hand. There are some late figure studies in which the warmth of colour is near to crudity. But there is splendour too in his realizations of rounded and sturdy female forms. He achieved a final triumph of these plastic values in the translation to sculpture carried out by craftsmen to his instructions.

There is a parallel in the later activity of Degas, as much absorbed in the study of the figure as

Renoir, though he took to sculpture to compensate for failing sight. Up to about 1905 he was still able to produce the brilliant pastels that grew ever freer in handling and more startlingly unconventional in the poses he demanded from his models. His shortness of sight made it practicable to concentrate on these studies at close quarters, and perhaps the wish to avoid any suggestion of the falsely classic associated with the nude dictated the casual poses of the female model getting in or out of the tub, or using sponge or towel. Nature 'taken unawares' in this fashion was the equivalent of the fleeting accident of light that Monet sought to surprise and entrap.

The sculpture to which he turned between 1905 and 1911 was, as he put it, 'a blind man's art', a matter of the touch with which he fashioned his wax figurines. In this departure Renoir considered him superior even to Rodin. But both painting and sculpture were given up in final disheartenment when in 1912 he was forced to leave the house he had occupied for twenty-five years in the rue Victor Massé, then due for demolition. By then, though he lived until 1917—a melancholy and almost blind recluse when the German guns threatened Paris—the magnificent evolution of his work was complete.

The paintings of the same subject in series—the Poplars, the Haystacks, the Cathedrals, the Water-lilies—were the principal work of Monet's later years. He was finally settled at Giverny, half-way between Rouen and Paris, in 1890 when he was able to buy the house he had rented for some years. The poplars on the bank of the Epte, the tributary of the Seine near his house, were first painted from his boat in different lights and at different times of day. This series was followed almost at once by the Haystacks in all the seasonal variations of light, a great success when exhibited in their entirety by Durand-Ruel. There followed the series depicting Rouen Cathedral in various lights and conditions of weather.

It is possible to think of Monet as providing the one certain and complete criterion of Impression-

ism. The aims of Renoir, Degas and Cézanne diverged considerably. Even Pissarro strayed into what Monet considered the heresy of Neo-Impressionism. If Sisley was exemplary as a painter of landscape in the open he was limited in the pursuit of atmospheric truth beyond the cheerfulness of a sunny summer afternoon. The elderly Monet alone could carry the logic of his research to the uttermost point, taking out thirty canvases into the field where the haystacks were, going quickly from one to another as the light altered and the requisite effect of colour for each was arrived at in turn.

Yet even such thoroughness could not be perfectly objective. Monet could not so completely identify himself with nature as to give no hint of the period he lived in. The long slightly undulating stems of the poplars along the Epte announce by the artist's design and arrangement of them on the canvas that the age of *art nouveau* had come—so too does the colour contrast of purple and pale orange. Wonderfully impressive as the cathedral paintings are, they seem gorgeous dreams far-removed from the need to scrutinize a façade from dawn to sunset at an hotel window. This is not to criticize Monet but to suggest that he like other artists—Cézanne, shall we say, before Mont Sainte-Victoire—carried with him a vision of his own to superimpose on the scene before him. There could be no guarantee that the observation of any hour or season would produce a work of beauty. It was because Monet was a great artist that he had this capacity to touch the imagination. A spectator might be little moved by the translation of atmospheric phenomena as such into paint but would justifiably admire the harmony of colours and unity of effect.

Monet used colour with an increasing freedom in these later years. London as he saw it again at the beginning of the present century suggested chromatic richnesses far beyond any he had contemplated in 1871. A view of the Houses of Parliament in 1904 with the sun coming through fog departed from the Whistlerian silhouette of

thirty-three years before to picture densities of purple and blue with a contrast of gold that already forecast André Derain's *fauve* paintings of the city. Venice, the beauty of which pleased him much more than it had Renoir, evoked in 1908 a shimmer of violet, yellow and green in buildings and canal reflection, that so far resembled the Venice of Turner, albeit in a different key, as to dissolve its palaces in a coloured haze.

The crowning achievement of the later years was Monet's paintings of the water-garden he made at Giverny. He first painted the garden in 1892. The Japanese style of bridge, suggested very likely by one of the Japanese prints of which he had formed a large collection, provided a central feature (as bridges so often had in his compositions) for a first series, of 1899 to 1900. The garden and its water-lilies were soon to become not one series among others, but an obsession that occupied him for the rest of his life.

Like Degas in his portraits he varied the angle of vision. In a second series between 1905 and 1910 he painted the water-lilies and reflections of the sky and subsequently larger canvases that again altered the line of sight until the floating plants might seem to be viewed directly from above.

After his second wife died in 1911, Monet, rarely leaving Giverny, grew more and more absorbed in his garden. The execution of the large decorative panels of the water-lilies commissioned for the State by Monet's friend and great admirer, the politician Georges Clemenceau, occupied him from 1916 to the time of his death ten years later. They were a Herculean labour partly because of the pains he took to ensure that each represented a given condition of light, partly because of his failing sight. An operation for cataract in 1923 restored vision to one eye and enabled him to finish the series destined for the State. These and others that remained at Giverny were a near-abstraction of light, colour and vegetal nature which, like the final stage of Turner's art, arouses wonder at the daring and far-reaching experiments of a great artist's old age.

53

9 MODERN APPRAISAL

Though Impressionism can now be appreciated fully as a splendid and fruitful epoch of art it was for a long time the object of adverse criticism even after the individual masters had successfully run the gauntlet of antipathy and indifference. Unchanged since Manet's day, the ire of the philistine and the academic reactionary found renewed vent when Gustave Caillebotte's magnificent bequest of sixty-five paintings by Monet, Pissarro, Renoir, Sisley, Cézanne, Manet and Degas, was offered to the State after his death in 1893. Renoir, who was named as executor, was called by *Le Temps*, 'a veritable malefactor who had misled the youth of art'. If the Government were to accept such 'filth', pronounced the aged diehard of the Salons, Léon Gérôme, it would show a moral degeneration. (Gérôme was later publicly to exhort President Loubet to refrain from opening the Impressionist gallery at the 1900 Exposition on the ground that it was the 'dishonour of France'.) Absurd as the outcry might seem especially at so late a date, the State was cautious enough to admit only about half the Caillebotte collection into the Luxembourg. Prejudice was to come from an opposite and even avant-garde viewpoint. In the first decade of the twentieth century a succession of movements seemed to relegate Impressionism to the past as being in various ways deficient. Fauvism, Cubism and Futurism in turn appeared on the scene. The *fauves* ('wild beasts' of critical description) of the Salon d'Automne of 1905, Matisse, Derain,

Vlaminck, Marquet and others owed much to Cézanne, Gauguin and Van Gogh, but the extent to which these latter had been nurtured by Impressionism was less apparent than their liberation of colour from any realistically descriptive role.

The double influence of Cézanne, which encouraged Matisse to an intensified richness of colour and Braque and Picasso to the structural geometry of Cubism, was that of the 'pupil of Pissarro', once classified among the 'minor Impressionists'. But the insistence on the essential architecture of form which grew out of his advice to 'treat nature by the sphere, cone and cylinder' became a criticism of the movement with which he had early association. The solid values of structure were contrasted with the evanescence of atmosphere. The water-lilies of Monet's decorative panels came to be regarded in the Cubist era of the nineteen-twenties as the final decadence of Impressionism, not only the incoherent work of a painter enfeebled by age and dimmed in sight but a reduction to absurdity of the fallacious ideas he had cherished.

How much more was implicit in Monet's art than the transient light quickly transferred to canvas has been better understood in recent times. The acute observation of Kandinsky at a time when he had not yet devoted himself to abstraction and was used to such naturalistic art as the Russians practised, enabled him to see an extraordinary and unfamiliar value in one of Monet's

Haystack paintings. The picture 'impressed itself indelibly on the memory' and brought home to Kandinsky 'the unbelievable power unlike anything I had ever known, of a palette that surpassed my wildest dreams'. The haystack as an object manifestly did not exert this power, was not the indispensable element. Indispensable was the luxuriance of abstract colour. In the *Waterlilies*, with that freedom of personal expression, that final dissolution of matter into a sort of ecstasy that creates a certain parallel at last with the paintings of Turner in his final phase, Monet has, like Turner, found new understanding and appreciation in the second half of the twentieth century *(pl. 53)*.

It might be assumed that Impressionism as a style or outlook ceased to exist after Monet's death in 1926, or was represented only by painting of little value. The art of Pierre Bonnard, and that of his friend Edouard Vuillard in some degree also, gives evidence to the contrary. It is a measure of Bonnard's sense of continuity that he went over ground already trodden by the Impressionist masters and of his originality that he traced out at the same time a path of his own. He had the faculty of the original artist for absorbing influences of different kinds and turning them to entirely personal account. The Japanese print, in France so pervasive in effect, encouraged a graphic faculty in the Bonnard of the 'nineties that ranks with that of Toulouse-Lautrec. He and Vuillard were caught up somewhat incongruously in the theoretic agitation of the Nabis and the cult of Symbolism but their direct contact with and admiration for Monet was unchanged. Bonnard,

Monet's neighbour in the country for some time, respected his approach to nature and use of colour and adopted the same practice of painting a series of one subject, not at different times of day but in varying transformations of colour. He seems the heir of both Monet and Degas in those paintings of the nude in an interior, as unconventional in pose as the models of Degas, or floating in the bathtub at a like angle to that from which Monet had viewed the nymphéas in his pond. Impressionism has come even closer in date to the present time at least in the trend of thought that has led artists to take up the informal abstraction, as distinct from the geometrically abstract, at the point where Monet left off.

In this way Impressionism has survived, with heightened credit, the view that would make it simply a fashion of yesterday. Revaluation has latterly proceeded apace. An ironical contrast may be drawn between the vast sums fetched in the sale rooms of today for works by Monet, Renoir, and Pissarro and the paltry few francs the artists themselves received. But economics should not be allowed to intrude into the discussion of what it is that now makes Impressionist paintings so desirable. The perspective of time makes it possible to see in the most favourable aspect their idyllic qualities, the general absence of dominant or disturbing subject matter, and, quite apart from technical innovation, harmonies of colour that delight the eye. Yet this is not all. Impressionism was a major historical event, bound up by many threads with all that has happened in modern art, and losing none of its freshness with the passage of time.

THE PLATES

PLATE I

J.M.W.Turner

The Thames near Walton Bridges
1806–7
Tate Gallery, London

The work of Turner seems most nearly related to Impressionism in a particular group of pictures, of which this is an example, painted between 1805 and 1810 along the Thames between Walton and Windsor. As Daubigny and Monet were later to do along the Seine and Oise, he painted from a boat and finished the picture on the spot in the open air without adding finish later in the studio. It is indeed complete as it stands, conveying the atmosphere of southern English country with what one feels to be entire authenticity.

An open-air oil painting was unusual for Turner. Here, as was afterwards the Impressionist practice, he excluded anything in the nature of a story or episode and his choice of scene was a modestly attractive landscape with no exceptional feature of natural beauty, in which he concentrated on the expanse of sky and river. In this mood he is clearly distinct from the Turner of fire, flood and storm, of vehement expression, of shimmering colour poems, of philosophical comment on the trials and tragedies of the human race in its collisions with nature.

The Turner of this immense range may be regarded from several points of view as something other than the 'father' or precursor of Impressionism which admirers long assumed to be a valid description. In one aspect he was a Romantic, a role certainly considered without sympathy by Claude Monet. Again, the vehemence of effect and a stridency of colour in certain works (against which Renoir inveighed, according to Ambroise Vollard) could describe him in the modern term as Expressionist; in others, the works of his later years, he became abstract in a way that the nineteenth century was not conditioned to appreciate. It was the more romantic and the more highly-finished pictures by Turner that Monet and Pissarro would see when they were in London in 1871 and react to with admiration not unmixed with criticism. An oil sketch such as *The Thames near Walton Bridges* had still to wait a long time for public display and admiring appraisal. It may be felt that this was a facet of Turner's many-sided genius in which the French artists would, without qualification, have recognized a kindred spirit.

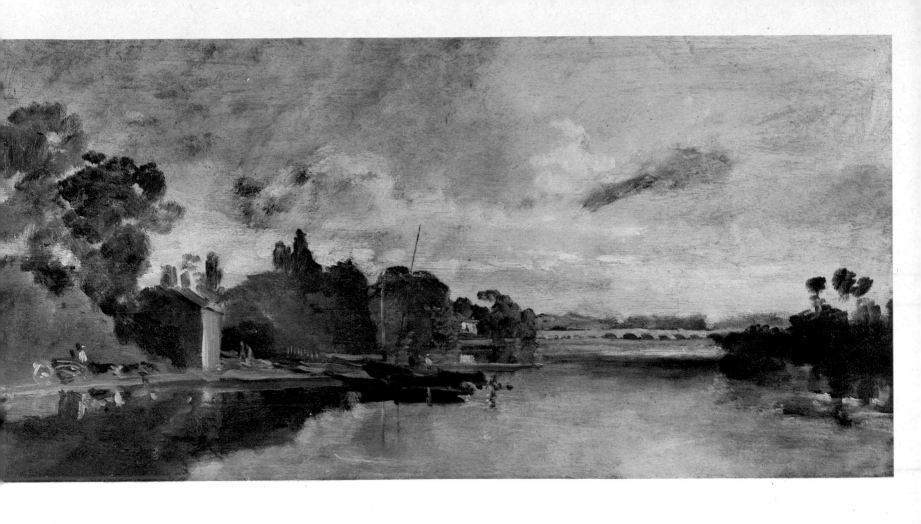

PLATE 2

John Constable

Study for The Haywain
1821
Victoria and Albert Museum, London

The sensation created at the Paris Salon of 1824 by the finished version of Constable's *Haywain* marked the beginning of a new era in French painting. Even farther ahead of its time was the full-scale sketch for the picture made in 1821 when the completed work was exhibited for the first time at the Royal Academy under the title, *Landscape: Noon*. The sketch, or study, gives the effect of light and the movement of light as the clouds billow across the sunny sky, creating distant gleams on the meadows, but differs markedly from the final version in technique and has the advantage of the vigour and spontaneity of feeling to which direct painting lends itself. Working for exhibition, Constable elaborated effects of detail in building, trees, water and waggon with something of the thoroughness of a Netherlandish master yet it was necessary to sacrifice for this result the liveliness of paint he had achieved in the study. The *Haywain* as the French painters saw it set up a criterion of freshness and luminosity in painting that was absorbed into their tradition and had its eventual outcome in Impressionism. But there is a parallel with Impressionist painting, rather than any question of influence, in the study, where instead of smooth layers of tone the surface is broken by sparkling touches of pure colour and the highlights that jesting contemporaries referred to as 'Constable's snow'. There is the difference, however, that although Constable was able in this way to give an extraordinarily vivid suggestion of both the pervasiveness of light and the life that colour might take on, he did not systematically translate light and shade into distinct patches of colour in the Impressionist fashion.

58

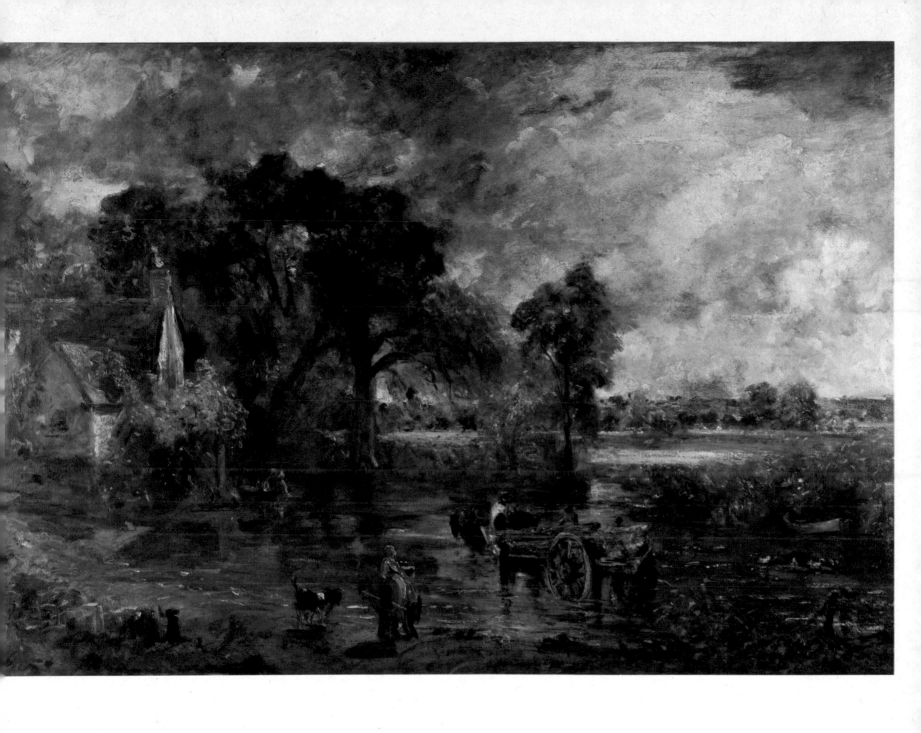

PLATE 3

Jean-Baptiste Camille Corot

Avignon from the West
c. 1836
National Gallery, London

The achievement of Corot, like that of Turner (dissimilar though they are in other respects) has been variously assessed at one time or another because of the different phases into which his art divides. There is the Corot who sought to emulate Claude, peopling his woodlands with nymphs and personalities of legend; the Corot of the *Souvenirs*, delicate and insubstantial, which aimed at an effect akin to that of music; but there is also the Corot who came to maturity in the atmosphere fostered by the appearance of Constable and Bonington in French exhibitions, much given to painting in the open air, the observer of effects of light rendered with both freshness and decision, the subtle colourist who had cleared his palette of dark and dingy hues.

This is the Corot who can be appreciated in his view of Avignon, painted around 1836, the year in which he travelled in the Auvergne and also to Avignon and Montpellier. He was then forty but had been a late starter and had his first picture hung in the Salon (near works by Constable and Bonington) only in 1827. He had brought a fresh outlook subsequently to paintings in a variety of places in Italy, Normandy and the forest of Fontainebleau. The *Avignon* reflects the idea of freshness he had arrived at by that time: 'I recognized from experience that it is very useful to begin by drawing the picture very simply on white canvas—to have one's effect noted first on grey or white paper, then to do the picture bit by bit as completely as possible at the first attempt so as only to have very little to do when the canvas is completely covered. I have noticed that everything that is done straight off is freer and pleasanter and that one gets the advantage of happy accident in doing it, but when one repaints the first harmonious tone is often lost'.

In this method—his habit of painting in the open air and the ability, shown in his *Avignon*, to establish a comprehensive relation of light as between sky and ground—he was close in sympathy to the Impressionists on whom he had a direct influence as teacher and admired example. The silvery grey tones of which he made use in many paintings distinguish his colour from theirs yet the style of the *Avignon* has a clarity, reappearing at a later date in *The Belfry of Douai* (Louvre) 1871, that shows how close he could come to them. It is the less surprising that Monet, looking in 1897 at one of the important collections of Impressionist and other nineteenth-century paintings should have remarked—though with characteristic modesty—'There is only one person here, that's Corot; we others are nothing compared to him'.

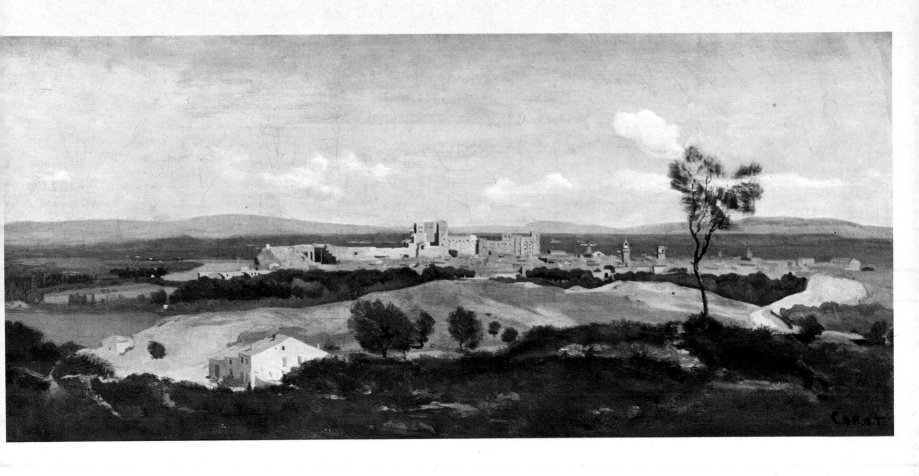

PLATE 4

Théodore Rousseau

Marshy Landscape
1842
Private Collection

The art of Théodore Rousseau was one of the channels by which the romantic and subjective feeling of the early nineteenth century in France was transformed into the objective study of nature that characterizes Impressionism. As a leader of the Barbizon School, he and other 'men of 1830' gave a prestige to the region and the forest of Fontainebleau that brought a younger generation, including Monet, Renoir and Sisley, to paint there.

But Rousseau's own work presents a by no means simple evolution. At the outset of his career he was one of those who felt the enthusiasm generated by Constable and Bonington and painted with a light palette in the open air. But with the passage of time his work became more sombre and for various reasons—the nature of his temperament, domestic misfortune and also continued disappointment at the Salon which rejected him so consistently between 1836 and 1849 that he was known as 'le grand refusé'—a growing darkness of tone may be associated with a personal depression. The 'grande mélancolie' that Baudelaire found in his paintings may be felt in the painting of marshland of 1842, the sense of desolation being deepened by the contrast between the intensely dark patches of ground and the somewhat lurid light of day. Yet the picture also shows that intimacy with nature and the assurance that 'pure landscape', i.e. light and space without recourse to added incidental interest, could create an impressive composition that the Impressionists were to develop. There is a grandeur in the unity and simplicity of this work that later productions, imitative of seventeenth-century Dutch landscape in detail, were apt to lose but Rousseau was a master of weight in the evolution that extended from Barbizon to Impressionism.

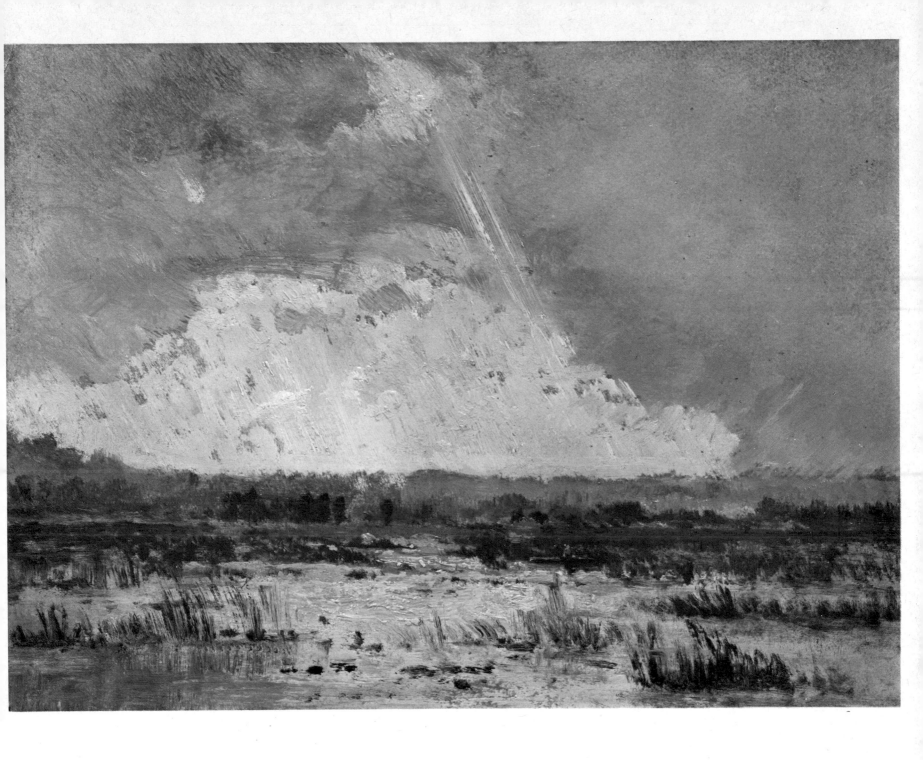

PLATE 5

Charles-François Daubigny

Beach at Villerville
1875
Private Collection

In method, outlook and practical sympathy, Daubigny was closest to the Impressionists among painters of an older generation. Though associated for a while with Barbizon he worked for preference—as the younger men were inclined to do—in Normandy and the Ile de France, was a constant devotee of *plein-air* painting, and was an example and a friend to Monet and Pissarro in their years of development and difficulty. The painting of Villerville reproduced here was one of his numerous pictures of this place on the Normandy coast which alternated in his favour with the reaches of the Seine and Oise. Executed in the year after the first Impressionist exhibition, it shows how nearly related his art had become in his later years to that of Monet and his fellows. Monet had long been his admirer, to the extent of following his example in painting river subjects from a specially constructed small boat. But a reciprocal influence may be discerned in the progress Daubigny had made to lightening his palette (an evolution very different from that of Théodore Rousseau), the stress on *plein-air* given by the large area of sky and the way in which a scene with no notable feature of structure or other interest is made full of vivacity by the varied touches of different colours on the land as well as by the clear blue of sky. The *Beach at Villerville* was formerly in the collection of Alexander Young, one of the Scottish connoisseurs of the Barbizon School. The insular vogue for Barbizon favoured Daubigny at a time when his relation to Impressionism would have been little appreciated.

PLATE 6

Eugène Boudin

Jetty at Trouville

1865

Collection Mr and Mrs Paul Mellon

The painter *par excellence* of breezy skies and choppy waters at the mouth of the Seine, the harbours and jetties of the Normandy coast, the animation given to its seaside resorts by groups of Second Empire visitors, the coming and going of Channel and fishing boats, Boudin was an artist of the open-air and marine atmosphere who illuminates a distinct phase of Impressionist development. In the 1860s (and until the outbreak of the Franco-Prussian war) he was especially active at Trouville making numerous studies in both oils and watercolours of the holiday-makers at this new rendezvous of fashion though the 'little dolls', as he regarded the figures he painted, served mainly to give accent to the effect of stir and movement permeating the whole scene.

One of numerous delightful versions of the theme, this picture traces the pattern of movement in the smoke from the steamboat's funnel adding emphasis to the scudding clouds, the long shadows on the ground, the flow of crinolines like sails against the wind, the many dispersed touches of light. The example was not lost on Claude Monet who worked with Boudin at Trouville during this period and for him at this time Boudin prophesied a great future. He lived to see his prophecy come true though he himself remained unaffected by the later products of Monet's art and the Impressionist vision of colour. Although, as here, he introduced an incidental sparkle of bright colour, Boudin remained substantially faithful to the 'grey painting' he derived from Corot.

PLATE 7

Johan-Barthold Jongkind

Bas Meudon Landscape
1865
Private Collection

A painter with qualities of greatness, Jongkind was the most creative of artists to come from Holland in the nineteenth century before Van Gogh (whom in certain aspects of personal tragedy he resembles). He revived the landscape tradition of his native country in the seventeenth century, but in a new form, involving his affection for sky, sea and flat land, that led Paul Signac to describe him as 'the first Impressionist'. He has at least a claim to considerable influence on Boudin and Monet in inspiring them with the aim of approaching nature with a direct and spontaneous technique. Although he reverted from time to time to Holland and its landscape, he was magnetically drawn to France and much of his work was produced at those cardinal points of Impressionist geography: Paris, the coastal region of Le Havre, Sainte-Adresse and Honfleur, and the countryside of Normandy.

Jongkind did not habitually paint in oils in the open as did his friends—and in some degree followers —in the 1860s, Boudin and Monet, but he was remarkably well able to preserve the immediacy of impression in the medium with the aid of the watercolours and swift notes he made on the spot. An example is this landscape belonging to the period when the wandering Dutch genius was working in Normandy and at Le Havre. It fulfils perfectly what may be regarded as two of the essential conditions of an Impressionist master-work: firstly in the feeling of unity it gives—there is nothing lacking and nothing too much—and secondly in the art that conceals art. It would indeed be contrary to the whole idea of an 'impression' if a deliberately formal and carefully organized composition were to obtrude itself on the attention. It is the art of the Impressionist to arrest the moment and to accept the challenge of imparting beauty to any collection of objects in nature by the pervading light in which they are seen. This is what Jongkind achieves. The undistinguished road and stretch of water become quite magically full of interest and by a few sensitive and crumbling touches the horse and cart of the right foreground are made a vivid focus of the light, otherwise generally diffused.

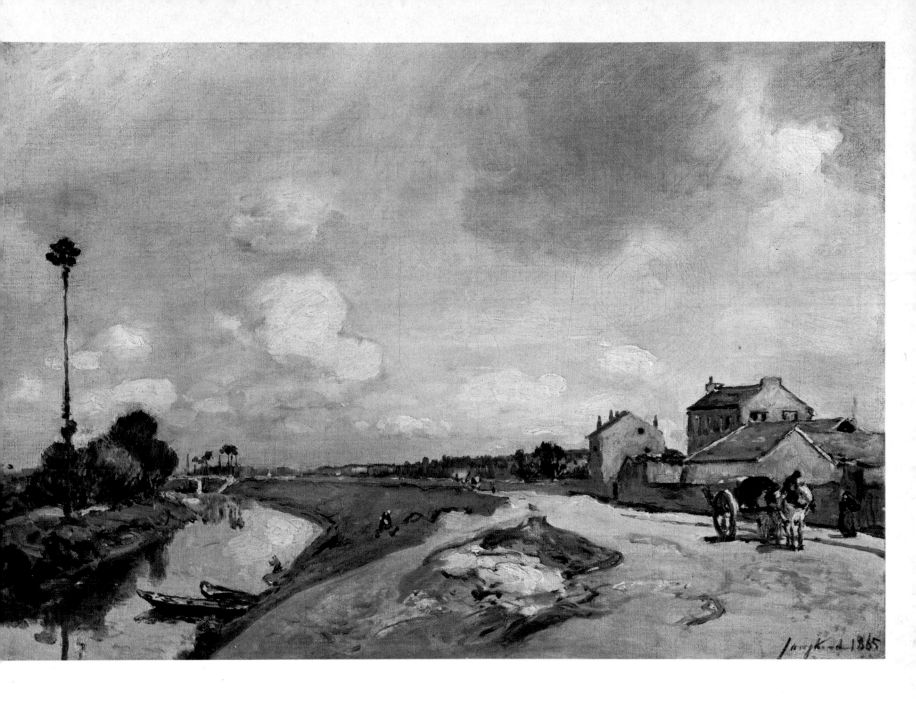

PLATE 8

Gustave Courbet

Landscape under Snow
c. 1867
Louvre, Paris

In his paintings of winter scenes in the neighbourhood of his native Ornans, Courbet revives an appreciation of the season that had largely been dormant in European art since the popular pictures of skaters on frozen canals and other snow scenes by artists of the Netherlands in the seventeenth century. The appetite of the great French realist for every visible aspect of nature, animate and inanimate, brought him with gusto to the spectacle of the wintry glade where the mantle of snow emphasized the solidity of trees and ground.

His example was not lost on the Impressionists and has a parallel also in the work of his contemporary, Jongkind, who made a conscious renewal of Dutch tradition in some winter scenes. Both Claude Monet and Camille Pissarro followed Courbet's lead though comparison of their snowscapes underlines the difference between Realism as a mid-nineteenth century phase of painting and Impressionism. For Courbet the snow-bound country was almost monochrome, defined by tonalities of white and grey. For Monet, who painted a number of snowscapes in the 'sixties (and at intervals later), the importance was that of discovering colour—the blue shadow cast by the wintry sun on the surface of newly-fallen snow, the delicate yellows and pinks where it caught the light. The difference between the artists is one of outlook and technique though not of quality.

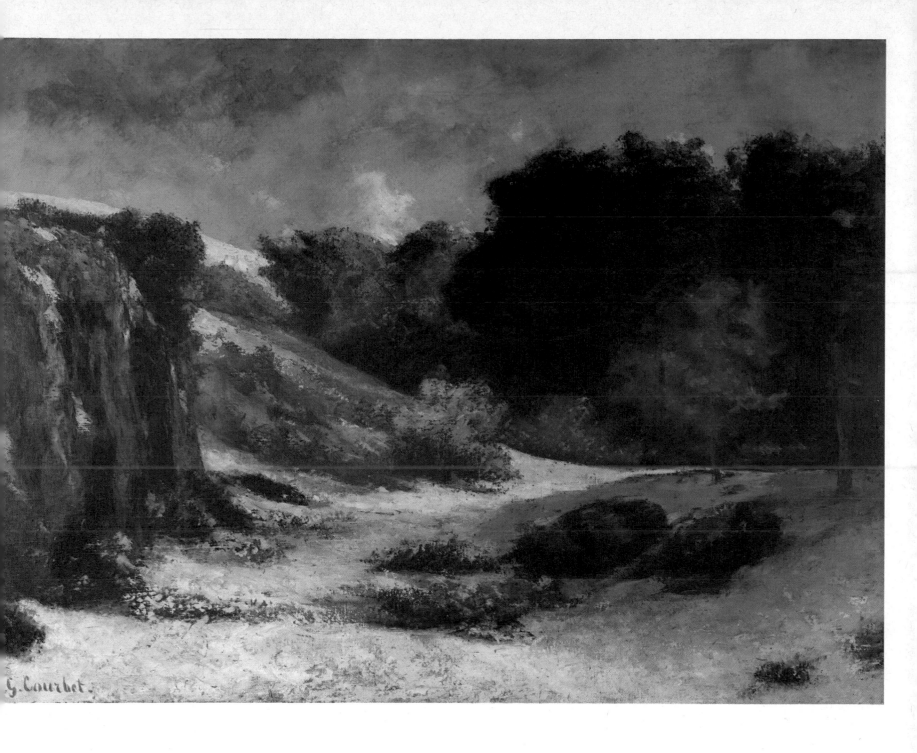

PLATE 9

Edouard Manet

Olympia
1863
Louvre, Paris

In this famous painting Manet showed a different aspect of realism from that envisaged by Courbet, his intention being to translate an Old Master theme, the reclining nude of Giorgione and Titian, into contemporary terms. It is possible also to find a strong reminiscence of the classicism of Ingres in the beautiful precision with which the figure is drawn, though if he thought to placate public and critical opinion by these references to tradition, the storm of anger the work provoked at the Salon of 1865 was sufficient disillusionment. There is a subtlety of modelling in the figure and a delicacy of distinction between the light flesh tones and the white draperies of the couch that his assailants were incapable of seeing. The sharpness of contrast also between model and foreground items and dark background, which added a modern vivacity to the Venetian-type subject, was regarded with obtuse suspicion as an intended parody. The new life of paint and method of treatment in this and the other works by Manet that aroused the fury of his contemporaries had a stimulus to give to the young artists who were eventually to be known as Impressionists. In a more general sense, they rallied to his support as one heroically opposed to ignorant prejudice and their own ideas took shape in the heat of controversy.

 Olympia was the gift of a group of art lovers and painters to the Luxembourg in 1890 and was transferred to the Louvre in 1908.

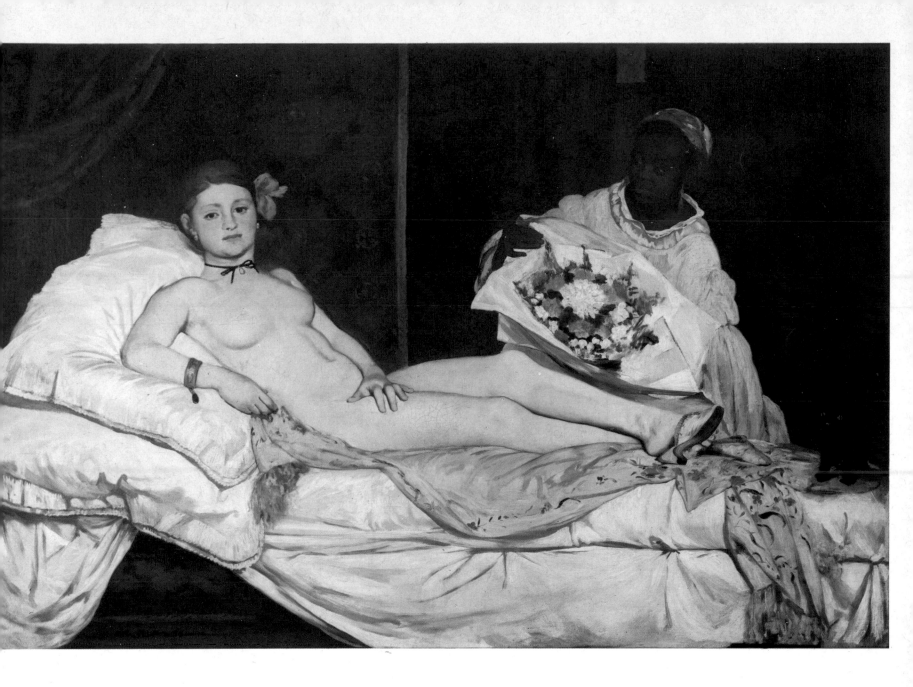

Edouard Manet

The Fifer

1866

Louvre, Paris

Brilliant as this picture is to modern eyes it is not so startling as it appeared to Manet's contemporaries, accustomed to the masking of colour by the veil of heavy chiaroscuro. Daumier, for example, used to near-monochrome effect in painting, thought *The Fifer* resembled a playing-card, the flatness and brightness of colour giving rise to his comparison. A concealed element in the design is the influence of the Japanese print which was so marked on French painting in general in the second half of the nineteenth century. It is to be traced here in the almost flat areas of colour against a plain background. Colour seems on the point of escaping from a subservient descriptive role into the dominant factor it was later to become.

Except among the few, this picture shared the unpopularity that previous works by Manet had suffered and was refused at the Salon of 1866. The refusal brought Emile Zola to the artist's defence in *L'Evènement* but Zola's assertion that he was 'so convinced that M. Manet would be one of the masters of tomorrow that he would think it a good stroke of business, if he had money enough, to buy all his canvases now' infuriated the readers, and their anger caused the editor to dispense with Zola's services as critic. The novelist returned to the attack elsewhere with a longer eulogy. His description of the fifer as 'le petit bonhomme' who 'puffs away with all his heart and soul' was a literary approach but his polemics served to keep the issue of aesthetic freedom a living force for the younger generation.

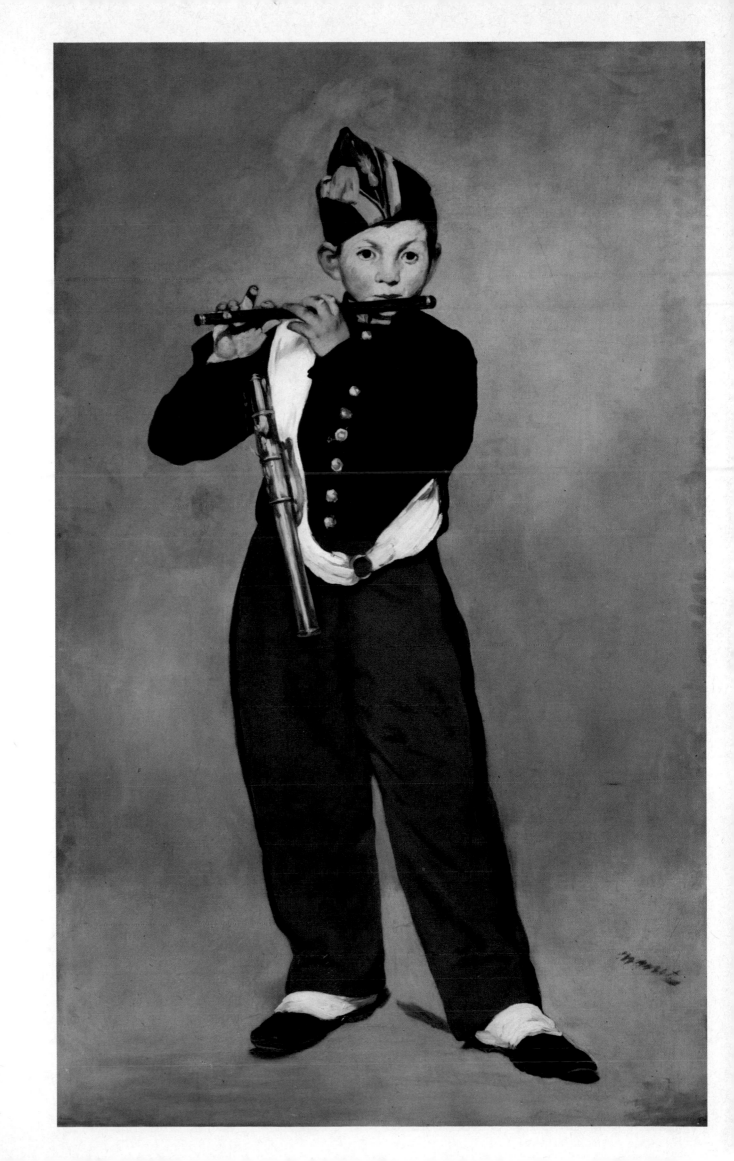

PLATE II

Edouard Manet

Luncheon on the Grass (Le Déjeuner sur l'Herbe)
1863
Louvre, Paris

The active spirit of independence in Impressionism—if not its style—may be considered to date from this famous work, refused by the Salon in 1863 and exhibited, under the title of *Le Bain* at the Salon des Refusés of the same year. It is the larger of Manet's two versions of the subject, a smaller and freer version being in the Courtauld Institute Gallery in London. According to Antonin Proust, the idea of the picture suggested itself to Manet when they were watching bathers at Argenteuil. Manet was reminded of Giorgione's *Concert Champêtre* and determined to repeat the theme in clearer colour and with modern personnel. A closer likeness of composition has been found in an engraving by Marcantonio of a group of river gods, after a now lost original by Raphael of *The Judgment of Paris*. An Old Master element of formal arrangement remains to distinguish it from an essentially Impressionist work and yet as well as being ostensibly set in the open there are various hints and suggestions in light and colour of fresh possibilities in open-air painting. The furious outcry it caused as the principal exhibit among the Salon rejects was based on the alleged indecency of two fully-dressed men appearing in the company of the naked female bather (an accusation no one had thought to make against the comparable juxtaposition in the work attributed to Giorgione). But the respectable persons represented in sedate conversation were Manet's favourite model, Victorine Meurend (whom he also painted as a toreador), his brother-in-law, Ferdinand Leenhoff, and Manet's younger brother, Eugène.

Public hostility not only helped to make Manet a hero in the eyes of the young painters but brought together in his support the group from which the Impressionists emerged.

How far Claude Monet was impressed by the picture may be gauged from the fact that in 1865 he decided to paint his own *Déjeuner sur l'Herbe*, though simply as a group of picnickers without the element of dress and undress and in more natural attitudes than the figures in Manet's composition. Only a fragment of this large work has survived but a *Déjeuner sur l'Herbe* by Monet in the Hermitage, Leningrad, is apparently a replica—not so grand a work as Manet's but with more veracity of informal, sun-lit grouping. Manet himself changed the title of his painting to *Le Déjeuner sur l'Herbe* at his exhibition of challenge and protest in 1867. It came to the Louvre as part of the Moreau-Nelaton Collection in 1906.

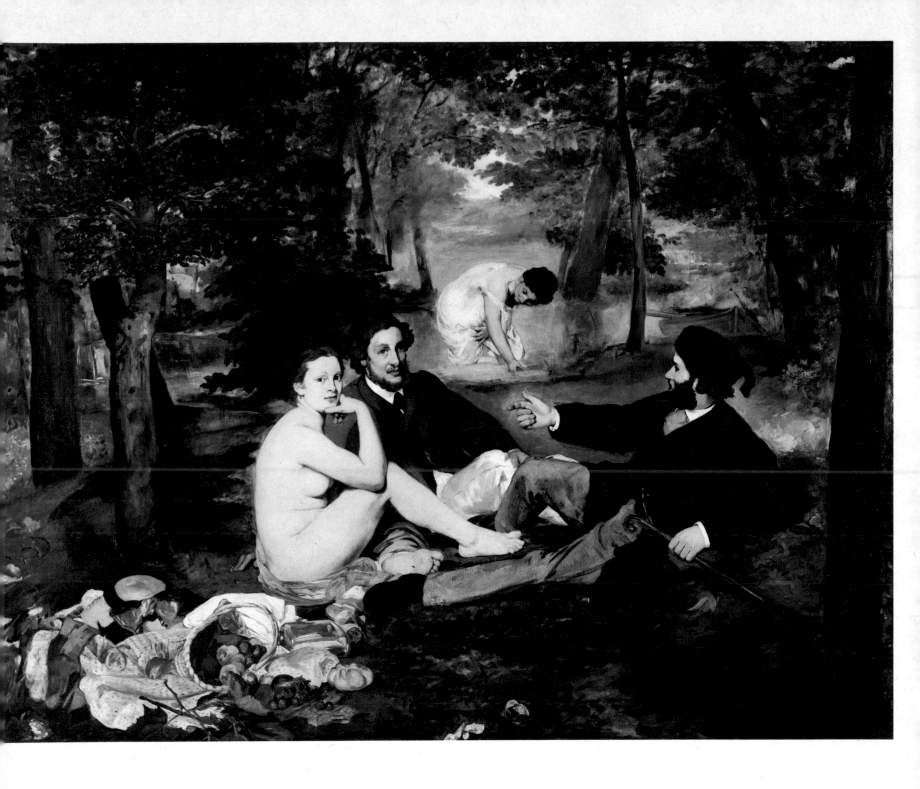

PLATE 12

Claude Monet

The River

1868

Art Institute of Chicago

Painted at some point—not obviously identifiable—of the Seine, this painting shows that effort to place a human figure in a convincingly natural way in an open-air setting that other painters were attempting about this time. John Rewald in his *History of Impressionism* compares it with a contemplative figure outdoors in two pictures by Bazille, *The Pink Dress* (Louvre) 1865 and *View of the Village* (Musée Fabre, Montpellier) *c.* 1868, though this is a comparison of attitude and only in the Monet is there the embracing magic of light that brings figure and setting together in unity. Another picture of the kind is the *Harbour of Lorient* by Berthe Morisot, painted in 1869 and much admired by Manet, in which she represented her sister Edma seated on the harbour wall.

In these works the artists faced the typically Impressionist problem of not merely placing figures in landscape but of creating a harmony from their being equally subject to the play of light. Monet's work is the most beautiful solution. His picture may have been painted at Bonnières-sur-Seine where he spent a little time in the spring of 1868 with Camille (probably the woman of the painting) in a year when he was in the depths of poverty and misfortune.

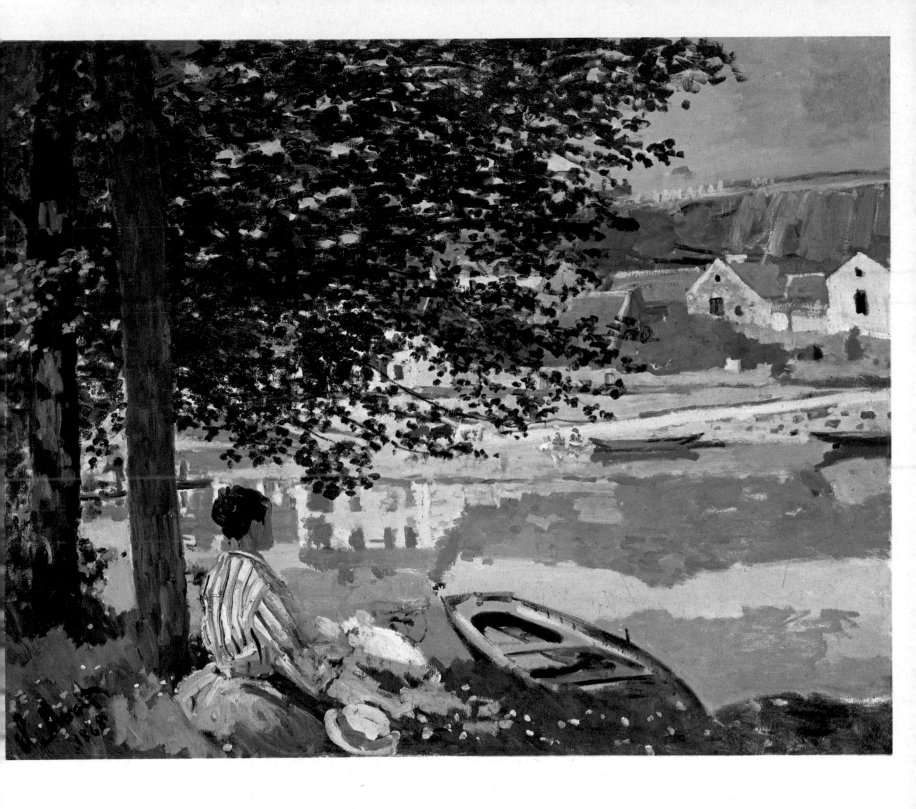

PLATE 13

Alfred Sisley

Canal St Martin, Paris
1870
Louvre, Paris

Paintings of Paris by the Impressionists were numerous in the period shortly preceding the Franco-Prussian war and the years immediately following. Consistent with the nature of their aims, in general they were not topographical in approach nor did they seek out picturesque older aspects of the city for their historical and romantic interest. They added to their feeling for nature as expressed in trees, sky and river, the animation belonging to a metropolis which in some measure provided all these things. Monet and Renoir especially applied themselves to a rendering of the movement of crowds against the background of the boulevards. Perhaps they took example to begin with from the varied groups in Manet's *View of the World Fair* of 1867 (now in the National Gallery, Oslo). There is a fascinating evolution from the people individually seen in Renoir's *Pont Neuf* of 1872 to the blurred figures, caught in a moment in time, in Monet's *Boulevard des Capucines* shown in the first Impressionist exhibition in 1874.

Sisley was not so bold as they in the inclusion of human beings but his sensitiveness to atmosphere is apparent in so delightful an evocation of Paris as this view, one of two exhibited in the Salon of 1870. It was painted at a time when Sisley had progressed in style from a less adventurous early manner—mainly influenced by Corot though to some extent also by Courbet—to a mature technique bearing the unmistakable stamp of the already well-defined Impressionist movement. This appears in the use of broken colour, the importance given to an atmospheric blue and the way in which the picture is knit together by the pervading light. Buildings and figures are carried only so far as is necessary to suggest that they are instantaneously seen as part of the general effect. The picture has a gentle harmony that can fittingly be called lyrical, the buildings forming an unobtrusive frame to the sky and water, painted with an evident delight.

Sisley did not paint as many such evocations of the city as his Impressionist friends and was perhaps of them all the one who liked the countryside best, for its own sake as well as for a subject to paint; but the quiet ripples of the Canal St Martin and the mild cheerfulness of the sky are elements in this picture of which he gave many rural variations.

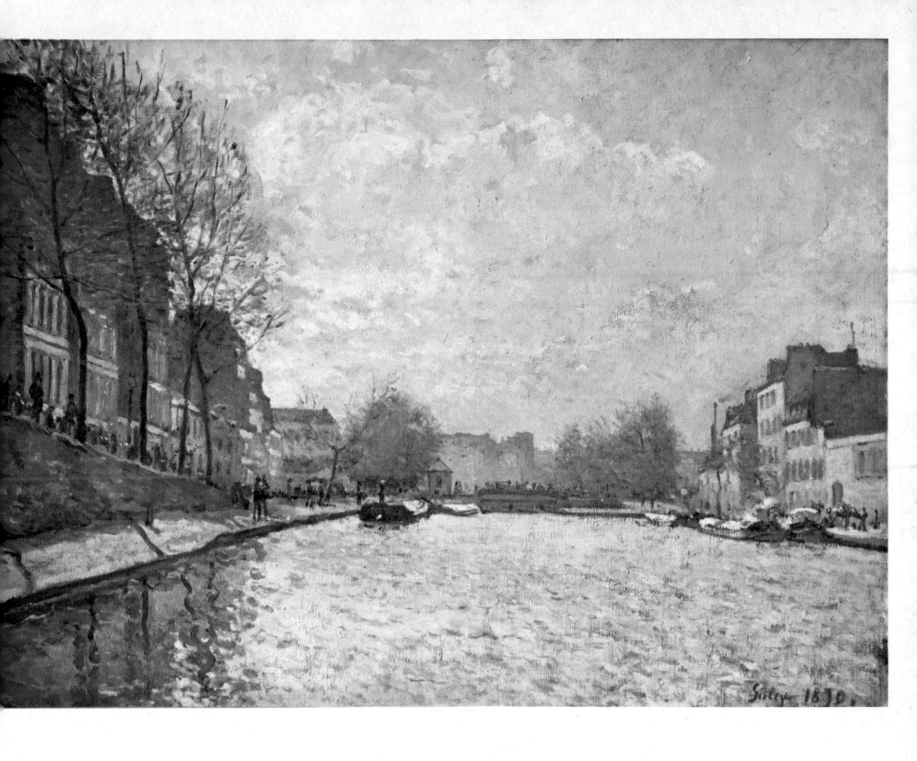

PLATE 14

Camille Pissarro

Lower Norwood, London
1870
National Gallery, London

Having taken refuge with a married sister in south London during the Franco-German war, Pissarro, true to the Impressionist practice of painting whatever there was wherever one happened to be, applied himself to pictures of the not remarkably pictorial suburbs of Sydenham and Norwood. It is an evidence of his great ability and also the applicability of Impressionist methods that he could make so interesting a picture of Lower Norwood as this. A comparison of his approach to the suburbs, French and English, shows him steadily pursuing his way of painting, and a greater similarity of style appears in his *Road, Louveciennes* and *Lower Norwood* than difference of place. In each there is a sturdiness of brushwork that shapes form without outline. Sharp accents of colour have their vitality to add.

It may well be accepted that during his months in London Pissarro was deeply impressed by the works of Turner he saw for the first time. There is, however, no visible evidence of any sudden change of style or outlook that might be attributed to this cause. What does appear is the steady and logical development of the course on which he was already well embarked. But in late-Victorian England, pictures that depended so much on treatment and so little on imposing subject-matter found no favour. 'My painting', he wrote in his bitter letter to Théodore Duret announcing his intention of returning to France as soon as possible, 'does not catch on in the least, a fate that pursues me more or less everywhere'.

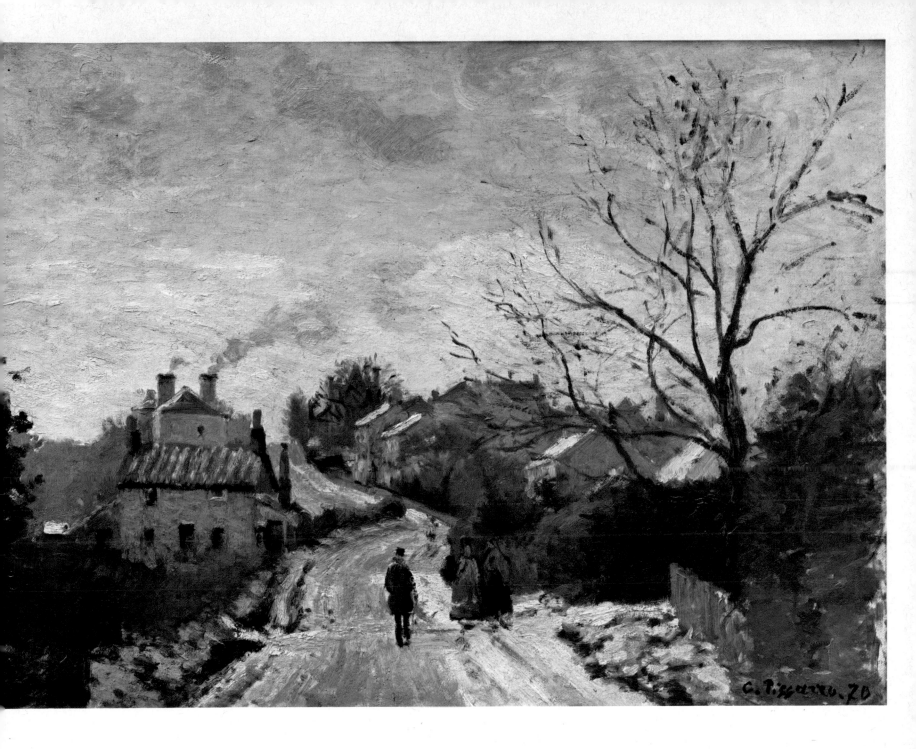

PLATE 15

Camille Pissarro

The Seine at Marly
1871
Private Collection

As soon as war and the disturbances of the Commune that followed it were over, Pissarro lost no time in returning to France. He was back at Louveciennes by the end of June, 1871. *The Seine at Marly* was one of the first pictures to announce his homecoming. In style it has a broad treatment so closely related to his work at Louveciennes immediately before the 1870 war and to what he produced while in London that it would be impossible to deduce from this group of paintings anything of the drama of contemporary history. Realists of a kind as the Impressionists were, the avidity for light and atmospheric colour as Pissarro displays it here, tended to create an idyll and to exclude the emotional reaction to current events that had been an aspect of Romanticism.

Often painting on the curving bank of the Seine, the Impressionists were inclined by the nature of their subject to describe a diagonal across the canvas spreading outwards to one side. In conjunction with the vertical of the river steamer's funnel this adds an originality of composition to the effect of colour in Pissarro's picture.

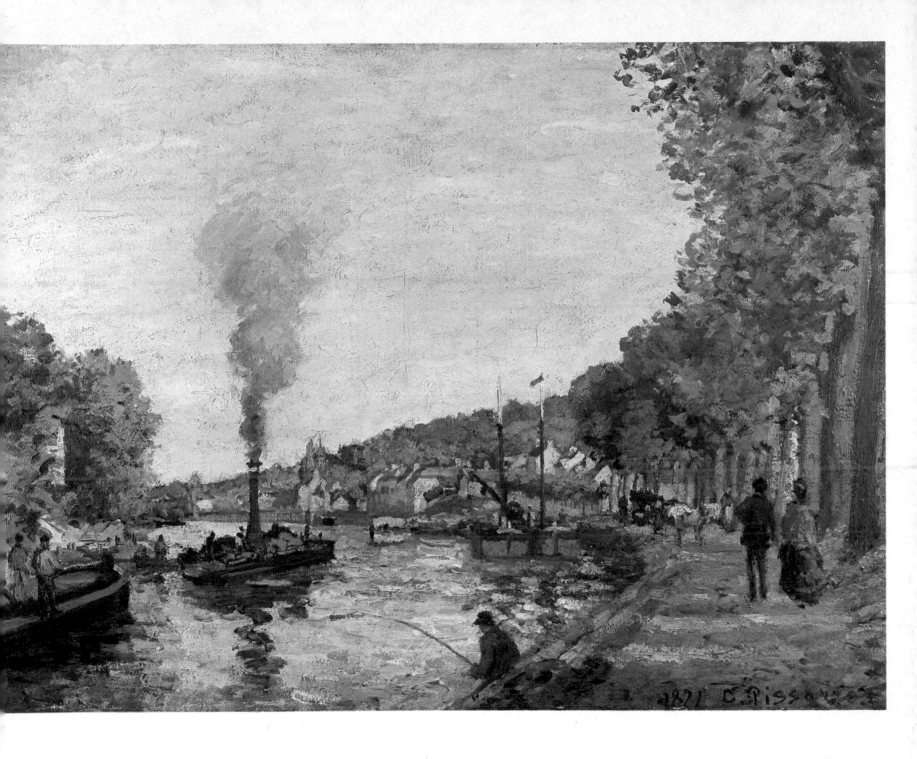

PLATE 16

Camille Pissarro

The Road, Louveciennes
1872
Louvre, Paris

The quite sudden and confident emergence of a mature Impressionist technique to be observed in Sisley's *Canal St Martin* appears also in this picture by Pissarro. Louveciennes, not far from the Marly aqueduct, was a middle-class suburb of Paris with modest bourgeois villas and gardens where Pissarro had settled in 1868. It had the advantage of being within reach of the centre and the dealer P. F. *(le père)* Martin from whom he received twenty to forty francs for a picture, according to size—the more acceptable since his allowance from home ceased about this time. The Salon catalogue of 1870 in which he had two paintings of Louveciennes gave him the addresses: 'Louveciennes (Seine et Oise) and Paris, c/o M. Martin, 52 rue Lafitte'.

An earlier painting of the same title—also in the Louvre—was completed just before Pissarro was compelled to evacuate his house by the surprising rapidity of the German invasion after war began in 1870. Apart from the paintings mainly sold through Martin, who bought Pissarro's contributions to the 1870 Salon, he was forced to leave behind nearly everything he had painted since coming to Paris in 1855, as well as canvases left with him by Monet. The best part of fifteen hundred paintings were either destroyed by the German soldiery, who turned his house into a butcher's shop, or conveyed by devious routes to Germany, to reappear only after a long interval.

Back in Louveciennes after the war, Pissarro painted this second view of the road. The scene was humdrum enough in itself but the faculty of the Impressionists for investing even a commonplace scene with the magic of light and vision is beautifully demonstrated.

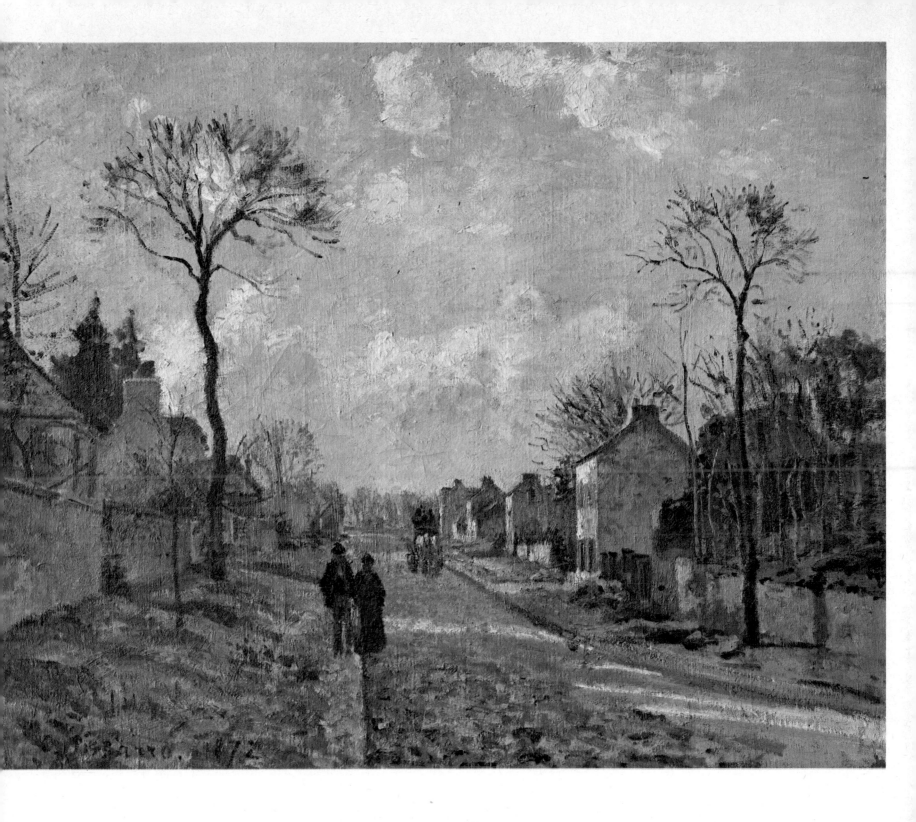

PLATE 17

Claude Monet

Westminster Bridge

1871

Collection Lord Astor of Hever

Of Monet's and Pissarro's experience of England during the Franco-German war, Pissarro was later to write, 'Monet and I were very enthusiastic over the London landscapes'. However, they chose different aspects of it: Pissarro, what he described as 'at that time a charming suburb' (Lower Norwood) and Monet, Hyde Park and Westminster. Monet's paintings of Hyde Park in 1871, though nothing more than stretches of grass and pathways with an indication of strolling figures are remarkably true to character though the principal product of his stay in London was the beautiful view of Westminster Bridge and the Houses of Parliament, dated 1871.

The suggestion of colour in the fog-laden sky is certainly Impressionist but the silhouette of the Parliament buildings does not suggest any debt to Turner, whose works the two French artists now saw. Monet observed and made use of the same flattening result of the heavy atmosphere as Whistler, whose Nocturnes belong to the same decade.

The resemblance, fortuitous as it may be, is increased rather than otherwise by the evidently well-considered relation of the foreground timber pier and the buildings and bridge behind, a reminder that Monet like Whistler was an admirer of the Japanese prints in which these decorative relationships had a studied importance. Monet was to come nearer to Turner in the later more vividly chromatic paintings of the Thames at Westminster made on his later visits in the first decade of the twentieth century.

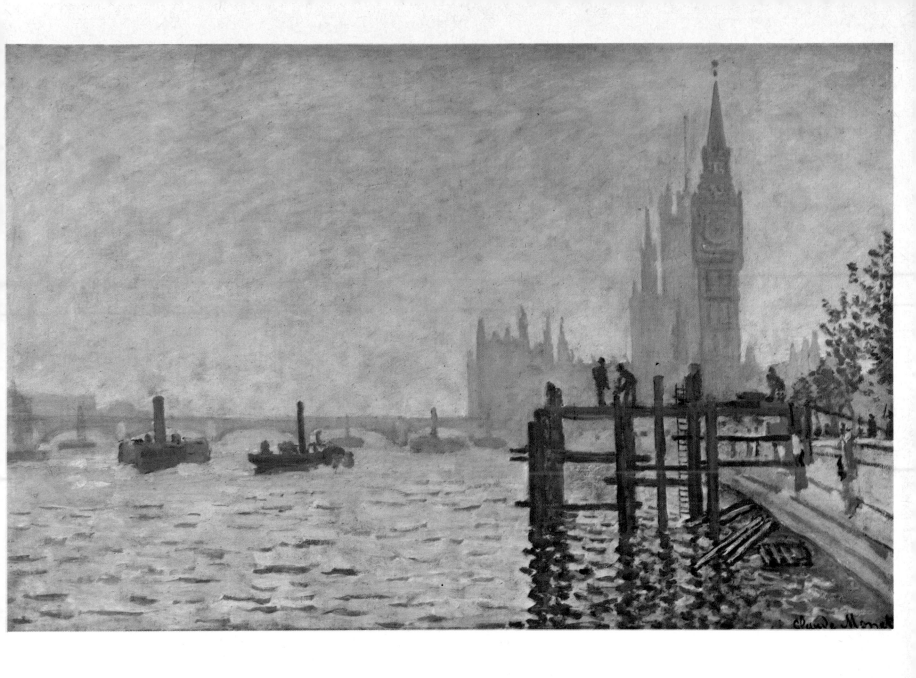

PLATE 18

Claude Monet

Impression: Sunrise
1872
Musée Marmottan, Paris

Monet painted this picture of the sun seen through mist at the harbour of Le Havre when he was staying there in the spring of 1872. A sketch quickly executed to catch the atmospheric moment, it was catalogued as *Impression: Soleil Levant* when exhibited in 1874 in the first exhibition of the group (as yet described simply as the Société Anonyme des Artistes-Peintres). The word 'Impression' was not so unusual that it had never before been applied to works of art but the scoffing article by Louis Leroy in *Le Charivari* which coined the word *Impressionnistes* as a general description of the exhibitors added a new term to the critical vocabulary that was to become historic. It was first adopted by the artists themselves for their third group exhibition in 1877, though some disliked the label. It was dropped from two of the subsequent exhibitions as a result of disagreements but otherwise defied suppression.

Monet's *Impression* was not in itself a work that need be regarded as the essential criterion of Impressionism, vivid sketch though it is. There are many works before and after that represent the aims and achievements of the movement more fully. Yet it has a particular lustre and interest in providing the movement with its name.

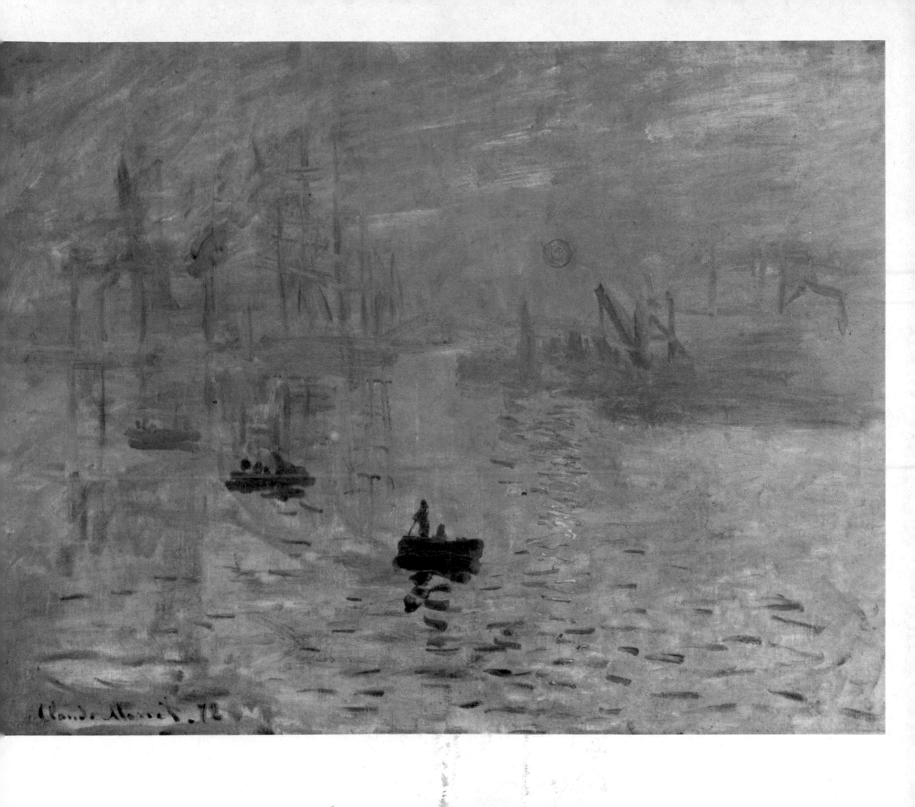

PLATE 19

Paul Cézanne

The Suicide's House
1872–73
Louvre, Paris

The Suicide's House, painted when Cézanne was thirty-three, marks the stage in his career when he was much encouraged and assisted by Pissarro. The latter's friendship and the sympathetic feeling for artists of Dr Gachet—an amateur painter who was later to have Van Gogh under his professional, medical care—brought Cézanne to the region of Auvers-sur-Oise and Pontoise. He lodged with Pissarro at the Hermitage Inn at Pontoise and set himself to the division of colour in the Impressionist fashion according to Pissarro's precepts. They imposed a severe discipline on one whose tendency so far had been to let himself go with Romantic violence in lurid colour and subject but here the result was a magnificent work. Cézanne still painted with more of impasto than Pissarro or Monet found suited to their purpose and applied extra layers that created a heavy grain (or 'scumble') though he smoothed down the heaviness in the areas of light with a palette knife. He already evinces a greater concern with the solidity of objects than his Impressionist acquaintances but there is serenity of atmosphere as well as strength in his composition. The fact that a man had hanged himself in the house Cézanne painted at Auvers is quite irrelevant to his picture in which there is no hint of sinister association but an aesthetic preoccupation with form and colour.

Exhibited at the first Impressionist exhibition in 1874, *The Suicide's House* was bought by Count Armand Doria, an early and enthusiastic collector of Impressionist works, in whose country house at Orrouy-sur-Oise, Cézanne would have a place with Manet, Renoir, Pissarro, Monet and Sisley.

PLATE 20

Claude Monet

Rough Sea, Etretat
c. 1873
Louvre, Paris

It would be possible to make a whole anthology of paintings of the chalk cliffs of Etretat with their remarkable and distinctive formation and of the sea at the same point of the French coast by artists of the nineteenth and twentieth centuries. Among them Monet's several works at this spot would have a distinguished place. Like Honfleur, Le Havre and Sainte-Adresse, Etretat was not merely a temporary resort but part of the whole pattern of his life, a place to which he repaired at various times—not rarely in his early days to seek a poverty-stricken artist's refuge—but always with refreshment to his art.

Etretat offered a painter many attractions. There was the *roche percée*, a natural sculpture, hollowed out by the constant action of wind and wave; the nuances of colour on the chalk surface induced by the reflections of sky and sea—and the sea itself. It was here that Courbet in the decade prior to that of Monet's picture, when painting on the Normandy coast with the young Whistler, had watched the waves breaking on the shore and with his predilection for what was solid and massive had brought out on canvas all the weight of structure that could be discerned in them.

Without Courbet's interest in the architectural solidities of nature, Monet would no doubt have his example in mind. But for a painter used to regarding landscape as a kind of still-life, a rough sea presented problems that Monet was less accustomed to solve than Turner, for instance, with his large experience and appreciation of nature in fury. He conveys a great sense of movement but reduces the impetuosity of the breakers to a pitch that allows of their taking on a certain decorative character, faintly reminiscent of Japanese print design. At a moment such as he depicts here, the most devoted of open-air painters might well be expected to rely on memory rather than to erect (or try to erect) his easel before the scene itself. There is a reduction of colour into tone, admirably carried through though unlike Monet's customary sparkle of colour. The painting is in contrast to several of his pictures of Etretat in the 'eighties which take full advantage of the chromatic suggestions afforded by land and sea. It is additionally of interest that for once the figures so expressively sketched on the shore imply something of narrative drama instead of incidental aesthetic accessories.

PLATE 21

Auguste Renoir

Monet Working in his Garden
1873
The Wadsworth Athenaeum, Connecticut

The years between 1872 and 1878 have a special significance in the history of Impressionism as the period in which Monet, Renoir, Sisley, and Manet along with them, were closest in accord, frequently working together in harmony of aim and style at the pleasant village of Argenteuil on the outskirts of Paris. Manet, who helped to solve Monet's housing difficulties at Argenteuil, and Renoir were the most regular visitors. Monet was the central figure, then entering on a new and vigorous phase of his art and producing many paintings of great beauty of the Seine, its pleasure boats and wooded banks and of his own garden where Renoir depicts him at his easel.

Neither Manet nor Renoir was entirely happy to leave out the human element in a painting and though persuaded by Monet's example to paint in the open they were more apt than he to introduce figures either of their friends or of the holiday-makers on the river, as main features of their compositions. This picture has a documentary interest in its portrayal of Monet, showing how he stood before his portable tripod easel, a stocky figure with brush poised to catch the transient moment of light on his small canvas. Paintings of gardens have a special place in Monet's work and in all probability he is here seen engaged on one of those intimate glimpses of bright flower beds (perhaps with Camille as a note of colour in the background) that at this time provided him with an alternative to the river prospect.

Figure painter though Renoir was by natural inclination, he is here akin to Monet in the pleasure he obviously took in the opulent pattern and sensuous colour of growing flowers against their setting of foliage. He makes full use of the indispensable blue of the Impressionist palette as indicative of both atmosphere and shadow. Apart from the illustrative interest the picture has the quality of a rich still-life.

PLATE 22

Claude Monet

Autumn at Argenteuil
1873
Courtauld Institute Galleries, University of London

Monet was the most responsive of all the Impressionists to the changes of the seasons and by no means confined himself to the summer season when *plein-air* painting could most comfortably be pursued. He studied open-air effect the year round, in this instance the autumnal colour of trees by the riverside. As autumn dyed the leaves with its own local colours of red, orange and yellow, this aspect of nature might be thought adventitious from an Impressionist point of view, somewhat disguising that relationship of light and colour at which they aimed; but Monet was able to add an extra intensity to the glow of foliage not only bright in itself but observed in bright sunlight.

The view looking along the Seine was evidently painted from his 'floating studio', the small boat which he had had fitted up with a hut to house his painting materials, and if necessary to sleep in, and with sufficient deck space for his easel. In this he imitated Daubigny who cruised happily on the Oise in a like craft. The boat gave Monet a wider choice of viewpoints for his river subjects than he could obtain from the shore. Here he is able to do full justice to a foreground and long perspective of water, the mirror-like gleam of its surface and the colourful depth of reflections.

PLATE 23

Alfred Sisley

Molesey Weir, Hampton Court
c. 1874
National Gallery of Scotland, Edinburgh

After the first Impressionist exhibition in the spring of 1874, Sisley spent part of the summer and autumn on one of his rare visits to England, painting views of the Thames at Hampton Court of which this is a striking example. The visit was made at the invitation of the singer, J.-B. Faure, who was one of the earliest and most enthusiastic Impressionist collectors. He acquired five of the landscapes Sisley painted on this occasion, among them *Molesey Weir*, which passed after Faure's death to his widow, was eventually acquired by Mr (later Sir) Alexander Maitland and was part of the Maitland Gift to the National Gallery of Scotland. The picture, painted with a decided vigour and confidence, is full of movement and even movement of two kinds—in the sky with its broken areas of cloud and in the foaming water of the weir. The purposely limited range of blue and green conveys freshness though there are subtle passages of warmer colour lighting up the effect, such as the far bank behind the two bathers on the left, the glimpse of a building and some foreground touches. Like his friend Monet, Sisley was aware of the contrast to be gained with atmospheric effect by a rigid structure such as a bridge. Here the weir so boldly defined serves as a vertebral column to a composition which shows the painter in his freest and most decisive mood.

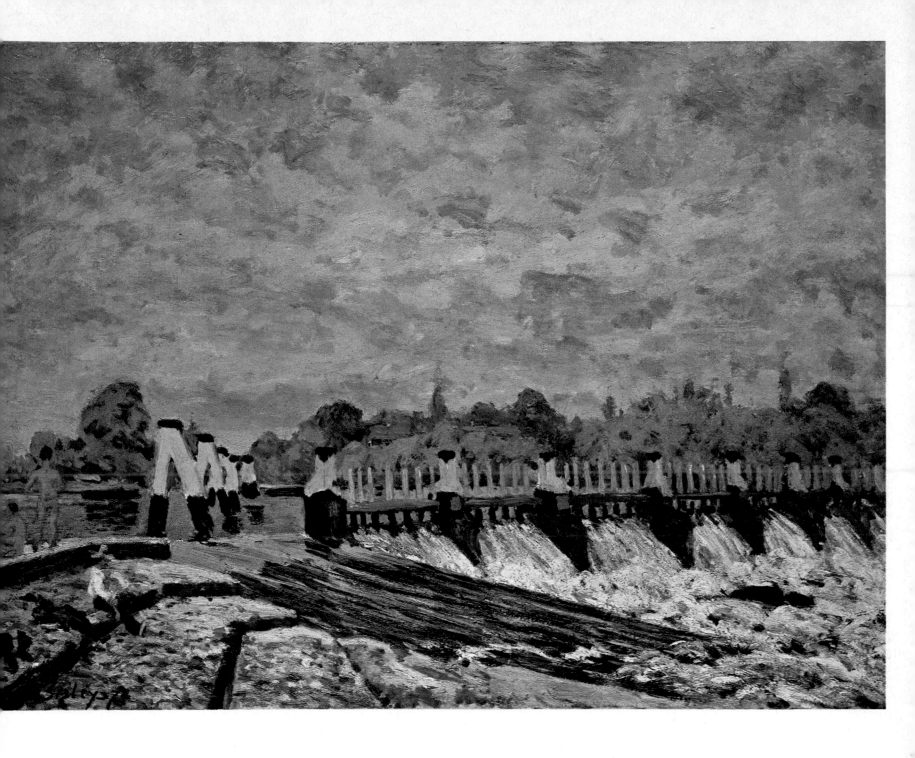

PLATE 24

Alfred Sisley

Misty Morning
1874
Louvre, Paris

On the whole the Impressionists tended to favour the clear light of day rather than mistiness and this would generally apply to the work of Sisley but here is an exception in which he attains an exquisite result. It contrasts sharply in treatment and character with his *Molesey Weir* where everything is boldly defined, and as well as the particular subtlety of colour the subject demanded shows a delicacy of brush-stroke appropriate to the suggestion of objects taking dim shape through a veil of atmosphere. The faint warmth that is already saturating the vaporous blue and beginning to tint the foreground flowers is beautifully conveyed. The varied informality of brushstroke corresponds to the method of which Sisley expressed his approbation in one of his few observations on painting. He considered that even in a single picture there should be this variety of treatment, adapted to the demands of one passage or another of the work. It is one of the reasons for the vitality of Impressionist painting.

If few comparisons offer with the work of other Impressionist masters there is one striking parallel in Monet's *Impression* of the 1874 exhibition, where his freely and swiftly manipulated brush causes the harbour of Le Havre to take shape in the fog. And it is not unlikely that Sisley was influenced by an experimental departure of Pissarro, the *Misty Morning at Creil* painted the year before Sisley's canvas.

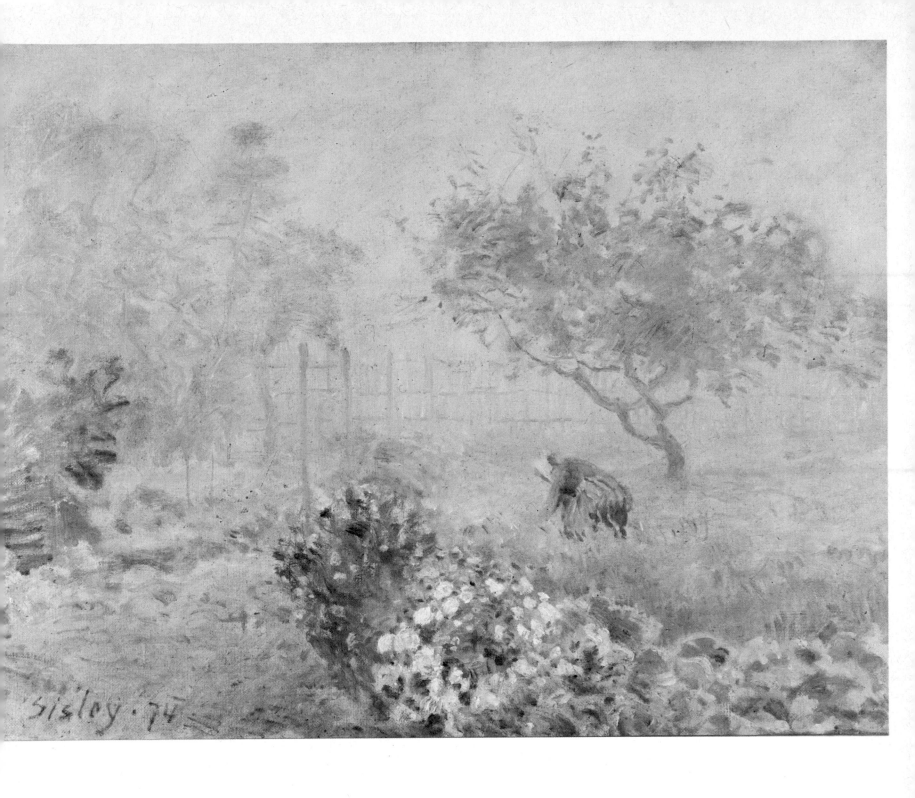

PLATE 25

Edouard Manet

River at Argenteuil

1874

Collection The Dowager Lady Aberconway, London

The year 1874 was momentous in the history of Impressionism. After the first group exhibition in the spring, Argenteuil on the Seine near Paris became the focus of brilliant and combined effort. Manet had abstained from sending to the exhibition, unwilling to be labelled one of a new clique and still believing that the Salon was the proper gateway to success but he was nevertheless on friendly terms with Monet. He was also well-disposed, partly through the influence of his sister-in-law Berthe Morisot, to the idea of *plein-air* painting.

When Monet, in his usual dire straits at this time, was evicted from his lodgings at Argenteuil, Manet was instrumental in finding him another house there to live in. Manet himself spent the summer not far away at Gennevilliers, frequently painted in Monet's company and could be described as a convert to the gospel of open-air light and colour. Renoir was also a constant visitor. An atmosphere of enthusiasm was generated which brought them all close together in style. They painted the same subjects and they painted each other—Manet and Renoir portrayed Camille Monet and her son in the garden, Renoir painted Monet at work in the garden and Manet painted him in his floating boat. Monet painted Manet at his easel also and all three made their pictures of the Seine and its pleasure-boats.

Such is the background to this beautiful work in which Manet seems to have entrapped sunlight by the exercise of some personal magic rather than a system. The intricate play of blues in varying degrees of sharpness is thoroughly Impressionist, so too is the renunciation of studio light and shade though Manet still admits a note of black, as in the woman's hat and its streamers and on the boats, as an enriching supplement to colour. The luminous effect is in part due not so much to the translation of light into colour as to the contrast of a bright yellow on the deck of the central boat with the blue of the Seine. But in general the painting falls harmoniously into the same category as the pictures of yachts and regatta by Monet and Renoir.

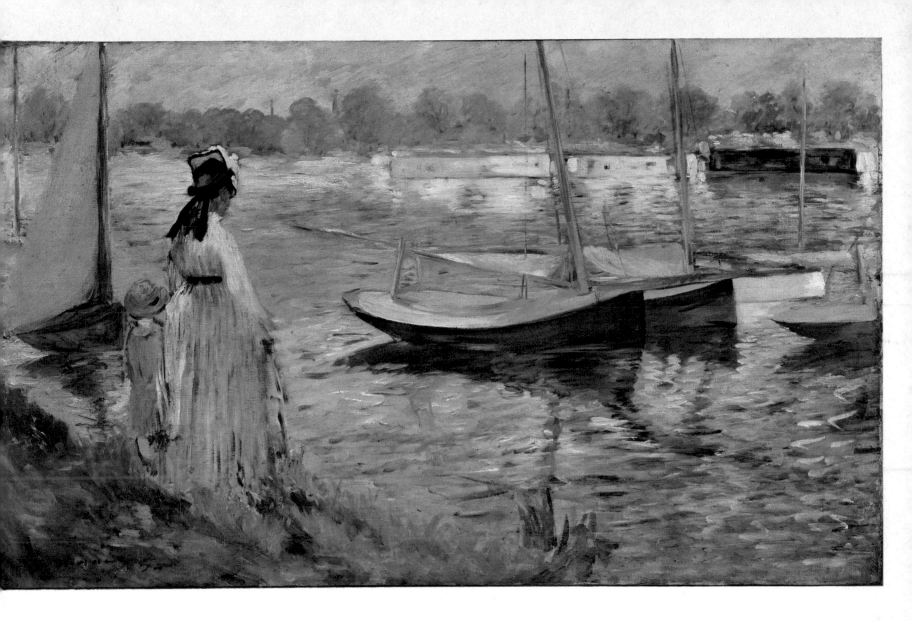

PLATE 26

Claude Monet

The Bridge at Argenteuil
1874
Louvre, Paris

Whereas Manet gained effect by sparkling accents standing out against low tones in his open-air pictures, Monet worked out the equation of light and colour more comprehensively and in more variety. In *The Bridge at Argenteuil* the equivalence is complete, the glow of light produced by pure and unmixed colour pervades the canvas and surrounds the forms appearing in it. The interplay between the short strokes indicative of ripples and the larger areas of colour is made with a typical flexibility of skill.

The accusation is sometimes made against the Impressionists that in their concern with atmosphere they lost sight of qualities of form and composition. Analysis of this painting would show, in spite of its apparent lack of pre-intended arrangement, how coherent it is in design. The verticals of the masts, of the houses and bridge piers and their reflections are set down firmly with an obvious sense of their pictorial value. There are those echoes of form and colour in which harmony of composition is to be found. The line of the furled sail is caught by the ribbed sky at the left; the warm tones of buildings are echoed in the details of the yachts; the dapple of clouds in the blue sky (with its deeper richness of blue in reflection) has its tonal equivalent in the reflections of the boats. To relax and look at the picture without analytic effort, however, is to see it resolve into an idyllic vision in which modern life has introduced no jarring note.

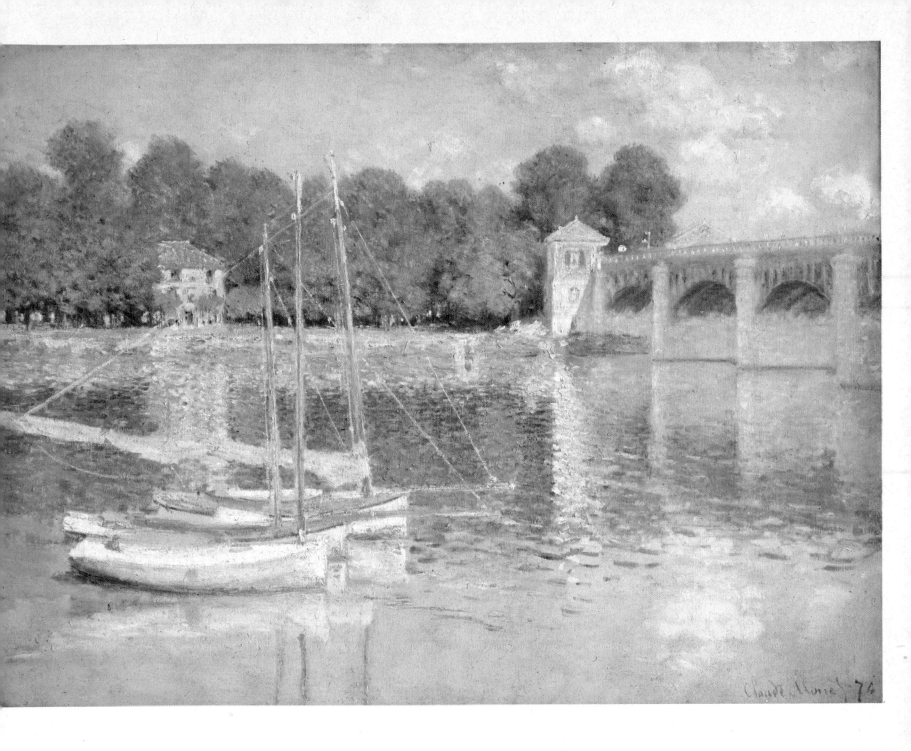

PLATE 27

Claude Monet

Regatta at Argenteuil
1874
Louvre, Paris

Monet was intensely productive at Argenteuil in 1874 but although his output was prolific, he kept wonderfully clear of repetition and seems to have worked in a fever of inspiration in which he went on from strength to strength. He looked at the Seine from every angle, either from the shore or from his studio-boat on the river and found variety in the scenes of regatta the summer offered. Yet the variety was also that of a brush responsive to the changes of weather conditions and the different nuances they imparted to a scene. Some paintings were patterned with a series of restless touches that conveyed the suggestion of squally conditions, but in others—of which this is a brilliant example—he became masterfully broad in handling. Fascinated by the spread of sail in warm, creamy silhouette against blue sky, he made a bold simplification, treating the river and its reflections with equal breadth. It was a constantly practised hand that could sweep in those long foreground strokes so suggestive of the river's long placid ripple.

Renoir, who sometimes painted the same boats as Monet from the same viewpoint, was equally fascinated by their sails and was very close to Monet, as represented in this picture, in the exclusion of detail and an almost abstract rendering of light. The two artists working side by side seem to have encouraged one another to feats of brilliance of the most adventurous kind.

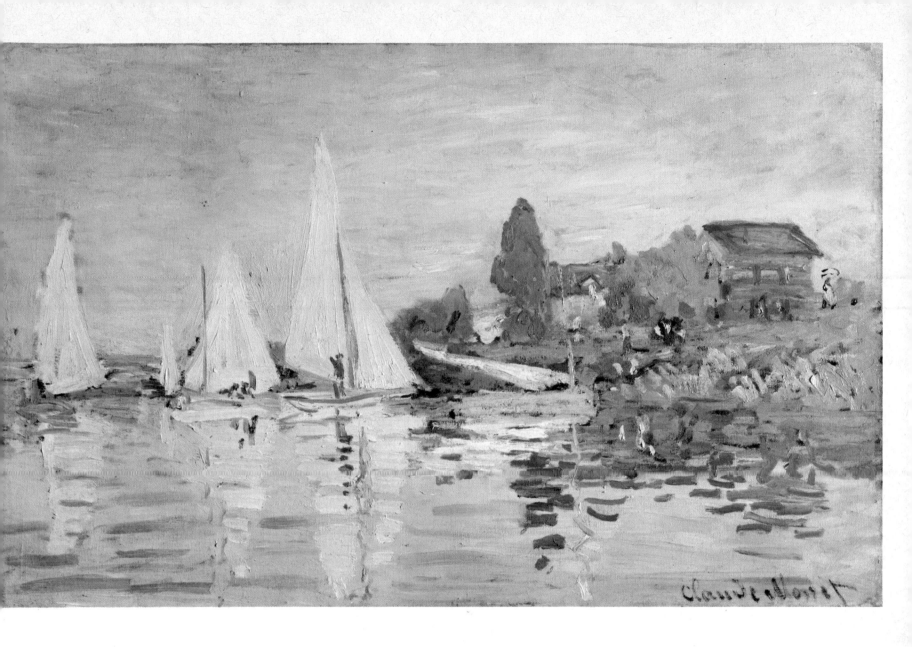

PLATE 28

Alfred Sisley

Floods at Port-Marly
1876
Louvre, Paris

The best of Sisley's several versions of the floods at Port-Marly, this was probably the picture exhibited in the third Impressionist exhibition of 1876. Since the end of the Franco-German war he had worked in several of the environs of Paris—at Louveciennes, Bougival, Argenteuil and Voisins but mainly at Marly. The collapse of the family business in the war had transformed the well-to-do young man under no urgent necessity to sell his pictures into a professional faced with as hard a struggle as Monet and Pissarro and braving it, fortunately, for a long time without detriment to his art. In these years he developed in freedom of style on somewhat similar lines to Monet but a particular grace and lyrical feeling were personal to Sisley.

Something of Corot's feeling for grey recalls his early attachment to that paternalistic master, and appears in the delightfully painted sky with its pale tints of blue appearing through the clouds. There is a hint of Corot too in his sensitive treatment of the building shown, very French—if not especially Impressionist—in the pink and blue of its façade. There is even an architectural element of composition in the rectangles created by the café and its reflection and the lighter flooded area. The Impressionist habit of accepting as subject whatever they found in front of them often quite fortuitously produced an interest of composition as appears here in the perspective of poles and trees.

Sisley's modest and retiring disposition may sometimes be traced in the undemonstrative nature of his art which is none the less of intrinsic value. In its quiet fashion this is one of the Impressionist master-pieces.

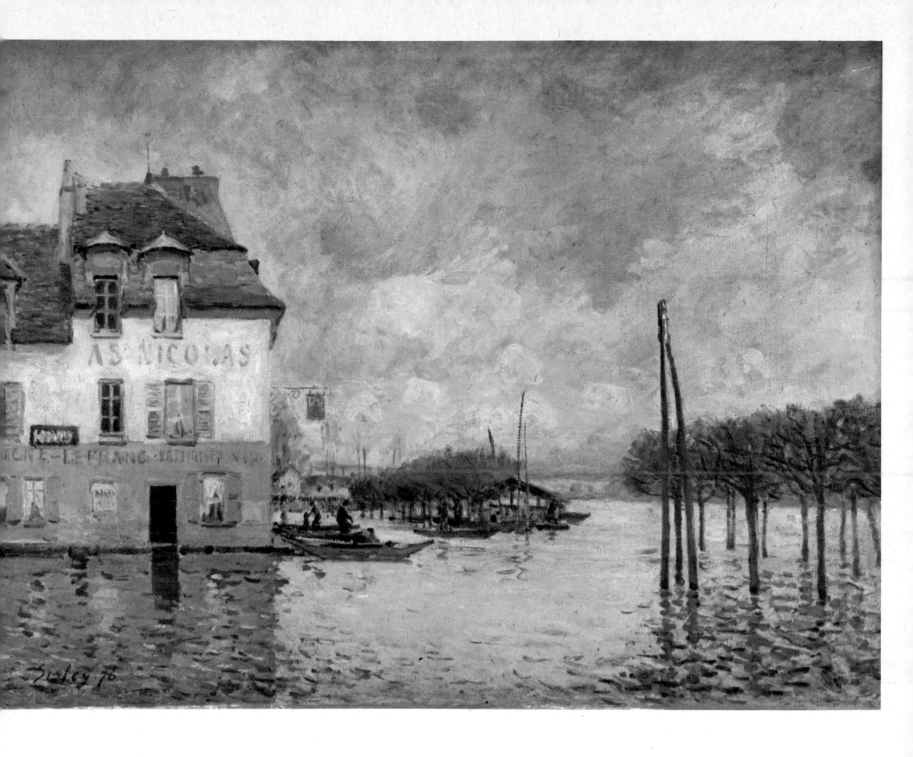

PLATE 29

Camille Pissarro

Orchard with Flowering Fruit Trees, Springtime, Pontoise
1877
Louvre, Paris

Pissarro lived at Pontoise, some ten miles north-west of Paris, from 1872 to 1882, taking great pleasure in its rolling and fertile countryside and its gardens and orchards. He had reached middle-age in this period but for most of it was in a parlous financial state that caused desperate trips to Paris to raise what small sum he could get for a picture, perhaps from Eugène Murer, the pastrycook in the Boulevard Voltaire, or another of the sympathetic few who bought his work. Yet his paintings of this period give no hint of the anxieties of his life and there seems a profound rural contentment in this orchard picture. It is low in tone though there is nothing of sombreness on this account. The blue that was so great an Impressionist standby in their rendering of shadow gives serenity and richness to the intervals between the trees with their load of white blossom. The taller tree placed so near the centre adds stability to the composition.

One might see here the rural philosopher in paint whom the critic Théodore Duret seems to have appreciated in Pissarro. Making a comparison with Monet and Sisley in one of his letters, Duret remarked, 'you have what they have not, an intimate and profound feeling for nature and a power of brush with the result that a beautiful picture by you is something absolutely definitive.' He advised Pissarro to pursue this 'path of rural nature' without thought of Monet or Sisley. The artist himself refused to entertain any invidious comparison with these confrères though at this period he was in closer touch with Cézanne, with something of that exchange of thought that had earlier shown itself between Monet, Manet and Renoir at Argenteuil. They painted together in the same orchard at Pontoise in 1877, as elsewhere in the region, Cézanne becoming conditioned to Pissarro's practice of working in the open air and finding out the value of Impressionist objectivity.

Pissarro's *Orchard* was exhibited at the fourth Impressionist exhibition of 1879 and eventually came to the State as part of the Caillebotte bequest.

PLATE 30

Camille Pissarro

The Red Roofs
1877
Louvre, Paris

This painting is certainly one of Pissarro's masterpieces and an illustration of some of the essential aims of Impressionism. It gives a dual sensation—of truth to a particular region and aspect of nature so exactly realized that the spectator seems transported to the scene; and of colour that, while creating this effect, has a vibration and lyrical excitement of its own. Pissarro has been described as an unequal painter but if this was from one standpoint a shortcoming it had also an advantage in enabling him to attain exceptional heights from time to time. The low tones of his *Orchard at Pontoise* might lead one to think of him as one confined by a particular mood or capacity of vision yet in *The Red Roofs*, painted in the same year, the low tones are exchanged for brilliance of light, the grave utterance of the rural philosopher turns into song.

The effect can be appreciated without analysis but it is enlightening as to his method and general approach to consider the picture in relation to the advice he gave at a later date to a young painter, Louis Le Bail, whose unpublished notes of conversation with Pissarro were summarized by John Rewald in his *History of Impressionism*: 'Do not define too closely the outlines of things; it is the brushstroke of the right value and colour which should produce the drawing'. A look at this painting shows how Pissarro made this his own practice. 'Don't work bit by bit but paint everything at once by placing tones everywhere with brushstrokes of the right colour and value . . .' This has an important bearing on the colour harmony so splendidly carried out here. Colour is not localized but is picked up like a melody in various parts of the canvas—the blue of the sky in the blue of doors and shadows, the red of the roofs in field and foreground earth—so that all comes into happy relation.

PLATE 31

Claude Monet

Gare Saint-Lazare
1877
Louvre, Paris

Monet's wonderful series of paintings of the Paris railway-station was a major work of 1877 though he began the enterprise in 1876 and completed it in 1878. He had previously painted variations on one theme but this was his first systematic effort to ring the changes of light and time of day on a chosen subject. At least four of some ten paintings were executed at about the same spot under the large angle of the station roof, others in the open outside. He was interested in the diverse colours of steam, at one time deep blue against warm sunlight as in this instance or at another light against dark, and of course also in all the associated contrasts between the covered space and the city beyond. The way in which he used thick paint, blending numerous small bright touches of colour, was especially forceful in accordance with the suggestion of mechanical power the subject demanded.

To paint steam engines was certainly to be 'contemporaneous' in the sense that Manet had used the word. It cannot be supposed that Monet was unaware of the dramatic spectacle they provided. It is just possible that some memory of Turner's *Rain, Steam and Speed* which he had seen in the National Gallery in London six years earlier crossed his mind and suggested the subject. So far did he become absorbed in what he painted that the spectator experiences all the sensation of being actually on the spot. Yet the fact that he could paint so many versions does not indicate a special interest in locomotives and steam power but rather in the changing effects of light in terms of colour that make each version different from the others.

This was the beginning of the several series of paintings made in his later years in which the subject matter became of decreasing importance and light/colour became their *raison d'être*. The logic of this veering away from the fidelity to surface appearance, that had been an earlier Impressionistic stage, led towards abstraction.

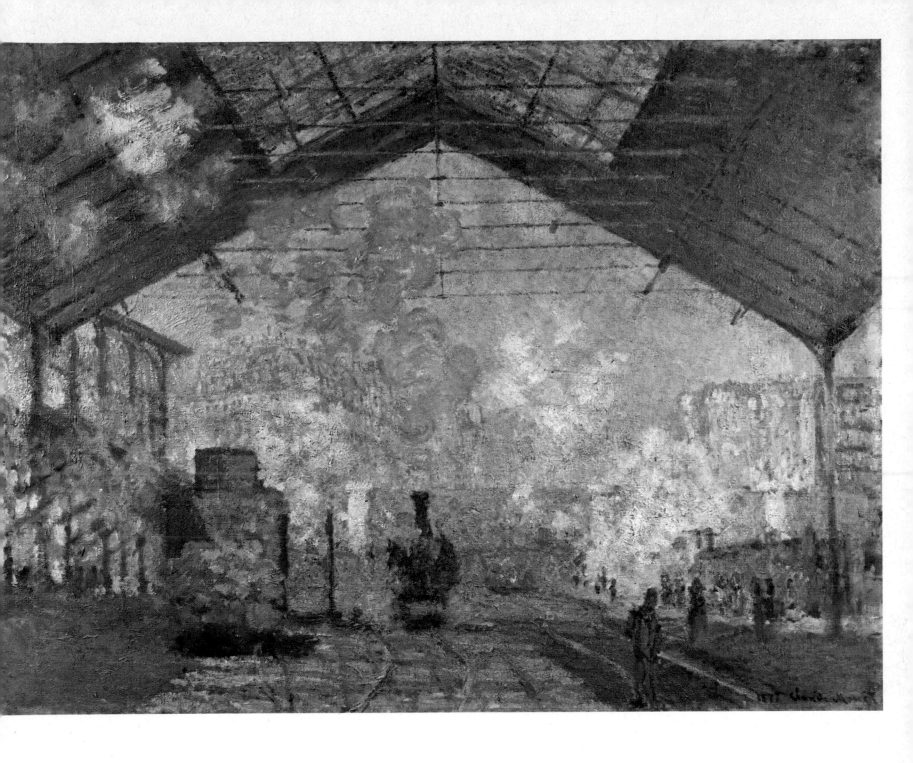

PLATE 32

Edouard Manet

The Roadmenders in the Rue de Berne
1877–78
Collection Lord Butler

Manet produced many memorable pictures of Parisian life from his picture of *Le Skating* to the final triumph of *Un Bar aux Folies-Bergère* but as an outdoor scene his *Rue de Berne* is unsurpassed, conveying the very essence of a Parisian street and bringing into relation the Proustian elegance of some wealthy person's carriage and the group of proletarian workers, without the least element of social comment but with an instantaneous realism that goes beyond the camera.

There is a personal kind of Impressionism in this superlative vision of everyday life. The blue shadows were perhaps an acquirement from the period spent at Argenteuil. Certainly all trace of the sombreness of Spanish art, by which he had at one time been attracted, had disappeared leaving a breathable air and a credible light of day. Manet's immense facility in presenting the whole reality of a figure in a few sketchy but magically suggestive touches appears in the labourers while in typical fashion he indicates sunlight by those sudden patches of lighter colour that tally with their movements.

No picture could be less topographical and yet, by the empathy of his genius, Manet sets the spectator down in Paris in a way that leaves no doubt as to where he is—at the same time creating lovely intricacies of colour.

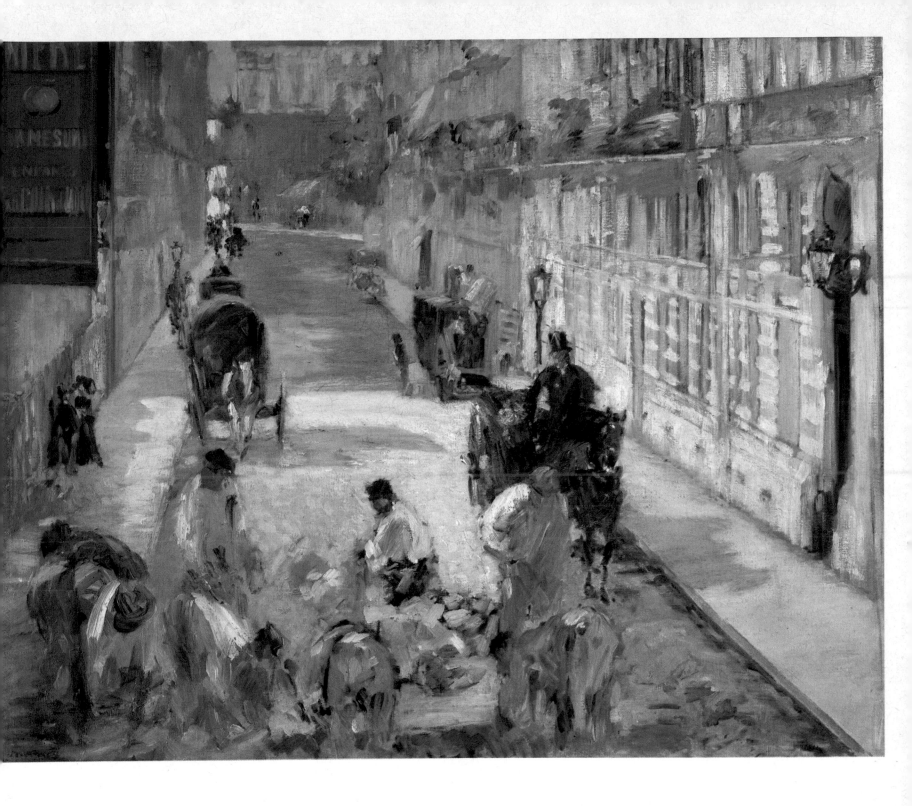

PLATE 33

Claude Monet

Snow Effect at Vétheuil
c. 1878–79
Louvre, Paris

Monet left Argenteuil and the near neighbourhood of Paris in the spring of 1878 for the village of Vétheuil, half-way between Paris and Rouen but also on the Seine that meant so much to him as an artist. The winters of that year and the year following were especially severe and gave him ample opportunity of painting snow scenes in which, like Courbet, he had always been interested. One of his outstanding early works had been *The Magpie* (Société Guerlain, Paris) of *c.* 1869 in which he had enjoyed demonstrating the variations of colour created by sunlight on the virgin mantle of snow. The mood of his views of Vétheuil, snow-bound, and of the Seine, frozen and in subsequent thaw, had more of melancholy and harshness which may be associated with events in his life at this time. His wife Camille, less able to endure the hardships of their life than he, remained seriously ill after the birth of their second son in March, 1878 and died in the autumn of 1879. He had also the problem of looking after Mme Hoschedé, the wife of his former patron, left destitute with two sons and four daughters. He himself was in the direst poverty. It would not be far fetched to discover a trace of sadness in the austere colouring of his pictures.

Here he depicts the village as seen from the river, dominated by its Romanesque church. He uses a characteristic variation of technique as between the broad separate brushstrokes of the foreground and the blended colours of the hedge behind the snowy bank, but despite the absence of any decided warmth, the total effect is richly harmonious.

Paul Signac (in *D'Eugène Delacroix au Néo-Impressionnisme*) leads one to suppose that Monet and Pissarro derived their method of painting snow from the study of Turner's effects in which 'a marvellous result is obtained, not by a uniform white but by a number of strokes of different colours'. Yet Monet had already shown his awareness of such possibilities before he had been to England and it would be difficult to find in Turner any likeness to Monet's Vétheuil.

Other paintings in the winter series to which this belongs study the many subtleties of colour produced by the break-up of the ice on the Seine, this series of débâcles being as systematically carried out as the foregoing views of the Gare Saint-Lazare.

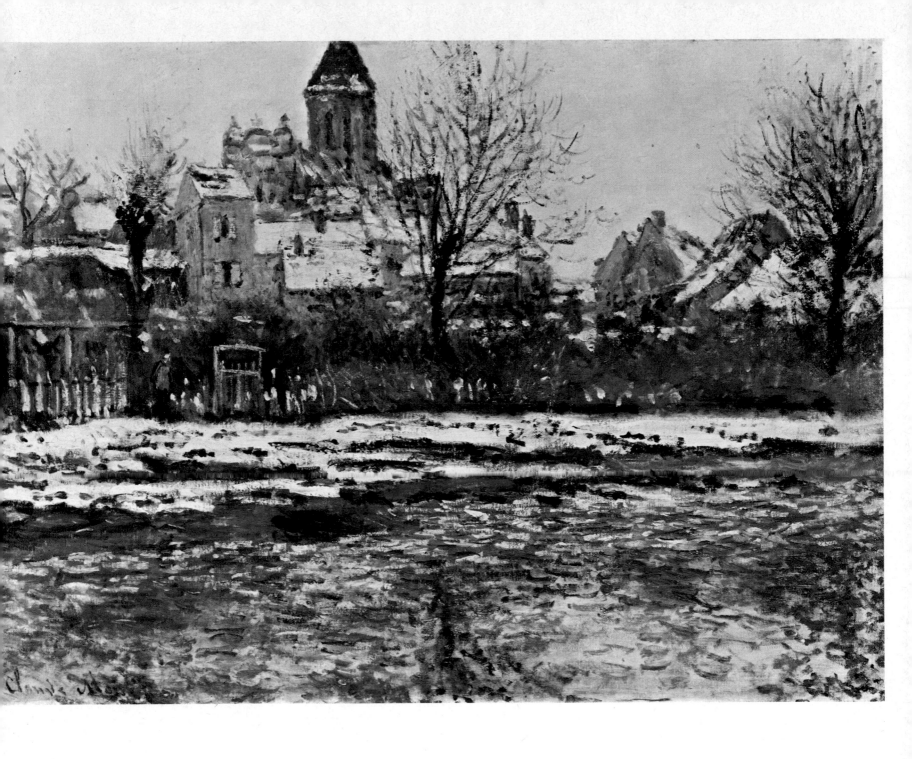

PLATE 34

Alfred Sisley

The Small Meadows in Spring (Les Petits Prés au Printemps)
1882–85
Tate Gallery, London

Sisley was essentially the visual poet of spring and early summer and the freshness of the season is here conveyed in a way that can scarcely fail to infect the spirits with something of its tingling vivacity. The riverside path along which the girl walks in meditation—the small meadow path or *chemin des petits prés*—was between By and Veneux some three miles north-west of Moret-sur-Loing. Sisley settled in Moret in 1882 but worked both before and after at Veneux and Les Sablons and there are several pictures painted around the spot shown in this example. The gleam of light on the opposite side of the Seine locates the village of Champagne.

A walk by the river bank was a favourite theme with Sisley. The blue sky with its soft and placid flocks of cloud is typical. The follower of Corot may be discerned in the appreciation with which the slender trees are treated and also in the significance that carefully selected points of focus have in the composition. Not only does the blue of the girl's dress bring sky colour down in to the picture but the yellow brim of her hat and the white of her collar are gleams caught up and repeated by the patch of light in the background and the distant sparkle on the other side of the Seine, so helping to diffuse the effect of light throughout the picture space. That the sun seems to shine is not due to any forced brightness but to the lively and varied touches of the brush as it picks out highlights or follows the track of cast shadows across the path and over the bushes.

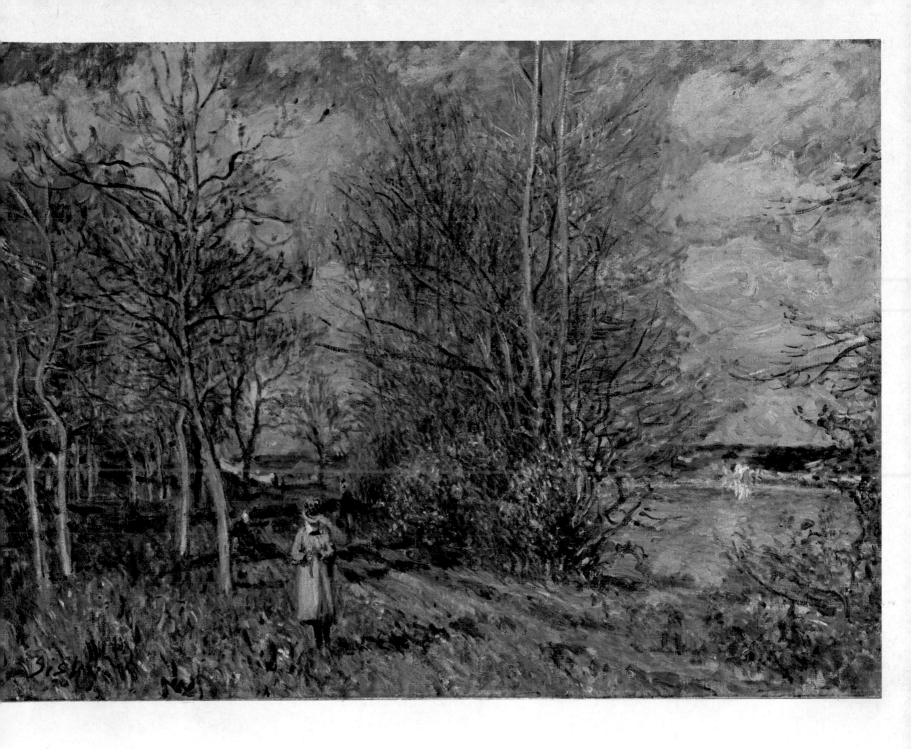

PLATE 35

Paul Cézanne

L'Estaque

1885

Collection Lord Butler

From the period of the Franco-German war in 1870 to the year of his father's death in 1886, Cézanne alternated a good deal between Paris and the village—as it then was—of L'Estaque near Marseilles. He was there during the war, and for a number of years afterwards he had the satisfaction of painting at intervals in his native Provence at a place which, though it already had its factory chimney, was endowed with a splendid natural situation. It was also not a negligible factor that he was there far enough away from Aix to be out of the immediate range of his father's disapproval.

In studying the Provençal landscape, Cézanne had first begun to canalize the violent outpouring of his genius. Of the several pictures he painted at L'Estaque this is a mature example in which the disciplines that came of his induction into Impressionist aims and methods by Camille Pissarro and his own self-schooling in objective approach are both traceable. There is none of the violently heavy paint he had used in his earlier days. As much of the Impressionist manner remains as is represented by the separate brushstrokes with which the paint is fluidly applied. These rectangular strokes form a kind of translucent masonry, building up an essentially, though not obtrusively, geometrical structure. Although there are delicate gradations, such as may be found in the Mediterranean blue of the sea, the general effect is one of solidity and permanence. The work is a magnificent example of development from the Impressionist starting-point.

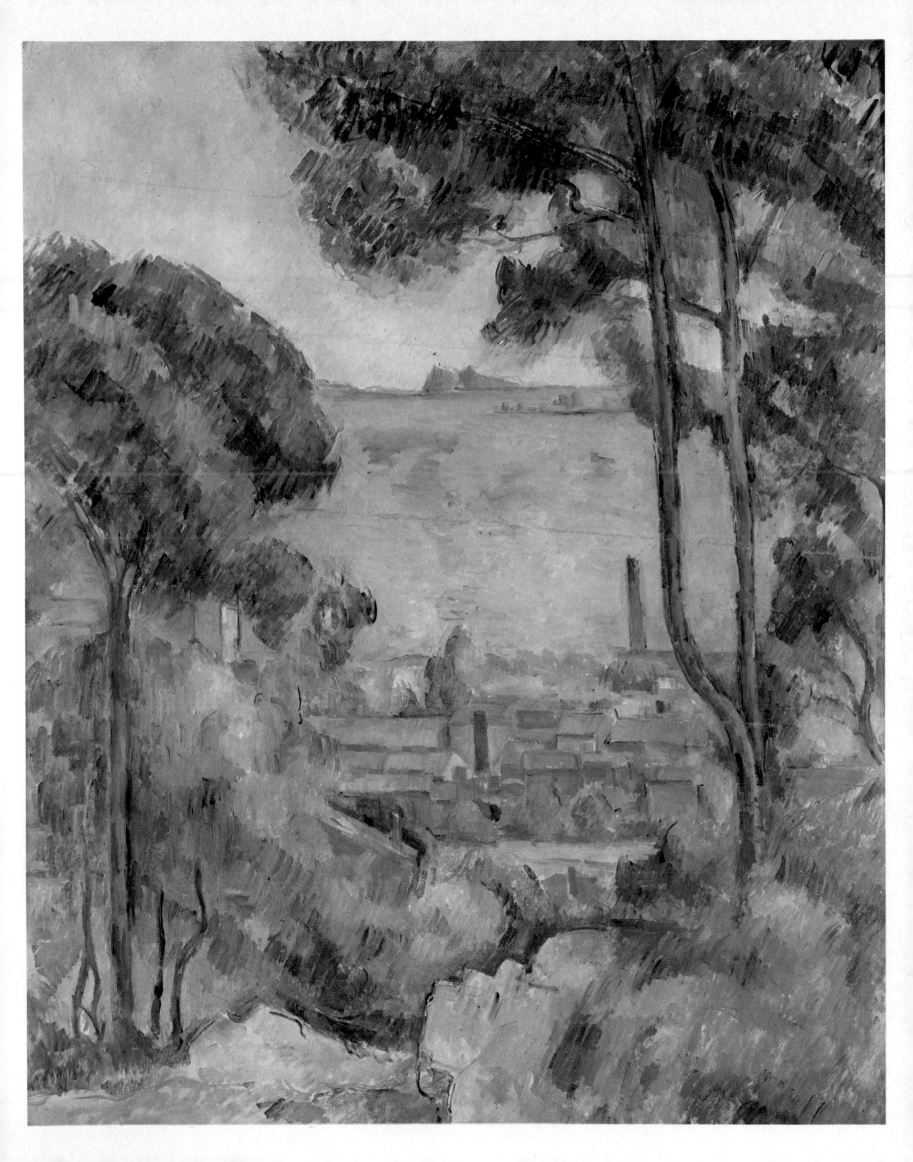

PLATE 36

Paul Cézanne

Mont Sainte-Victoire

1885–87

Courtauld Institute Galleries, University of London

In Cézanne's paintings of the Mont Sainte-Victoire near his native Aix-en-Provence it is possible to appreciate what he derived from Impressionism and also the extent to which he had departed on a different and personal course. Painting with Pissarro had made him aware of the value of a direct study of nature and of the importance colour might possess. Yet Cézanne was much more interested in the structure of objects as distinct from the atmosphere through which they were seen than were his friends among the Impressionists. The bare bones of his Provençal mountain had more to give him than the lush and gentle contours of Pontoise.

There is a superficial residue of Impressionist method in his application of separate touches of colour. A fundamental difference appears in the fact that he did not seek to provide an analysis of light by the division of colour but to make use of subtle gradations that expressed solid form. There were a great many colours on his palette and he did not exclude the white and black which were inadmissible according to strict Impressionist theory. The strong, architectural structure he sought out and the colour gradation that took on a singular delicacy and beauty are factors alike in this superb version of his favoured subject.

In speaking of solid form, however, it is necessary to avoid the suggestion that Cézanne aimed simply at imitation. His remarks on the 'powerful sensation' to be experienced *devant la nature* suggest the extent to which personal feeling modified the objective view. He found, he said, that the realization of his sensations was a painful matter, by which, perhaps, he did not imply that copying the appearances of nature was so hard as to be painful, but that his naturally tempestuous feeling struggled with the discipline involved. His series of paintings of the mountain, unlike Monet's various series, does not show how a subject alters in appearance under different atmospheric conditions but in different impacts on the imagination. The Mont Sainte-Victoire in the Hermitage is a volcanically restless, upheaving mass; in the version preserved at Philadelphia it is crystalline and jewel-like; in the Courtauld picture it has the grandeur and dignified stability of an acropolis.

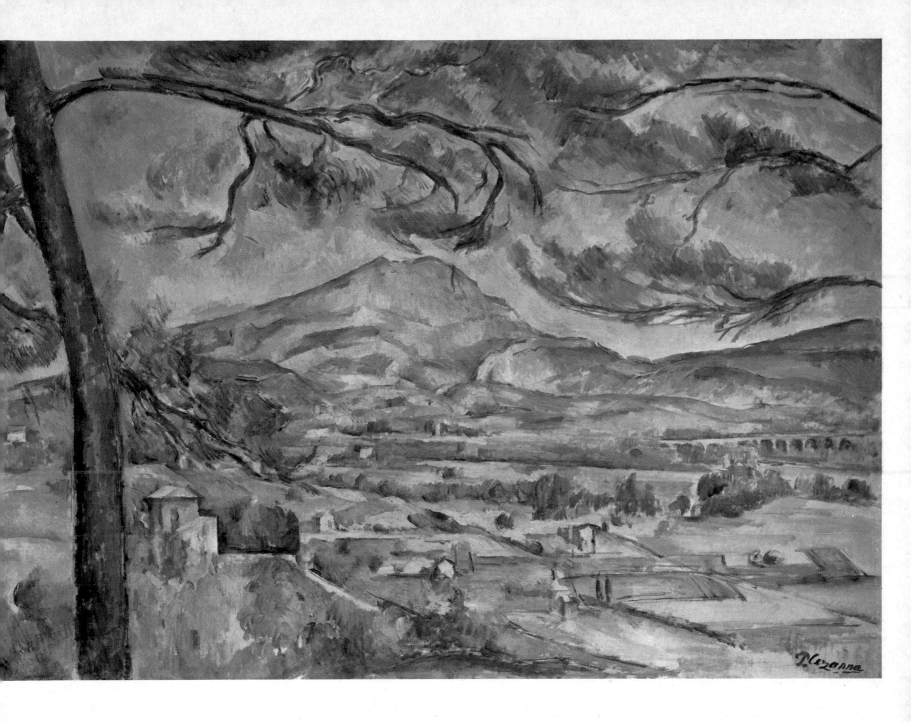

PLATE 37

Vincent van Gogh

Le Moulin de la Galette, Montmartre
1886
Glasgow Art Gallery

Cézanne had a painting in the first Impressionist exhibition of 1874; Van Gogh came to Paris in the year of the last Impressionist exhibition in 1886. Cézanne had known members of the movement in the course of its development; to Van Gogh, newly arrived in Paris, their work came as a revelation. These are some of the great differences between the two painters who are both described by the vague and somewhat unsatisfactory term 'Post-Impressionist'. Van Gogh, used as he was to the dark tones of the old Dutch School, an enthusiast for the English illustration of the 'seventies and its 'social realism' and accustomed to nothing more exciting than the work of the brothers Maris, of Anton Mauve and Josef Israels, was dazzled by works in which for the first time he realized what splendour colour and design could assume.

If Van Gogh had been writing letters to his brother from a distance he would undoubtedly have left on record his immediate reaction to the Impressionists and his excitement at seeing the still controversial developments of Neo-Impressionism as represented by the works of Seurat and Signac. In fact he was lodging with his art-dealer brother, Theo, first in the rue de Laval (now rue Victor Massé) and later at 34 rue Lepic, so the record was never made, yet the revelation is clearly apparent in his *Moulin de la Galette*. The dark tones of his Dutch period palette have been entirely cleared. The gentle flock of Impressionist clouds moves placidly across the sky. In the powerful brushstroke there is more of ease and relaxation than his earlier work displayed. The windmill is an ambivalent factor as Van Gogh paints it, recalling the feature of the Dutch lowlands rather than the popular resort that Renoir had painted at close quarters in 1876, ten years before. But already one feels that the Van Gogh sadly taking refuge in Paris from earlier failures is here on the threshold of vital new experience.

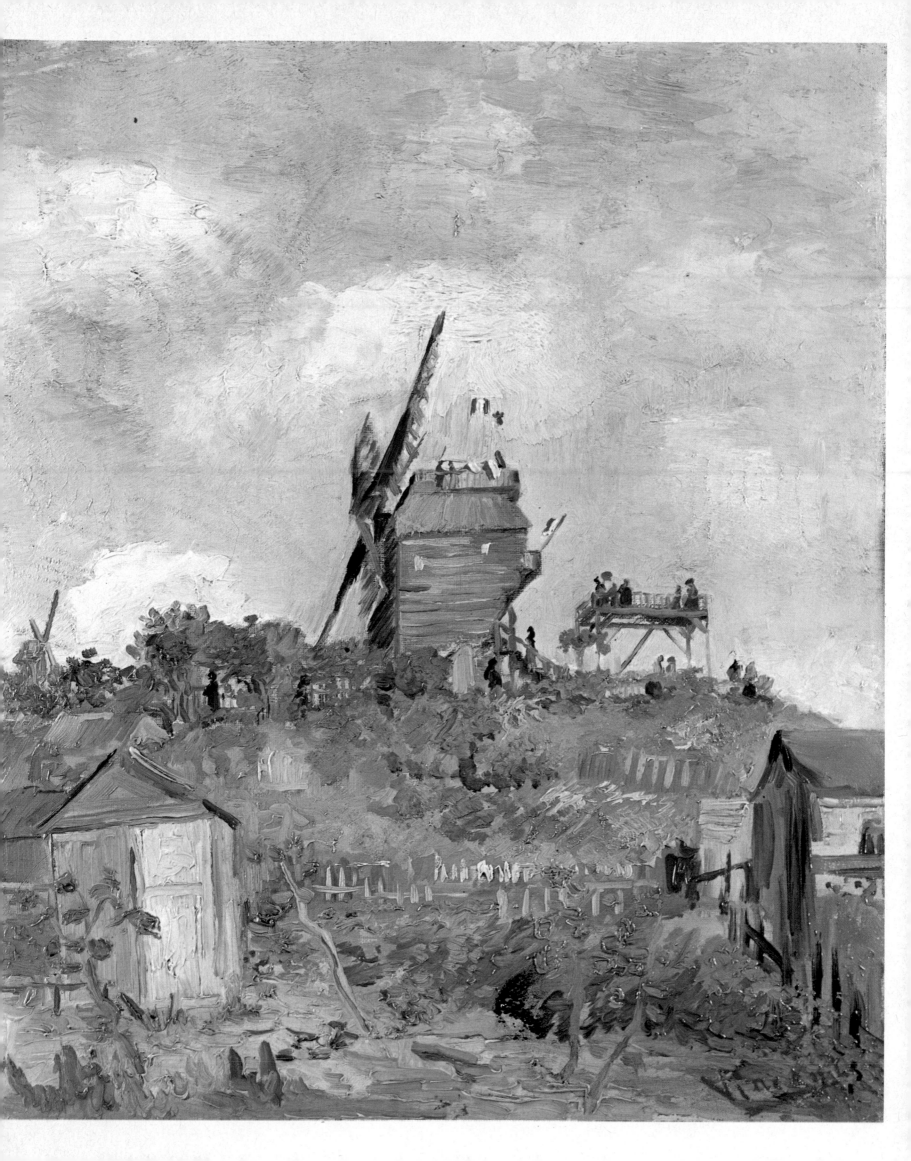

PLATE 38

Vincent van Gogh

Montmartre

1886

Art Institute of Chicago

One of the numerous paintings of Montmartre, then still a countrified suburb where Van Gogh shared living quarters with his brother, this picture illustrates both his interest in his new surroundings and also his change of style from dark and heavy tones to light and tender colour. From the terrace and observation post of the Moulin de la Galette he suggests not so much a view of the city as the prospect of infinite space. It is surprising to think that only the year before this, back in Nuenen, he had painted in an entirely different key and mood his dusky, lamp-lit peasant genre-scene, *The Potato Eaters*.

His style was not yet finalized (though he could give even the row of lamp-posts a unique individuality). He did not venture to challenge comparison with Monet, Sisley, Renoir and Degas whose work was shown by Theo van Gogh on the Boulevard Montmartre and whom Vincent referred to as 'the great impressionists of the Grand Boulevard'. He styled himself one of the 'painters of the Petit Boulevard', exhibiting with Bernard, Anquetin, Gauguin and Toulouse-Lautrec at a café on the Boulevard Clichy. Yet in this period of two years before the craving for sunlight and warmth drove him southwards to Arles, it is evident that he was absorbing influences and ideas at a feverish rate. In 1886 the Neo-Impressionism of Seurat and Signac in the last Impressionist exhibition was to be absorbed into his consciousness with extraordinary results.

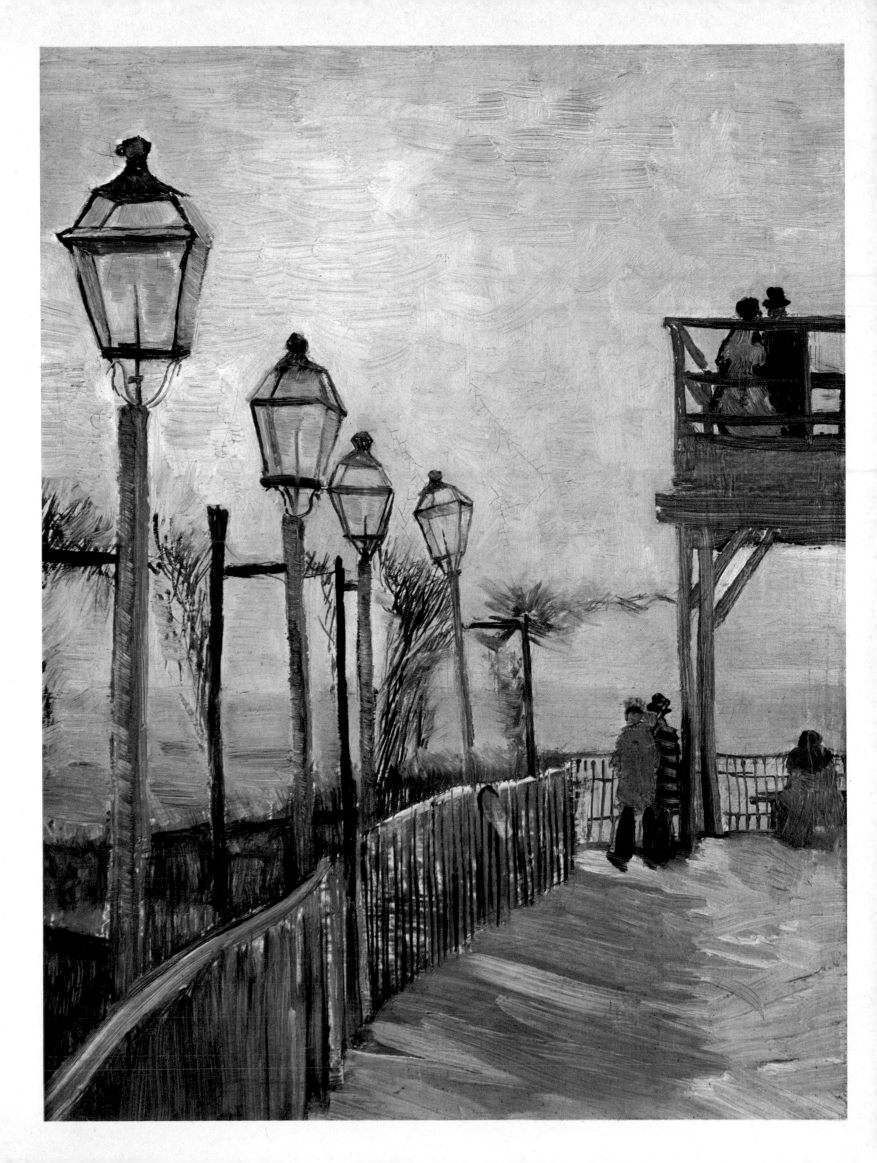

PLATE 39

Georges Seurat

Shore at Bas Butin, Honfleur
1886
Musée des Beaux-Arts, Tournai

What may be regarded as the final stage of Impressionist theory, or perhaps more accurately as the eventual provision of a theoretic base for what had been a free technique, appears in the work of Seurat and his friend Paul Signac and was a central theme of controversy in the year this landscape was painted. It is carried out in what Seurat called 'divisionism' (for which his friend Félix Fénéon coined the alternative title 'Neo-Impressionism' but which is still popularly known as 'pointillism'). This was the method of painting with small dots of the spectrum colours, blue, violet, red, orange, yellow and green and their intermediaries placed in juxtaposition without mixing, though sometimes with white between or with modification by white. The effect is one of near fusion to the spectator's eye though the method imparts a vibration of colour that a ready-mixed tone could not give. The beauty of this arrangement of minute 'tesserae' of colour has a complement, or contrast, in the clear definition of area and outline in deliberately simplified form.

Though a similarity with Impressionism as earlier practised may be found in the use of pure colours, the method obviously excludes the swift and spontaneous nature of *plein-air* painting. This was recognized by its practitioners but considered a gain. In his book, *D'Eugène Delacroix au Néo-Impressionnisme*, Signac remarked: 'If certain painters who could more aptly be called chromoluminarists have adopted the title of Neo-Impressionist, it is not with the object of cashing in on the success of their elders. It is a mark of homage to them (i.e. Monet, Pissarro, Sisley). The difference is that they relied on instinct and instantaneity; we have turned to what is carefully thought out and built to last.' Seurat did in fact make studies on the spot—which he called his *croûtons*—in the spontaneous Impressionist way, as in the oil sketches for his *Sunday Afternoon at the Grande Jatte* but the finished painting (in the Art Institute of Chicago) shows their transformation into a highly formalized scheme.

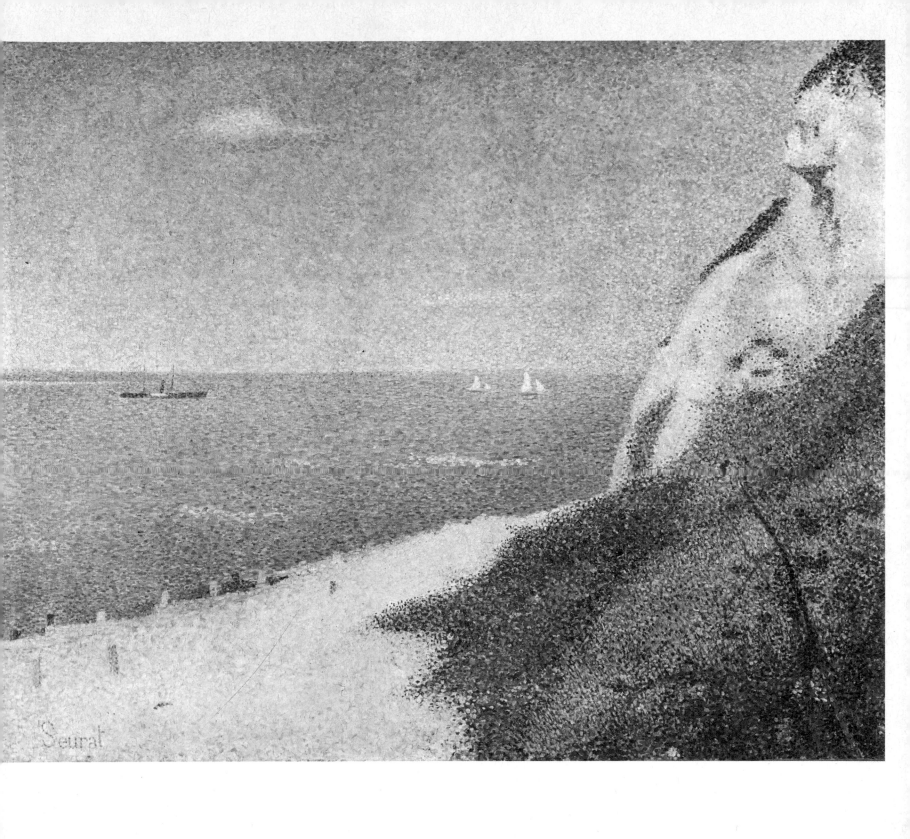

PLATE 40

Georges Seurat

Bridge at Courbevoie
1886–87
Courtauld Institute Galleries, University of London

Repose, stability and the value of the geometrically-measured interval between objects—as much as the vibration of divided colour—are the special beauty of this painting. Seurat so far conformed to Impressionist habit as to work in their favourite regions, on the one hand the coast of Normandy, on the other the Parisian riverside suburb—the locale of this painting, which is a view taken from the north bank of the Island of the Grande Jatte. Yet the masts of the small boats and their reflections, the factory chimney in the background and the rigid figures on the shore make up a system of verticals that, with the lateral intersection of bridge and landing stage, precludes movement and insists on the basic order of design. Seurat's analytical mind was equally concerned with the abstract geometry of composition and with the interactions of colour that had been scientifically discussed by the chemist Chevreul. Argenteuil was not many kilometres distant from the scene of the *Bridge at Courbevoie* but to refer back to the paintings made there in the previous decade by Monet and Renoir is to become aware of the perceptible current that was moving away from the aim of rendering atmospheric and instantaneous effect to other regions of discovery. Seurat's exquisite small landscapes together with the large *Grande Jatte* were a new beginning from which, short though his life was, Seurat was able to indicate that further prospects opened up.

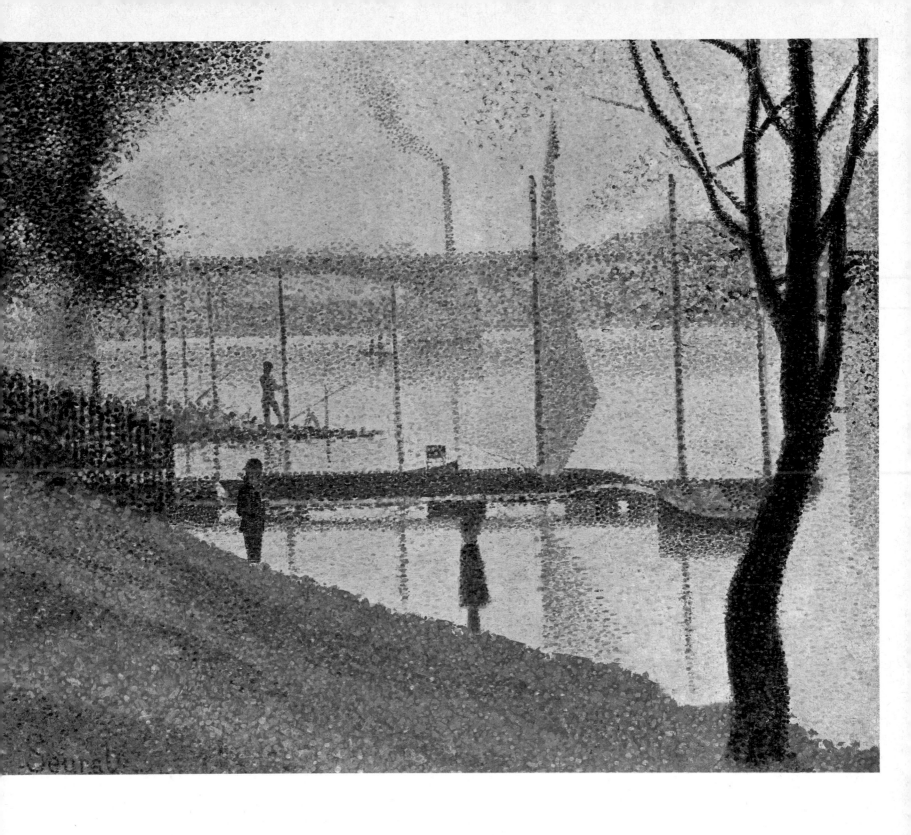

PLATE 41

Camille Pissarro

Woman in a Field
1887
Louvre, Paris

Pissarro was technically the most experimentally-minded of the Impressionists and also a bold adherent of causes in which he believed. He settled at Eragny near Gisors in 1884 where he evinced a restlessness that led him to try various media—watercolour, pastel, etching—and not long after to become absorbed in the divisionist theories of Seurat and Signac. Pissarro met them in 1885 and he and his son Lucien were promptly converted to the idea of what Camille described as 'a modern synthesis by methods based on science; that is, based on the theory of colours developed by Chevreul, on the experiments of Maxwell and the measurements of O. N. Rood'. Regarding himself as a 'scientific Impressionist' and to that extent dissociating himself from his old friends whom he now thought of as 'romantic Impressionists', Pissarro added to the already pronounced dissensions of the group by insisting that Seurat and Signac should be represented in the eighth (and last) Impressionist exhibition of 1886. He himself took to their methods with an enthusiasm that made him appear a leading innovator.

The altered method which he pursued for two years is effectively illustrated by this work of 1887. It is none the less attractive because there is a certain measure of unconscious compromise. Pissarro is still in spirit the *plein-air* painter, capturing the transient moment and dispensing with outline in order to give the shimmer of sunny atmosphere. Although he applies colour with methodical touches the functional nature of the rainbow colours in creating tone is not realized with Seurat's severity of system—there is perhaps more sentiment than science. Pissarro clung to his experiment in the face of objections from buyers and dealers but apart from their doubts and criticisms the outlook and method most natural to him was not to be repressed and he gradually returned to his earlier style.

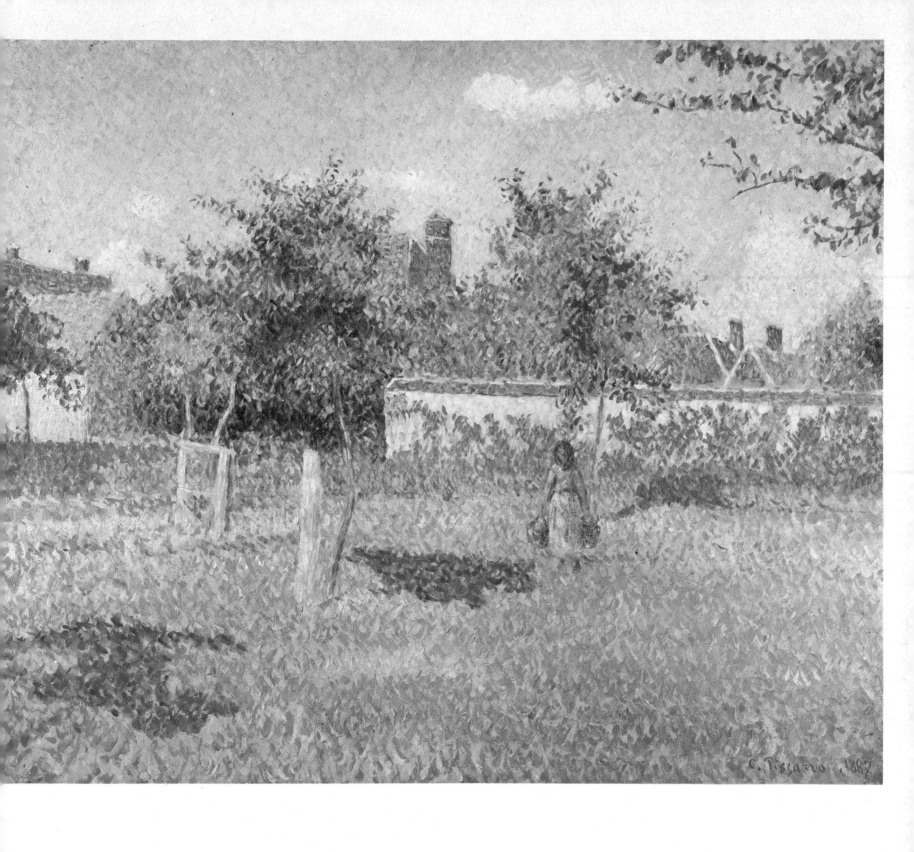

PLATE 42

John Singer Sargent

Claude Monet Painting at the Edge of a Wood
1888
Tate Gallery, London

If not one of the Impressionists, Sargent was certainly an adherent of the movement. The derision aroused by his portrait of Madame Gautreau when exhibited at the Paris Salon in 1884 interrupted what might have been a close connection with French art and led him to make London his headquarters as a portrait painter. But he contributed to the establishment of an insular offshoot of Impressionism in the New English Art Club, of which he was one of the founder members in 1886, and sought to arouse interest in Monet's work in America. He had the greatest admiration for Monet and was influenced in his own style by the French master. At the time he painted this portrait he had recently bought one of Monet's paintings (*Rock at Tréport*).

The portrait was painted in the spring of 1888 at Giverny where Monet had gone to live not long before. The wife of his former patron, Mme Ernest Hoschedé, whom Monet had befriended and who was to become his second wife, appears at the right of the picture. Sargent has not attempted the translation of light and shade into terms of pure colour in the essentially Impressionist fashion but indicates the splashes of sunlight through the trees with his own vivacity, and his capacity for the brilliant sketch is well exemplified in the figures.

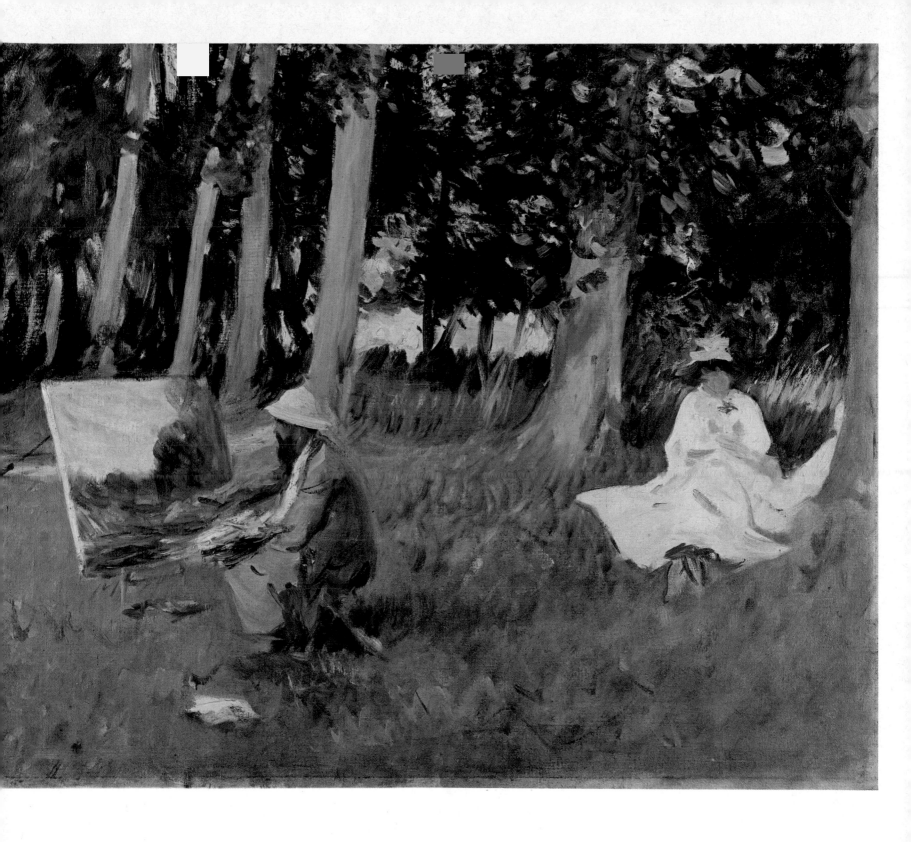

PLATE 43

Vincent van Gogh

Wheatfield with Cypresses
1889
National Gallery, London

The last two years of Van Gogh's life were productive of marvellous pictures—painted though they were under constant strain. During this period he travelled far from his Impressionist starting-point in Paris. The equable balance of Impressionism was replaced by an emotional turbulence. Calm objectivity gave way to the expression of intense feeling. Yet there remains an evolution that can be traced back to the time when his brother first showed him works by Monet, Pissarro, Degas and Cézanne and when he first began to apply separate patches of colour in the manner of Seurat. The freedom and variety in the use of the brush that counted for so much in Impressionist painting still belong to his later work, though exaggerated and distorted by the agitations and difficult circumstances that followed his quarrel with Gauguin. The Neo-Impressionist juxtaposition of near-primary colours was also exaggerated to a point of intense brilliance.

 This picture was painted at St Rémy in Provence after he had entered the asylum there in May 1889 and was one of three versions (the other two being a larger and a smaller copy). It is possibly the painting he refers to in a letter to Theo written towards the end of June with 'a cornfield very yellow' and the cypress—a tree just then 'always occupying my thoughts' that was 'a splash of *black* in a sunny landscape'. The whirling brushstrokes of the sky may at first give the disturbing suggestion of mental imbalance and violence beyond control, but the longer the picture is considered the more consistent it appears as a whole in the multitude of curves that twist and turn and repeat themselves throughout. Nor is it to be supposed that Van Gogh was incapable of anything else. The flame-like form of the cypress sets a key that is followed through with a pervading vibration that represents a sustained effort.

PLATE 44

Vincent van Gogh

The Roadmenders
1889
Cleveland Museum of Art, Ohio

The variety of Van Gogh's later style can be illustrated by a comparison of this picture with his *Wheatfield with Cypresses*. Painted in the same year and at the same place, St Rémy, it is executed with short, thick, brushstrokes instead of the scheme of whirling curves and the well-knit design is held together by the bold contours enclosing forms of lighter tone. The technique is as sympathetic to the rough and ancient bulk of the avenue of trees as the sinuous curves of his brush are to the form of his cypress.

Van Gogh went into the asylum at St Rémy of his own accord. After the quarrel with Gauguin and the mutilation of his ear, he had become an object of fear and suspicion at Arles, but as a voluntary patient of generally reasonable behaviour he was allowed considerable freedom at St Rémy and could go out into the main street of the village where he painted this picture. Unfortunately, the jeering of the village children brought on one of his recurrent fits of angry excitement; this and others led to his being more closely supervised during the rest of his stay. It was then that he turned from nature to making free copies of Millet and Delacroix before leaving for Auvers in May 1890. He was entered in the asylum register as 'cured'. The circle of his tragic career came back to Impressionism in his final stay at Auvers under the care of Dr Gachet, the friend of Pissarro, in whose company Pissarro and Cézanne had painted together.

PLATE 45

Georges Seurat

Le Chenal de Gravelines: Petit Fort-Philippe
1890
Indianapolis Museum of Art

The art of Seurat, short though his life was, was one of complex and contrasting elements. It has been said that he used the weapons of Impressionism to conduct an offensive against it. He was as much concerned as his Impressionist elders with luminous effects of light and colour in one group of paintings; but in those later works, *Le Cirque* and *Le Chahut*, there is an effort to express or formularize movement by means of emphatic repetitions and angularities of form, together with an edge of social comedy or satire. In both respects a scientific bent showed itself. As Chevreul interested him in the combinations and interactions of colour, so, it would appear, the work of another scientist, Charles Henry, interested him in the record of paths of movement.

Yet in a landscape such as *Le Chenal de Gravelines* painted in the same year as the high-kicking performers in the current dance craze—*le chahut*—the beauty of the picture is that of classical calm. The division of colours, little more obtrusive than the dots in the mechanical three-colour process of reproduction, fuses in exquisite tone. He is near to Impressionism in the feeling of atmosphere he gives but the stability conveyed by his systematization of colour is reinforced by the quiet firmness of geometric line and careful spacing. There is a sense of reality too, though in a different coastal season from that of Boudin's scudding clouds and choppy seas.

PLATE 46

Claude Monet

Poplars on the Epte
1891
Philadelphia Museum of Art

Monet painted the tall poplars on the banks of the river Epte near his house at Giverny under varying climatic and seasonal conditions in 1890 and again in 1891. A row of tall vertical stems backed by a receding line of other poplars provided the basic arrangement which he observed from his boat. He began his series of Haystacks before he had finished with the Poplars, a distant line of the trees often forming a background. In both series he took enormous pains to wait for and entrap exactly the light each picture demanded. Yet in spite of the stubborn effort made with the aim of attaining a complete objective truth, causing him to take out a whole set of canvases to the chosen site on which he could work one at a time as a particular phase of light allowed, another element insidiously crept in. The subject in constant repetition came to matter less and less; aesthetic considerations apart from a scientific naturalism came into play. The slenderness of the poplars seemed to take on something of the exaggerated elegance of the contemporaneous *art nouveau*. The colour scheme became more of a contrived and artificially heightened contrast between blues and purples, oranges and yellows. The new aspect of Monet's art after he had reached the age of fifty can be appreciated in the ecstatic colour of this example.

With the public the series were a great success, the Haystacks especially. Fifteen of them exhibited at Durand-Ruel's were all sold within a few days at 3,000 to 4,000 francs each. But there were some critics and some among Monet's Impressionist confrères who were dubious of the course he now pursued. The adverse opinion gained strength that Impressionism so interpreted involved too great a sacrifice of substance and construction. Yet they attached too little value to the poetic and abstract characteristics of Monet's art.

PLATE 47

Claude Monet

Rouen Cathedral: Full Sunlight
1894
Louvre, Paris

Monet's persistence in painting in series, beginning with the Gare Saint-Lazare and continuing in the Poplars and Haystacks, attains an impressive climax in the series he devoted to Rouen Cathedral. He began work at Rouen early in 1892, the year after he had finished the Haystacks and the last of the Poplars, and took a room above a shop in the rue Grand-Pont from which to observe the west front of the great church. He broke off to return to Giverny but resumed work at Rouen in the spring of 1893. The rest of that year and most of 1894 was spent in completing the paintings from memory. Twenty of them, ranging in effect from dawn to sunset, were exhibited at Durand-Ruel's gallery in 1895 with great success. Monet's friend Clemenceau justly praised their 'symphonic splendour'. Pissarro reproved adverse criticism in the letter to his son in which he remarked on the series as 'the work, well thought out, of a man with a will of his own, pursuing every nuance of elusive effects, such as no other artist that I can see has captured'.

Monet, it is clear, was as little concerned with the subject, masterpiece of Gothic architecture though it was, as when painting his Haystacks. Where the building invited and challenged his ability was in the fretting of the surface as it caught the light and the profound effects of shadow in the deep recesses. The heavy grain of his thick paint gave its own animation to the façade. Working largely from memory he exchanged the more fluent technique of the *plein-air* picture finished at a sitting for this entirely opposite quality of carefully worked-up impasto. In addition, without direct reference to the building in reality, a poetic element in his nature seems to have come uppermost. There remains the sensation of Gothic without its detail curiously similar to that of Gaudi's Church of the Holy Family at Barcelona (mainly built about the same time as Monet was painting his Cathedrals)—another instance perhaps of the subtle and far-reaching influence of *art nouveau*. Otherwise, rather than conveying the atmospheric reality of sunlight, a painting such as the example given here can be appreciated as a gorgeous dream.

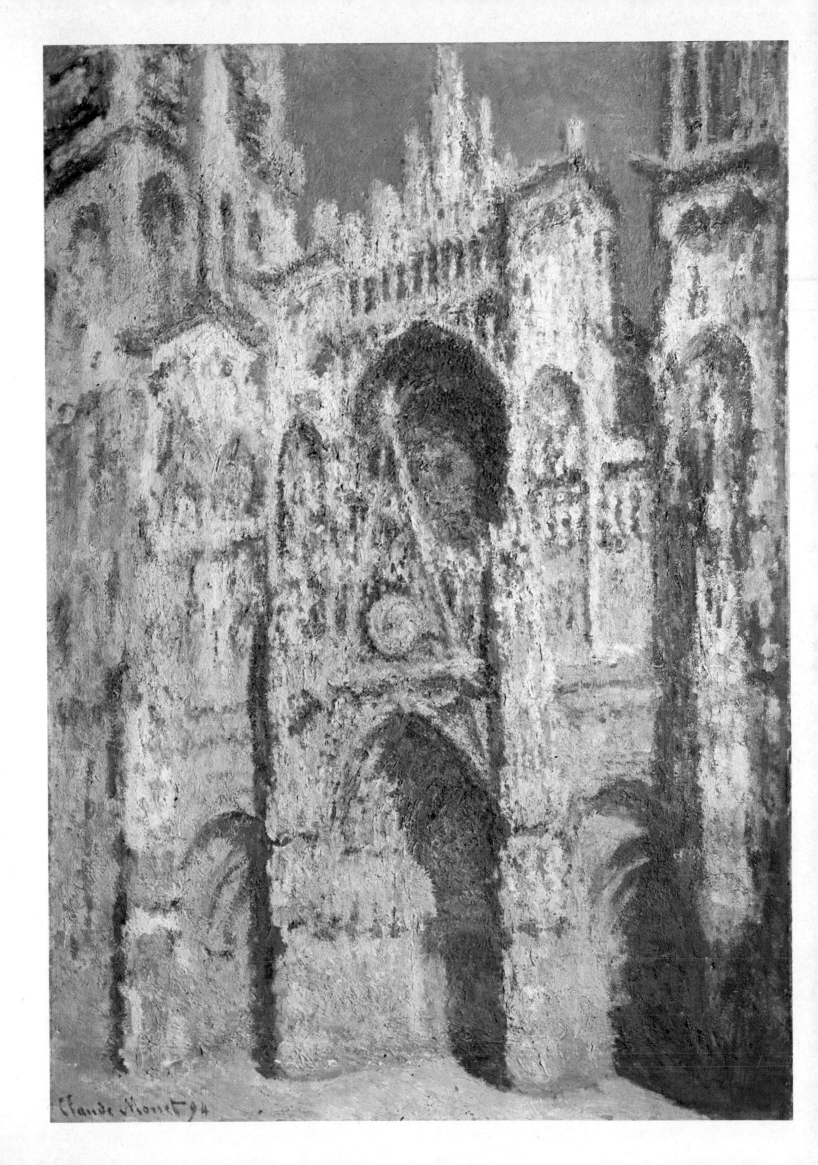

Claude Monet 94

PLATE 48

Camille Pissarro

Place du Théâtre Français
1898
County Museum of Art, Los Angeles

Pissarro was intensely active in the last ten years of his life when he enjoyed an affluence previously unknown. He not only travelled a good deal but showed a new interest in city views of both buildings and crowds. In 1897 he began the series depicting Paris in vivid combination of buildings and movement which occupied him for several years. He worked from the windows of hotels and other buildings that offered a desired prospect and painted this view of the Place du Théâtre Français in 1898 from the Hôtel du Louvre.

Here he excelled in weaving an intricate pattern of moving humanity and horse-drawn vehicles, enjoying it the more, perhaps, as a change from the painting of rural scenes at Eragny. The effect of momentariness is perfectly caught, rather recalling the views of Paris made by 'instantaneous photography', though Pissarro has more to give in design and, of course, colour. The amateur and Impressionist patron Gustave Caillebotte had earlier produced paintings of the boulevards seen from above in a way that has invited comparison with the contemporary photographs of Hippolyte Jouvin. Whether Pissarro used photographs as a reference it is impossible to say. The idea of painting the impression of a moving crowd was an innovation in nineteenth-century art made by the Impressionists. Pissarro follows the lead given by Monet in his *Boulevard des Capucines* of 1873. It is of interest however that photography was advancing towards a comparable innovation at about the same time.

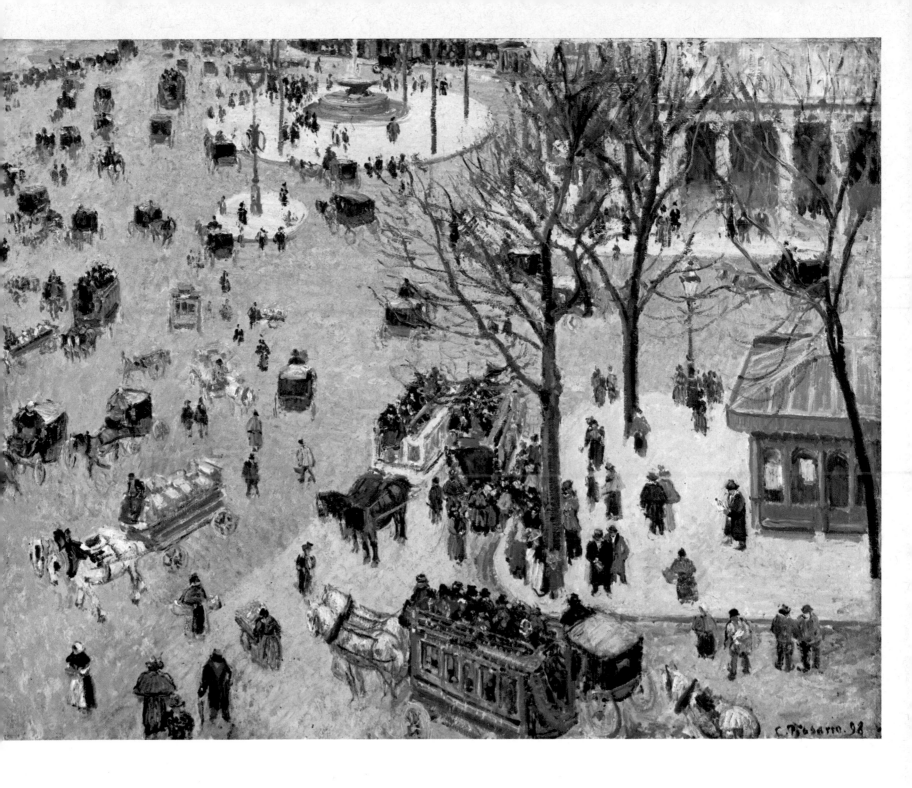

PLATE 49

Walter Richard Sickert

Café des Tribunaux, Dieppe
c. 1900
Tate Gallery, London

Impressionism did not gain a great deal of appreciation or understanding in late Victorian England either among art patrons or painters, but had an intelligent advocate in Walter Sickert who organized the 'London Impressionists' exhibition at the Goupil Gallery in 1889 and had a measure of support from the New English Art Club of which he was a prominent member. He himself was not a practitioner of *plein-air* painting with pure colour in the fashion of Monet or Pissarro. Dusky tones relate his early work to that of his first master, Whistler, and he was mainly influenced by Degas among French artists, following him in working from memory and slight sketches made on the spot.

 This picture still shows traces of Whistler's method in the simplified tones of light and shade and the suggestion of figures with touches of thin paint, but also gives an impression of sunlight in a vivacious manner that is Sickert's own. It has been dated about 1900 though an earlier date of *c.* 1890 is likely on the evidence of style. It shows a view along the Grande Rue of the Café des Tribunaux in the Place du Puits Salé, Dieppe. Sickert had made an etching of the café when he began his visits to Dieppe in 1885. His favourite French resort inspired more pictures when he took up residence there from 1899 to 1905. The appearance of Dieppe at the point shown in this one has been much altered since 1945 by the refacing of the café and widening of the Grande Rue.

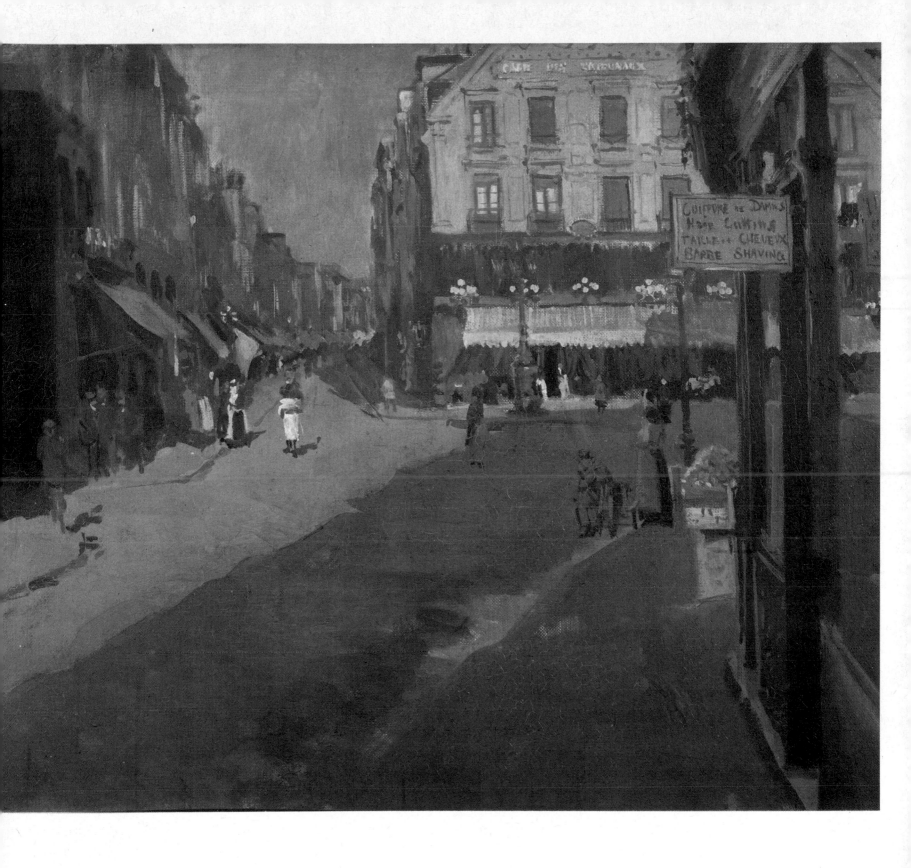

PLATE 50

Camille Pissarro

Le Pont Neuf

1901

Collection Mr and Mrs William Coxe Wright, Philadelphia

One of the triumphs of Pissarro's later period is this view of Paris, sparkling with light and at the same time richly harmonious in its colour. In 1901 when this picture was made Pissarro was living on the second floor of the house of the Louis XIII period, at the corner of the Pont Neuf and the Quai, which had once belonged to Madame Roland. He was well-placed there to paint his views of the bridge and the Cité. The figures and vehicles are not sharply differentiated as in the more photographically seen groups of his *Place du Théâtre Français*. It is perhaps more in the essential spirit of Impressionism that the eye can take in all this incident as a totality. While a good deal is left to the imagination, the colour of the transient elements in the scene is preserved intact. As so often in Impressionist landscapes and townscapes the structure of the bridge itself strengthens the composition and provides a foil to its shimmer of colour and atmosphere and the supremely delicate sky.

The year before, Pissarro had expressed himself to Monet as not very pleased with what he had been doing in Paris. 'I am struggling against old age', he said, though of this his work gives no visible sign. His *Pont Neuf*, painted when he was over seventy, has a youthful freshness.

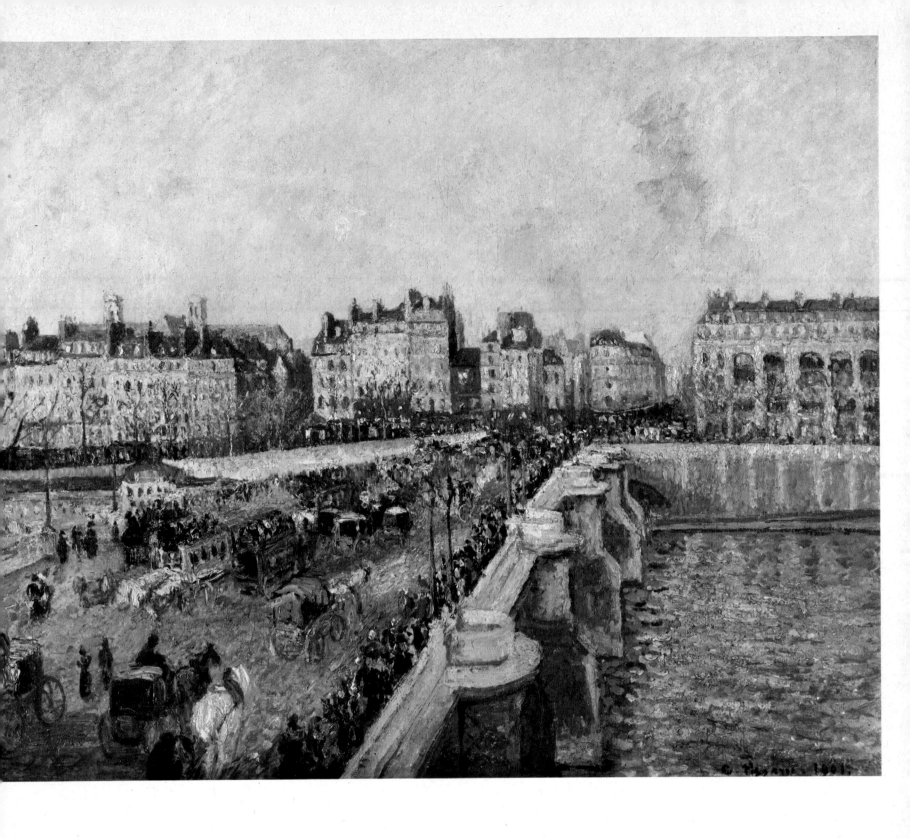

PLATE 51

Camille Pissarro

The Church of Saint-Jacques at Dieppe
1901
Louvre, Paris

Pissarro's activity towards the end of his life was truly remarkable. After his views of the Tuileries, the Pont Neuf and other aspects of Paris he produced a series of paintings of Dieppe and its harbour, following this, at a collector's suggestion, by a series at Le Havre. He was about to make a start on still another Paris series when he died in 1903. His painting of Dieppe's fourteenth-century church pays respect to its greyness of Gothic stone, though he contrives to invest it with an added chromatic depth and to relate this to the colour of the neighbouring buildings. In Impressionist fashion he painted the church from roughly the same viewpoint under different weather conditions. A rainy morning was the incentive for another version.

A comparison with Monet's treatment of Gothic (which might include a sidelong reference to Pissarro's view of Rouen Cathedral) brings out differences of temperament and outlook between the two artists. Neither was inclined to sentimentalize over the work of the past but Pissarro was more the realist, accepting fact while Monet, perhaps unconsciously, pursued colour to the point when it became something other than reality—a dream or a poem. In this respect a likeness to Turner was latent in Monet. Though Pissarro of the two had a greater respect for the English painter, it was not in his nature to venture into strange imaginative country. But his truth to his capacity of vision has a magnificence apparent in this example of his work.

PLATE 52

Claude Monet

Water-garden at Giverny

1904

Louvre, Paris

Monet's paintings of his water-garden and water-lilies at Giverny occupied him for many years in the latter part of his life and were his last great work. Like the works of Turner in the final stage, they were for a long time misunderstood and unappreciated but similarly revived in esteem in the light of modern reappraisal. By the end of 1890 Monet was making enough from the sale of his pictures to buy his house at Giverny outright and soon after began improvements to the garden which included the formation of a pond from a marshy tract by damming a stream that ran into the river Epte. He had a bridge built over the pond 'in the Japanese taste' and his first paintings of the water-garden in a series, 1899–1900, give prominence to the bridge with water-lilies beneath and weeping willows, by that time well-grown, around it. These pictures formed a quiet beginning to what was to become an increasingly exciting enterprise.

In the second phase of forty-eight pictures produced between 1903 and 1908, to which this example belongs, he dispensed with the bridge which had been a somewhat conventional accessory, set his angle of vision nearer to the water surface and composed his picture simply of the water-lilies and reflections in the water, with only a suggestion of trees and other vegetation on the banks in the background. The pond became a sort of magic mirror holding such amazing depth and beauty of colour and variety of light as can be appreciated here. More akin to Japan in spirit than the hump-backed bridge was the decorative sense that Monet now displayed in the selection of the areas of blue and green leaf and the touches of white and red in vivid design against the deeps of colour to the right and in the foreground of this painting. As the series continued Monet made modifications in his scheme of design; although he used large canvases he limited the number of plants to appear in them and increased their size. Finally he painted them from almost directly overhead, thus eliminating normal perspective, the play of light on the surface plane being now the main feature. In this decorative treatment, as may be noticed in other works of the turn of the century, there came a certain suggestion of *art nouveau*.

PLATE 53

Claude Monet

Water-lilies: Sunset (detail)
1914–18
Musée de l'Orangerie, Paris

The magical reflections of the later paintings of water-lilies, like the last works of Turner, take one into a realm of abstraction where material reality dissolves into the beauty of mystery. They involved a long struggle with a subject he found both difficult and absorbing, complicated by other circumstances. The progressive failure of his eyesight and the death of Madame Monet in 1911 had their adverse effect on his spirits. Yet the success of his exhibition of forty-eight Water-lilies at Durand-Ruel's in 1909 had encouraged him to begin a new series and in spite of his worries he continued to work on the theme with the dedicated stubbornness he had always shown. The enterprise gained a decorative purpose when Clemenceau commissioned a series of *Nymphéas* for the French State. Monet worked on these large decorations during the First World War. Clemenceau made his choice after the Armistice in 1918 and the paintings were installed in the setting especially designed for them in the Musée de l'Orangerie in 1925. Earlier, when handing them over, Monet had reserved the right to retouch them and after an operation for cataract had partly restored the sight of one eye in 1923 he insisted on some repainting.

Criticism has been levelled at the setting for a certain want of decorative effect in the sense of harmonious relation between painting and wall but the works at the Orangerie and other Water-lilies of the same late period are much more than simple mural decorations—they are a final magnificent testimony to the wonder of nature. This was hard for his contemporaries to understand, so far out of their orbit had he moved. There were the sympathetically disposed who nevertheless deplored the paintings as mere incoherence resulting from Monet's inability to see. In a period when Cubism flourished there was a tendency also to regard them as the final failure of the Impressionist idea, sinking into a shapelessness no longer tolerable to the devotee of geometrical form. The reversal of this attitude in the second half of the twentieth century is no less strongly marked. Abstract expressionism has helped to adjust the critical balance, pointing to affinities that show Monet to have been prophetic of an era in which the pure, visual sensation is ardently cultivated. His work in this direction has not yet been improved upon.

PLATE 54

Edouard Manet

Peonies

1864–65

Louvre, Paris

Although landscape played a very important part in the development of Impressionist painting, most of the artists associated with the movement at one time or another applied their ideas of light and colour to other genres—flower and still-life painting, portraiture, the nude and scenes of everyday life—to all branches of the pictorial art in fact, except anecdotal, narrative, didactic or 'history' painting. Manet's flower-pieces were brilliant departures from the tradition that required every bloom to be botanically precise and accurate, like those of the Dutch and Flemish artists of the seventeenth century who catered for the requirements of floriculturist patrons. Flowers for the nineteenth-century artist with no such purpose to carry out were objects that invited study of the relationships of light and colour, uncomplicated by the informative detail of the specialist.

This is what Manet does so effectively in his *Peonies* with the spontaneity and directness of brushwork that was always at his command. The form of the flower is no more than suggested but its splendour as a receptacle of light is fully conveyed by the seemingly simple division of colour tones.

PLATE 55

Paul Cézanne

Blue Vase
c. 1885–87
Louvre, Paris

It is not such opposition of light and shade as Manet effectively used that gives brilliance to this painting, but carefully considered gradations of colour. Cézanne achieves the intensity of colour vibration he had sought to attain in early works by a reckless impasto through the more disciplined methods in which Impressionism had instructed him. Colour is applied with something of the delicate thinness he used to so much effect in watercolour. It defines the roundness and brightness of an apple in a way that is emphasized by the approximate contour, roughly indicated. This roughness appearing in the contours of other objects seems a deliberate abstention from the smooth finish of popular Salon works and contributes to the feeling of originality the painting gives. At the same time one is conscious of subtle variations of tone and colour that play on each surface.

Cézanne was between forty and fifty when he produced the *Blue Vase*, a period to which many of his masterpieces of still-life belong but a period also in which the works he sent to the Salon were constantly rejected. The still-lifes had all the simplicity, austerity and grandeur that Maurice Denis and other artists of the younger generation admired as a combination of qualities that seemed to them to advance a stage beyond Impressionism.

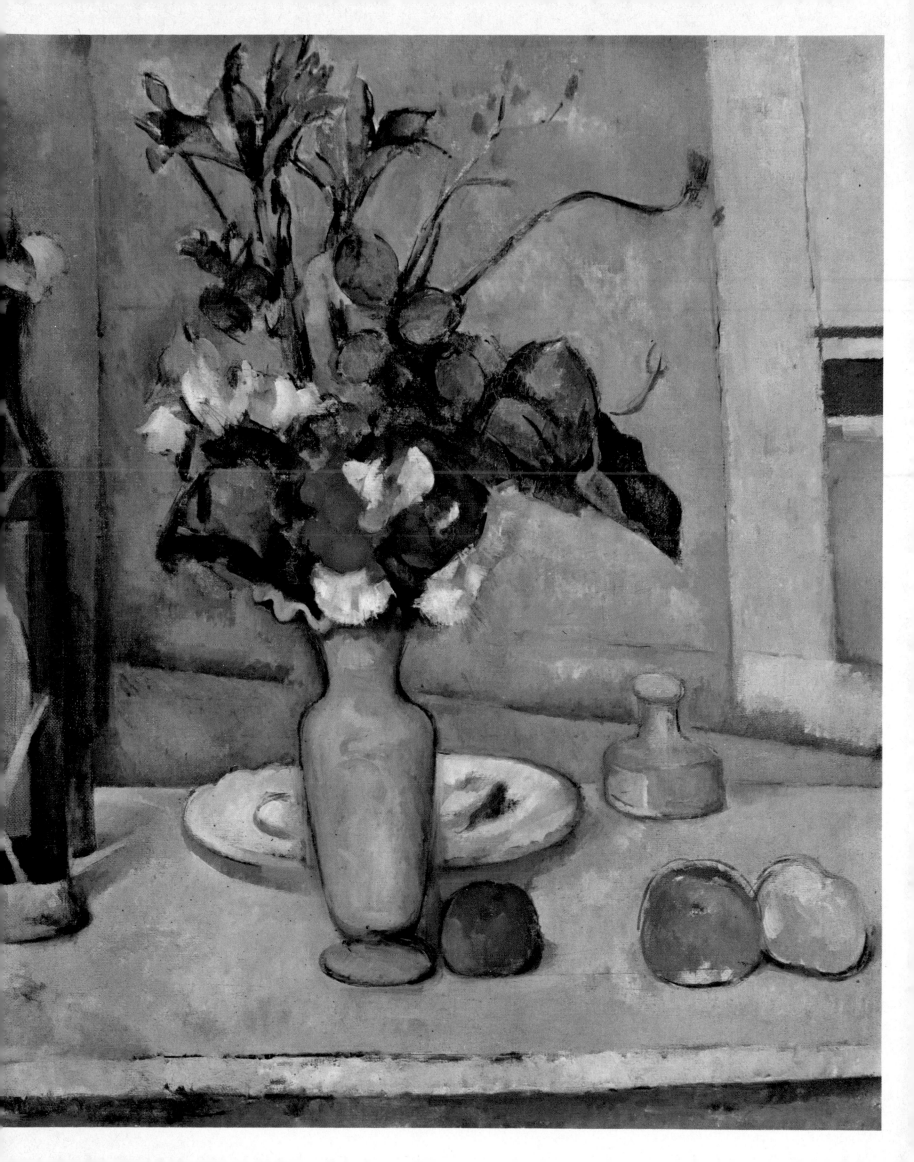

PLATE 56

Paul Cézanne

Still-life with Peppermint Bottle
1890–94
National Gallery of Art, Washington

This is certainly one of Cézanne's masterpieces and the grandeur which Maurice Denis and his associates were among the first to admire at the turn of the century is manifest in its majestic folds and authoritative completeness of effect. He favoured still-life for the opposite reason from that which led the Impressionists to study transient effects of light. The objects remained still, contributing to that idea of permanence and durability in which he found the essence of tradition.

One of those young men who by some instinct beat a path to the door of the unknown great, Louis Le Bail, described how he watched Cézanne prepare a composition of this kind. 'The cloth was draped a little over the table with instinctive taste; then Cézanne arranged the fruit, contrasting the tones one against another, making the complementaries vibrate, the greens against the reds, the yellows against the blues, tilting, turning, balancing the fruit as he wanted it to be, using coins of one or two *sous* for the purpose. He took the greatest care over the task and many precautions; one guessed that it was a feast for the eye to him'. There remained beyond the art of arrangement the sense of the massive dignity of fold, the related rhythms and the freshness of fruit colour against the sobriety of cloth and the reflective quality of glass. In this work Cézanne seems to exchange a greeting with Chardin.

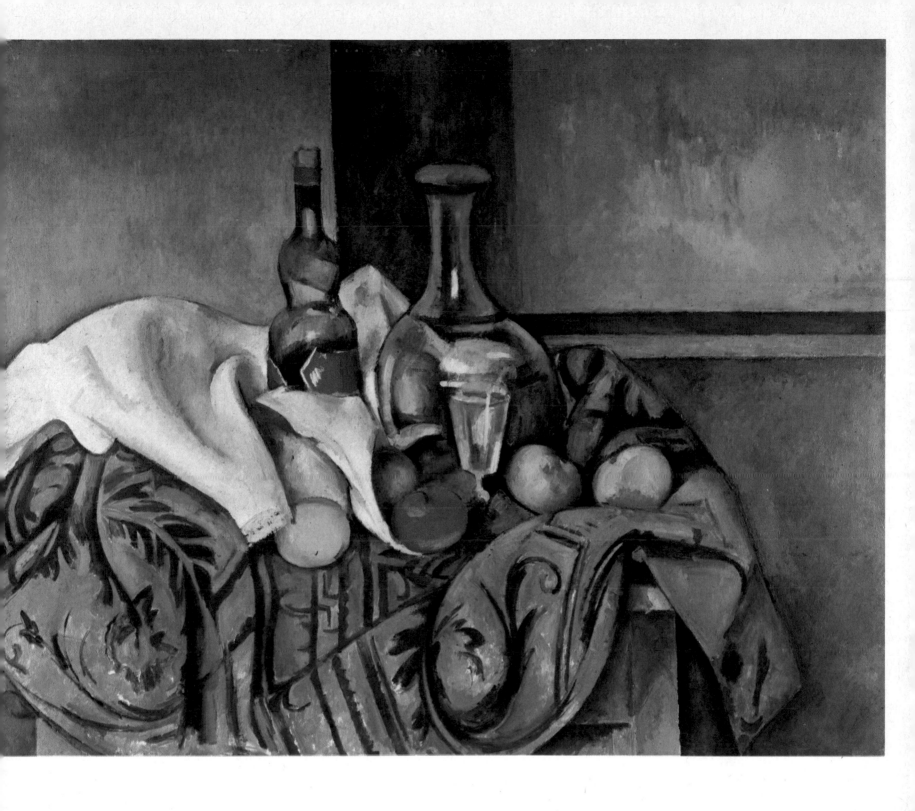

PLATE 57

Edouard Manet

Music in the Tuileries (La Musique aux Tuileries)
1862
National Gallery, London

This painting of a fashionable audience at a concert in the Tuileries gardens was one of the earliest of Manet's scenes of contemporary life and a brilliant evocation of the Second Empire and its finery. Though such an assemblage of figures could only be painted in the studio, the picture is not lacking in open-air feeling and according to Antonin Proust (writing on Manet in the *Revue Blanche* in 1897) the artist 'went nearly every day to the Tuileries between two and four o'clock, making outdoor studies under the trees of the children playing and the groups of nannies who had subsided on to the chairs . . .' They were painted studies and Proust speaks of the curious glances levelled at the elegantly dressed artist who set to work with canvas and palette.

Many portraits have been recognized in the assembly. Manet himself is at the extreme left; beside him and a little in front is Albert de Belleroy, a painter of hunting scenes with whom Manet had at one time shared a studio; to the right behind them is Zacharie Astruc, sculptor and painter. The figure prominent at right centre looking to the left is supposed to be Manet's brother Eugène and the man behind him seated against a tree is possibly Offenbach. Baudelaire, an habitual companion, incidentally, of Manet on his sketching visits to the Tuileries, is seen in profile against the large tree on the left, to the right of Astruc. With him is Théophile Gautier and behind to his left in full face, Fantin-Latour. The two ladies in the foreground at left have been identified as Madame Lejosne (with a veil) wife of Commandant Hippolyte Lejosne, a friend of both Manet and Baudelaire, and with her a Madame Loubens. The notes of blue, red and yellow distributed through the composition gaily offset the black of tail coats and tall top hats.

Baudelaire, of whom Manet had made an outline etching in 1862, had already praised him in an article on painters and etchers (reprinted in *L'Art Romantique*) for 'a decided taste for reality, the modern reality—a good thing in itself—united to a vivid, ample, sensitive and daring imagination . . .' *La Musique aux Tuileries* is a work to which these terms would perfectly apply.

The picture was first acquired by the singer, J. B. Faure. It came to the Tate Gallery in 1917 as part of Sir Hugh Lane's Bequest and was transferred to the National Gallery in 1950.

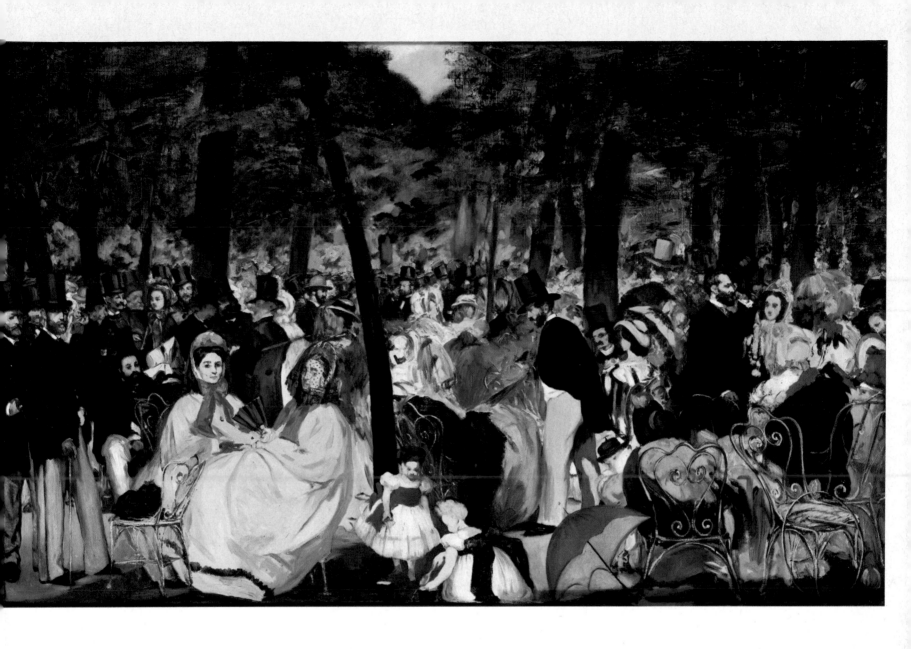

PLATE 58

Edgar Degas

At the Race Course
1869–72
Louvre, Paris

Degas is to be ranked alongside Manet as a magnificent interpreter of the contemporary scene and it is perhaps significant that in the year of Manet's *La Musique aux Tuileries*, Degas, who met him then for the first time, abandoned such fancy subjects as the *Semiramis Founding a Town* which he had painted in the preceding year and applied himself to picturing the races at Longchamps. He continued to produce race course pictures for a long time, this one being an outstanding example. The influence of photography or the Japanese print led him to give an appearance of informality to his composition by the unconventional way in which forms are cut off at the edges of the canvas, the head of the horse at the right, the shadows of the two foreground horses and the spectators at left. He approached the subject primarily in the capacity of draughtsman interested in movement. There is little effort to convey open-air effect, the horses' shadows giving only a perfunctory suggestion of sunlight. The jockeys' colours are patches of local colour unmodified by the light of day. With a distaste for impasto that warred against precision of drawing he painted thinly using a spirit medium.

The beauty of the picture is concentrated in the drawing. Degas, as was his usual habit, chose a moment before the race had begun when he could observe and store in memory those casual attitudes and movements that the eye could actually follow. The movements of the gallop had always set a problem to artists who in the past had suggested swift movement by a position with legs outstretched and clear of the ground that was impossible in fact. In several works Degas had accepted this convention of old sporting art— indeed the impossible position appears in this example in the horse at the rear, a contrast with the natural aspect of the others. Paul Valéry has said that Degas 'was one of the first to study the appearance of the noble animal by means of Major Muybridge's instantaneous photographs'. This applied after about 1880 when Degas began to show the correct positions of the running horse. Dr Aaron Scharf has effectively demonstrated (in his *Art and Photography*) the use Degas made of Muybridge's *Animal Locomotion*, which was probably not without influence on his later studies of unconventional human attitudes.

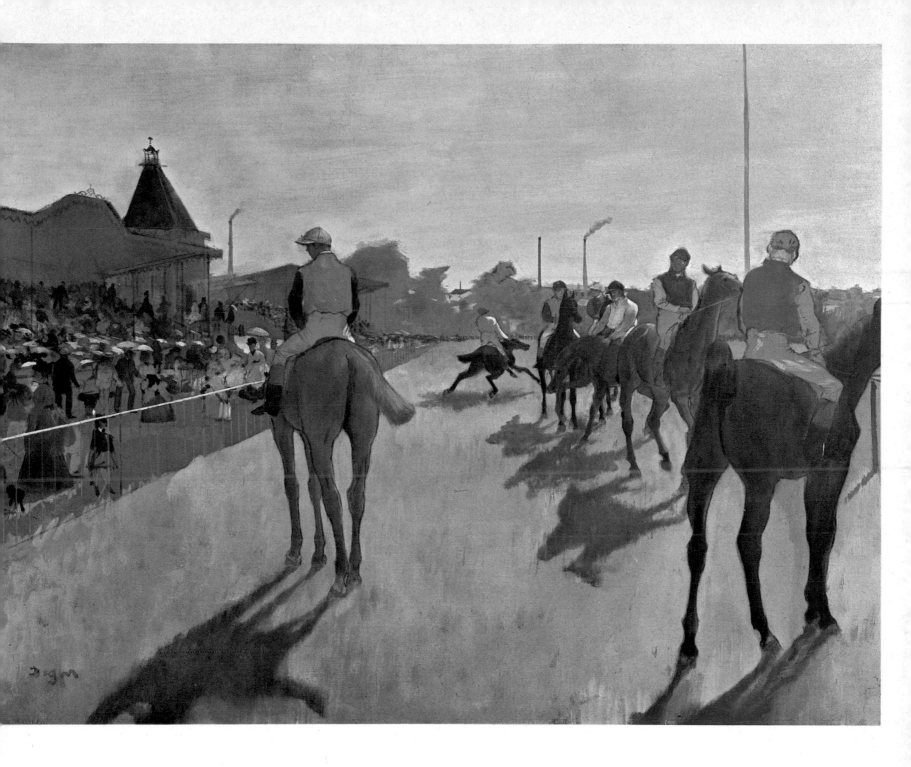

PLATE 59

Auguste Renoir

La Grenouillère
1869
National Museum, Stockholm

When Monet was enabled by his patrons, the Gaudiberts, to take a house at Bougival he and Renoir, who lived close by, worked amicably together on the banks of the Seine and both painted at least three versions of the popular bathing-place and riverside restaurant, La Grenouillère, (i.e. the 'frog pool' or 'froggery'). Both produced superb pictures of the scene and were equally concerned with the ripples of the water, which they rendered with the patches of colour that later became distinctive of Impressionism in a more general application. The play of sunlight was also their joint concern. Monet was the more forceful in his treatment of the effect of light; Renoir more delicate in style and evidently the more interested of the two in the scene as an aspect of contemporary life. Where Monet sees the figures as so many accents of colour, dark or light, Renoir, even if sketchily, has given his group humanity. There is something of pre-Revolutionary daintiness—a quality perhaps to be associated with Renoir's youthful experience of painting porcelain—in such a figure as that of the girl in a bustle and carrying a parasol. He applies the same delicacy of touch to the misty background of trees. There are delightful gleams where the sun catches, lighting up a leafy branch of the tree in shadow and adding its warmth to the canopy of the boat-restaurant. The gentle harmony of colour completes the idyllic quality that Renoir conveys.

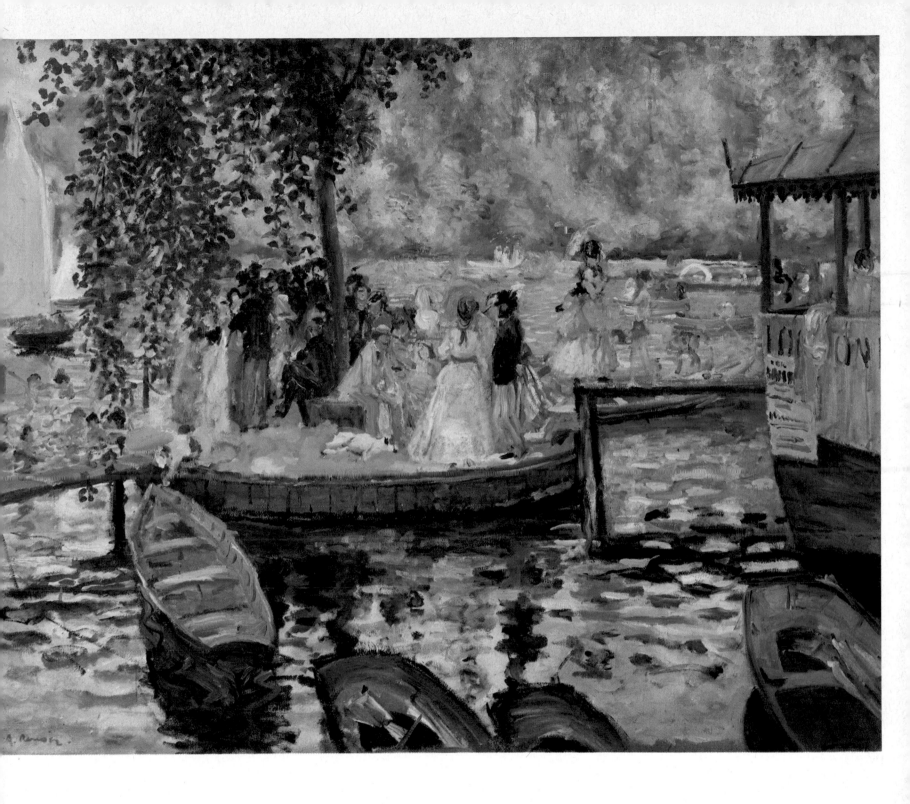

PLATE 60

Auguste Renoir

Le Moulin de la Galette
1876
Louvre, Paris

Renoir delighted in 'the people's Paris', of which the Moulin de la Galette near the top of Montmartre was a characteristic place of entertainment, and his picture of the Sunday afternoon dance in its acacia-shaded courtyard is one of his happiest compositions. In still-rural Montmartre, the Moulin, called 'de la Galette' from the pancake which was its speciality, had a local clientele, especially of working girls and their young men together with a sprinkling of artists who, as Renoir did, enjoyed the spectacle and also found unprofessional models. The dapple of light is an Impressionist feature but Renoir after his bout of *plein-air* landscape at Argenteuil seems especially to have welcomed the opportunity to make human beings, and especially women, the main components of a picture. As Manet had done in *La Musique aux Tuileries* he introduced a number of portraits.

The girl in the striped dress in the middle foreground (as charming as any of Watteau's court ladies) was said to be Estelle, the sister of Renoir's model, Jeanne. Another of Renoir's models, Margot, is seen to the left dancing with the Cuban painter, Cardenas. At the foreground table at the right are the artist's friends, Frank Lamy, Norbert Goeneutte and Georges Rivière who in the short-lived publication *L'Impressionniste* extolled the *Moulin de la Galette* as 'a page of history, a precious monument of Parisian life depicted with rigorous exactness. Nobody before him had thought of capturing some aspect of daily life in a canvas of such large dimensions'.

Actually Renoir painted three versions of the subject, a small sketch now in the Ordrupgard Museum, near Copenhagen and a painting smaller than the Louvre version in the John Hay Whitney collection. It is a matter of some doubt whether the latter or the Louvre version was painted on the spot. Rivière refers to a large canvas being transported to the scene though it would seem obvious that so complete a work as the picture in the Louvre would in any case have been finished in the studio.

174

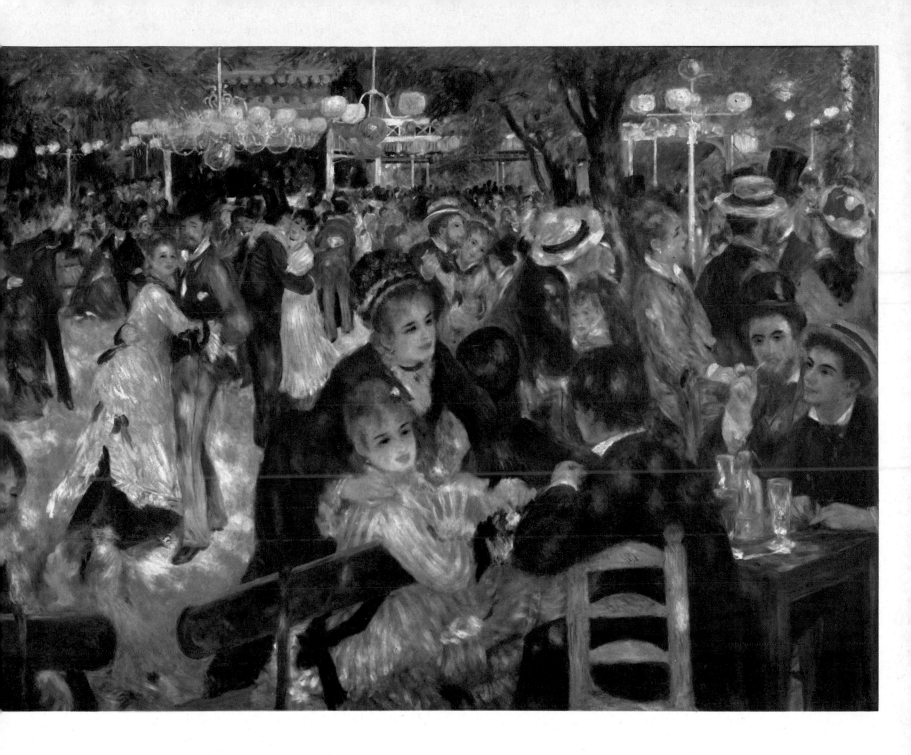

PLATE 61

Auguste Renoir

Muslim Festival at Algiers
1881
Louvre, Paris

Renoir's success with his portraits, following his group of Madame Charpentier and her children that attracted great attention at the Salon of 1879, gave him the means to travel and the example of Delacroix, who had found Algeria so inspiring, prompted a visit to that country in 1881. He did not stay very long and was there at a rainy season but he described Algeria in writing to Madame Charpentier (perhaps with a shade less enthusiasm than Delacroix had shown) as 'an admirable country'. He was able to produce a striking souvenir of the visit in this impression or fantasia which conveys a personal response to the colour of the 'Orient', as the French described North Africa, and the picturesque scene. The warm blue of shadows and the notes of red and white form a spirited pattern. The picture is unique in Renoir's work as a study of exotic manners. He did visit Algeria a second time, in 1882, and painted some female heads but they were more European than Algerian in type in spite of accessories of costume.

He married on his return from his first visit and made a further, honeymoon, expedition to Venice, Rome and Naples. He does not appear to have been receptive to any great extent to the architecture and general character of the Italian cities but was absorbed in the paintings he saw in the museums. The Pompeian works preserved at Naples in particular impressed him with the long and consistent tradition of painting as a craft, making him critical of the value of new departure.

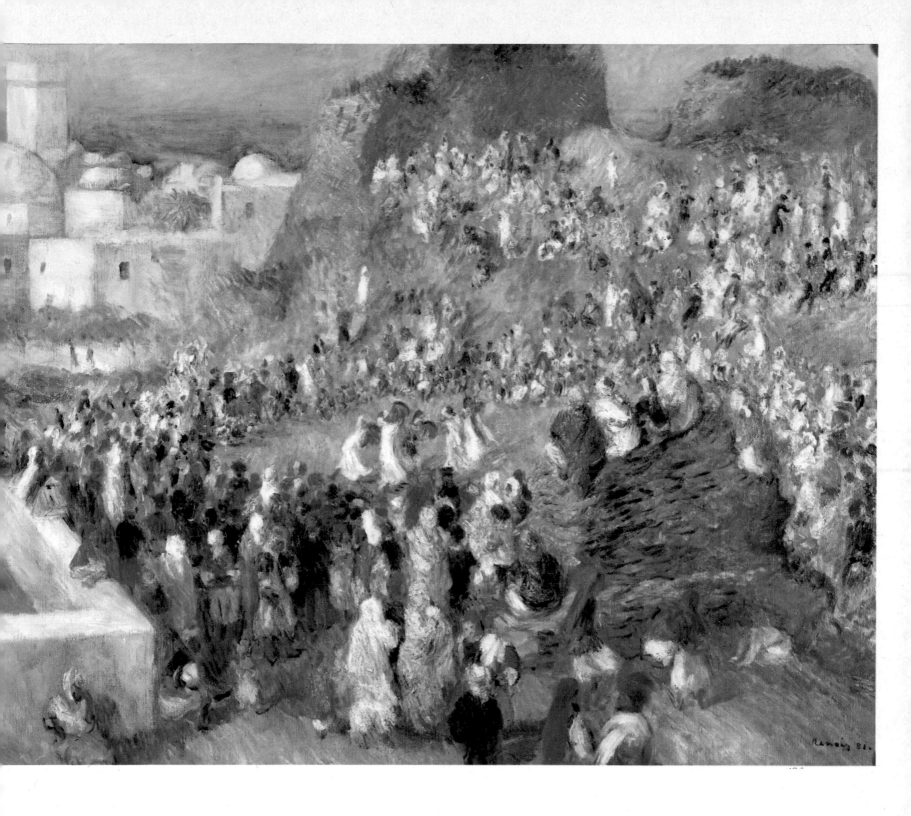

PLATE 62

Auguste Renoir

Umbrellas (Les Parapluies)
c. 1884
National Gallery, London

This picture, as well as being a delight in itself, illustrates a transitional aspect of Renoir's art. It shows a new attention to design as a well-defined scheme of arrangement, the umbrellas forming a linear pattern of a far from Impressionist kind, the linear element also being stressed in the young modiste's bandbox, the little girl's hoop and the umbrella handles. In this care for definite form, apparent also in the figures at the left, one can see a discontent with Impressionism and a search for a firmer basis of style that would date the work to about 1883–4, after his journeyings abroad and the revision they brought into his ideas. It is unlikely that it preceded the *Muslim Festival* of 1881 and more probably represents a subsequent reaction. The Cézanne-like treatment of the tree at the back also suggests it was painted after Renoir stayed with him at L'Estaque in 1882. The children and the lady with them are more indicative of the style of the 'seventies than the rest of the picture which may well have passed through stages of repainting over a period. The charm of the whole is nevertheless able to overcome the feeling of slight discrepancy that may result from close examination.

Durand-Ruel bought the picture from Renoir in 1892 and sold it to Sir Hugh Lane, in whose bequest it came to the Tate Gallery in 1917. It was transferred to the National Gallery in 1935.

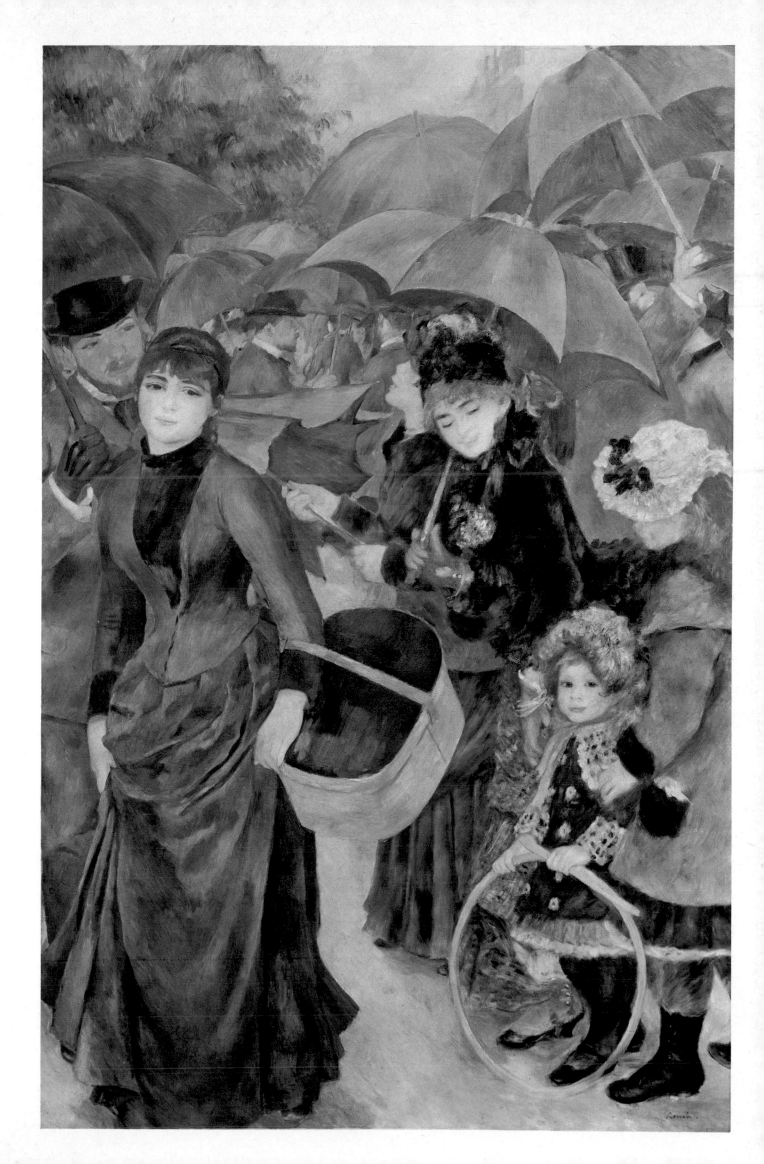

PLATE 63

Georges Seurat

A Sunday Afternoon at the Grande Jatte
1884–86
Art Institute of Chicago

The question has been asked whether Seurat's great work should be regarded as the necessary outcome of Impressionist ideas or as deliberately anti-Impressionist, and an answer might be that it contains elements of both. In pursuing the analysis of colour, Seurat carried on, though in more systematic fashion, what Monet and Pissarro had been doing. The division of colour was scarcely new, though the primary colours were more scientifically defined by the range he based on the spectrum; but he added to this divisionism or pointillism an equally elaborate and scientifically considered treatment of line in order to attain a harmonious unity of composition, which was distinct from the Impressionist aim of suggesting light, atmosphere and movement.

The difference is more readily perceptible in a figure composition as here than in landscape. The men, women and children enjoying the sun in the public park on the island of La Grande Jatte in the Seine have the sort of fixity that a moving film acquires when it comes suddenly to a halt; they are frozen in their various attitudes. As a preliminary, Seurat made a number of oil sketches on the spot in a free and indeed Impressionist style. The finished work was intentionally different. The technique used is so interesting that it is apt to gain exclusive attention. One becomes absorbed in the geometric order that Seurat has imposed on the scene and this certainly is an opposite value to that of Impressionism. Pissarro, Signac and other artists attracted by the *pointilliste* method were somewhat led astray by the assumption that it opened up a new prospect solely in terms of translating light into colour. The comparison that has often been made between the Italian master of the geometrically-conceived composition, Piero della Francesca, and the Seurat of *La Grande Jatte* is justified in demonstrating the latter's essential direction. Absorbed though he was with theory, it would be wrong to assess Seurat as one unaware of the life around him. The statuesque figures to the right are the acme of bourgeois propriety though the lady may show pretensions to the eccentricity of 'high life' by having a pet monkey on a lead. In many details it is a reality magically become unreal. A moment of charm is made lasting in the little girl running and the nearer girl bending over her bunch of flowers. The racing four that flashed across the canvases of Monet and Renoir at Argenteuil and other river craft here have the sharpness of a miniature.

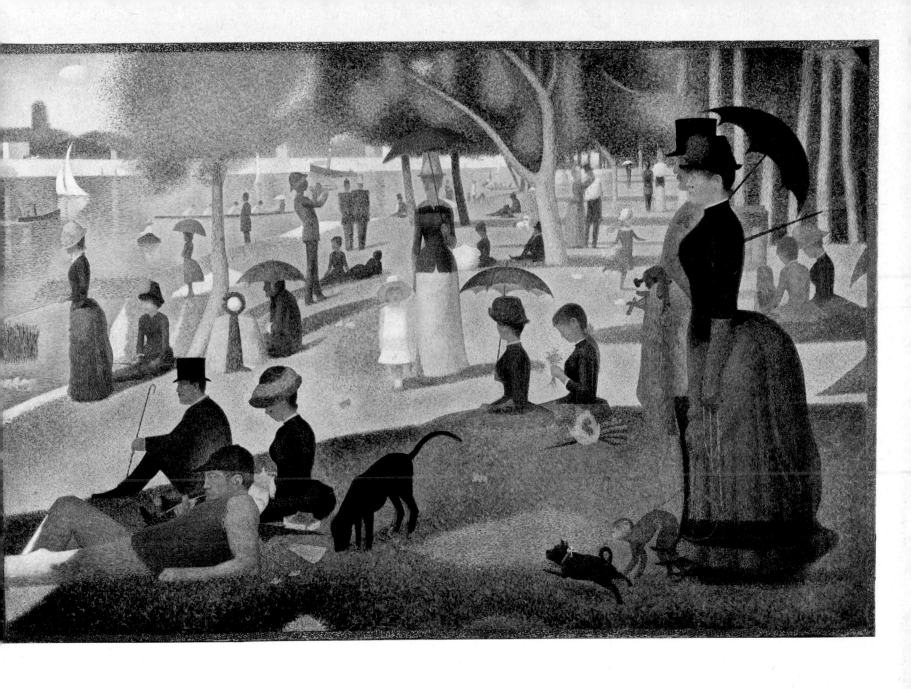

PLATE 64

Paul Cézanne

Three Bathers
1879–82
Museé du Petit Palais, Paris

In various ways Impressionism marked a departure from the habits of the past, one of them being the exclusion of the mythical and allegorical subjects which belonged to the classical tradition, creating a special problem as regards the treatment of the nude figure. The nude in the unreality of some imagined ancient setting had long been a stock property of the conventional Salon painter. Without the raison d'être of a subject of a fanciful kind, nakedness in painting came as a shock to a prudish age. Courbet's *Baigneuse* of 1853 had angered Napoleon III; above all there was the scandal of Manet's *Olympia* in 1863. But the classical past remained in the memory of artists by no means conventional. *Olympia* paid salutation to Giorgione and Titian. Renoir's *Baigneuse au Griffon* of 1870 was painted in the antique pose of the Cnidian Venus. Cézanne gives a more unusual illustration of this reference to earlier models.

The feckless eroticism of such a painting as *A Modern Olympia* disappeared as he became involved in the disciplines of Impressionism. Yet his study of nature was of inanimate nature or of human beings in their normal clothed aspect. While he yearned to make a grand composition of the nude, the dread he developed in middle-age of painting from the living model left this sedulous observer without the advantage he might thus have gained. He had made drawings from the life when attending the Académie Suisse but those were distant student days. In the paintings of bathers that occupied him in later years and at intervals until the end of his life he had recourse to reproductions of Old Masters which he pinned on his studio walls. Signorelli, El Greco and Rubens have been enumerated among his sources. The group of sirens in the latter's *Disembarkation of Marie de' Medici* seems to have influenced him greatly in his paintings of female bathers. The baroque opulence of style comes into the painting shown here. Within the classically symmetrical balance of leaning trees, a device he used in other *Bathers*, he arrives at his fascinating combination of form incompletely or tentatively realized and a splendour of general effect in which the vibration of Impressionist blue and clarity of colour plays its part.

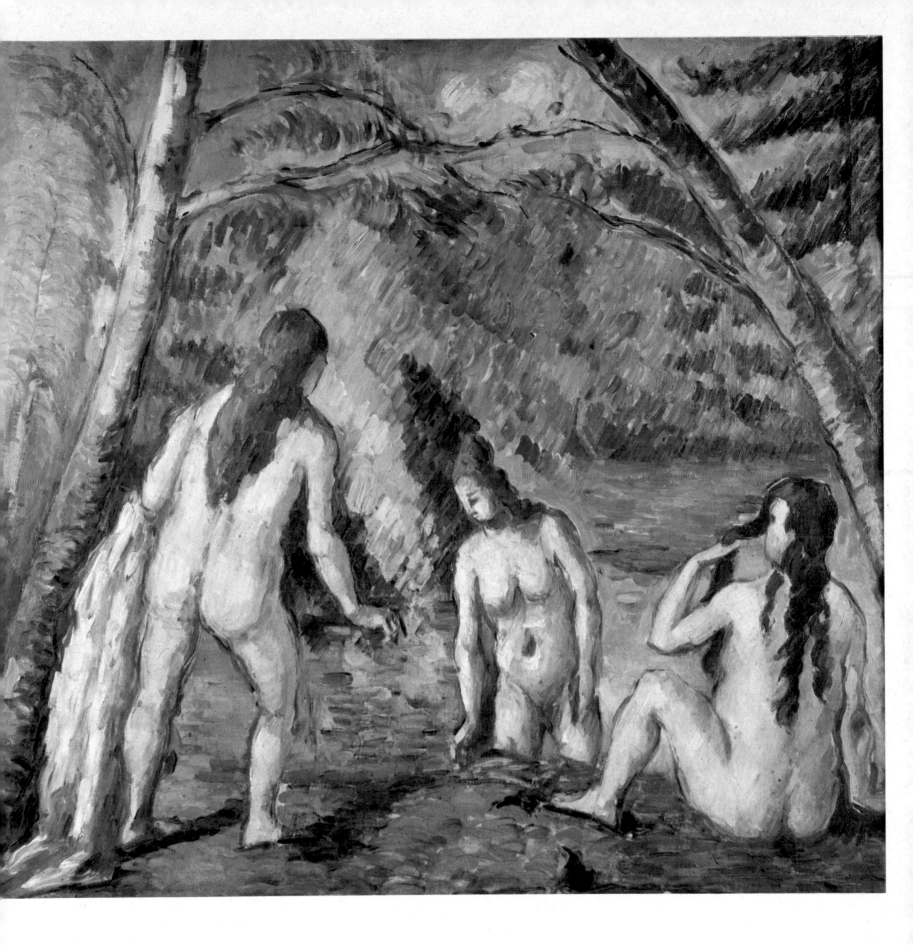

PLATE 65

Auguste Renoir

The Bathers (Les Grandes Baigneuses)
1884–87
Philadelphia Museum of Art

The different inspiration two artist friends might derive from the past and with what difference of result is illustrated by comparison between this work, *Les Grandes Baigneuses* by Renoir, and the *Bathers* of Cézanne. Both had moved away from Impressionism and had come to attach a renewed importance to the human figure, but there the likeness ends. Without any of the inhibitions that beset Cézanne, Renoir was well accustomed to paint from female models and had a command of structure and facility of execution that the other lacked. While Cézanne derived a certain opulence from the Old Masters, Renoir, in full reaction against the dominance of landscape and the effects of atmospheric colour, gave a new emphasis to outline and the harder and more precise modelling that is known as his *manière aigre* Monet and Sisley had little interest in sculptural form but Renoir gave his bathers something of the quality of figures in a sculptural relief and in fact borrowed the group from a bas-relief at Versailles by the seventeenth-century sculptor, François Girardon. The trees are deliberately simplified and made solid in shape to accord with the timeless and generalized scheme of composition and execution. His manner, however, was not so dry as to preclude the expression of his pleasure in depicting the charm of youthful faces and the rounded contours of feminine breasts and thighs. The conscious effort in style is modified by such gentle features as those of the central bather.

The *manière aigre* was a passing phase in Renoir's art but *Les Grandes Baigneuses* was a picture that indicated what was to be a future line of his development—the creation of a kind of golden age peopled by a beautiful race of creatures, warmer in tone in the southern sun and more maturely splendid of limb than the nymphs depicted here, as in his *Judgment of Paris* of 1908—a far cry from the subject as Cézanne had painted it.

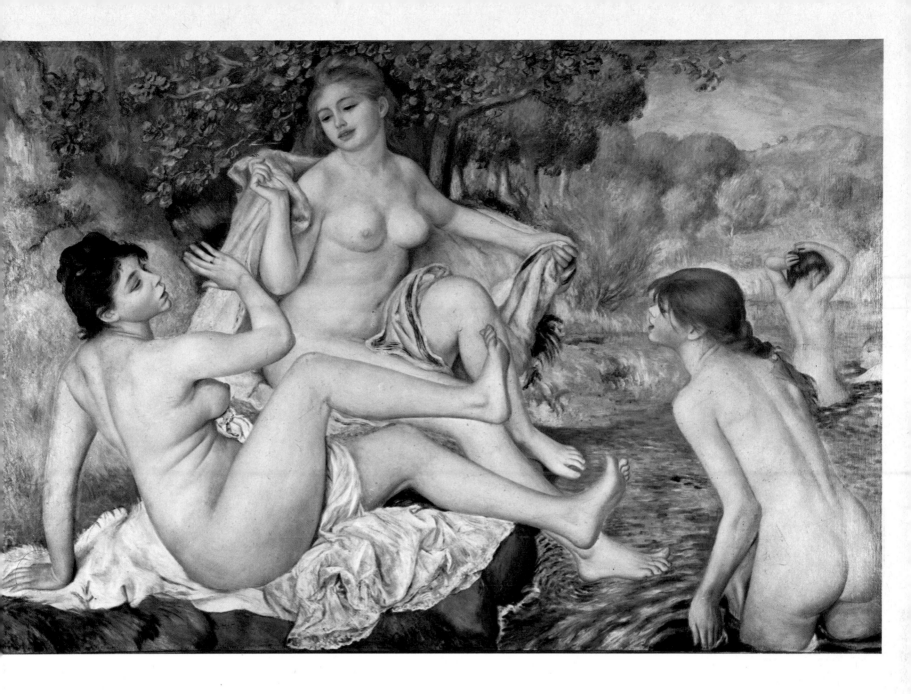

PLATE 66

Edgar Degas

Woman Combing her Hair
c. 1887–90
Louvre, Paris

Degas, in the classic line of descent from Ingres as a draughtsman—and one of the greatest in Europe since the giants of the Renaissance—exchanged oil paint for pastel, as in this example, with a sense of greater freedom in being able to draw in the medium as well as to apply colour. The word 'classic' refers to his preoccupation with the human figure but not to any desire to depict an ideal type of humanity. Remarking that 'la femme en général est laide' he showed no disposition to modify this supposed ugliness. He quickly abandoned the antique subject-matter of pictorial composition after his few early essays.

His meeting with Manet in 1862, his acquaintance with Berthe Morisot, Monet, Renoir and Pissarro and his introduction to the Impressionist dealer Durand-Ruel, all tended to draw him into the current of Realism and Impressionism, though open-air landscape painting did not interest him in the least. Realism required that the nude should be depicted in a situation of credible reality and not artificially posed as some character of fable. Impressionism no doubt contributed the idea that just as the landscape painter caught transient effects of light so it was possible to catch natural and transient phases of movement in the living model. The credible reality was usually that of bathers in the open. Degas made a logical enlargement of his field of study in depicting women in various stages of undress at their toilet or getting into and out of *le tub*. With its unconventional pose, this pastel shows the concentrated force of form and colour he was able to attain.

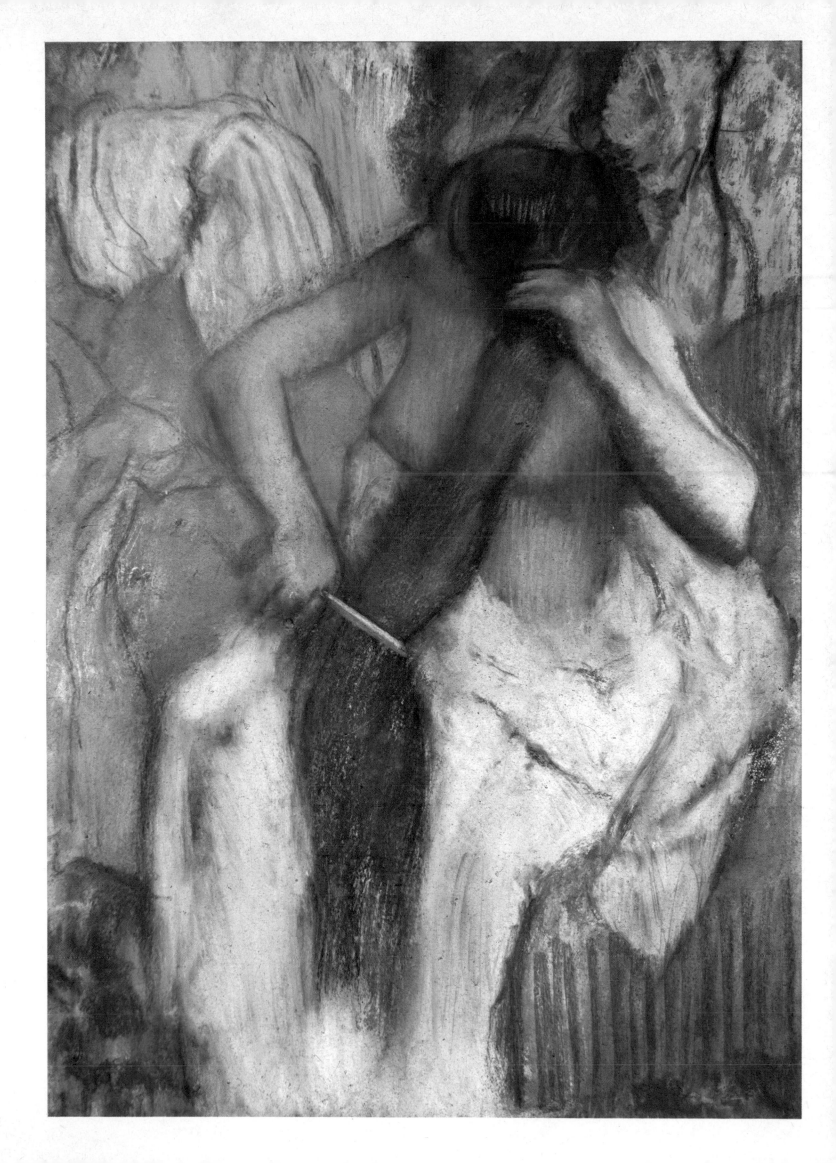

PLATE 67

Edgar Degas

Woman Drying Herself
1903
Art Institute of Chicago

Degas had the Impressionist habit of painting a series of variations on the same theme, though movement was a general motif extending through his race course scenes, his pictures of the ballet and its dancers and the series of women at their ablutions on which he embarked about 1886. By comparison with the foregoing (not dissimilar) pastel it can be seen here how wide a range of form and colour he was able to derive from his limitation of subject. There can be little doubt that Muybridge's publication of photographs in series, *Animal Locomotion*, which did in fact show the various stages of a woman drying herself as well as giving its accurate exposition of a horse's gallop, influenced Degas in pursuing this particular aspect of his art, though there is nothing that could actually be called photographic in these wonderfully original works. Nor, though he expressed the doubt that he had been too prone to picture woman as an animal, is there anything abnormal or repellent. The later pastel reproduced here shows a looseness of handling which was perhaps partly due to his failing sight though there is no decline of mastery in the conception and vigour of form. Like Monet, also defective in vision in later years, he used colour with an increased daring and intensity.

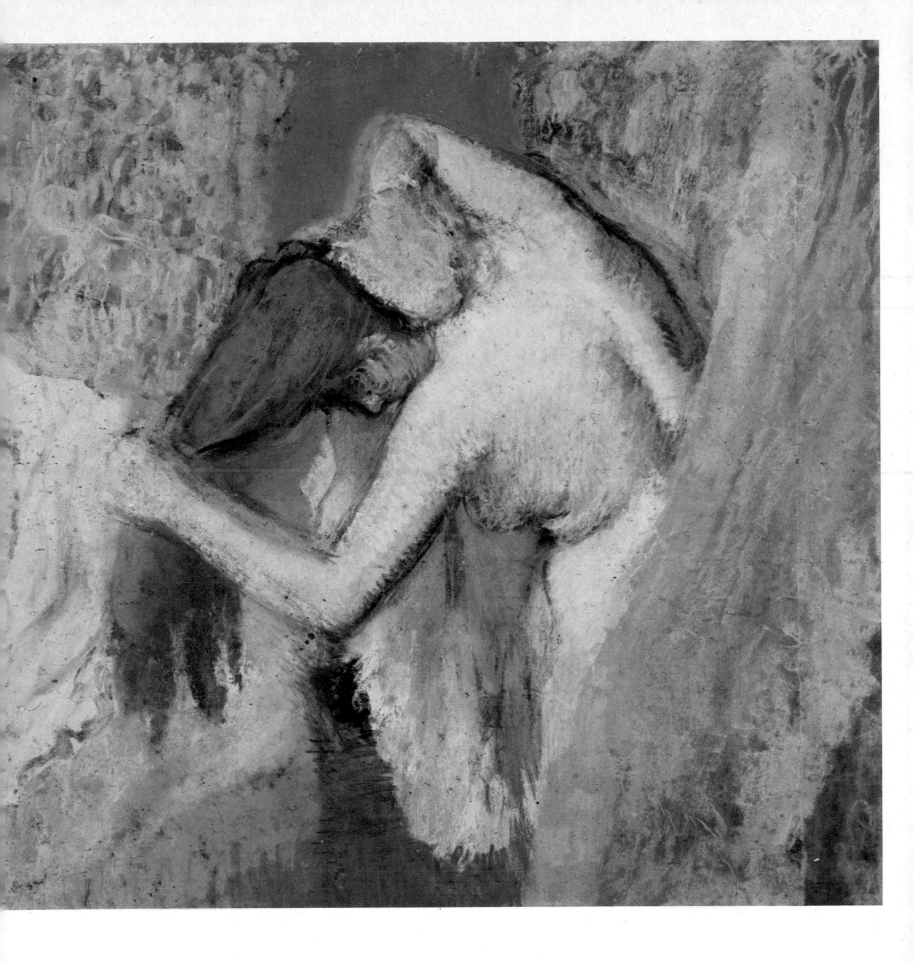

PLATE 68

Auguste Renoir

Alfred Sisley and his Wife
1868
Wallraf-Richartz Museum, Cologne

All the Impressionists, with the possible exception of Sisley, painted portraits at some time or other and general characteristics—consistent with the nature of the Impressionist movement in other ways—were the unconventional and natural attitude they looked for and the freshness of colour they introduced. Courbet and Manet both gave an example to the younger painters in France in the relish with which, as realists, they pictured contemporary dress and the young Renoir, when he painted his newly-married friend Sisley with his wife, was likewise emboldened to make much of the current fashion in men's and women's clothes, though endowing them with an attraction that came from his visual approach. The black and grey of Sisley's attire is well contrasted with the splendour of red and gold in Madame Sisley's spreading skirts but there is the further contrast to this finery in the intimate and affectionate gesture with which he offers and she takes his arm. It was already one of the Impressionist devices to place the figures in sharp focus against a blurred background. The background here gives a hint of the open-air portraits the group would paint some years later at Argenteuil, though the figures and faces are painted as yet with no attempt to suggest outdoor lighting.

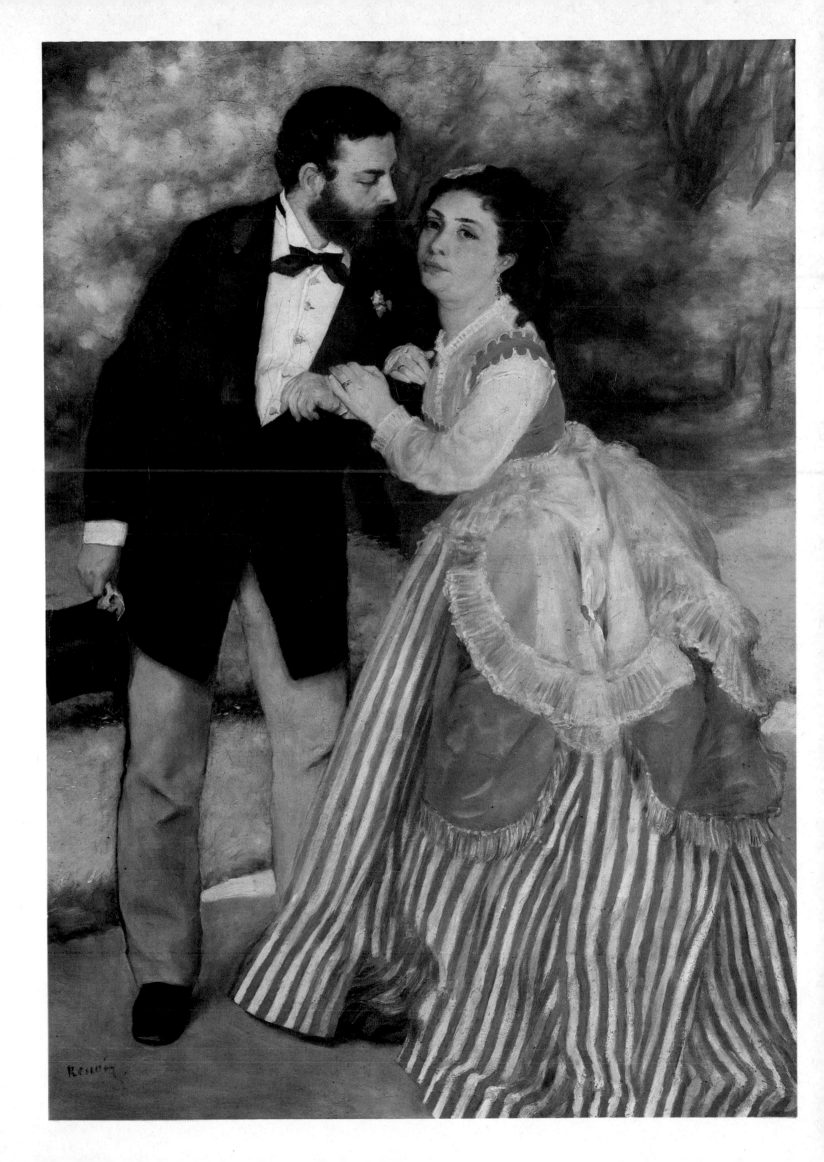

PLATE 69

Claude Monet

Madame Gaudibert
1868
Louvre, Paris

An unexpected facet of Monet's abilities appears in the skill and grace with which he carried out the always difficult commission of a full-length, life-size portrait. M. and Mme Gaudibert of Le Havre were the generous and understanding couple who came to Monet's rescue in a year of cumulative misfortunes. His family disowned him because of his association with Camille by whom he had a child. None of the pictures he sent in the spring to the International Maritime Exhibition at Le Havre was sold and the canvases were seized by his creditors. In the summer, together with Camille and the child, he was thrown out of the lodgings he took at Fécamp. He came near to suicide. The order for portraits of the Gaudiberts and their purchase of other pictures by Monet tided him over the worst of his difficulties for a time and enabled him to resume the painting he had almost abandoned in despair. 'Thanks to this gentleman of Le Havre who's been helping me out', he wrote to Bazille, 'I'm enjoying the most perfect peace and quiet'. He looked forward again to doing 'some worthwhile things'.

The portrait of Madame Gaudibert, painted in a chateau near Etretat, is none the less distinguished for being in a quiet key. The lady's dress was of that dull satin that offered little scope to the colourist but Monet gives dignity to its folds and adds colour—discreetly subdued—in shawl, carpet and curtained background that lightens the effect. This is further enlivened by the touches of white at collar and cuffs and in the design of the shawl. Head and hands are painted with a sensitive simplicity.

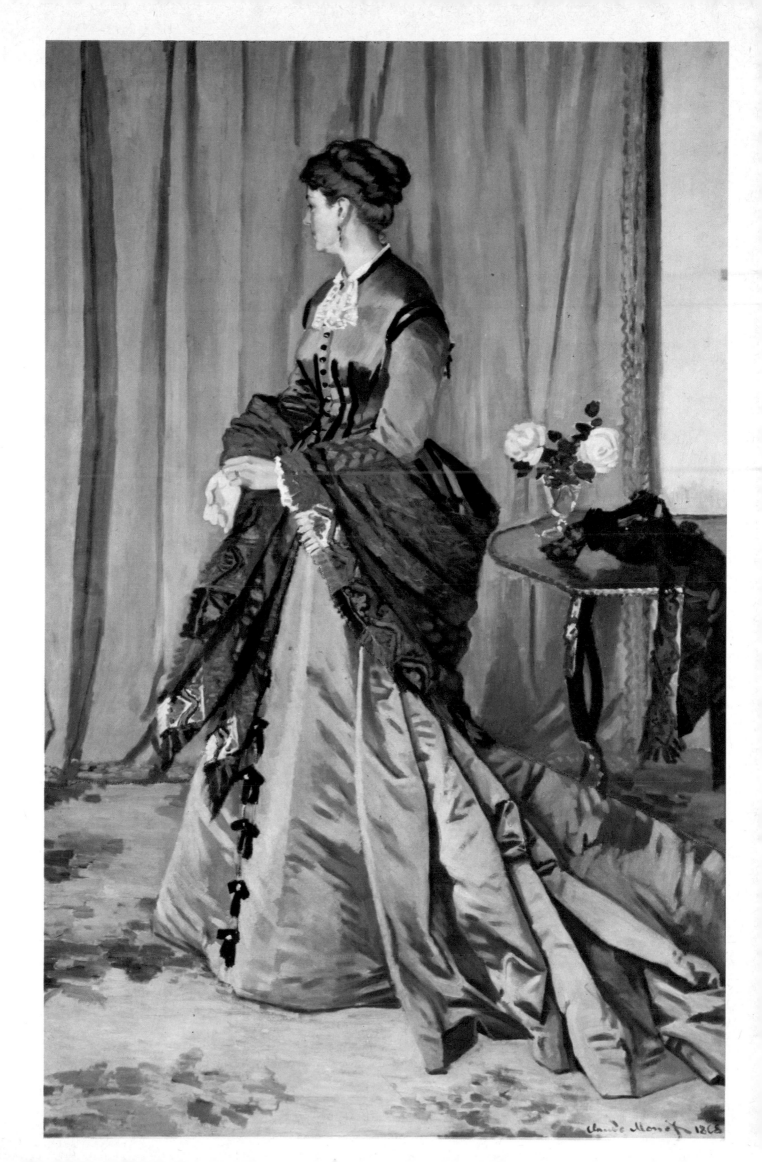

PLATE 70

Camille Pissarro

Self-portrait
1873
Louvre, Paris

Pissarro's distinguished features, fine brow and patriarchal beard were often portrayed by his confrères, by Cézanne, Gauguin, Guillaumin and Renoir, and he painted self-portraits at different periods, this example showing him at the age of forty-three. This was the period when he was working in company with Cézanne at Pontoise and Auvers and the year before the first Impressionist exhibition, to which Pissarro sent six landscapes. The self-portrait is painted with a due Impressionist regard for the incidence of light and the general disposition of light and shade rather than with any sharply detailed outline, but the scheme of colour still bears traces of the influence of Corot in its subtle variations of grey and lightly indicated flesh tones in shadow. At a later date he set himself to show that a portrait could be successfully carried out with the divided touches of colour of the fully-developed Impressionist technique. The simplicity of style, however, in this portrait of his middle-age is majestic in result and the likeness as compared with photographs of the artist and other iconographic records is unmistakable.

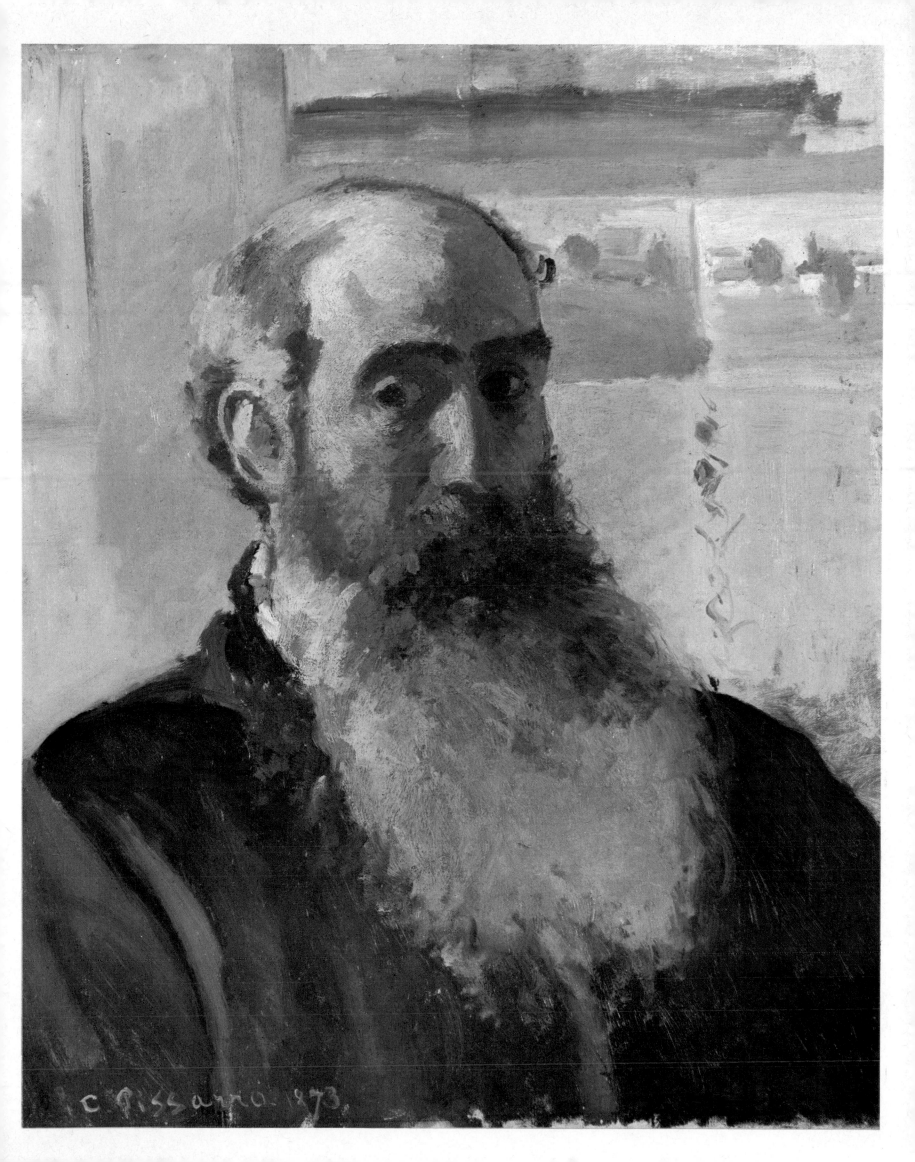

PLATE 71

Auguste Renoir

The Box (La Loge)
1874
Courtauld Institute Galleries, University of London

This masterpiece, painted when Renoir was thirty-three and shown in the first Impressionist exhibition of 1874, can be regarded simply as a glimpse of contemporary life but is in a sense portraiture also. Renoir's brother Edmond posed for the man, the girl was a well-known Montmartre model nicknamed 'Nini gueule en raie'.

Renoir had already been working in close accord with Monet at La Grenouillère but in this instance made no special effort at Impressionist innovation, such as might convey the impression of a theatre by the treatment of light. Nor did he have any scruple about using black, on which Impressionist theory frowned, deriving its utmost density from Edmond's evening dress and opera-glasses and Nini's richly striped attire. All his appreciation of feminine charm of feature appears in the eyes, the mobile mouth and delicate skin of his female model contrasted with the countenance of Edmond in shadow. In spite of the beauty and luxurious character of the painting it found no buyer and Renoir by his own account was only too glad to dispose of it to the dealer known as *le père* Martin for 425 francs. He was adamant in not taking less as this was the exact amount needed to pay rent due and he had no other resource. But Nini of *La Loge* was the first of the long series of portraits that Renoir was able to invest with an inimitable charm.

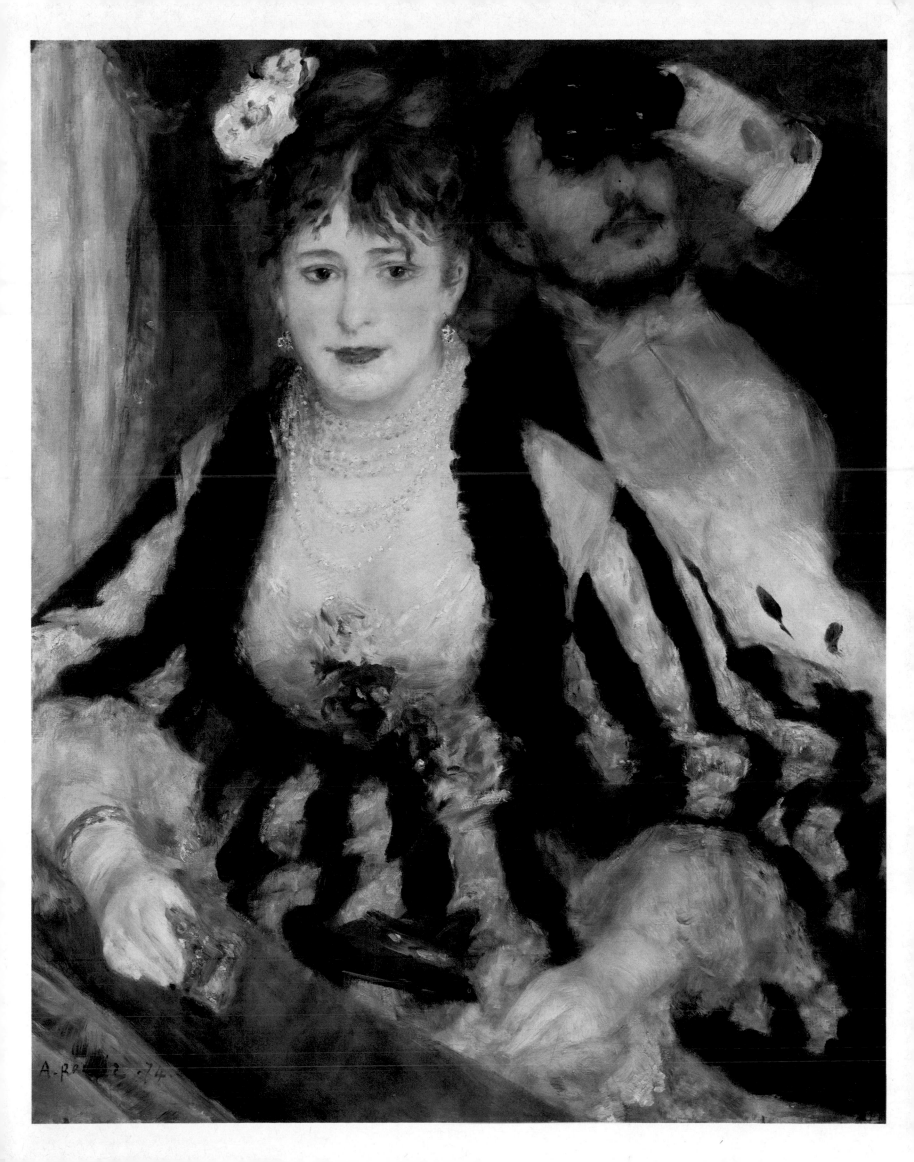

PLATE 72

Edouard Manet

Waitress Serving Bocks (La Serveuse de Bocks)
c. 1878–79
Louvre, Paris

Manet's feeling for scenes of contemporary life was actively displayed at the period to which this brilliant picture belongs. It was one of those inspired by the Cabaret de Reichshoffen on the Boulevard Roche-chouart in Paris and though painted in Manet's studio has all the atmosphere of the café-concert. His models were the authentic types, a waitress and one of the customers. The simplified opposition of light and strong colour which he always favoured is used with immense virtuosity, as on the hand and wrist of the man with a pipe and on the face of the waitress, suggesting rather than fully modelling form. Characteristic of Manet are the varied streaks of paint that enliven the surfaces, and his pleasure in the abstract variations of reflection comes out in the way he paints the glass jugs of beer.

Although he could scarcely be called a genre painter the persons represented are full of character. There is a perhaps somewhat puzzling contrast between the top-hatted figure behind and the proletarian pipe-smoker. In the larger version of the picture, now in the National Gallery, London, a species of bowler replaces the top-hat, possibly as being more in keeping. There is a close relation otherwise, apart from some obvious differences of placing and detail, between the National Gallery work and the smaller Louvre version formerly in the collection of Baron Matsukata. There are indications that Manet originally conceived the composition on a large scale and that these paintings represent only a part of the whole scene.

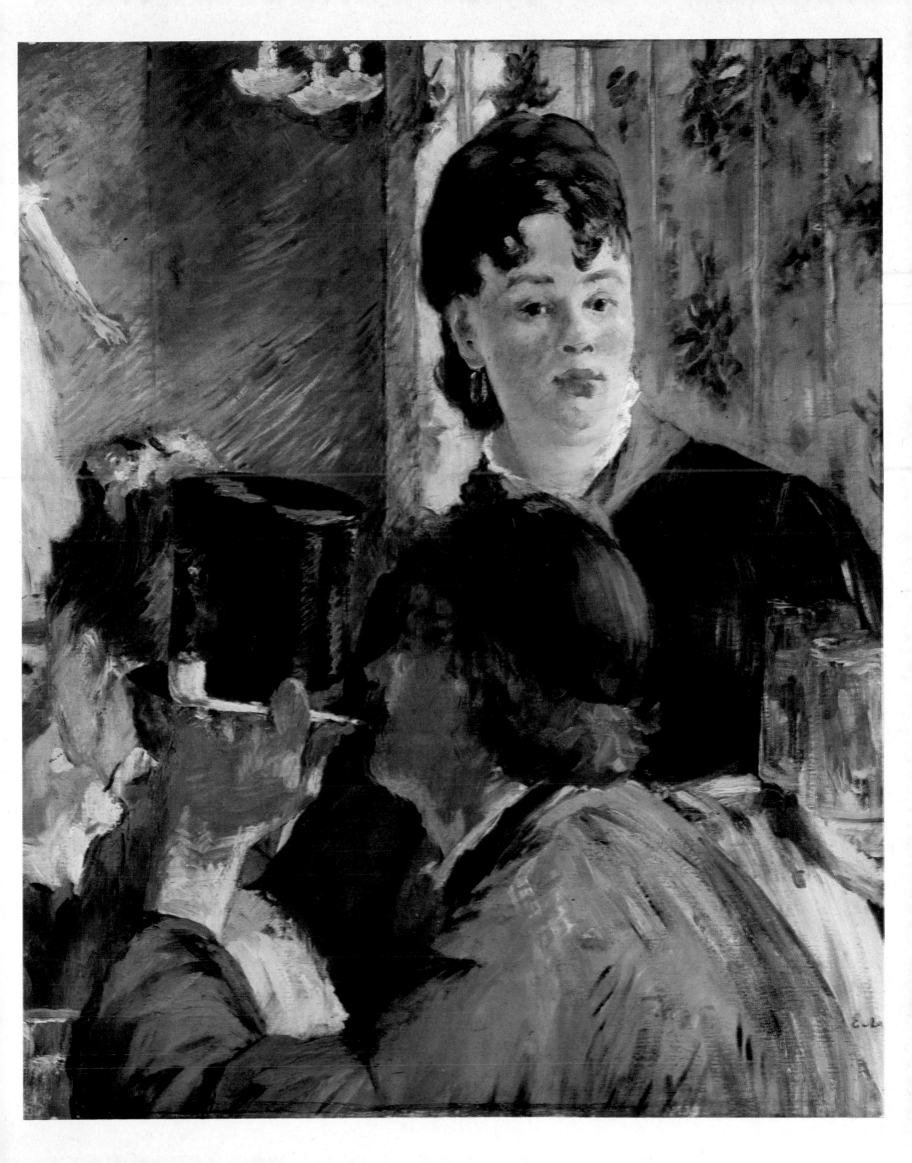

PLATE 73

Edgar Degas

Diego Martelli
1879
National Gallery of Scotland, Edinburgh

Degas, like Manet, carried Impressionism into the field of portraiture in the sense of employing great technical resource to convey an immediate impression. The truth he aimed at was not therefore primarily that of effect of light but of the most informal aspect of humanity. Two portraits made in 1879 arrive brilliantly at this result—the painting of Edmond Duranty, novelist, critic and supporter of the Impressionists, sitting deep in thought in his library, and that of Diego Martelli, an Italian adherent of the movement. Martelli was an art critic in Florence, associated with an avant-garde art magazine. He was probably introduced to Degas in Paris by Zandomeneghi, one of the younger Italian painters whom Martelli had defended. In 1879 Zandomeneghi contributed to the fourth Impressionist exhibition and Martelli, in the same year, was one of the few to defend the Impressionists in print.

A master of the art of concealing art, Degas gave careful study to the evidence of homely untidiness around his sitter; the red-lined carpet slippers by his chair, the confusion of papers on his table, on the top of which Martelli has placed his pipe. The unusual relation between the mass of documents and the man himself was evolved in a series of sketches and studies. In placing Martelli to one side Degas used a favourite device of his which gave even more importance to the main figure than would a central position and by viewing the sitter from above he made another unconventional innovation. The consequent foreshortening of the legs somehow adds to the idea the spectator may receive of character, and seen from this angle Martelli seems all the more unconscious of being observed by the painter.

The portrait was in the Degas sale of May 1918 and was acquired by the National Gallery of Scotland in 1932.

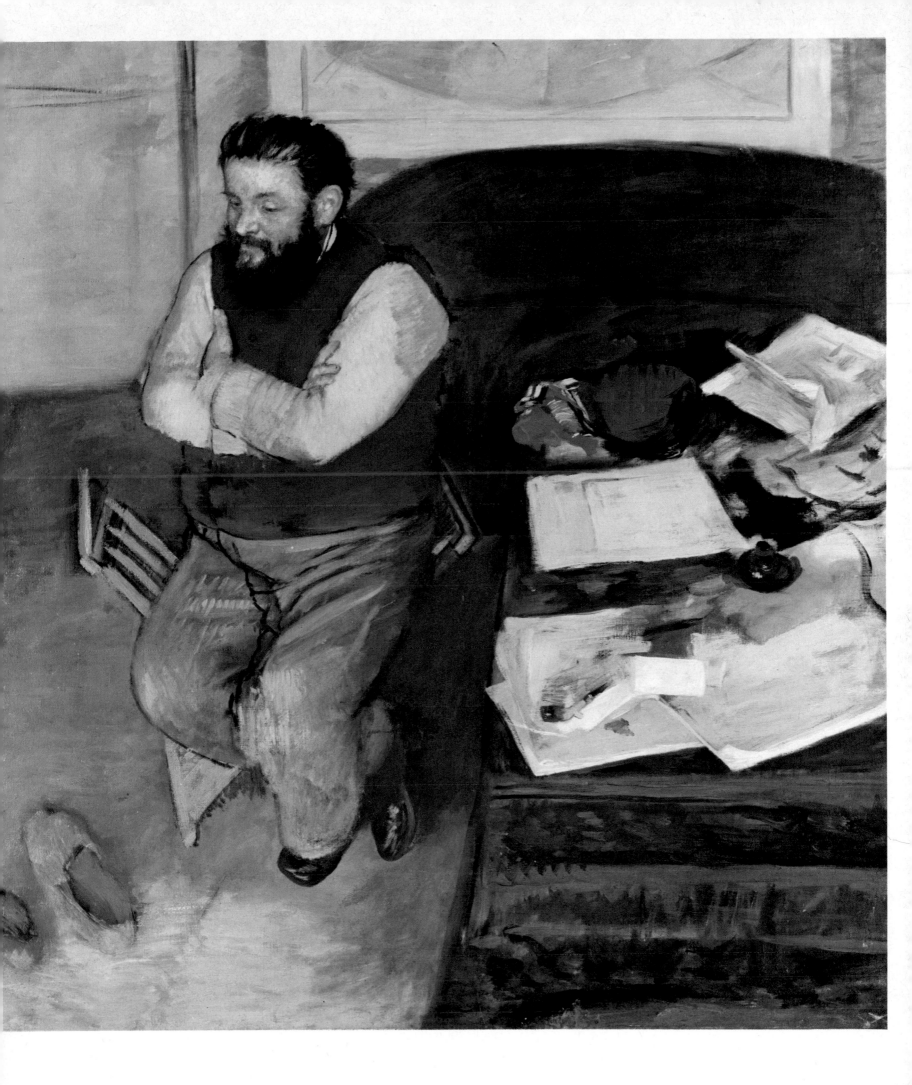

PLATE 74

Auguste Renoir

The First Outing (La Première Sortie)
c. 1875–76
Tate Gallery, London

There is a remarkable difference in technique between Renoir's two pictures of the occupants of a theatre-box, *La Loge* and *La Première Sortie* (as the latter is now entitled). In the intervening period Renoir worked with Monet at Argenteuil and, for the time being at least, had become thoroughly conditioned to Impressionist methods and outlook. The precision of drawing has gone to be replaced by a shimmering envelope of colour that surrounds the figures and gives them an actuality in space that the other picture does not display. This of course is a difference of aim rather than aesthetic quality. The rich blacks have gone, depth of colour being provided by ultramarine. But the Impressionist way of seeing concerned not only colour but what it might be optically possible to see at one particular moment. In focussing on one object the eye is only vaguely aware of others behind and around and thus Renoir assumes that attention is fixed on the young girl on her first evening out and that the spectator has only a confused and sidelong impression of the rest of the theatre and other members of the audience. There is another advantage in the way this is presented. Something of the excitement of the occasion is conveyed by the broken colour and the figures dimly visible. The calm of *La Loge* has no such suggestion.

Renoir's application of Impressionist ideas to figure compositions has other instances about the same time in *La Balançoire* (Louvre) and *Le Moulin de la Galette (pl. 60)*. *La Première Sortie* first belonged to Count Armand Doria and was included in the Doria sale of 1899 under the less appropriate title of *Café-Concert*.

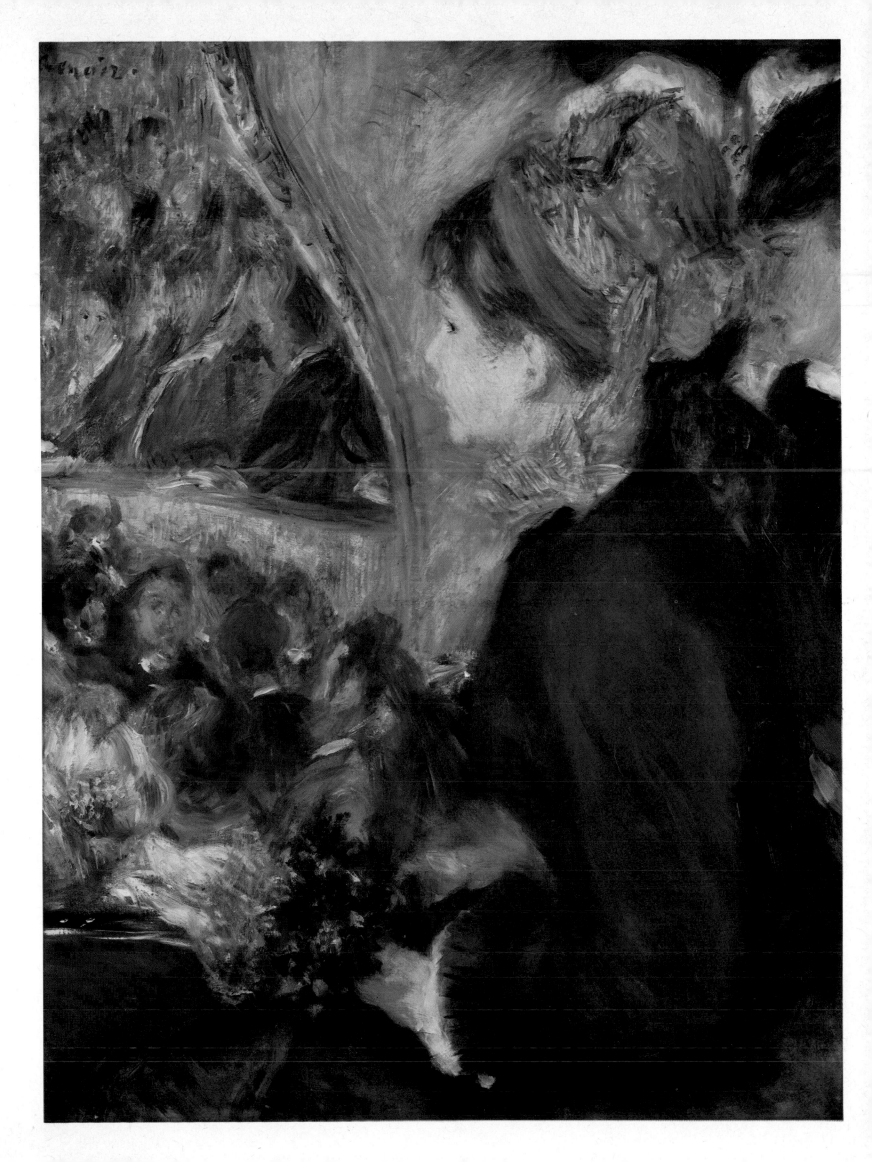

PLATE 75

Berthe Morisot

In the Dining Room
1886
National Gallery of Art, Washington

Berthe Morisot was a true Impressionist in the sense that she avoided the convention of giving three-dimensional form an outline and as in this painting, used touches of colour to indicate form and modelling. But loyal as she was to the same aims as Monet, Pissarro and Sisley, she was not imitative of their way of applying colour in small, distinct and fairly regular patches. She had an independent method of her own, as appears here in the bold brushstrokes moving in every direction with a look of entire freedom. As a result, light fills every corner of the interior she has painted. This vigour of brushwork, however, does not prevent her giving the girl she portrays a youthful smoothness of charm and effectively central position in the composition.

 Berthe Morisot was forty-one when she painted this picture and at the height of her ability. She exhibited fourteen works in the eighth and last Impressionist exhibition which she and her husband helped to organize and in the same year her pictures were exhibited in New York by Durand-Ruel. It says much for her individual gift that the works Paul Valéry compared to 'the diary of a woman who expresses herself by colour and drawing' should have held their own so well in great company. It was her special faculty to invest the everyday world with poetry and to paint rather than to write the life of her household.

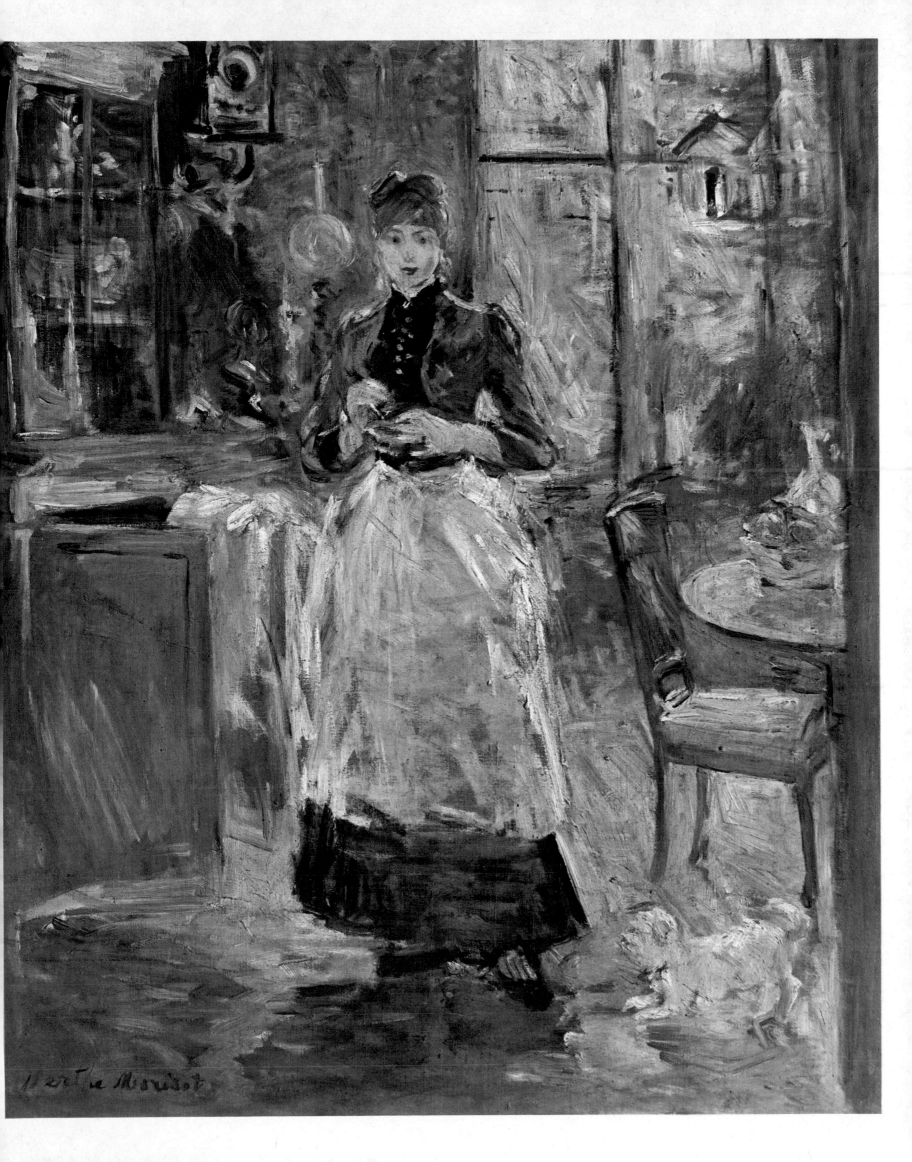

PLATE 76

Mary Cassatt

Girl Arranging her Hair
1886
National Gallery of Art, Washington

Mary Cassatt was the American artist most closely associated with the Impressionists and this picture, once in Degas's possession, was included in the eighth and last Impressionist exhibition. It shows how assiduously and with what faculty of assimilation she had studied the work of Degas. This appears in the realism of gesture, intimacy of setting and above all in the attention paid to drawing. In this last respect her quality of precision was of the kind that caused Degas, on first seeing her work in the Salon of 1874, to remark: 'There's someone who feels just the way I do'. There is an illustrative element in her work, however, that clearly distinguishes it from his, though lengthy comparison with the great French artist would be invidious.

Like the other female adherent of Impressionism, Berthe Morisot, she devoted herself to painting women and children. The two artists were alike in the independence of mind that led them to prefer the much abused Impressionist group to the conventional Salon, though Berthe Morisot was much nearer the core of the movement in rendering the effects of light on her sitters—to the exclusion of those outlines that Mary Cassatt insisted on so firmly, and which she was able to turn to advantage in the colour prints she also produced.

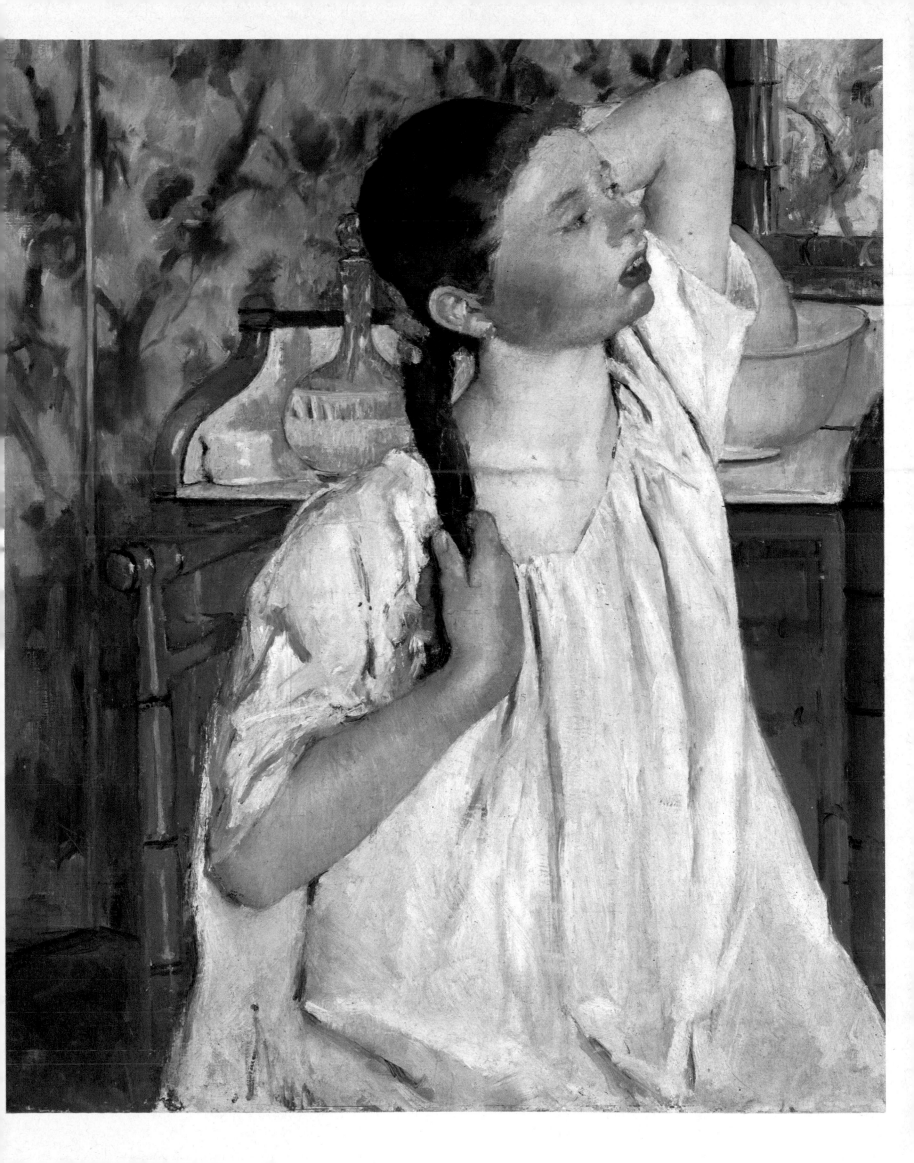

PLATE 77

Henri de Toulouse-Lautrec

Comtesse Adèle de Toulouse-Lautrec in the Salon at Malromé
1887
Museum of Albi

Toulouse-Lautrec painted this portrait of his mother two years after he had left Fernand Cormon's studio, when he was twenty-three. He had been subjected to a variety of influences in art since he took to painting as a boy. Before going to Paris to study he had so far adopted Impressionist practice as to paint pictures of horses and workmen outdoors on the family estates, showing his effort to convey natural effects of light. But at this stage he was perhaps more influenced by Bastien Lepage than by the greater masters. As a student in Paris, although never especially attracted by theory, he did not escape the ferment of the time; fellow-students were enthusiastic for new ideas and methods. Emile Bernard and—recent arrival in Paris—Vincent van Gogh were eagerly absorbing the lessons of Impressionist colour and Toulouse-Lautrec inevitably shared their interest in what was going on. Both Impressionism (better understood now than in his earlier youth) and Neo-Impressionism (the great topic of discussion in the later 'eighties) played their part in his development, as this portrait shows.

The way in which light and colour are airily distributed about the interior setting is reminiscent of the work of Berthe Morisot but more markedly apparent is some approximation to Seurat's division of colour. There is, however, nothing of Seurat's systematic procedure. The delicacy of the painting throughout in both feeling and colour is exceptional. It is signed 'Treclau', the anagram for 'Lautrec' which he used because his father, Comte Alphonse, objected to his signing paintings with the family name.

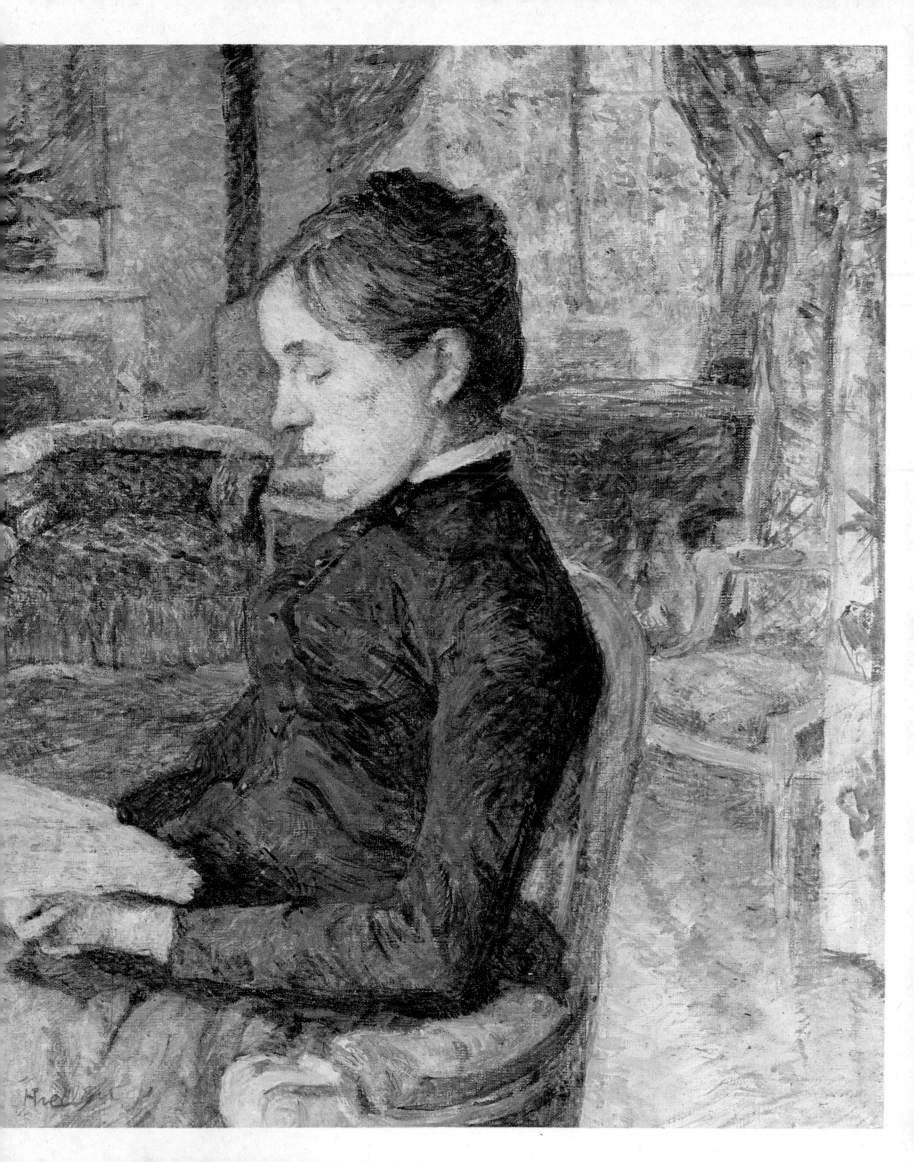

PLATE 78

Paul Gauguin

Mme Angèle Satre (La Belle Angèle)
1889
Louvre, Paris

The divided brushstrokes and use of thinly-applied, fresh colour still recall Gaugin's Impressionist phase though the decorative arrangement and unrealistic assortment of motifs in this portrait of Mme Angèle Satre of Pont-Aven project a Symbolist fancy and love of the exotic which would not have appealed to Pissarro or Monet. Gauguin's association with Emile Bernard during his stay in Brittany had led him to evolve a tapestry-like effect. Breton costume added its own touch of the medieval though the background has a suggestion of Japanese design. The idol has been variously accounted for. One improbable suggestion is that it was a later addition as a caricature of Mme Satre's husband who became mayor of Pont-Aven. It could, however, reflect an early memory of Peruvian ceramic sculpture brought to the surface by the exotic objects and ethnographic collections in the Paris Universal Exposition of 1889. He had a special interest in this exhibition as he and his friends Schuffenecker and Bernard contrived to show pictures of their own in a café opposite the official art pavilion. Symbolic as the idol may be of some thought stirring in Gauguin's mind, it has no obvious relevance to the portrait, though aesthetically considered the whole work achieves a surprising unity.

When the picture was finished, probably in August 1889, Mme Satre refused to have it as a gift, with the exclamation 'Quelle horreur!' On the other hand the work was singled out by Theo van Gogh among the pictures Gauguin sent him in September of the same year as 'a really fine Gauguin. He calls it *La Belle Angèle*. It is a portrait put down on the canvas like the Japanese *crêpons*. . . .' He went on to remark that 'the woman is somewhat like a young cow, but there is something so fresh in it and then again something so countrified, that it is very pleasant to see'. The picture was greatly admired by Degas, who bought it for 450 francs at the sale Gauguin held in 1891 on the eve of his departure to Tahiti. At the sale of Degas's effects after his death in 1918, *La Belle Angèle* was bought by the dealer Vollard. He presented it in 1927 to the Luxembourg whence it was transferred to the Louvre in 1929.

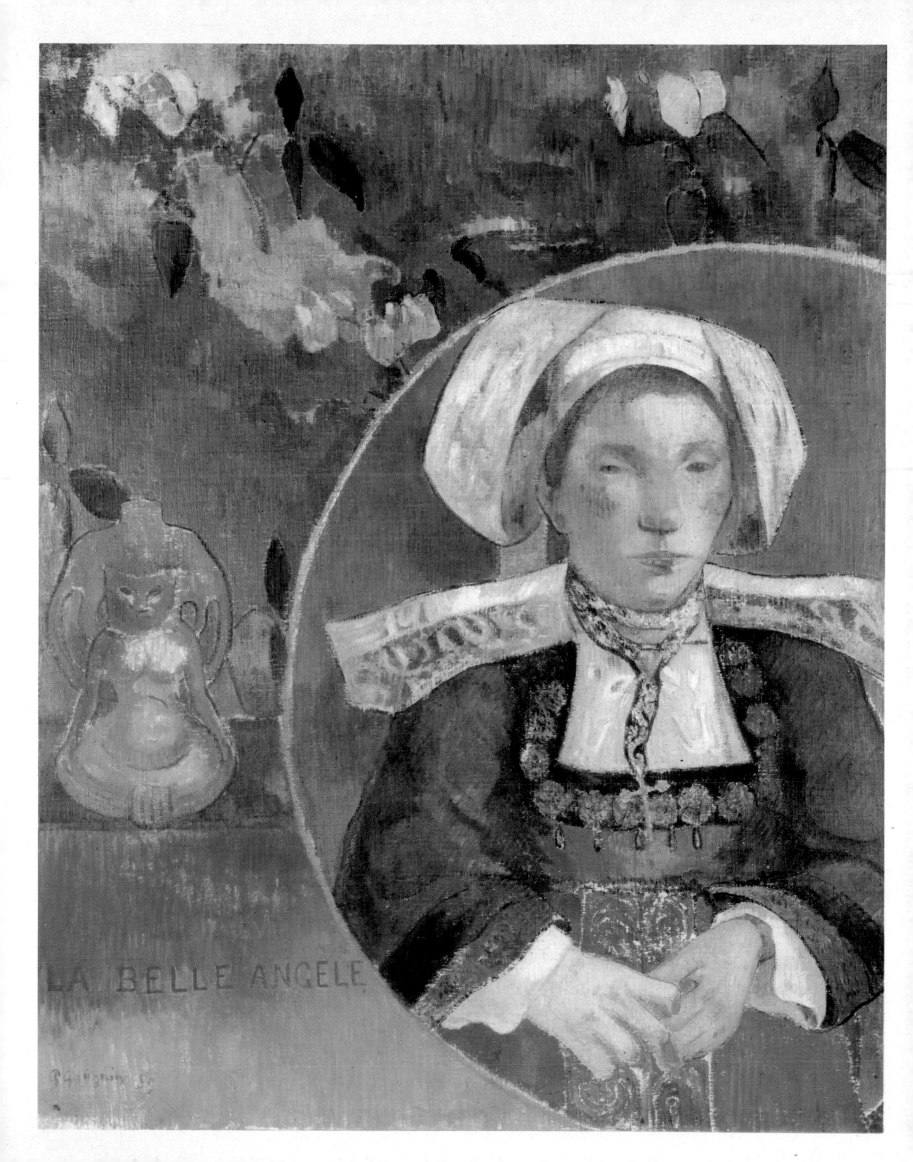

PLATE 79

Vincent van Gogh

Portrait of the Artist
May 1890
Louvre, Paris

In the most limited definition of the term, Impressionism as the objective study of light did not encourage so essentially a subjective study as the self-portrait but in the later expansion of the movement this self-representation was given renewed force by Cézanne and Van Gogh. The latter has often been compared with Rembrandt in the number and expressiveness of his self-portraits but while Rembrandt's were distributed through a lifetime, Van Gogh produced some thirty in all in the short space of five years— from the end of the Brabant period (1885) to the last year of his life at St Rémy and Auvers. In each there is the same extraordinary intensity of expression concentrated in the eyes but otherwise there is a considerable variety. From the Paris period onwards he used different adaptations of Impressionist and Neo-Impressionist brushwork, separate patches of colour being applied with varying thickness and direction in a way that makes each painting a fresh experience.

In May 1890, when this example was painted, there were three events of note in Van Gogh's life: he left the hospital at St Rémy, he visited his brother Theo in Paris, then went to place himself under Dr Gachet's care at Auvers. The picture is less likely to have been painted during his brief stay in his married brother's apartment than at Auvers. The spiral movement in which he had depicted the night sky and stars at St Rémy seems to take on a symbolic personal reference, conveying the disturbed pattern of his whirling thoughts. Dr Hammacher, Director of the Kröller-Müller Museum, has observed that 'the colours—pale blue, green and broken white—correspond to his increasing dislike of the South and the growing longing for the North which has revived his earlier conceptions of form and colour'. The sense of tragedy is there also. The portrait once belonged to Dr Gachet and was given to the Louvre by his son.

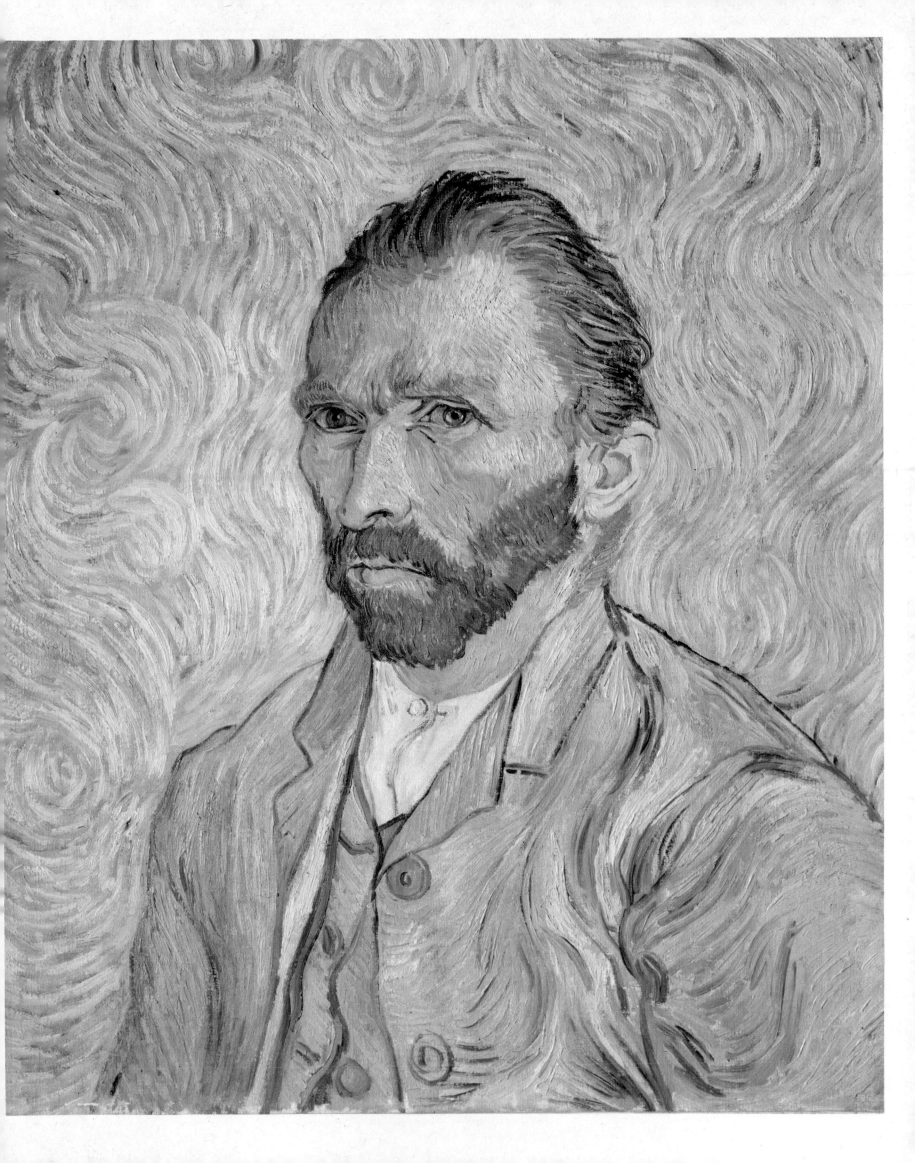

PLATE 80

Henri de Toulouse-Lautrec

Englishwoman at The Star, Le Havre
1899
Museum of Albi

In remarkable contrast with Van Gogh's sombre, last self-portrait is the gaiety of this portrait by Toulouse-Lautrec though he—as well as Van Gogh the victim of fate—was in no enviable condition when he painted it. He had shortly before been discharged from the sanatorium of Dr Sémelaigne at Neuilly to which alcoholism and other excesses had brought him. Sea air and travel being part of his convalescent programme he went to Le Havre in July to embark there for Bordeaux. At Le Havre he paid a nostalgic visit to The Star, a drinking club near the harbour for English sailors which had been one of his resorts before his breakdown. Attracted by the lively aspect of The Star's English barmaid, Miss Dolly, he sent for the painting materials that had been put aside for a while, and after making a drawing in red chalk on blue Ingres paper executed this portrait in oils on a limewood panel. The smooth surface of the panel favoured a fluency of execution which is brilliantly carried through. His own method of colour separation, exercised unobtrusively in the early portrait of his mother, is now vivid in the different blues that overlap in Miss Dolly's dress and create a distinctive harmony in conjunction with her pink collar and yellow curls.

The picture comes within the radius of Impressionism in the immediacy and freshness of effect gained by colour. 'I hope that my guardian will be pleased with his ward', he wrote to Maurice Joyant, the old friend who now supervised his allowance and expenditure, with the request to have the barmaid's portrait framed, thus evincing his own pride in this work, the freedom of which contains so much of life.

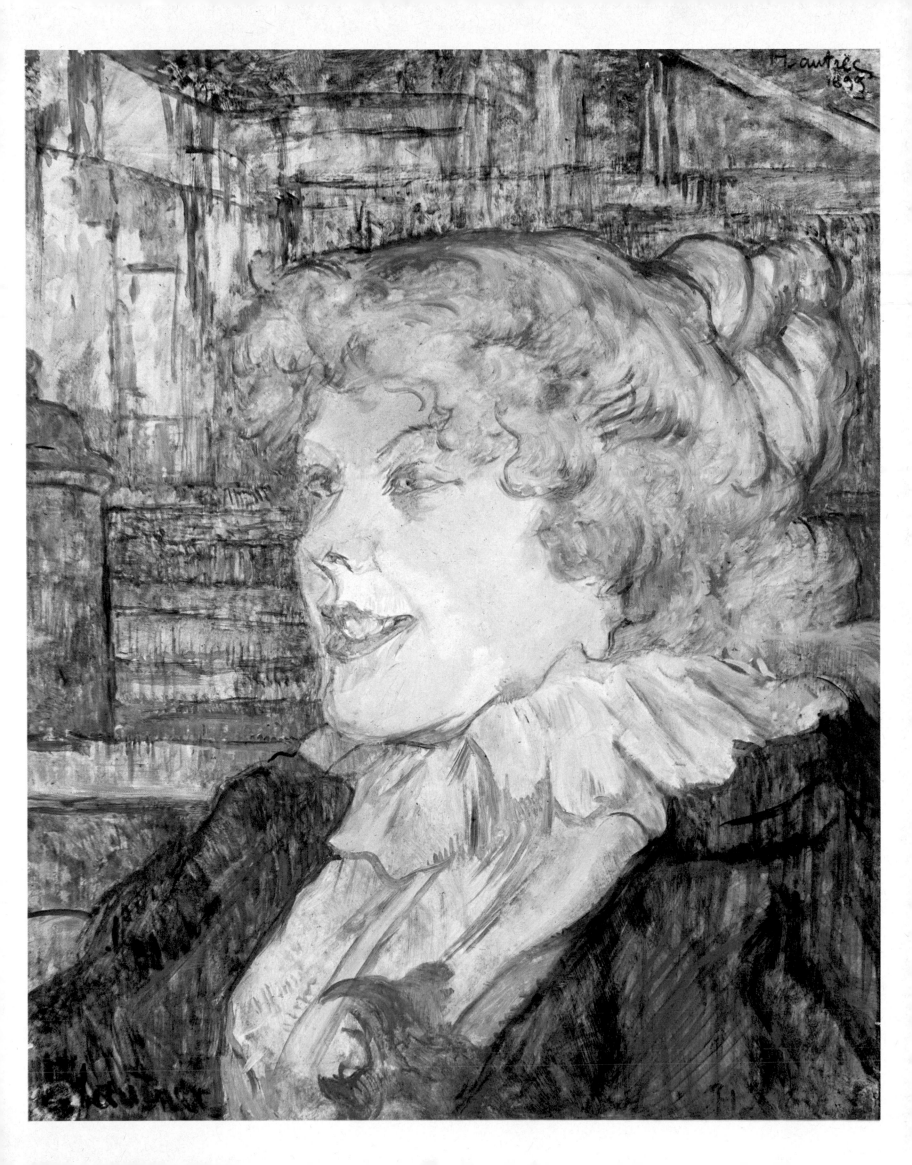

PLATE 81

Auguste Renoir

Gabrielle with Roses

1911

Louvre, Paris

The advance of arthritis caused Renoir to repair regularly to the warm south from 1903 onwards and then to settle at Cagnes. There his painting became to a large extent, as far as subject-matter was concerned, a family chronicle. He painted Madame Renoir, the children and the general factotum, Gabrielle. In addition there were young models who in this sunny region seemed like—or could be made to resemble—creatures of classical mythology. The portrait of Gabrielle, whom he painted many times, shows how his style had changed in this twentieth-century period of his art. After the phase of revolt against Impressionism he became in a sense Impressionist again; that is to say, he ceased to give hard outlines to his figures and restored colour to the importance it had once had in his work, though the cooler hues of Argenteuil, appropriate to the Impressionist north, were now replaced by a prevailing warmth of red. Yet Renoir also gained in appreciation of solid form, the general tendency of the post-atmospheric period of French art. Gabrielle's sturdy limbs are almost sculptural in their solid and rounded character.

The painter Albert André, who watched Renoir at work at 'Les Collettes', his villa at Cagnes, has described the method used in a painting such as this. It evolved from a series of transparent glazes thin enough to allow the grain of the canvas to show through in some parts. The outline was roughly drawn with Indian red, then colour was freely washed on with turpentine as the medium. When this dried he applied further thin glazes with a mixed medium of linseed oil and turpentine. The solid form magically emerged from a mist of warm colour. Touches of white were added finally to indicate highlights. As painters are apt to do when not under the strict professional necessity of aiming at exact likeness, Renoir imparted to Gabrielle a look of what seems to be the type his imagination favoured, to be discerned also in his portraits of Madame Renoir and others, with wide eyes, short nose and broad contours delicately tapering to the chin.

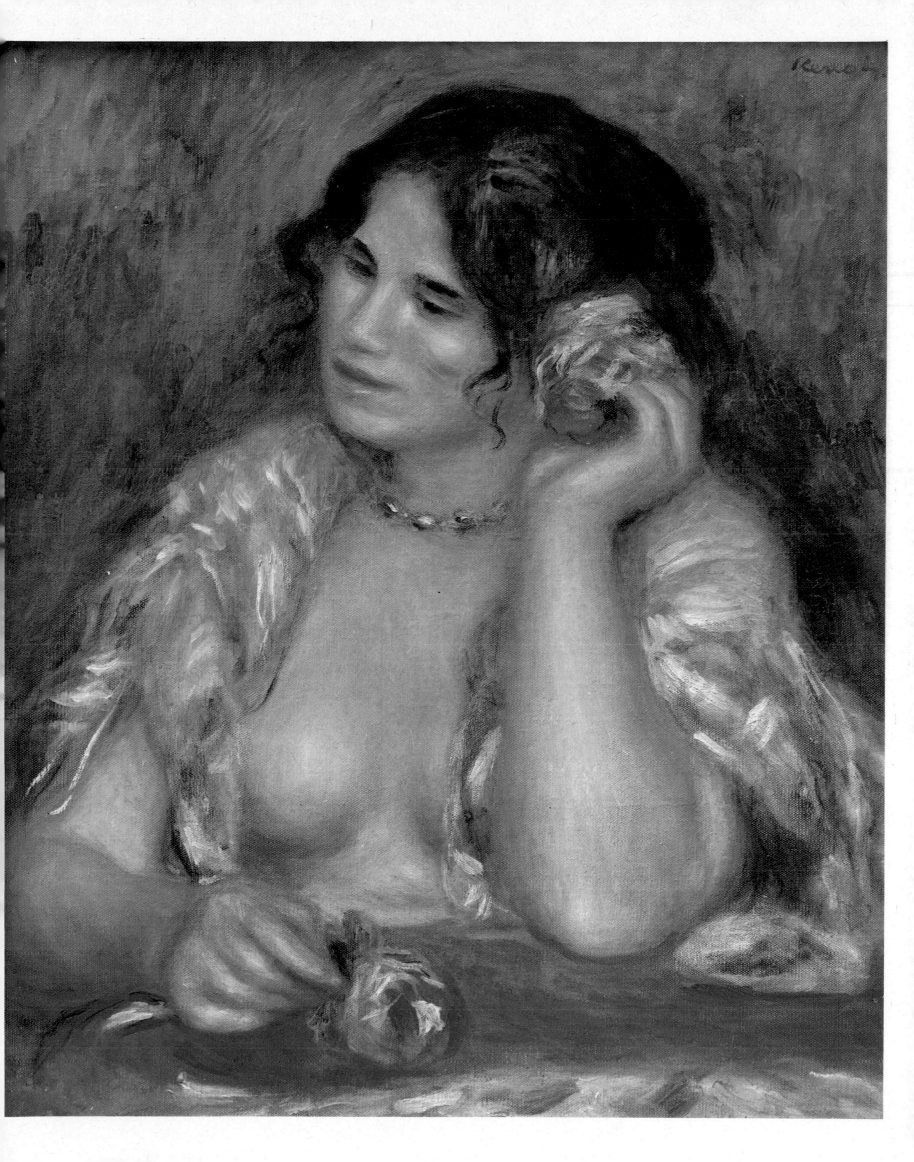

PLATE 82

Edgar Degas

The Dance Foyer at the Opera
1872
Louvre, Paris

There are many great paintings to remind us that the artists of the Impressionist age were sensitively aware of contemporary life. Among the supreme masterpieces of the century are Degas's pictures of the ballet and its dancers. The impulse towards painting the contemporary scene came to him not only from Courbet and Manet but from his friend, the critic Duranty, the exponent of the aesthetics of naturalism. Yet in the particular direction of his tastes and his conception of design he was entirely individual. To study and convey movement was a chosen task, first undertaken on the race course and then in his many pictures of the Opera, viewed from behind the scenes, in the wings, or from the orchestra stalls during a performance.

Over a period of years they show a remarkable evolution. Degas's fastidious intelligence, refinement of perception and precision of drawing appear in one of the earliest of the ballet pictures, reproduced here. There is nothing forced or assertive in the composition, so natural it might almost seem photographically so, though behind the appearance of informality there is conscious planning. It became one of his favourite devices, in which he profited by his study of Japanese prints, to arrange his figures in asymmetrical grouping instead of placing the more important centrally. This gave a new significance to space in itself as can be seen here. The expanse of floor, leaving emptiness in what would conventionally be considered the principal area and as such an area to be filled with incident, point the more emphatically to communication between balletmaster and pupil. The foreground chair, casual and even apparently irrelevant, serves the artist's purpose in giving dimension to the room as well as harmoniously repeating notes of colour distributed elsewhere in the picture. Although Degas scoffed at the Impressionist practice of painting in the open air, the natural effect of light they valued is applied to his purpose in illuminating the dancers' poses and to exquisite advantage against the general evenness of tone.

218

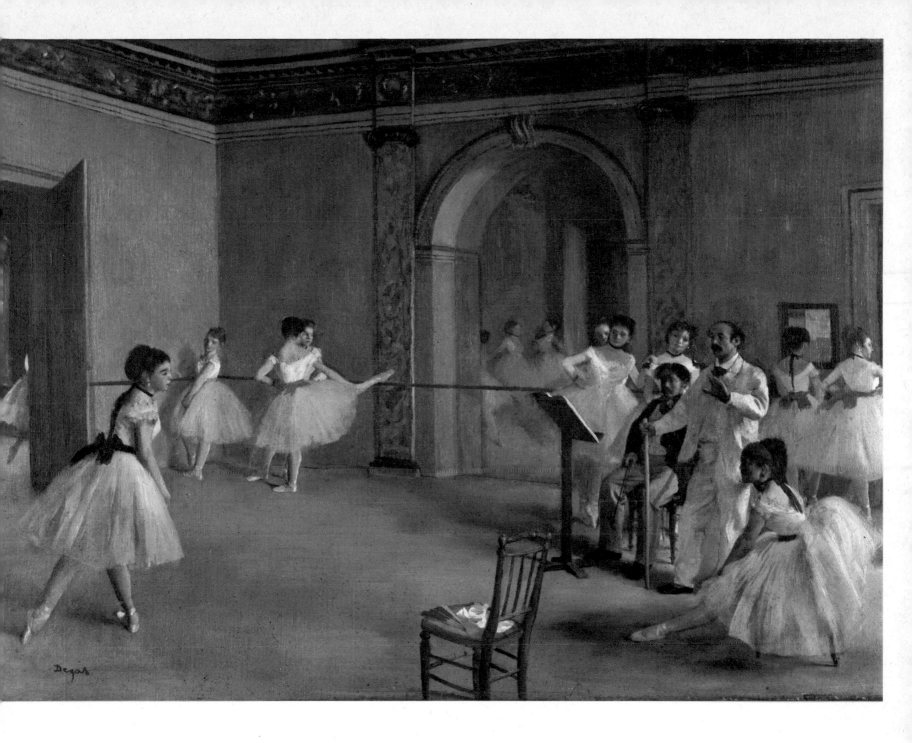

PLATE 83

Edgar Degas

The Dancing Class
1874
Louvre, Paris

Degas's resource in composition is again illustrated in this picture, which was included in the first Impressionist exhibition of 1874. There is rather less of the meticulous delicacy he had shown two years earlier. The dancers are not so abstractedly demure but more distinct as individuals. Within the vertical framework, however, another asymmetrical scheme is worked out. Empty space in the long perspective of floor is set in effective contrast against the varied detail of the dancers' steps and attitudes. Degas's interest in the momentary gesture has an example in the figure of the girl with a yellow sash at left who, perhaps in nervous tension or boredom, is scratching her back. He did not include such a gesture in the spirit of an illustrator but as part of a synthesis of gestures unified by his profound knowledge of picture-making. The careful planning of what was intended to look like an accidental glimpse of the class and their instructor, places the girl on the right half-in and half-out of the area of vision, the device Degas adapted from the 'slice of reality' that might be presented by a photographic print. Such accidental cuts also opened new prospects of composition to his perceptive eye.

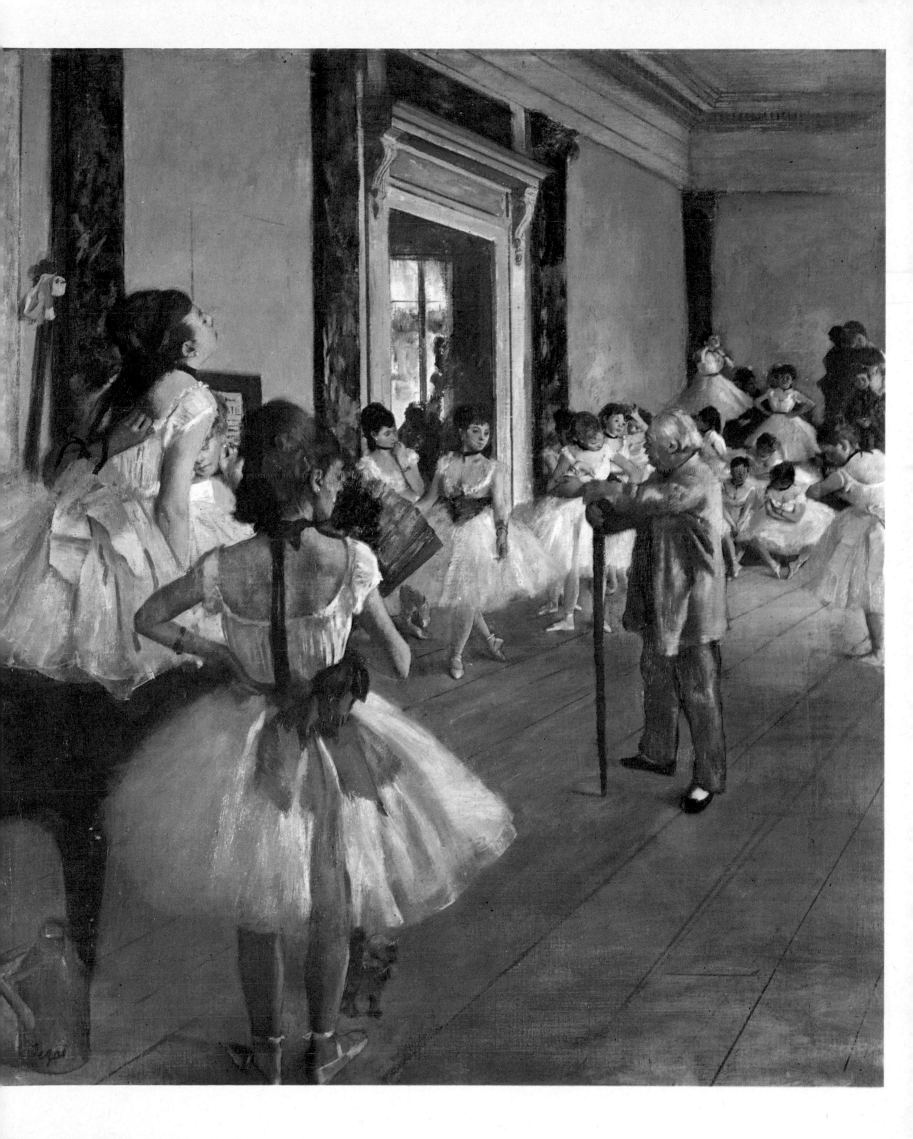

PLATE 84

Edgar Degas

Dancer with Bouquet, Curtseying (Danseuse au Bouquet, Saluant)
1878
Louvre, Paris

After representing the gruelling routine of the dancing class (which he studied with a special interest in its exacting technique) Degas added splendid works that showed the technique in action, the beauty of movement in the actual performance, its glitter and intoxicating colour beneath the artificial lights. His preferred medium was now pastel with which he could at the same time draw and paint, and which also had a repertoire of pure and brilliant tints. Of several examples produced about the same year, 1878, this pastel of a dancer curtseying is one which most poetically interprets the spirit of a triumphant moment in all its illusive sparkle. The idea that Degas was not a colourist loses any validity when one considers the quasi-musical relationships of lemon yellow, pink and lilac, vermilion, orange and pale blue. As in previous works, he designed the composition in such a way as to give space its maximum effect. The dancer would not appear so intensely and swiftly poised at the moment of her bow if it were not for the area of empty stage. As the mind's eye completes the implied diagonal across the picture suggested by her pose, the ballerina seems to advance towards the footlights.

Here was a scene impossible to paint on the spot but only as impressed on the memory. This was the transformation of which he himself spoke as that 'in which imagination collaborates with memory. One reproduces only that which is striking; that is to say, the necessary. Thus one's recollections and invention are liberated from the tyranny which nature exerts.'

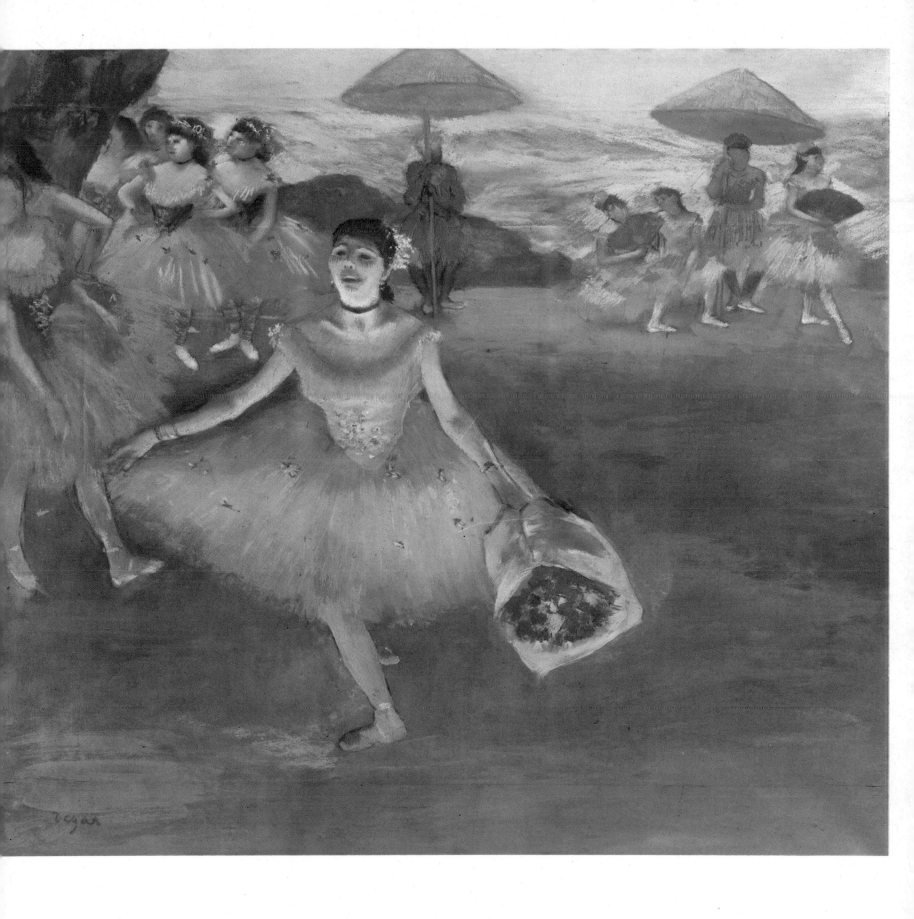

PLATE 85

Edgar Degas

Dancers Preparing for the Ballet
c. 1878–80
Art Institute of Chicago

Degas's later paintings and drawings inspired by the ballet included many single figures or small groups of dancers observed in the wings or behind the scenes, lacing up their dance shoes, hooking up their dresses or, as here, adding the final touches to their toilette. They follow a similar trend to that of the works in which he depicted female models in domestic surroundings washing themselves or combing their hair. As in this example he was not concerned with the butterfly-like grace of the dancer fluttering into a pose with well-trained adroitness and only in a minor degree with the theatrical setting. Absorbed in the details of corsage and coiffure, the dancers are taken unawares, have not had time to put on expressions of charm or occasion yet to display professional grace of limb. It was 'behind the scenes' in every sense of the phrase that Degas's sharp eye now found most striking and in technique he increasingly departed from smooth finish to a rougher vividness of form and colour that matched the candour of his immediate impression. This painting makes a great contrast with the delicate precision of the *Dance Foyer* of 1872 and equally with the glamorous dancer making her curtsey of 1878, though *Dancers Preparing for the Ballet* was painted about the same time as the pastel—or perhaps a little later.

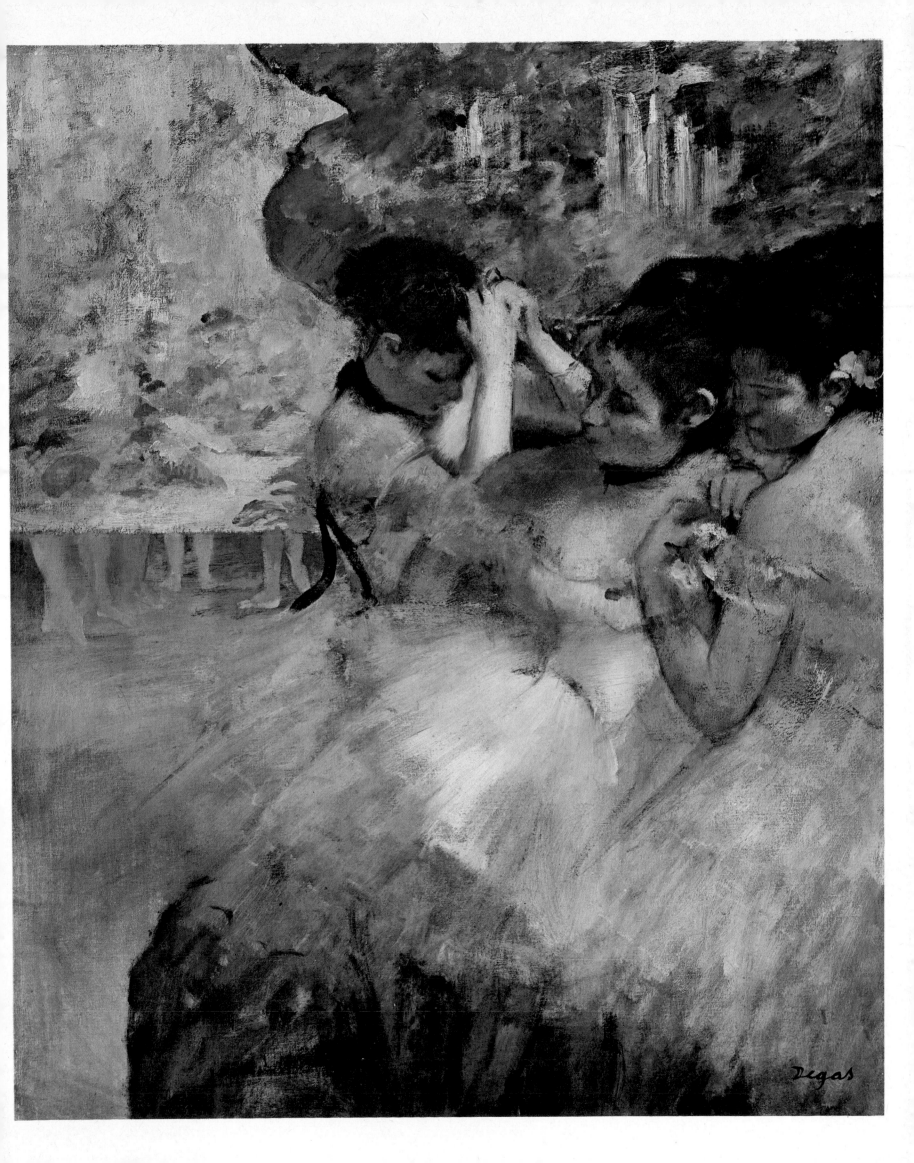

PLATE 86

Claude Monet

Women in the Garden
1866–67
Louvre, Paris

One of the most beautiful of Monet's early compositions, this picture was painted in 1867 in the garden of the house he had rented at Ville d'Avray. It was on a large scale, like the picnic scene—his version of *Le Déjeuner sur l'Herbe*—he had painted the year before, and according to Gaston Poulain (in *Bazille et ses amis*) was executed at the request of Bazille, no doubt as a companion piece to his own *Réunion de Famille*, also painted in 1867. However, there is little of the group portrait in Monet's picture, though he is said to have been provided with photographs of the Bazille family, taken at their house at Meric, near Montpellier. He determined to paint it entirely out of doors, encountering various difficulties in consequence. A trench had to be dug in the garden into which the huge canvas was lowered by an arrangement of ropes and pulleys so that Monet could reach the upper part with his brush.

It is said that Courbet, finding Monet not at work on the picture one day, asked why and was told that he was waiting for the sun. Courbet suggested that he might occupy his time meanwhile by filling in the background but Monet refused to do this on the ground that every item had to be painted in the same light. A significant difference may be found here between the realism of Courbet and the Impressionist search for objective truth.

Monet's Camille seems to have taken the poses of the photograph. Photography was a reference for instantaneous effect which the Impressionists did not hesitate to use, though the consistency of sunlight on figures, trees and flowers, as wonderfully well-maintained as the informal grace of pose and movement, is a triumph of colour.

The painting was refused by the Salon and to help Monet, who was then in dire financial straits, Bazille bought it for 2,500 francs, paid in monthly instalments. When Bazille was killed in the war of 1870, his father exchanged the work with Manet for Renoir's portrait of Bazille. Later it was returned to Monet and remained in his studio until it was acquired by the Musée du Luxembourg in 1921. It was transferred to the Louvre in 1929.

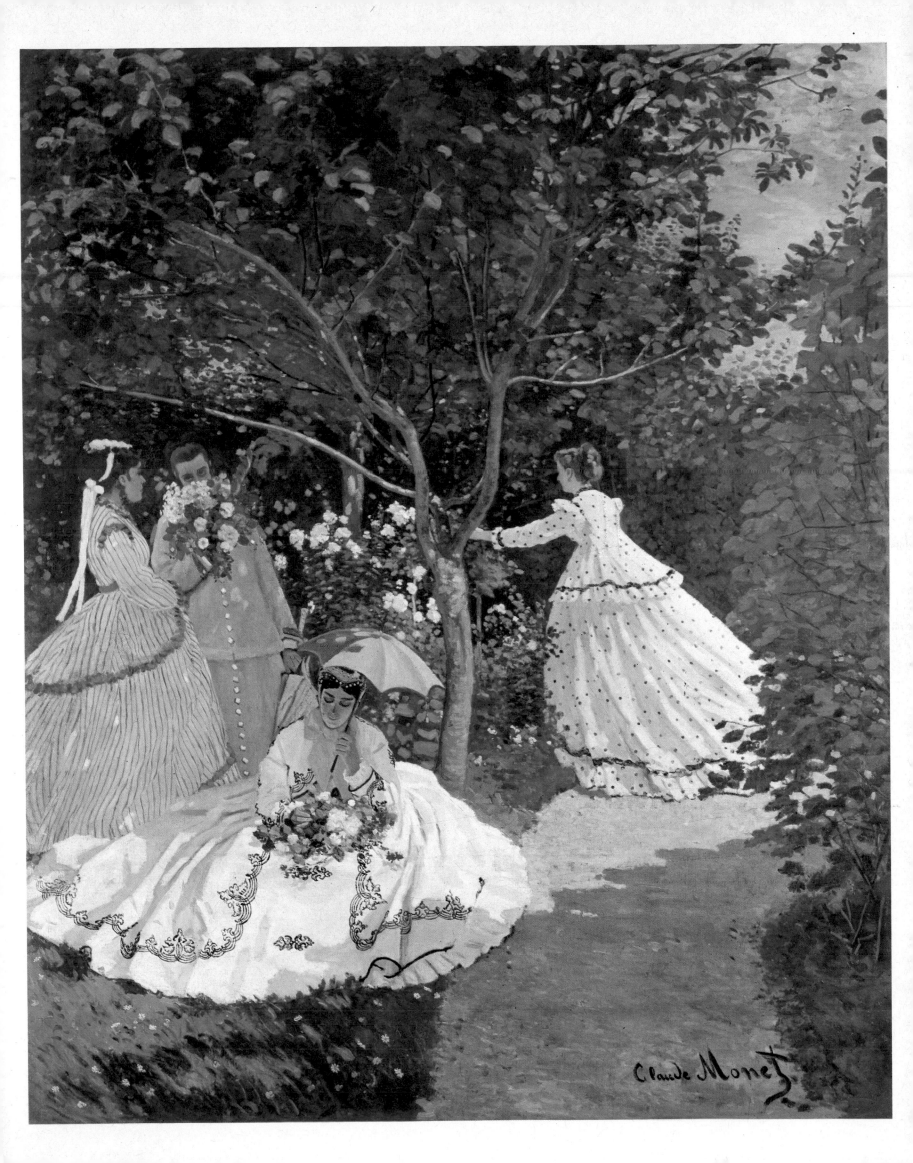

PLATE 87

Claude Monet

On the Beach, Trouville
1870
National Gallery, London

This picture, one of several seaside scenes painted in the summer of 1870 at Trouville, shows Monet at a transitional stage of his art, much influenced by the direct oil sketch as practised by Manet, with large areas of flat colour giving contrast of light and shade and realistic effect suggested with a minimum of modelling. The more distinctively Impressionist method of translating the incidence of light into separate touches of clear colour was not yet fully developed though Monet's paintings at La Grenouillère in the previous year (and those of Renoir) had already shown the direction of this technical evolution. In 1870 Monet had renewed acquaintance with Boudin and their meeting may have encouraged him to paint beach scenes such as Boudin favoured though of the latter's style no trace remains in Monet's work. The girl at left with flowered hat and light dress is presumed to be Camille Doncieux whom Monet had married in June and her companion to be Mlle Doncieux, Camille's sister, both young women appearing in several similar beach scenes at Trouville and Sainte-Adresse.

The snapshot character of the painting carries with it its own assurance of open-air veracity but if circumstantial evidence were needed it exists in the grains of sand incorporated with the paint surface, clear indication that the work was painted on the spot. Its peaceful nature would also suggest that it was painted prior to July 15—the date when war was declared between France and Prussia.

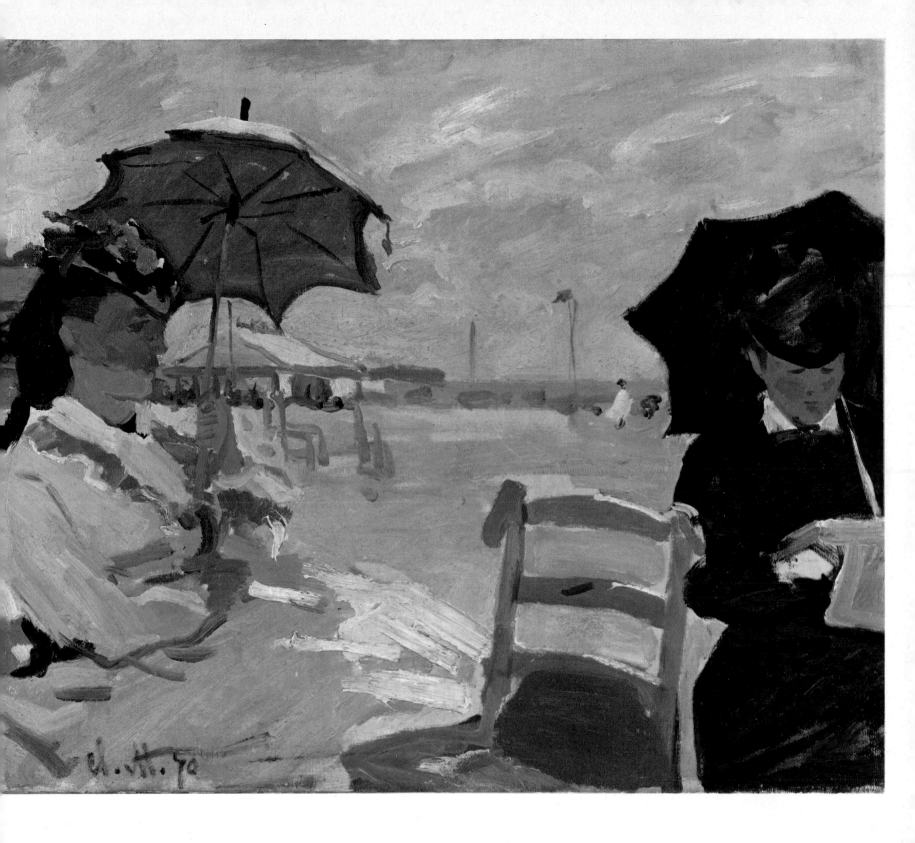

PLATE 88

Edgar Degas

L'Absinthe
1876
Louvre, Paris

Since the characters are known, this picture could be considered as an example of Degas's portraiture or, alternatively, as a characteristic glimpse of the Parisian café. The woman is the actress Ellen Andrée, the man Marcellin Desboutin, painter, engraver and, at the time, celebrated Bohemian character. The café where they are taking their refreshment is the Café de la Nouvelle-Athènes. Desboutin—a popular figure—seems to have led the move of those concerned with the arts from their previous rendez-vous, the Café Guerbois, to the Nouvelle-Athènes. It was frequented by Manet and Degas, by some critics and literary men as well as painters and had an interested observer from across the Channel in the young George Moore. The painting shows Degas's favourite device of placing the figures off-centre with a large intervening area of space in the foreground. A forceful and original composition results from the mode of arrangement and the dark but harmoniously related tones of colour and shadow.

Degas evidently retained in memory a moment when his sitters were in pensive mood. He did not seek to flatter them or make a 'pretty picture' (an idea he regarded with horror). On the other hand nothing could have been farther from his thoughts than to depict these familiar acquaintances as monsters of dissipation and degradation in order to draw a moral lesson. It might be observed, incidentally, that Desboutin was drinking nothing stronger than black coffee! In England, however, the persons represented were considered to be shockingly degraded and by an involved piece of reasoning the picture itself was regarded as a blow to morality. So it appeared to such Victorians as Sir William Blake Richmond and Walter Crane when shown in London in 1893. The reaction is an instance of the deep suspicion with which Victorian England had regarded art in France since the early days of the Barbizon School and the need to find a lesson at all costs that was typical of the age. George Moore in trying to defend Degas was as unperceptive as any. 'What a slut!' he had to say of poor Ellen Andrée and added, 'the tale is not a pleasant one, but it is a lesson', a remark for which he had later the grace to apologize.

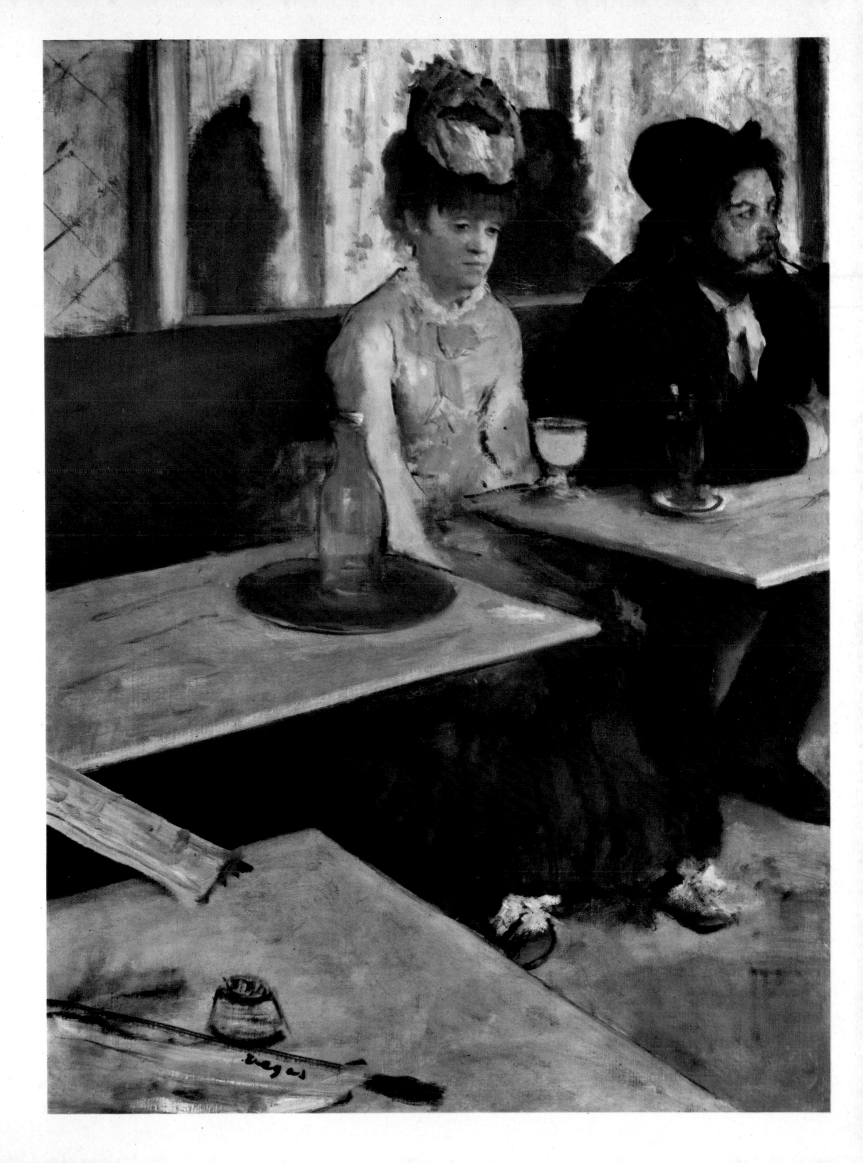

PLATE 89

Edgar Degas

Women on a Café Terrace
1877
Louvre, Paris

Discussion of the extent to which Degas was really an Impressionist is apt to depend too much on terminology. He did not care for the word, he was not interested in landscape and he himself pointed out that contrary to his Impressionist friends' need for 'natural' life, his need was for the 'artificial'. By this he implied the world of theatre, music-hall, café-concert and circus though subtle artifice of skill also underlay his apparent spontaneity. Allowing for these differences the fact remains that he was essentially linked with those who sought to give an instantaneous impression. How else should one regard the sensations imparted by this picture, the calculated difference of lighting between the café and the shadowy movement of the street. The central figure with thumb pensively in mouth is pure Degas though perhaps an unintended element of caricature comes out in the other types portrayed. There is an anticipation of the 'nineties, of Toulouse-Lautrec, not only in the shades of expression but in the combination of structural elements of design with the feeling of the moment. The severe uprights of the café's architecture offset the human element. Though nothing of the Japanese print obviously appears this is a combination of form and idea such as they often represent. The decisive verticals give an abstract framework to the informal drama. The approach and the type of composition appear again, after being taken up by Toulouse-Lautrec, in the work of Bonnard.

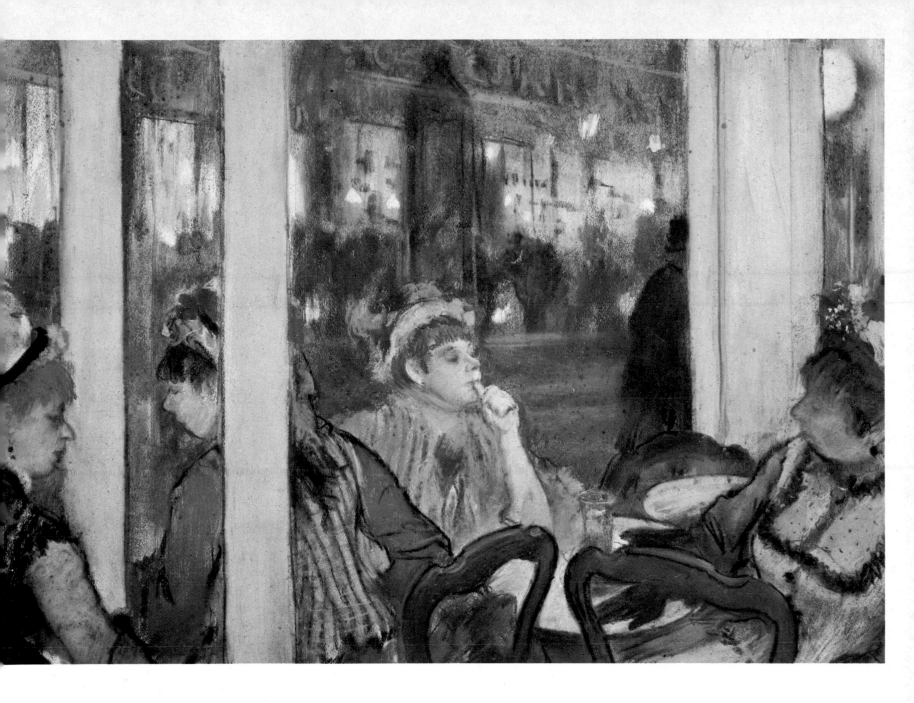

PLATE 90

Edgar Degas

Miss Lala at the Cirque Fernando
1879
National Gallery, London

Always alert to the possibilities of novel arrangement in composition Degas found an unusual suggestion for the asymmetrical design he favoured in a turn at a circus in which space also took on a new aspect. The painting was shown in the fourth Impressionist exhibition and described in the catalogue as *Miss Lola au Cirque Fernando*, though contemporary reference has since proved that the performer was in fact known as Lala or La La. She appears to have been a negress or mulatto noted for such feats as that shown in the picture where she is being hauled to the circus roof by a rope held between her teeth. The circus was in Montmartre and later became known as the Cirque Médrano, long being a popular resort and sketching-ground of artists.

Degas's investigation of how to give importance to the main figure when not centrally placed here takes a vertical instead of a lateral direction. The placing of the figure near the top of the canvas was obviously called for to suggest distance beneath. The sketch for the painting (in the Tate Gallery) shows only the performer's pose—the composition was worked out subsequently.

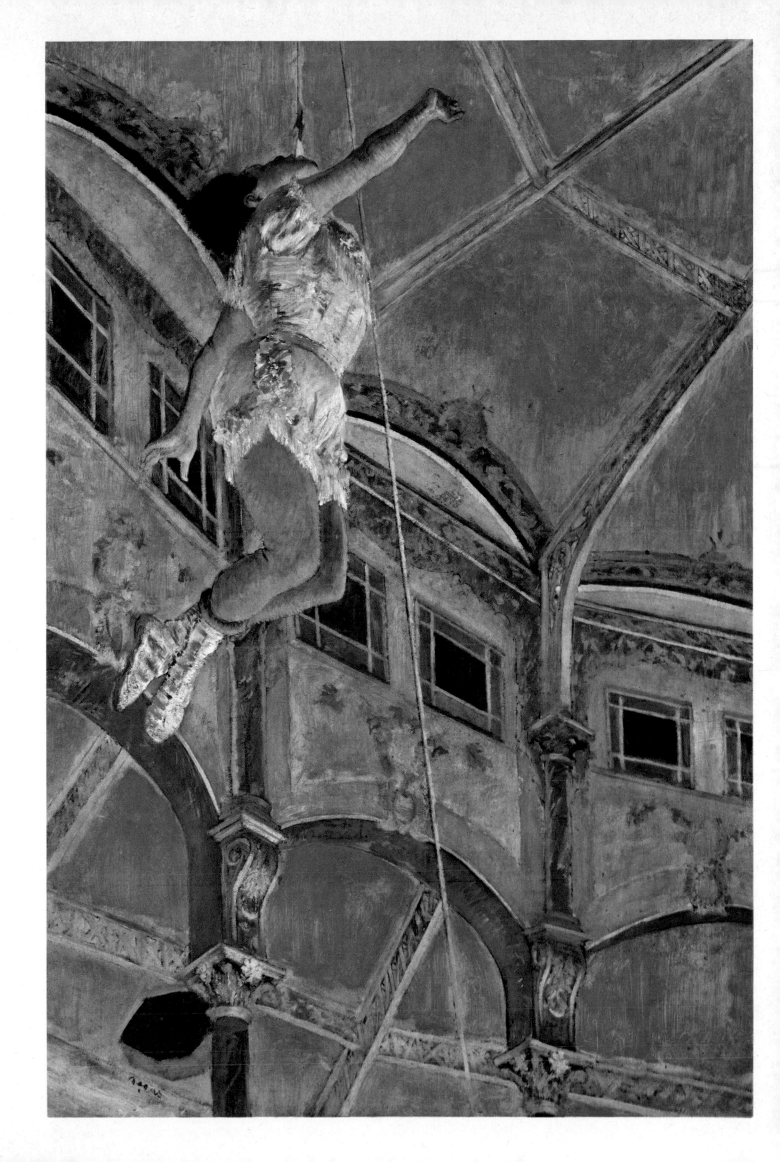

PLATE 91

Auguste Renoir

The Rowers' Lunch
1879–80
Art Institute of Chicago

When this picture was painted, Renoir had just achieved his first great success with his portrait of Mme Charpentier and her children in the Salon of 1879 and something of his triumph may perhaps be seen reflected in this work of the summer when he was at Chatou. There is a pronounced feeling of pleasurable relaxation after strenuous effort. Apart from this possible link with Renoir's own circumstances, however, the picture has a dual character. An Impressionist technique is combined with an interest in human life that makes the work into a genre study. Throughout, there is the absence of outline that the rendering of light made strictly logical. The glasses, bottle and compotier on the table are given shape with dazzling skill simply by the highlights. The figures are likewise defined by the way the light falls; no sharp contour appears anywhere. The sunny glimpse through the trellis of rowing boat and racing four on the Seine recalls the style of the pictures Renoir and Monet had painted at Argenteuil.

At the same time the artist does not conceal his interest in the gestures and expressions of contentment. Humanity contests for attention with the abstract values of light and colour. If Monet had been painting the same scene he would probably have painted only the river view in a similar way. Yet at this date he would not have undertaken such a group of figures as forms the main theme, precisely because of an abstract leaning that Renoir did not share. Renoir's *Rowers' Lunch* points the difference between them in outlook.

236

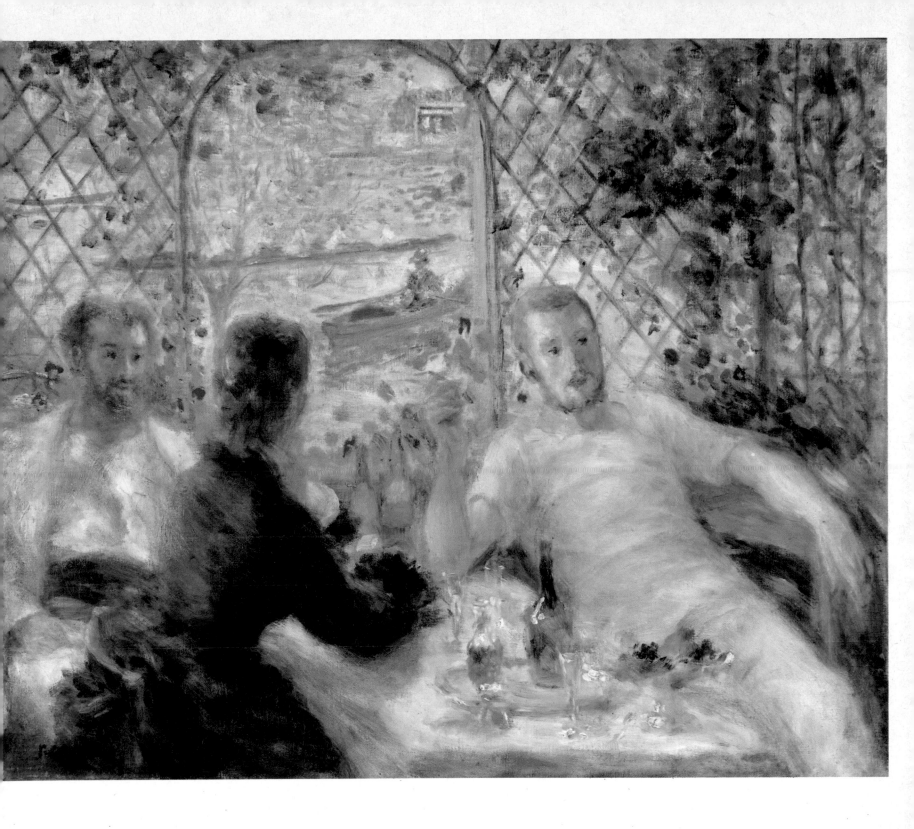

PLATE 92

Auguste Renoir

La Place Pigalle
c. 1880
Collection Lord Butler

This painting is a kind of open-air complement to Renoir's *La Première Sortie*. In a similar way he brings a foreground figure into immediate focus, giving only a blurred impression of the figures and traffic behind. He seems also for once to take a suggestion from Degas's mode of composition—the way in which the figure is cut off at the edge and side of the canvas recalling the means of suggesting unstudied movement that Degas derived from photographs. The feathery brushstrokes also play their part in conveying the transient aspect of figures in a street. Yet Renoir would not have taken kindly to the idea that Impressionism was a cast-iron system by which his art was to be appraised. Ambroise Vollard has quoted his comment on a book entitled *Les Règles de l'Impressionnisme*, a critical symposium— 'Always', he said, 'this passion for imposing on us an immutable collection of formulas and rules. To satisfy it we should all have to have the same palette and come to socialism in art!' In this particular work, with the various features that may be categorized as Impressionist, there is also Renoir the individual with his own idea, expressed in the foreground figure, of what feminine charm should be and the declared intention of painting women in the same way that he would paint a beautiful fruit.

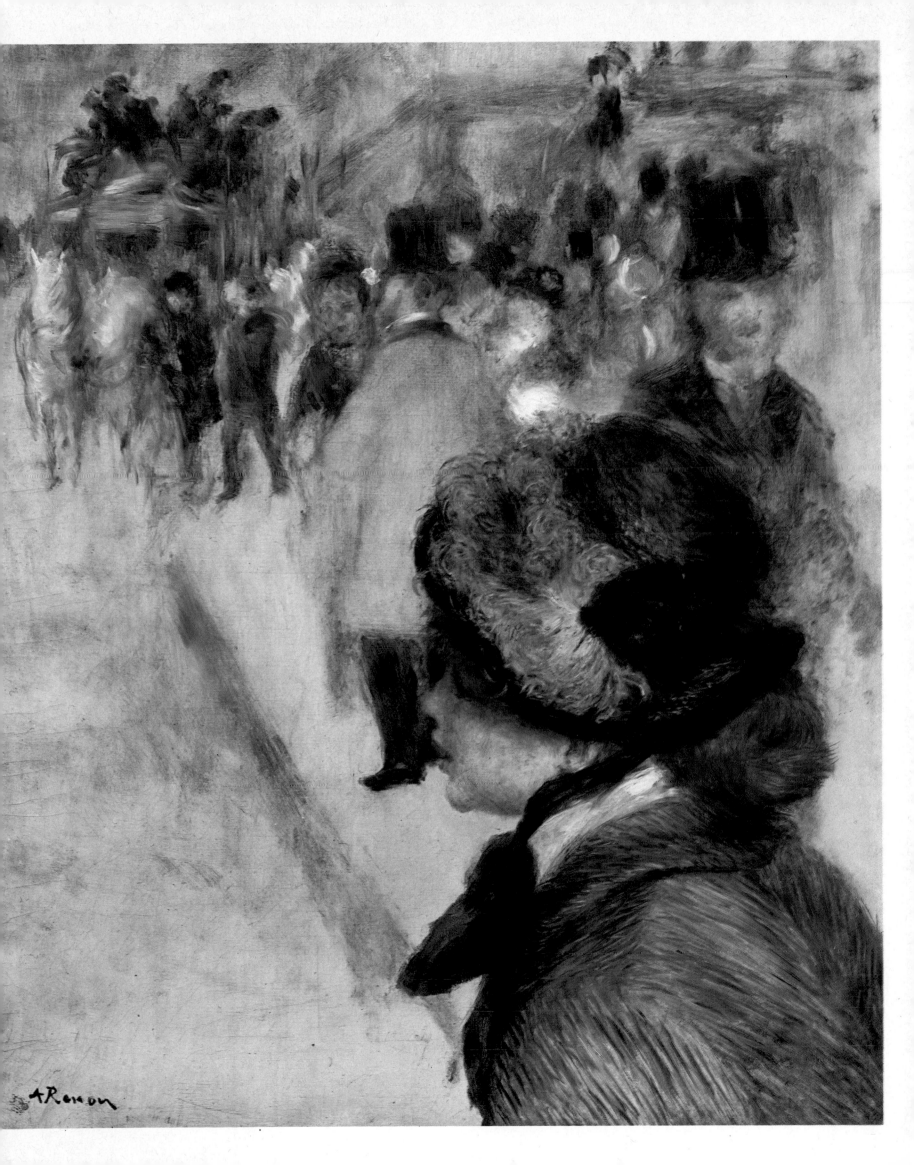

PLATE 93

Edouard Manet

Young Girl on the Threshold of the Garden at Bellevue
1880
Private Collection

It was Manet's decidedly Impressionist ambition, towards the end of his life, to paint open-air pictures in such a way that 'the features of the characters would melt into the vibrations of the atmosphere'. In 1880 his poor state of health caused him to spend the summer at Bellevue, on the outskirts of Paris, where he rented a house and while undergoing hydropathic treatment he contrived to paint several pictures according to his *plein-air* intention, in the garden of the house. They included one view of the garden without figures, a painting of Madame Auguste Manet seen in profile and the work reproduced here, all giving a sunlight effect.

The brilliant result in the picture of the girl reading is obtained by a development of Manet's personal style of oil sketching in which he concerned himself with the general opposition of light and dark areas to the exclusion of half-tones. This was not exactly Impressionism as Monet came to understand it though Monet had passed through a phase in which he adopted Manet's technique (*pl. 87*). But if Impressionism strictly meant the translation of light into colour irrespective of light and shade, Manet was still working to a more traditional recipe. What he meant by features melting 'into the vibrations of the atmosphere' would seem equivalent to creating an envelope of surrounding light but the figure of the girl reading is more of a silhouette against the sunny background than a form sharing the same source of light. The picture, however, has the verve that was Manet's individual gift.

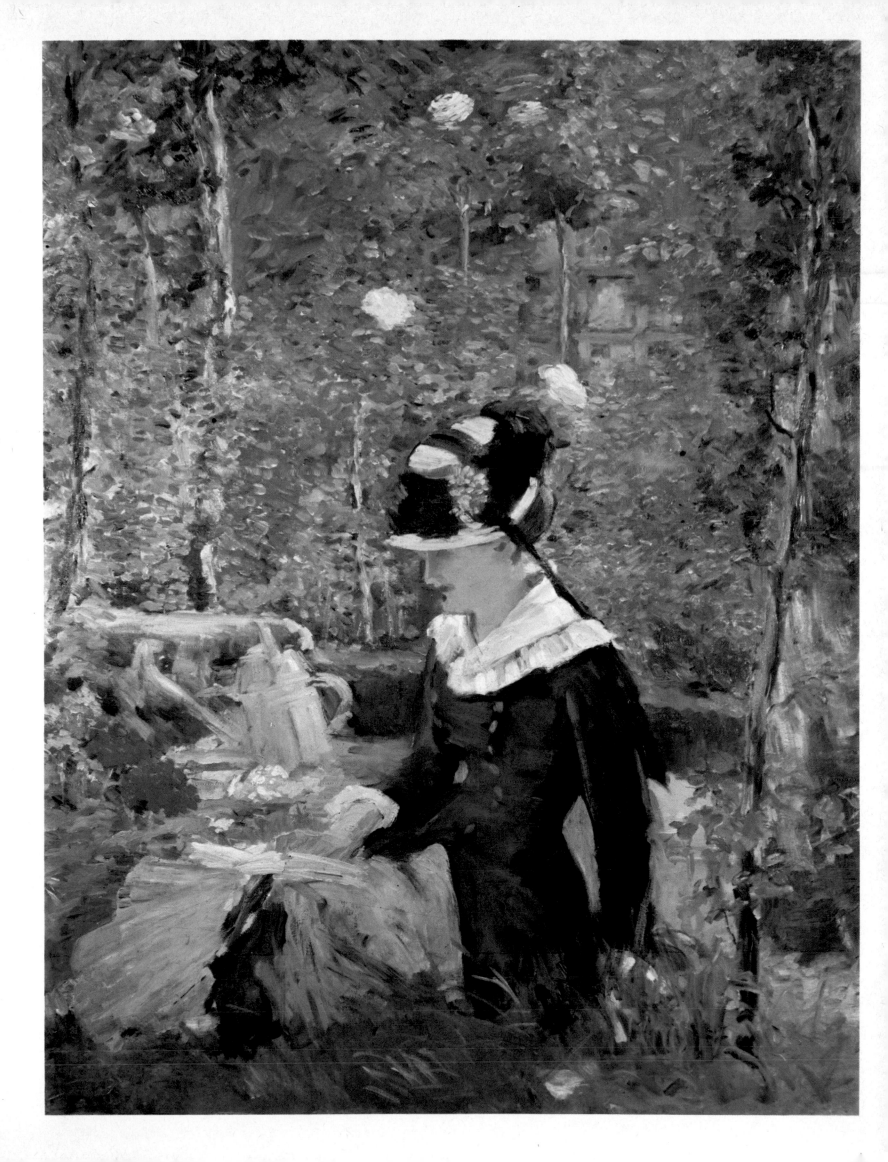

PLATE 94

Auguste Renoir

Luncheon of the Boating Party

1881

Phillips Memorial Gallery, Washington, D.C.

According to Renoir himself it was towards 1883 that there came a break in his work and he felt that he had reached the end of Impressionism, but a change of style is already discernible in this large painting of 1881. His earlier picture of *canotiers* at lunch (*pl. 91*) arrived at a balance between Impressionist technique and subject interest; here style is subordinate to genre, or is altered to suit its purposes. There is definite outline where formerly there was the surrounding ambience of light. The memory of the aristocratic *fête champêtre* that gave a lingering fragrance to earlier open-air groups has not entirely vanished but a sharper impression of slightly vulgar jollity tends to dispel it. In the wealth of detail and incident something of the unity that is so admirable a feature of Impressionism in general is lost. But there is also much to admire: the fascinating glimpse of the river; the still-life with its richness of fruit and wine; the varied poses and expressions of the party. Such a large work was of necessity painted in the studio but Renoir was already coming to the conclusion, contrary to his earlier practice, that painting direct from nature had many drawbacks compared with studio work—that it made composition impossible and soon fell into monotony. The work of Monet and Pissarro might disprove this assertion as a generality but it served to give Renoir a fresh individual impetus.

242

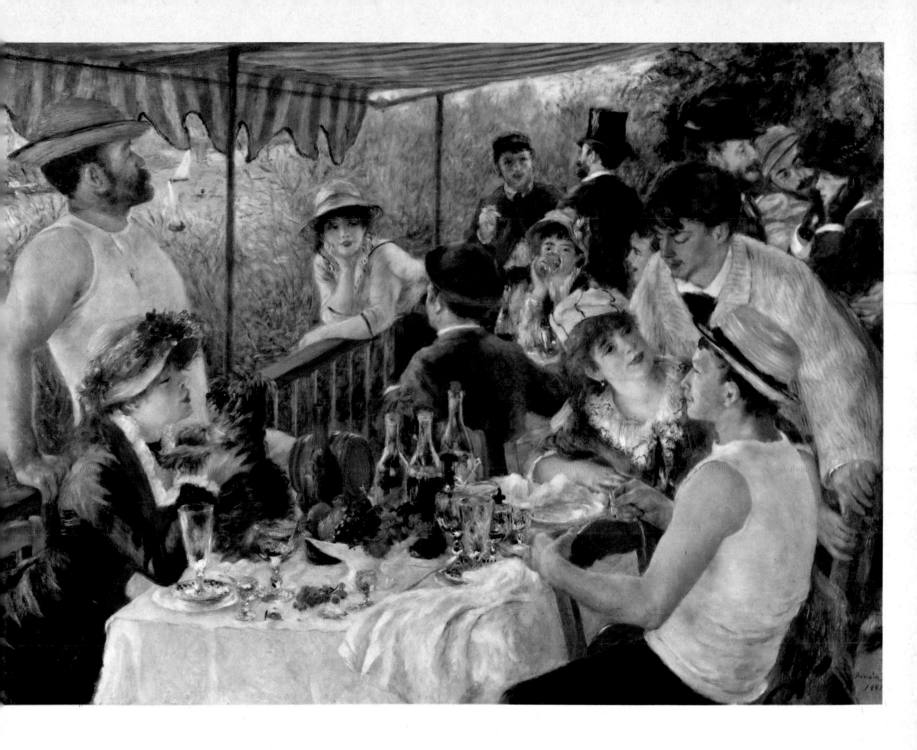

PLATE 95

Edgar Degas

The Millinery Shop

c. 1882

Art Institute of Chicago

Degas's habit of painting several versions of the same subject makes it possible to distinguish various series as clearly as those of Monet, though they were not necessarily painted consecutively at any one time. There are the racehorses, the ballet dancers, the nudes observed in poses that did not 'presuppose an audience' and finally the studies of women at their everyday work. These last included a number of pictures of milliners and their clients, and the painting reproduced here was probably among those exhibited by Degas in the eighth and last Impressionist exhibition (though the word 'Impressionist' was in fact omitted from the title). A far more controversial contribution to the exhibition was his series of ten pastels described as 'Series of nudes; of women bathing, washing, drying, rubbing down, combing their hair or having it combed', but the milliner series was also very original in design. The manner in which he has painted the variety of hats on the show-stands reflects an Impressionist or Realist acceptance of any object as material that a true artist could turn into an interesting design.

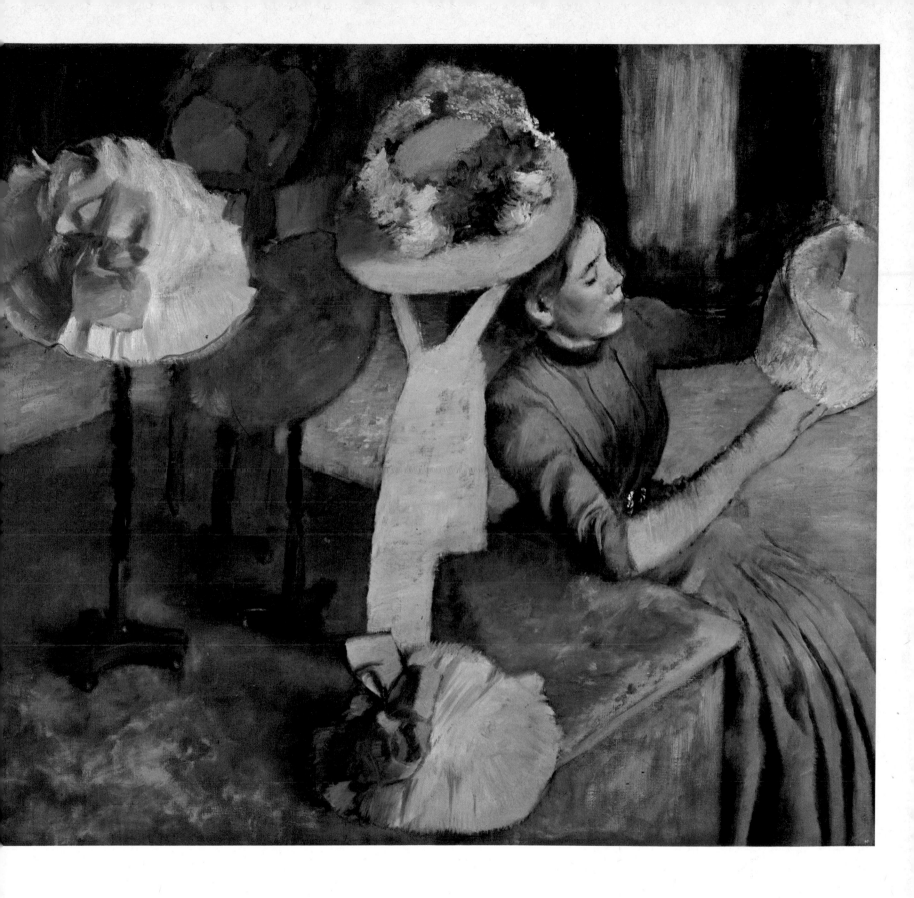

PLATE 96

Camille Pissarro

The Little Country Maid
1882
Tate Gallery, London

Whatever his subject Pissarro was very consistent in his Impressionist manner of dividing colour to give the vibration of light and the distribution of broken touches of rich substance throughout this picture provides an harmonious scheme for a work of perhaps lesser interest as an example of domestic genre. In 1882 Pissarro was extending his range of themes after long confining his efforts mainly to landscape. The little servant girl of the title is at work in a room in Pissarro's house at Osny, near Pontoise, where he worked with Gauguin. The child at the table (painted rather more vividly than the maid) is presumed to have been Pissarro's fourth son, Ludovic Rodolphe, who was to become known as a painter under the name of Ludovic-Rodo. Somewhat surprisingly, this gentle canvas was exhibited in London in 1913 in the Post-Impressionist and Futurist exhibition at the Doré Galleries but in its gentleness there is something of the disquiet of the artist, ever travelling rather than arriving, and also that humility of devotion to his art in which the most fastidious of Pissarro's artist contemporaries respected a quality of greatness.

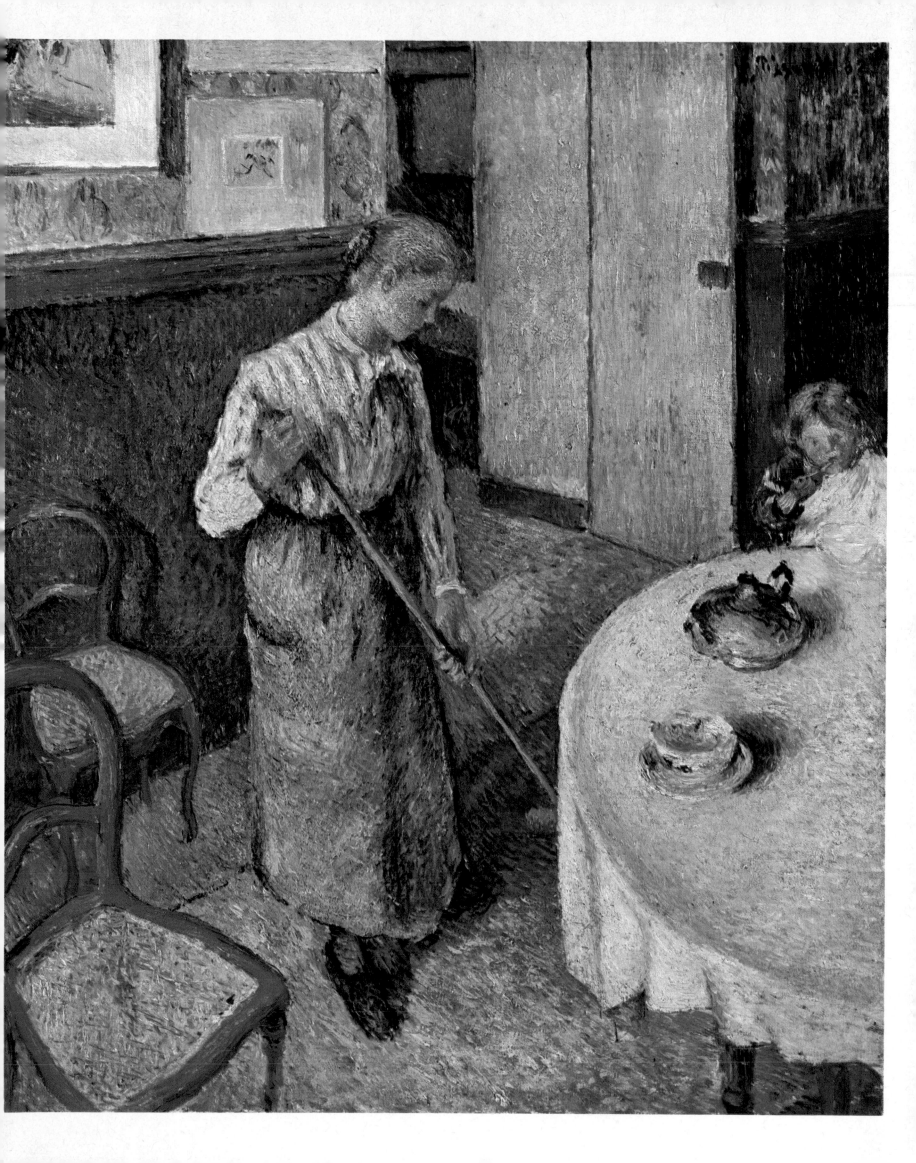

PLATE 97

Camille Pissarro

The Pork Butcher
1883
Tate Gallery, London

In the 1880s, when he was living at Osny, Pissarro made a number of drawings of market scenes at Pontoise and Gisors, providing material for several oil paintings of which this is an example. It is of interest as an effort to use a methodical division of colour in the rendering of a scene of contemporary life, though Pissarro in this instance may seem to have placed rather too much reliance on colour for the desired effect. It was subsequently left to Seurat to discover the secret of employing the technique with complete success. First it was desirable to leave free space unencumbered with detail so as to counter the busy effect of numerous small particles of colour. Secondly, some system of design appropriate to the character of the subject needed to be worked out also. In his preoccupation with divisionism, Pissarro misses something of market savour and character, although the colour is agreeable in itself. The Tate Gallery Catalogue of Foreign Paintings remarks on changes in the composition revealed by X-ray photographs. Pissarro repainted the figure on the right (formerly in profile and turned to the left) and also used a younger model than at first for the head of the foreground central figure, perhaps his niece Nini (Mlle Eugénie Estruc). Like *The Little Country Maid*, the picture was bequeathed to the National Gallery, London, by Lucien Pissarro and transferred to the Tate Gallery in 1950.

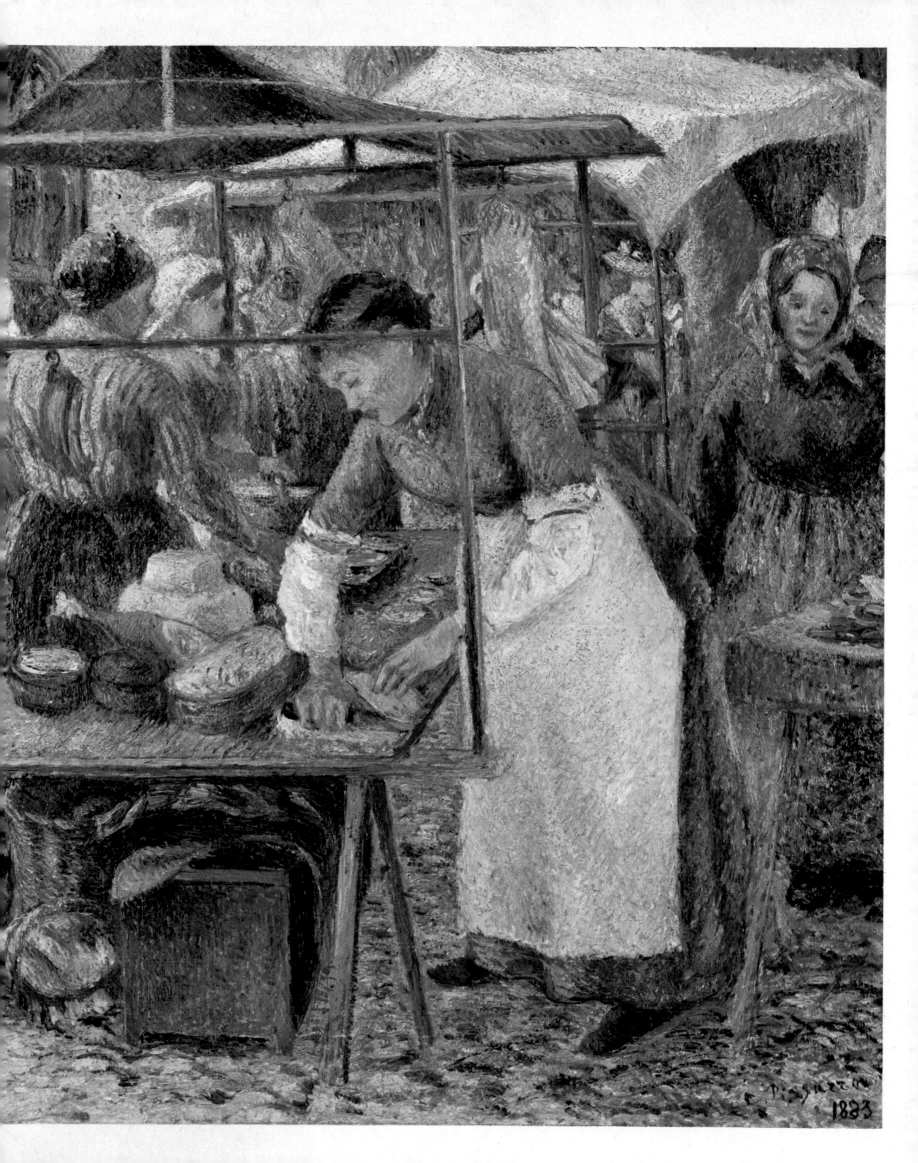

PLATE 98

Georges Seurat

Bathing at Asnières (Une Baignade, Asnières)
1883–84
National Gallery, London

Painted in the same year as Pissarro's *The Pork Butcher*, Seurat's first large picture shows in contrast the monumental sense of form which complemented the method (still in process of development) of dividing colour. This was a move away from Impressionism though there is an Impressionist atmosphere in the landscape background with the river distance, the Courbevoie bridge and the smoking factory chimneys of the industrial Paris suburb of Asnières. In Impressionist fashion also he made a number of small oil sketches from which the final composition was derived. The sketches have the character that belongs to work carried out on the spot.

Asnières was to Seurat and his friend Signac what Argenteuil had been to Monet and Renoir. The Seine and its boats offered a like attraction; the bridge at Courbevoie and the island of the Grande Jatte, seen across the river from the bathing-place on the right, were also to furnish material for magnificent pictures *(pls. 40, 63)*. *Une Baignade* is a whole collection of Seurat motifs—and a truly remarkable work for a young man of twenty-four. The kinship with Piero della Francesca that has often been remarked is distinct in the ordered rhythm of design and the firmly simplified contours. The feeling of repose is heightened by the lateral directions of figures, stylized shadows and river bank.

The picture was exhibited at the first Salon des Indépendants in 1884 and in 1886 was one of the 'Works in Oil and Pastel by the Impressionists of Paris' exhibited by Durand-Ruel at the National Academy of Design in New York. Too original to find immediate favour either in Paris or New York, it received harsh criticism. The critic in an American paper who described *Une Baignade* as the product of 'a vulgar, coarse and commonplace mind' seems with every epithet to present the exact opposite opinion to that with which the work is regarded now.

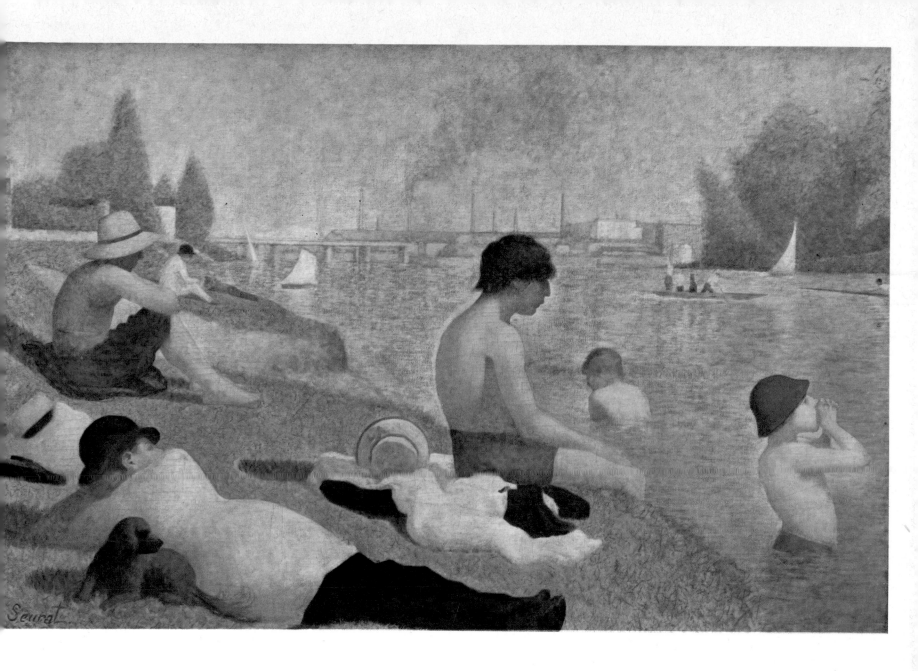

PLATE 99

Edgar Degas

Woman in her Bath, Sponging her Leg
1883
Louvre, Paris

Degas himself made the remark that if he had lived in the past he might have painted Susanna; as it was he had to be content with *le tub*. This was one way of saying that the original artist no longer had any incentive to embark on those elaborate subject compositions that sanctioned the presence of the nude figure in some historic or fabled role. It had been the inescapable trend of Realism and Impressionism to abandon subject-matter of this kind. Degas, a devotee of Ingres in his youth, a classicist in the sense that figure drawing was of the utmost importance to him, had soon given up the 'classical' subjects with which he had begun his career as a painter. Yet his superb gifts as a draughtsman were not to be denied expression. He was led by his various studies of movement on the race track and in the ballet to study nudity in natural and unself-conscious phases.

What he aimed at, he said jestingly, was the effect of peeping through the keyhole. This meant that his figure paintings and pastels were so devised that his models appear supremely unaware of any other presence—including that of the artist. This is in marked contrast to Ingres's *La Grande Odalisque*, for example, who turns a wide-eyed glance on the spectator or even Manet's *Olympia*, so obviously conscious of the invisible third party. Degas, of course, was under no necessity to peep through keyholes. The tin tub and other apparatus of the bath were introduced into the studio, but he had the art of concealing art. Even though, as in this example, one may be conscious of the signature of style, the effect of complete absorption in the business of washing is attained with an appearance of perfect ease. A selection of pastels of this kind was one of the scandals of the eighth and last Impressionist exhibition of 1886 but Degas continued after that date to produce wonderfully drawn and unconventionally poised nudes as long as his failing sight would allow.

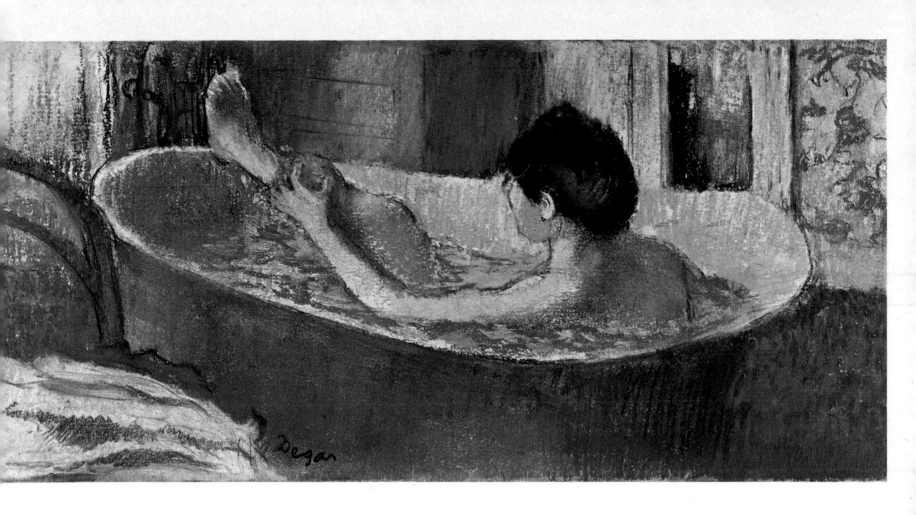

PLATE 100

Edgar Degas

The Laundresses

c. 1884

Louvre, Paris

With consummate skill Degas catches the fleeting moment, although it is certain that a great deal of carefully calculated effort lay behind the seemingly spontaneous result. The gestures are marvellously observed. Never, surely, can a yawn have appeared more natural than that of the left-hand laundress, nor is the pressure exerted on the iron by the other realized any less vividly. The contrast of arms upraised and lowered heightens the effect of each—it is an instance of that subtlety of composition by which Degas could give the illusory impression of a snapshot. The colour, delightful as it is, does not prettify the working women beyond credulity and he has brushed on the crumbling touches of pastel in a way which keeps an edge of roughness by allowing the raw canvas to show through. A picture such as this may prompt a question as to his social attitude—what his view was of the class he portrays— but it would probably be naïve to assume that he was either sympathetic or otherwise, or even especially concerned to inform the spectator that a laundress was feeling tired after a hard spell. It was enough for him that here was the human organism in the reality of what was unpremeditated. At this period, now that Monet had moved to Giverny and Pissarro to Eragny, Degas was pursuing his independent and solitary way in increasing separation from his Impressionist confrères.

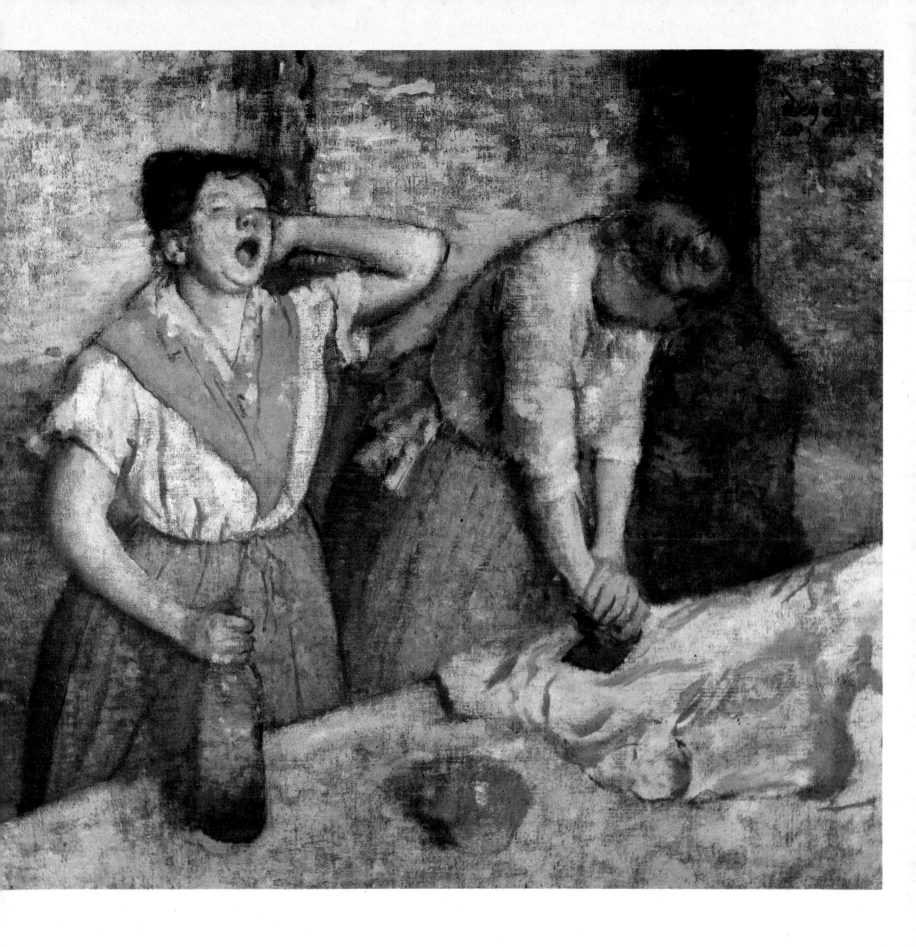

PLATE 101

Paul Cézanne

The Card Players
c. 1885–90
Louvre, Paris

The abstract side of Cézanne's art has always been given due weight. It was amusingly emphasized by Ambroise Vollard who, after sitting many times for his portrait, asked how it was getting on. Cézanne's reply: 'I am not displeased with the shirt-front' seemed to suggest that the human element did not enter into his calculations, that he was simply concerned with planes and gradations of colour. On the other hand, his several self-portraits give a remarkable sense of character and towards 1890 there are other signs of his interest in the aspect of human beings, as for example the five versions of *The Card Players* produced during this period at Aix. The Louvre version, reproduced here, with two players (and a bottle between them to mark the centre of the symmetrically balanced composition) could be looked on in the abstract as a magnificent rendering of solid forms, given their appearance of structure by the gradated areas of the thinly applied colour. But the fact remains that these are not abstractions but peasant card players in his native Provence. Whether by the sheer veracity of his study of facial planes or through some feeling of kinship with the solid countrymen he was portraying, Cézanne has made them live.

A picture of seventeenth-century card players from the studio of the brothers Le Nain in the museum at Aix and its peasant character first suggested the series to Cézanne though single peasant studies also show his interest in the essentially French type and his capacity to convey its essence. These pictures and the strange *Mardi Gras* of the same period (the clown and harlequin like two Romantic ghosts taking on substance and swaggering into a new era, perhaps by their strangeness leaving a deeper impression on French artists afterwards than by technique alone) realize the equation of form and content which Cézanne so often lamented he had not attained.

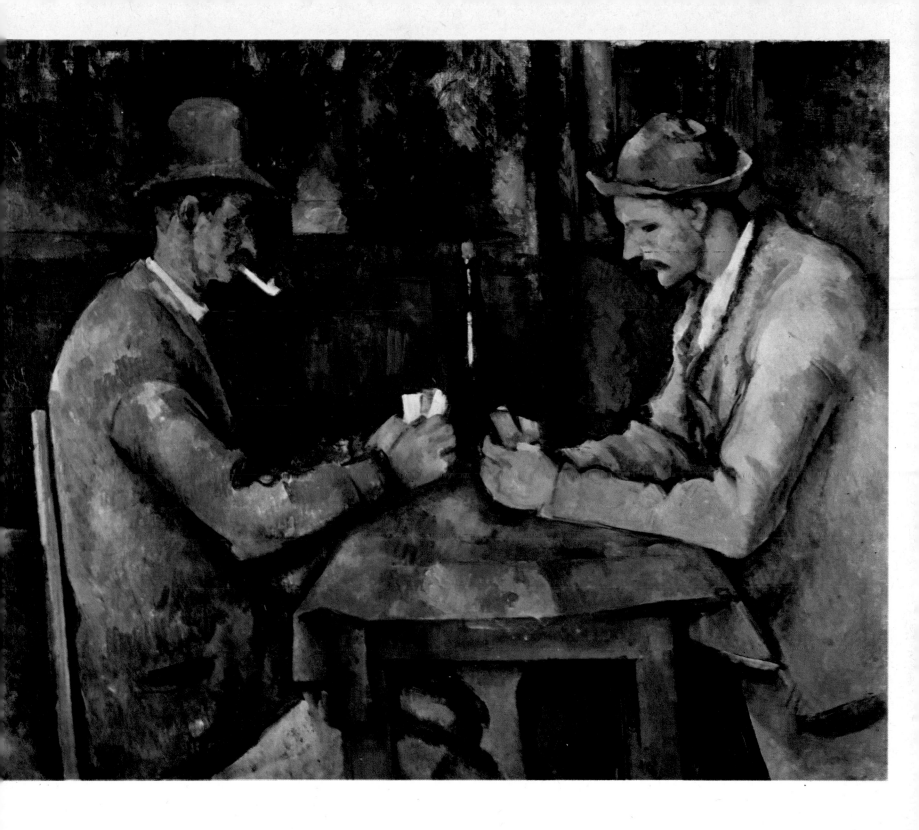

PLATE 102

Paul Gauguin

Jacob Wrestling with an Angel
1888
National Gallery of Scotland, Edinburgh

Gauguin's stay in Brittany and his acquaintance with the enthusiastic theorist Emile Bernard led him to diverge from the Impressionist course laid out for him by his mentor Pissarro, as is apparent from this remarkable painting. *The Vision after the Sermon* is an alternative title, the devout Breton peasant women thus performing an act of witness. The immediate effect, however, is not to tell a story of religious experience but to intrigue the eye with the brilliant red of the ground and the decorative simplification of peasant headdress and costume. Gauguin estimated that it would assort well with the simple interior of a Breton church though it is said that the curé of Nizon near Pont-Aven thought the artist was in jest when he offered the picture for this purpose.

The flat, simplified treatment shows the influence of the Japanese print but the intensity of colour is an application to visual art of the mystic and symbolic thought that gained currency towards the end of the nineteenth century. The vision is a mystical idea; the bright red is symbolic of conflict. *Jacob and the Angel* was one of the paintings that caused the critic Albert Aurier to acclaim him in the *Mercure de France* as a leader in symbolist art.

During his stay at Martinique in the previous year Gauguin was still Impressionist in style but the change observable in Brittany was deplored by Camille Pissarro as running counter to the aesthetic good sense and rationality of the Impressionist movement in general. Pissarro had two grounds of complaint. One was that Gauguin had made an unreal synthesis out of his borrowings from the Japanese and from Byzantine painting. (What he meant by 'Byzantine' remains a little vague—Giotto and Puvis de Chavannes were main influences on Gauguin's efforts to simplify.) But more crucial to Pissarro was the thought involved. Just when painting, in his view, had been cleansed of its romantic follies and irrelevances, they now reappeared in another form. Gauguin, said Pissarro, was in error in departing from 'our philosophy of today, which is an out-and-out social philosophy and an anti-authoritarian and anti-mystical philosophy'. Such a view is illuminating as to the point art had then reached in France and the various roads that opened, but from an impartial modern standpoint Gauguin's *Jacob and the Angel* may be adjudged a masterpiece.

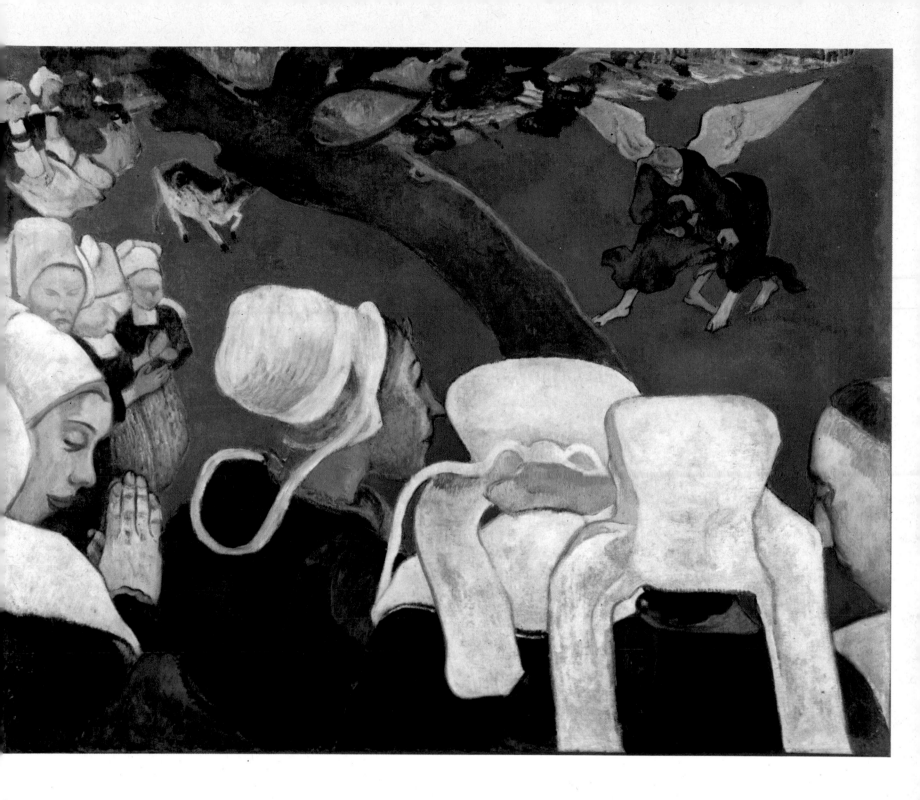

PLATE 103

Henri de Toulouse-Lautrec

At the Moulin Rouge
1892
Art Institute of Chicago

The two main formative influences on the art of Toulouse-Lautrec—the ideas and methods stemming from the Japanese print and the paintings of Degas—can be discerned both in his lithographic posters and colour prints and the paintings of his matured style. The Japanese use of flat colour and silhouette was more directly assimilated in his brilliant graphic art; his admiration for Degas is reflected in the painting reproduced here, one of the numerous works by which he made the Moulin Rouge renowned. This gay rendezvous, rebuilt on the site of an old dance-hall in the Boulevard de Clichy and opened in 1889 as a music-hall, had immediately caught his attention. Lautrec painted *La Danse au Moulin Rouge* in 1890 and his poster for the place in 1891 marked the beginning both of its fame and of his own. He frequented it nightly for some time and painted striking interior scenes, of which this is a later example.

Lautrec made effective use of Degas's characteristic devices of composition as in the long perspective of the balcony rail, serving as a foil to the diverse interest of the seated group, and the way in which the foreground figure is half in and half outside the picture area. Degas might not have employed so unrealistic a method of indicating light coming from below as the blue on forehead and nose of this figure but it contributes to the impression of artificial gaiety and pervasiveness of artificial light. The performers appear more often in Lautrec's lithographs than in his paintings (though the dancer, La Goulue, can be seen in the background adjusting her coiffure) but he gave the other habitués the close, slightly sardonic but not malicious scrutiny that is demonstrated here. Lautrec himself is seen in the rear with his tall cousin Gabriel Tapié de Celeyran. His characters are wittily individualized in a way that makes him distinct from Degas and removed also from the objective study of light and colour that counted for so much in Impressionism and deprecated the intrusion of psychology and narrative. Yet the night-life of Montmartre has its place in the movement as well as the villages of Normandy, and Toulouse-Lautrec may be said to give a brilliant epilogue to masterpieces by Manet and Degas in similar milieus. Maurice Joyant quoted as praise a remark made by Degas when Lautrec exhibited at Joyant's gallery in 1893: 'Well, Lautrec, it's clear you're one of us', though Degas's sarcasm on other occasions suggested some resentment at the borrowings from his style.

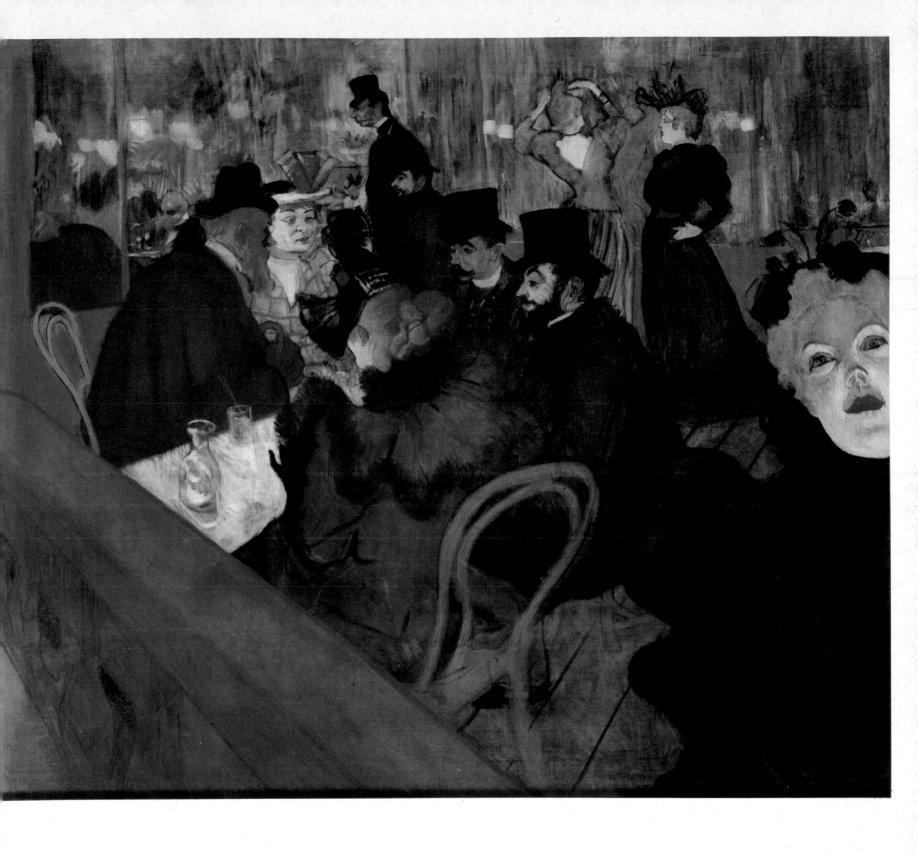

PLATE 104

Philip Wilson Steer

Girls Running, Walberswick Pier
1894
Tate Gallery, London

The painting of Wilson Steer has two surprisingly different aspects; in the work of his youth, so clearly in the vein of French Impressionism and Neo-Impressionism; and in what he later produced in England on his return to the tradition of Constable and Turner. Although he studied art in Paris between 1882 and 1884 there is scant documentation of this period of his career and it is passed over as comparatively unimportant by his biographer, D. S. MacColl. Yet the indications are that he was spurred on for a time by the developments of colour in France to paint works so vibrant with aesthetic life as this and other pictures of Walberswick in Suffolk. He first stayed at Walberswick, where he had friends, in 1884 on his return from Paris and visited there again on several occasions during the same decade. Although this example is inscribed 'Steer 94', it seems that it was first painted (from memory and not on the spot) in 1888 and that Steer dated it at a later time when he added some repainting. When he began the canvas he was twenty-eight.

D. S. MacColl reluctantly admitted the influence of Seurat on Steer 'by way of Pissarro' in one work, *A Procession of Yachts*, 1892–3, now in the Tate Gallery, following this with a diatribe on the 'heresy' of divisionism. Yet *Girls Running, Walberswick Pier* is certainly and even exhilaratingly divisionist in its dots of colour. Nor is the reminiscence of Seurat confined to this. The sharp definition of the shadows (correctly violet in the mellow light) and the distinct shapes of jetty and beach show that he had comprehended the value of a structural complement to the colour scheme. There may be a slight failure of design in the fact that the two girls are so nearly identical in their running pose; on the other hand, there is a freshness of atmosphere and a zest in the painting as a whole to which these running figures contribute. Roger Fry first rightly appraised this early period as including some of Steer's finest creations and spoke of them as possessing 'a peculiar intensity of conviction and singleness of aim that Steer (later) never quite recaptured.'

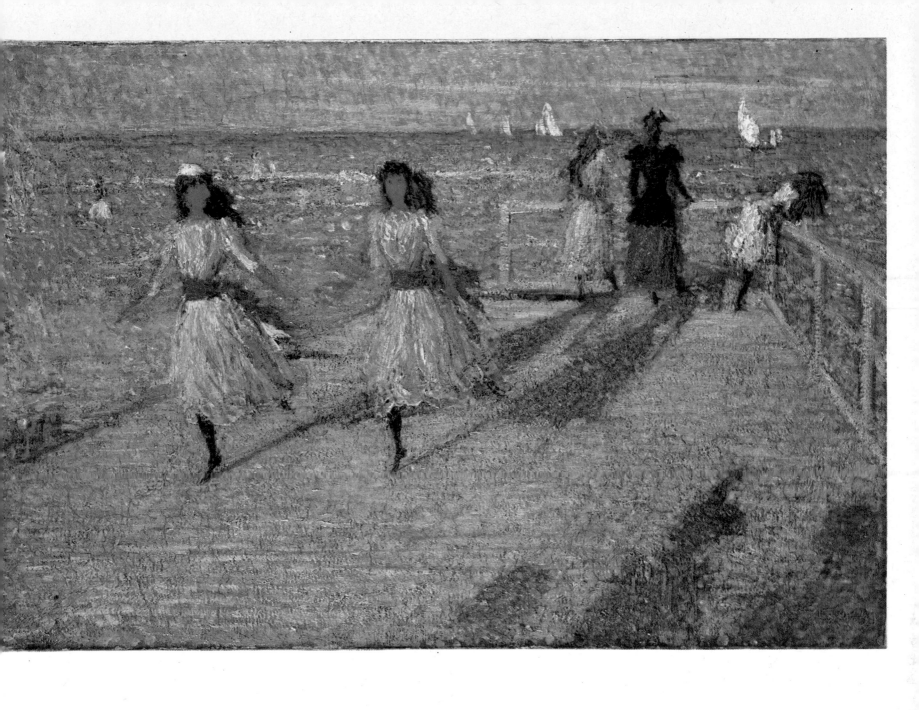

PLATE 105

Paul Gauguin

Nevermore

1897

Courtauld Institute Galleries, University of London

Long before he painted this picture Gauguin set out an abstract aim, namely that he used 'as pretext some subject borrowed from human life or nature' to obtain by arrangements of lines and colours, 'symphonies and harmonies that represent nothing real in the vulgar sense of the word; they express no idea directly but they should make you think as music does without the aid of ideas or images simply by the mysterious relationships existing between our brains and such arrangements of colours and lines'. Something of this was no doubt in his mind when he painted this picture though it is a work of a complex nature. It was inspired by Manet's *Olympia*, of which Gauguin was so great an admirer as to make a copy and to have a reproduction hung up in his hut while he was painting *Nevermore*. The title, he explained in a letter to his friend de Monfried, was not the refrain of Poe's *The Raven* (although Mallarmé had read this poem in his French translation at the farewell banquet to Gauguin in 1891). On the contrary, it was 'the bird of the devil that is keeping watch'.

The connection he had had with the mystical and symbolic trends of thought in Paris made it impossible for him to resist a symbolic reference to native superstition (or what he chose to represent as such). Thus the background suggests the fear laden thoughts of the girl cowering on the couch, making the painting rather more than a simple nude. He told de Monfried, however, that he 'wanted to suggest by means of a simple nude a certain long-lost barbarian luxury. The whole is drowned in colours which are deliberately sombre and sad; it is neither silk, nor velvet, nor *batiste*, nor gold that creates luxury here but simply matter which has been enriched by the hand of an artist.'

The companion picture in the Courtauld Institute Galleries, *Te Rerioa*, painted three weeks after *Nevermore*, also combined the real and the imaginary and was intended by him to be dream-like. Gauguin chose the title as the native word meaning 'dream' without reckoning with the fact that for Polynesians it signified 'nightmare'. From Impressionism Gauguin had come to an opposed extreme in these works, yet both are to be numbered among his best.

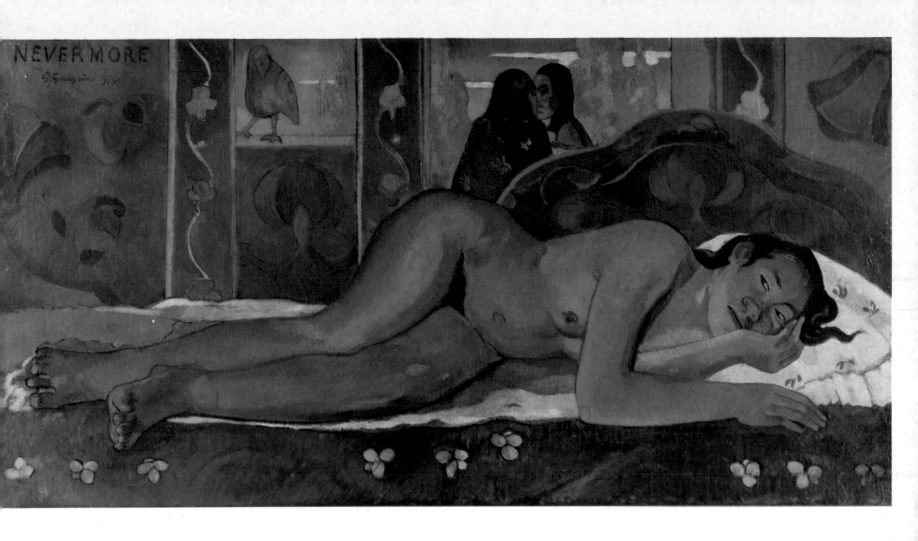

PLATE 106

Paul Gauguin

The White Horse
1898
Louvre, Paris

Although Gauguin was settled in Tahiti when he painted this superb picture, it does not primarily suggest a local connection but rather a final outcome of the sense of newly tapped powers in colour and new sensations to be derived from it that had been the preoccupation of a whole half-century. The seed of Impressionism, it might be said, expanded here into a marvellous exotic bloom. The colour, however, is no longer descriptive or atmospheric but makes an impact on the senses akin to that of music. The white horse itself suggests some creature of heroic fable, yet while it shares this appearance of belonging to an imaginary world with the riders in the background, the picture had its basis in Polynesian reality. The inhabitants used horses as a means of transport in the absence of roads and bridges. Bengt Danielsson, the anthropologist and historian, in his book *Gauguin in the South Seas*, makes this remark with special reference to the Marquesas where 'everyone still rides a horse from the bishop down to the smallest native boy'. Gauguin did not move to the Marquesas until 1901 but as this picture shows the native horsemanship had already caught his attention.

266

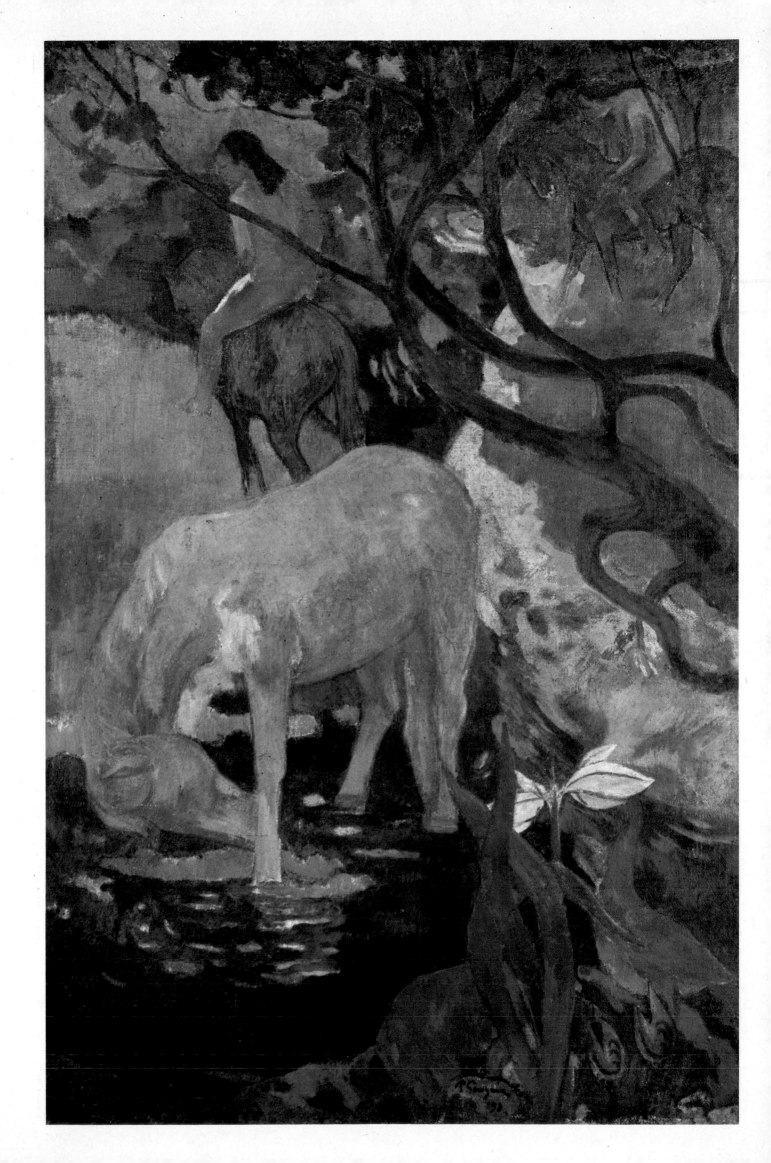

PLATE 107

Pierre Bonnard

Dining Room in the Country
1913
Minneapolis Institute of Arts

The work of Pierre Bonnard is a delightful epilogue to the Impressionist movement, containing much of the purity of colour sensation that had been sought throughout, though he was guided by no rigidly formulated theory. Here is one of the paintings in which he managed to combine the intimacy of the interior with the suggestion of open air, colour being subtly adapted to this purpose by reason of its quality as colour and not as a scientifically designed technique. The year before the picture was painted he had bought a small house at Vernonnet, near Vernon, close to the home of Claude Monet at Giverny. He knew and undoubtedly had a great respect for the Impressionist master though he cannot be regarded simply as an Impressionist follower, but as one who added to a sympathetically objective vision a personal originality.

When Bonnard painted the *Dining Room in the Country* he was forty-six and had passed through several phases of development. No one had assimilated the aesthetic message of the Japanese print with more understanding, results being the exquisite colour prints of the 1890s and decorative works in which the style of Japan and *art nouveau* are fused. Association with the Nabi group heightened his awareness of colour. He and his friend Vuillard showed the quality which earned them the title of *Intimistes* in homely domestic interiors and Bonnard applied the same intimacy to the many glimpses he painted of outdoor Montmartre.

Impressionism seems later to have renewed itself in his attitude to colour so affectionately expressed in the work reproduced here, where differences of tone are slight and the values of a middle range sing out. From this time onwards Bonnard spent long periods in the south, at Grasse, St Tropez and Le Cannet, with an increase of warmth and luminosity in his colour which, like Monet's late water-lilies, gained the esteem of a younger generation.

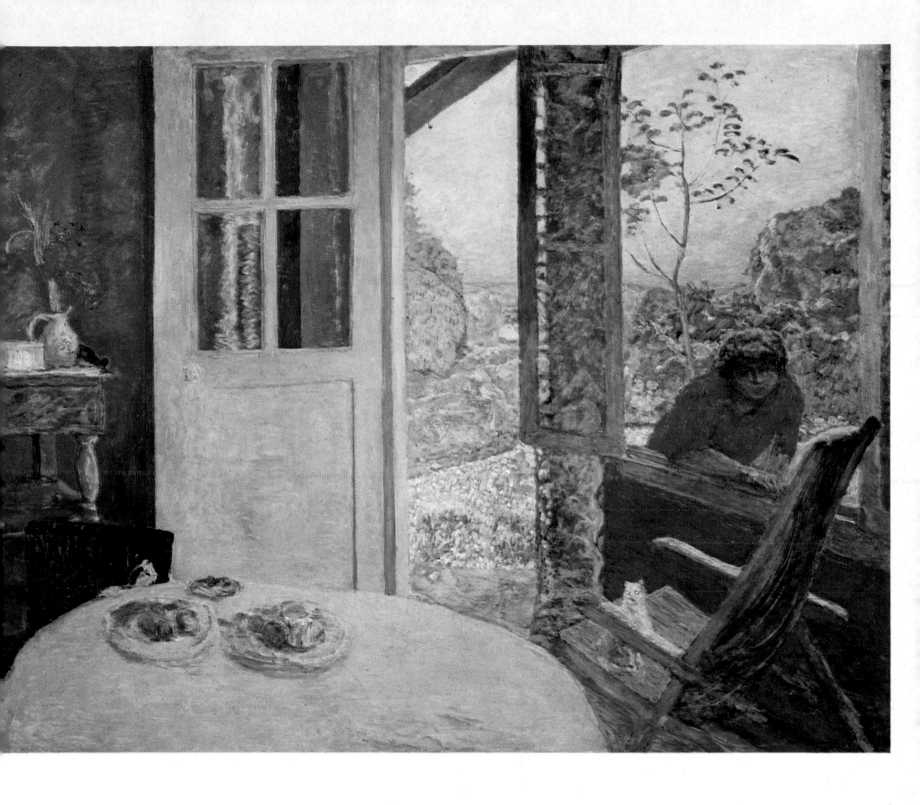

PLATE 108

Pierre Bonnard

Nude in the Bath
1937
Musée du Petit Palais, Paris

Like Monet and Degas, Bonnard painted a series of works with the same subject and some points of similarity with both the older artists may be found in his many paintings of the nude figure in the interior. The informal poses that Degas derived from *le tub* became Bonnard's theme though a number of differences from Degas's aims appear. The latter was interested in the various aspects of physical movement in the 'human animal'. The description might apply to some of Bonnard's early studies of the nude unconventionally viewed. In 1912 he painted a naked woman oddly crouched in the most awkward and antique of shallow tin tubs. Later his approach altered.

A distinction perhaps should still be observed between 'naked' as a term defining the body simply in the state of nature and 'nude' as indicating idealization or improvement on the merely animal. It is in this sense that Bonnard's mature series departs from his own work of 1912 or any special resemblance to the aims of Degas. In the 1930s, the period of which the work reproduced here is typical, Bonnard was more concerned with reverie than unusual posture. Contemplative and narcissistic, even at times wraith-like, the figures standing or reclining full-length in the bath, were 'nude' rather than 'naked'. They mostly represented Marthe Bonnard, his wife, who lived what seems to have been a somewhat morbidly reclusive life in the villa at Le Cannet near Cannes which Bonnard bought in 1925.

The old-fashioned tubs that had so often been represented by Degas were replaced in the 'thirties by baths which, if not the last word in design, allowed of a person's stretching out in them. Bonnard became so little concerned with movement that with variations of colour and décor he depicted this static pose again and again. It is here that a likeness to Monet may be encountered. Gently floating at water surface, the figure of Marthe (or Marthe etherealized) brings to mind the water plants to which Monet devoted the efforts of his last years. As he found infinite riches of colour in his water-garden so here did Bonnard in the shimmer of a limb, the colour of ripples, the golden mosaic of sunlight. Realism is transformed into poetry.

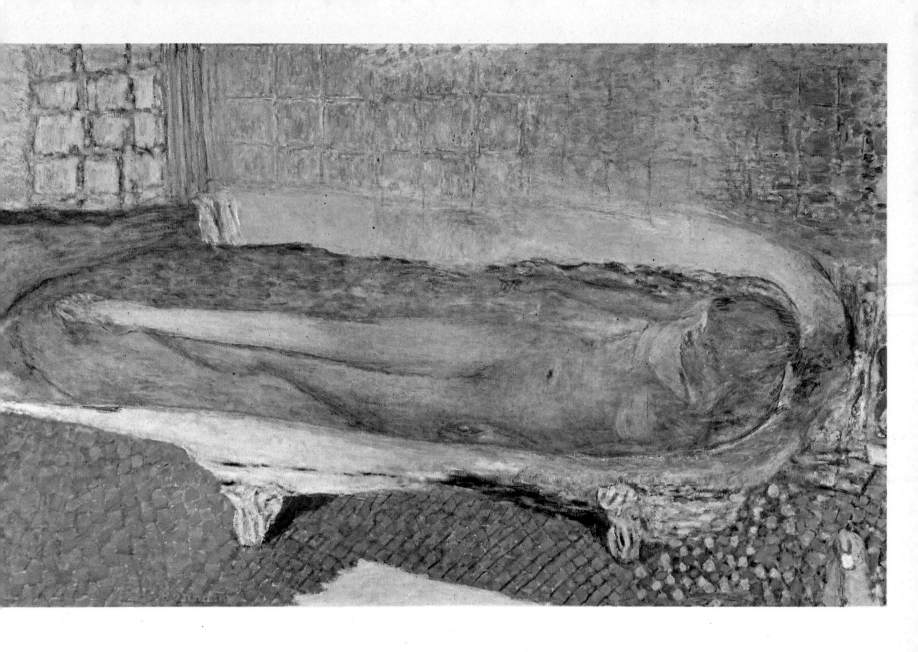

BIOGRAPHIES

Bazille, Jean-Frédéric

Born at Montpellier, December 6 1841 Bazille came of a well-to-do bourgeois family who intended that he should follow a medical career. After studying medicine for three years at Montpellier he went to Paris in 1862, planning to combine art and medical studies. In 1864 he failed an examination for a medical degree and his friendship with fellow-students at the atelier of Charles Gleyre—Monet, Sisley and Renoir—confirmed him in the ambition to become a painter. Like his friends he was influenced by Courbet and Manet, especially by Manet's preference for flat modelling and avoidance of semitones. In 1865 he posed for Monet in his *Le Déjeuner sur l'Herbe* and also appears in Fantin-Latour's *The Studio at the Batignolles*, 1870. He was one of the avant-garde group that met at the Café Guerbois and being in receipt of a small allowance from Montpellier was of great help to his friends, either in allowing them to share his studio in time of need or in buying works from them. In 1867 he bought Monet's *Women in the Garden* for 2,500 francs, payable in monthly instalments.

He enlisted in the Zouaves when the Franco-Prussian war broke out in 1870 and was killed in action on November 28 of that year at Beaune-la-Rolande. His friends always remembered him with personal affection and as one who would have achieved eminence in Impressionist painting. Although not entirely free from the stamp of academic training, he had already shown pioneer promise in the study of light and *plein-air* painting. The Louvre and the Montpellier museum have main examples of his work.

Bonnard, Pierre

Born at Fontenay-aux-Roses, October 13 1867, Bonnard first studied law at his father's insistence but was attracted to the artist's life and went to study art in 1888 at the Ecole des Beaux-Arts. Shortly after he changed to the Académie Julian where he met Maurice Denis, Paul Sérusier, Paul Ranson and Edouard Vuillard (who was to be his life-long friend). He and Vuillard were drawn with the others into the group known as the Nabis (signifying 'prophets' or 'divinely inspired' in Hebrew), much influenced by Gauguin. At that time, by his own account, Bonnard had not discovered Impressionism but Gauguin was too 'classical' for him and somewhat later he found Impressionism a liberating force. In 1889 he sold a champagne poster (in the style of Chéret) and this decided him on his career. In the 1890s and 1900s his work was divided between painting and decorative and graphic design, the latter arriving at the meeting-point between the influence of the Japanese print and *art nouveau*. He contributed lithographs to *La Revue Blanche* and illustrations to Vollard's fine editions (*Parallèlement*, 1900; *Daphnis et Chloé*, 1902). His early paintings included many views of Paris, intimately observed, but after 1912, when he bought a villa near Vernon and close to Claude Monet at Giverny, his range of theme widened and his colour became richer. In 1925 he bought a house in the south at Le Cannet near Cannes and in that year married Maria Boursin of whom he painted many reflective nude studies. Mme Bonnard died in 1940 and a will he devised subsequently caused legal complications which long withheld many

works from view or distribution. He died at Le Cannet, January 23 1947.

The large exhibitions of his work at the Orangerie, Paris in 1947 and the Royal Academy, London in 1966 showed that his painting could be regarded as a splendid final outcome of Impressionism.

Boudin, Eugène-Louis

Born at Honfleur, July 12 1824, the son of a ship's captain whose ferry-boat plied between Honfleur and Le Havre, Boudin was brought up in the marine atmosphere of Le Havre. For some years he worked in a shop selling stationery and artists' materials where he is supposed to have been first encouraged in painting by visiting members of the Barbizon School—Millet especially. A municipal grant enabled him to study in Paris, 1851–53. Years of struggle followed though he worked determinedly in the open air, modelling his style on that of Corot, and was highly praised for his paintings of sky and sea by Baudelaire (Salon of 1859). He has a place of importance in Impressionist history in having persuaded Monet in 1858 to take to landscape and *plein-air* painting. Both profited from subsequent acquaintance at Le Havre with Jongkind. Boudin contributed to the first Impressionist exhibition in 1874 and to the Salons, attaining success by degrees but was in an assured position after 1880. In 1889 he gained the gold medal at the Exposition Universelle. He died at Deauville, August 8 1898. He travelled and painted in Belgium and Holland and at Bordeaux and in later life wintered on the Côte d'Azur and at Venice but it was in his native Normandy and round the mouth of the Seine that he produced his most characteristic works, already advancing towards Impressionism in their freshness of atmosphere and directness of execution. The museums of Honfleur and Le Havre as well as the Louvre have many examples.

Cassatt, Mary

Born at Pittsburgh in 1845, Mary Cassatt was the daughter of a Pennsylvania banker. Her father was descended from French immigrants in the seventeenth century and the family was francophile in sentiment. Part of her childhood was spent in Paris with her mother. She first studied art at the Pennsylvania Academy and was for a brief space in Chaplin's atelier but her education in art was mainly gained by travel about Europe and study of the Old Masters before she became associated with the Impressionists. She began to exhibit at the Salon in 1872 and her *Jeune Fille aux Cheveux Roux* in the Salon of 1874 caught the attention of Degas who gave her advice and also painted her several times. On his recommendation she gave up the official Salons to join in the Impressionist exhibitions to which she contributed in 1879, 1880, 1881 and 1886. A loyal partisan, she did much to further interest in Impressionism in the United States. She herself bought a number of pictures by members of the group and persuaded other wealthy Americans to do the same. Drawing was her strong point and her favourite theme was that of mother and child. Her sight began to fail in 1912. She died at Château Beaufresne, Beauvais, June 19 1926.

Cézanne, Paul

Born at Aix-en-Provence, January 19 1839, Cézanne was the son of a provincial man of business, a one time hatter who had become a successful banker. Paul was educated at the Collège Bourbon at Aix, where Zola became his friend, and was intended for the law but his father reluctantly ceded to his wish to be a painter and in 1861 he went to Paris to study. He failed in the entrance examination of the Ecole des Beaux-Arts but gained some experience at the Académie Suisse where he met Camille Pissarro and Armand Guillaumin. His early Romantically violent canvases were regularly refused at the Salon and his

work was included in the Salon des Refusés of 1863. He joined occasionally in the sessions at the Café Guerbois in defence of Manet and for the propagation of budding Impressionist ideas but was never entirely happy in the capital. Until the death of his father in 1886 when he settled down at Aix for good, he oscillated uneasily between north and south. During the war in 1870 he worked at l'Estaque but the period 1872–74 was spent at Pontoise and Auvers with Pissarro whose advice was of great advantage in directing Cézanne to landscape, the study of nature and the development of a flexible technique. Pissarro's support gained his inclusion in the first Impressionist exhibition in 1874 and he again exhibited with the group in 1877 but for years after he worked in isolation in Provence at Aix, Gardanne or l'Estaque, unknown except to a small circle of artists and unusually discerning collectors. Recognition came at last in the Salon d'Automne and Salon des Indépendants of 1904 and 1905. Working to the end, he died at Aix, October 22 1906.

The retrospective exhibition of 1907 firmly established his importance and extended his influence. On Impressionism as represented by Monet and Pissarro he had no effect, but he is inseparable from the movement in having drawn out its potential. In landscape, still-life and figure painting he not only 'made of Impressionism something solid and durable like the art of the museums' but began the inquiries that led on the one hand to the colour of the Fauves and on the other to Cubist research into structure.

Constable, John

Born at East Bergholt, Suffolk on June 11 1776, the great English landscape painter figures in Impressionist history as a forerunner in *plein-air* painting and as a pioneer in the use of broken colour to express the action of light. His influence on French landscape, as a result of the exhibition of *The Haywain* at the Salon of 1824 (when he was awarded the gold medal), is undoubted; less definite is the influence his paintings had on Monet and Pissarro when they visited London during the Franco-Prussian war, though an affinity in outlook and technical approach is clear. Constable died at Hampstead, April 1 1837.

Corot, Jean-Baptiste Camille

Born in Paris, July 16 1796, Corot was not only a great landscape artist in his own right but exercised a beneficent influence on French nineteenth-century painting generally, and directly on younger artists so much linked with Impressionism as Boudin, Pissarro, Sisley and Berthe Morisot. The sight of the Constables at the Salon of 1824 may well have encouraged the freshness and directness of the pictures which resulted from his first visit to Rome in 1825, though Corot was by no means a simple artist and his work has a variety of aspects; landscapes painted outdoors from nature in France, Italy and elsewhere; the *Souvenirs*, imaginative compositions with a misty charm; Salon works with religious, mythological or literary themes and figure paintings of unexpected power. His silvery tones of grey do not come within the Impressionist canon but in other ways his work was prefatory to that of the Impressionists, whose first group exhibition was held the year before he died in Paris—on February 22 1875.

Courbet, Gustave

Born at Ornans, June 10 1819, Courbet came of a farming family but had a classical education and studied law in Paris before the sight of Old Master paintings in the Louvre made him decide to become a painter. His interest in socialism which attracted such realist writers as Daudet and Zola contributed to the Realism with which he aroused a storm of controversy in the 1850s. The refusal of his picture of a peasant burial at Ornans and his *The Studio* (paradoxically called a 'real allegory')

by the jury of the Exposition Universelle in 1855 was one of the century's great art crises in France, causing him to hold a defiant one-man exhibition (repeated in 1867).

The 1860s were a period of triumph when he had a great influence on such young artists as Monet and Renoir. A meeting-point was the Normandy coast in 1865 when Courbet and his young friend Whistler, Daubigny and Monet were painting at Trouville at the same time. In general he paved the way for Impressionism by upholding 'the representation of real and existing things' as opposed to the decaying ideals and historical falsities of subject of Classicism and Romanticism.

He was pronounced responsible for the destruction of the Vendôme column in 1871 and sentenced to six months imprisonment. He suffered still further for his part in the Commune when the case was reopened in 1873: his goods were confiscated and he fled to Switzerland, dying in exile at La-Tour-de-Peilz, December 31 1877.

Daubigny, Charles-François

Born in Paris, February 15 1817, Daubigny was the pupil of his father, also a landscape painter, and later of Delaroche. After a period of hack-work he turned to landscape and worked in the spirit of the Barbizon painters adding, however, to their study of nature the practice of completing quite large pictures in the open air. His favourite subjects were quiet stretches of the Seine and Oise and he attained success with contributions of this kind to the Salons of the 1850s though he painted in Holland, Spain and England as well as northern France. He visited England in 1866 and again during the wartime period of 1870–71 when he was helpful to Monet and Pissarro—stranded in temporary exile in London. He was a consistent supporter of the Impressionist group and in several ways near to them in his own work, investing simple rural and river scenes with interest of atmosphere and mode of execution. He had a boat

specially constructed (which he called his *botin*) in which to paint on the rivers and in this Monet followed his example. He died in Paris, February 19 1878.

Degas, Hilaire Germain Edgar

Born in Paris, June 19 1834, Degas came of a wealthy banking family. He entered the Ecole des Beaux-Arts in 1855 and was introduced to Ingrès who imbued him with a sense of the supreme importance of drawing. Between 1855 and 1858 he travelled frequently in Italy studying the early Renaissance masters. The vogue of Japanese prints in France gave him new ideas of composition in the 1860s and the prevailing spirit of realism among painters of original mind caused him to abandon the 'history' painting he began with and turn, like Manet whom he met in 1865, to scenes of contemporary life and portraiture. Race course scenes were followed in the 1870s by paintings of theatre and ballet. Degas was one of the frequenters of the Café Guerbois where Manet's adherents foregathered and thus came to know members of the Impressionist group. Durand-Ruel in 1870 exhibited his works in London with those of Monet, Pissarro and Sisley and from 1874 he was one of the most regular exhibitors in the Impressionist exhibitions in Paris, missing only one of the series (that of 1882). After the last, however, in 1886 he tended to lose touch with the other members of the group, and to become a recluse. In these later years he concentrated on the study of women in pastels and drawings representing the various incidents of the toilet and the postures of getting into and out of *le tub*. Failing sight caused him to turn to sculpture as a final resort, his models of dancers and racehorses rivalling Rodin in mastery of form and feeling for movement. Degas stands somewhat apart among the Impressionists and had no direct following in France though Walter Sickert in England translated his impressions of places of entertainment in terms of the music-hall. He

never recovered from being forced to leave his house in the rue Victor Massé in 1912 and in his last years was both sad and almost blind. He died on September 27 1917.

Fantin-Latour, Ignace Henri Jean Théodore

Born at Grenoble, January 14 1836, Fantin-Latour was the pupil of his father, Jean Théodore and of the exponent and teacher of memory drawing, Lecoq de Boisbaudran. He worked in Courbet's studio in 1862 and was the friend and defender of Manet. He was often to be found in company with Manet's Impressionist supporters at the Café Guerbois and along with Manet found inclusion in the Salon des Refusés of 1863. With his capacity for admiration, however, he did not care to attach himself to a school or movement and there is nothing of the Impressionist in his work, which has three distinct aspects: there is the valuable documentation of his group portraits, the *Hommage à Delacroix*, 1864—including likenesses of Manet, Whistler, Baudelaire and the critic Duranty—and *The Studio at the Batignolles*, 1870 —in which Manet appears with Renoir, Bazille and Monet. He is probably best known by the flower paintings for which he found appreciative buyers in England. Another category is that of the interpretations of music in paintings and lithographs that occupied him in his later years. He died at Buré, August 25 1904.

Gauguin, Paul

Born in Paris, June 8 1848, Gauguin, the son of a journalist and a mother of Spanish-Peruvian origin, was taken to Peru when three and after the death of his father and his mother's return to France entered the merchant marine. He left the service in 1871, went into a stockbroker's office where he did well and married a Danish girl of decorous middle-class background in 1873. Twelve years later, aged thirty-seven he left wife, five children and comfortable living forever to devote himself to painting. The dramatic nature of the circumstances tends to obscure what happened before the break and the extent to which his painting had its basis in Impressionism. He began to draw and paint in his free time soon after his marriage. The collection of Impressionist paintings he had formed by 1876 provided him with examples for study. A year or two later he was painting with Pissarro at Pontoise and in 1880 was invited by Pissarro to contribute to the fifth Impressionist exhibition, exhibiting also in 1881, 1882 and 1886. Impressionism was thus his definite point of departure though various factors tended to complicate and intensify the key of his later work.

His stay at Pont-Aven and Pouldu in Brittany in the 1880s and his contact with such eager theorists as Emile Bernard, Paul Sérusier and Maurice Denis established him as the central figure of a movement towards symbolic and synthetic (i.e. non-realistic) art. His stay at Arles with Van Gogh in 1888, apart from its disastrous quarrel, heightened his sense of colour. His paintings of Tahiti, 1891–93 and from 1895 when he returned permanently to the South Seas, first at Tahiti and then in the Marquesas, attain in colour and design that next step beyond Impressionism that Cézanne also sought. Gauguin died at Atuana, Marquesas Islands on May 8 1903.

Jongkind, Johan-Barthold

Born at Lathrop near Rotterdam on June 3 1819, Jongkind was first a pupil of a Dutch landscape painter, Schelfort, but went to Paris in 1846 where he was befriended by Eugène Isabey. Isabey introduced him to picture buyers and took Jongkind with him to Normandy and the Channel coast but after a time the alcoholism and erractic behaviour of his Dutch protégé proved too much for him. Jongkind went back to Holland and, it would seem, his dissipated courses but in 1860 the painter Cals at the instance of a group of painter-admirers of Jongkind brought him to Paris again

where the dealer Martin introduced him to Mme Fesser, a Dutch teacher of drawing. She took him in hand and brought about an apparent rehabilitation at the time when he met Boudin and Monet at Le Havre in 1862. His work, in watercolours as well as oils, made a great impression on both of them by the sensation of atmosphere his broken and sensitive touches of colour created. Both acknowledged the value of his example and Monet regarded him as his 'true master' to whom he owed 'the education of his eye'.

With the aid of Mme Fesser's salutary discipline Jongkind had success with pictures painted in Normandy, the Dauphiné (from 1873) and even in Provence and Switzerland but in spite of her ministrations he was not cured of alcoholism or a distressing form of persecution mania. In 1878 he was installed in the Fesser household at the village of Cité-Saint-André between Lyon and Grenoble but it became necessary to remove him to the asylum of Grenoble where he died on February 19 1891. He is one of those with a claim to being 'the first Impressionist'.

Manet, Edouard

Born in Paris, January 23 1832, the son of a magistrate, Manet belonged to a family of high standing in Parisian society. After a trial voyage as a boy in a training ship for naval cadets which took him to South America, he entered the studio of Thomas Couture and remained there for some years, supplementing Couture's academic training by study in the Louvre and the galleries of Italy, Germany and Holland. He did not visit Spain until 1865 but his early work was strongly influenced by the Spanish masters, Velasquez, Murillo and Zurbaran, the influence of Goya coming later.

The first picture he sent to the Salon, *The Absinthe Drinker*, was refused (the first of a long series of sensational rejections) in 1859. The *Portrait of the Artist's Parents* and *The Spanish Guitar Player*, however, were traditional enough to be accepted in 1861 and given honourable mention. Baudelaire

wrote a laudatory article in 1862 and commemorated Manet's portrait of the Spanish dancer Lola de Valence (1861) in verse. But the realism that was in the air and given forthright definition by Courbet now brought Manet into violent collision with critics, public and the official juries. In succession *La Musique aux Tuileries*, 1862, *Le Déjeuner sur l'Herbe*, 1863 and the *Olympia* of 1865 aroused furious controversy. The principal hero and martyr of the Salon des Refusés in 1863, Manet became the idol of the group of younger generation artists that formed round him at the Café Guerbois. This was the seeding-ground of Impressionism. Although Manet never exhibited with the Impressionists, there followed periods of fruitful interaction, especially after the Franco-Prussian war (in which Manet was staff-officer in the National Guard.) Claude Monet was impressed by Manet's vividness of style and contrasting areas of flat clear colour. Manet was brought by his example and the persuasion of Berthe Morisot, his pupil, to paint in the open air. A period of outdoor painting was spent with Monet at Argenteuil in 1874, although Manet reverted later to pictures of the cabaret and its frequenters, e.g. *La Serveuse de Bocks*, 1879 and *Un Bar aux Folies-Bergère*, 1881–82. Garden pictures in which he sought for Impressionist effect of light were works of his last years, 1880–82. He died in Paris, April 30 1883.

Millet, Jean-François

Born at Gruchy near Cherbourg, October 4 1814, of a peasant family, Millet was one of the first French artists of the nineteenth century to portray the life of the rural poor and it is in this aspect that he has a distant relationship with Impressionism, though none in style or colour. The link is closest with Pissarro who had admired Millet since 1859 when Pissarro's first Salon landscape hung in the same exhibition as Millet's *Woman Taking her Cow to Pasture*. Pissarro's shepherdesses and other

country folk are part of a more realistic pastoral scene than Millet's and in saying 'It is I who am Hebrew and Millet who is biblical' he seems to have dissociated himself from the older artist's romanticism. Van Gogh's admiration for Millet likewise appears in original works and the free copies of his last years. Millet died at Barbizon, January 20 1875.

Monet, Claude-Oscar

Born in Paris, November 14 1840, Monet was the elder son of a grocer. His father moved his business to Le Havre in 1845 and Claude Monet spent a happy childhood there. As a boy he gained local repute in caricature but meeting Eugène Boudin in 1858 turned him to landscape and open-air painting. In 1859 he went to the Académie Suisse where he met Pissarro. He did military service in Algeria, 1860–61 and was discharged in 1862. In that summer he painted with Boudin and Jongkind, who greatly influenced his outlook, and in the autumn entered Gleyre's studio, where he met Renoir, Sisley and Bazille. He painted with them in the forest of Fontainebleau and until 1870 was engaged in the development of style and outlook to which the realism of Courbet and the direct method of Manet both contributed. Works of especial note were his *Déjeuner sur l'Herbe*, 1865 *La Terrasse à Sainte-Adresse* and *Women in the Garden*, 1866, paintings of *La Grenouillère*, 1869, plage scenes at Trouville, 1870.

A sojourn in London during the 1870 war was followed by a return to France via Holland and Belgium and his six years stay at Argenteuil. Manet and Renoir worked with him and Impressionism could be termed fully-fledged in their paintings of the Seine—Monet working from a floating studio. He painted at Vétheuil, 1878–83 and in 1890 bought a house at Giverny where he constructed his famous water-garden. At intervals meanwhile he had worked again on the Channel coast, producing beautiful paintings at Etretat.

With the beginning of prosperity he travelled also to the Mediterranean.

Works in series with the same subject were frequent in his later years (Gare Saint-Lazare, 1876; Poplars and Haystacks, 1890; The Cathedrals (Rouen), 1892; Thames at London, 1899–1903). His last great work was the series of the Water-lilies on which he was busy from 1904. They included the large decorative panels commissioned by Clemenceau for the State. Monet was much hampered by the failure of his sight but an operation for cataract in 1923 enabled him to put the finishing touches on the works preserved in the Musée de l'Orangerie.

Although he did not contribute to three of the eight Impressionist exhibitions through various disagreements, Monet in the extent, nature and consistency of his art was essentially the driving-force of Impressionism. He died at Giverny on December 5 1926, aged 86.

Morisot, Berthe

Born at Bourges, January 14 1841, Berthe Morisot was one of the three daughters of the then Prefect of Bourges. The family moved to Paris in 1852 and Berthe and her sisters had drawing lessons from, to her, somewhat disappointing masters. Her independence of mind declared itself in her decision to paint outdoors under the guidance of Corot. Engaged thus from 1860 to 1866, she profited greatly from Corot's teaching and advice. Not long after, she came to know Manet who admired her *View of Paris from the Trocadéro* in the Salon of 1867. In the following year he painted her in *Le Balcon*. She acquired from Manet the free and direct style that always distinguished her painting; in return she was able to interest him in the idea of open-air painting which led her to side with the Impressionists. She exhibited nine works at the first Impressionist exhibition in 1874. In the same year she married Eugène, Edouard Manet's younger brother. She exhibited at all but one of

the subsequent Impressionist exhibitions, the exception being in 1879 when her daughter Julie was born. Paintings of Julie at various stages of growth form a main motif in her delightful art which, in this respect so naturally feminine, never lost from view the Impressionist aim of filling a picture with light. From 1890 some trace of Renoir's influence might be seen in her work but still more in evidence is an increased firmness of drawing which was personal in effect. She died in Paris, March 2 1895.

Pissarro, Camille

Born on the Island of St Thomas in the Antilles, July 10 1830, Pissarro was the son of a French-Jewish storekeeper there and a Creole mother. He was sent to school in France, 1842–47, but came back to work in the store, drawing in his spare time. After leaving home to paint in Caracas with a Dutch artist, Fritz Melbye, he was enabled to go to Paris to study in 1855 with a small allowance. At the Académie Suisse he met Monet in 1859 and Guillaumin and Cézanne a little later and also had personal encouragement from Corot. Corot and Courbet influenced his early work but he was closest in sympathy among his younger contemporaries to Monet. He was among the Refusés of 1863 but exhibited regularly at the Salon, 1864–70 (except in 1867). In 1869 he moved to Louveciennes where the development of his Impressionist mode of painting was well under way at the time of the German invasion in 1870. Most of his output to that date was destroyed, only some 40 canvases being retrieved from about 1500. After working in London until June 1871 he returned to France and devoted himself to rural scenes at Pontoise. In all the eight Impressionist exhibitions from 1874 to 1886 he was the constant supporter of the movement. He settled at Eragny in 1884. Between 1884 and 1889 he was attracted to the systematic colour division of Seurat as the logical extension of Impressionist method. This,

however, did not work out satisfactorily in practice and he returned to his earlier style. In his later years he produced many beautiful views of Paris and Rouen. His patience in teaching and the wisdom of his advice was gratefully acknowledged by Cézanne and Gauguin whom he set on the way that led to their great individual development. Pissarro died in Paris, November 12 1903.

Renoir, Pierre Auguste

Born in Limoges, February 25 1841, Renoir was one of the five sons of a poor tailor. The family moved to Paris when he was still a child. He was first employed at a porcelain factory in ornamenting the wares with painted designs. He saved enough money by painting blinds and other hackwork to pay for tuition to become a professional picture painter and entered the atelier of Gleyre in 1862. There he made friends with Monet, Sisley and Bazille, often sharing the latter's studio in his impecunious Bohemian days. He exhibited at the Salon in 1864 and 1865 but the influence of Courbet became an element in his work that displeased the selection committees and in spite of the support of Corot and Daubigny he was rejected in 1866 and 1867. In 1869 he was working at Bougival with Monet—both painting versions of the bathing-place, La Grenouillère—in which the Impressionist style and outlook took shape. For some years after the Franco-Prussian war (during which he served in the cuirassiers) and especially at Argenteuil, he again worked with Monet in the fully-developed Impressionist manner. He contributed to the Impressionist exhibitions in 1874, 1876, 1877 and 1882. Success came when his portrait of Madame Charpentier and her children was exhibited at the Salon of 1879. In 1881 he visited Algeria and Italy where he was impressed by works of Raphael and by Pompeian frescoes. These experiences, added to a visit to Cézanne at l'Estaque where Cézanne was trying to give Impressionism a more durable form, led him to

develop the harder, linear style of his *Les Grandes Baigneuses* of 1885. Following the onset of arthritis in 1888 he began to spend the colder months in the southern warmth of Cagnes. Settled near Cagnes in his later years he developed his final style flushed with hot colour and more plastic than linear. Many paintings were now a family record: he painted Mme Renoir, their sons Pierre (b. 1885), Jean (b. 1893), and Claude ('Coco', b. 1901) and the servant-of-all-work, Gabrielle. The room devoted to his work at the Salon d'Automne in 1904 was acclaimed a triumph. Suffering increasingly from arthritis, in 1912 he began to paint from a bath chair with a brush attached to his wrist and in his last years produced sculpture carried out by workmen under his close supervision. He died at Cagnes on December 3 1919.

Rousseau, Pierre Etienne Théodore

Born in Paris, April 15 1812, Rousseau was the pupil of his cousin, Pau de St Martin and two other minor landscapists, though he learned more from the example of Corot and Constable and in his later years from Ruisdael and Hobbema. He travelled widely in France but settled in the village of Barbizon in 1834 where he was joined by Dupré, Diaz and Millet. His frequent lack of success at the Salons earned him the name of 'le grand refusé' but in 1849 he gained a first-class medal at the Salon and was commissioned by the State. A conclusive mark of recognition was the important space assigned to his work at the Exposition Universelle of 1855. He is described as having a fiery and difficult temperament darkened also by the mental derangement of his wife. His career also suggests the Romantic sense of grievance, hurt or distaste for city life that made for withdrawal and communion with nature. He was the virtual founder of the Barbizon School and in his feeling for nature a pioneer of Impressionism. He died at Barbizon in 1867.

Sargent, John Singer

Born at Florence, January 12 1856, Sargent was the son of American parents living in Europe, his father being Dr Fitzwilliam Sargent of Boston. He studied art at the Florence Academy and in Paris under Carolus-Duran while a visit to Spain in 1879 introduced him to the art of Velasquez. He lived in Paris until 1885 but the criticism aroused by his portrait of Madame Gautreau caused him to move to London. Established in Chelsea, but travelling often across the Atlantic to portray American celebrities, he was able to give a remarkable picture of Anglo-American society in the course of twenty-five years. After 1910 his favourite pursuit was watercolour landscape in which he showed a certain reflection of the Impressionist concern with light in terms of colour. His main association with Impressionism, however, is in his friendship with Monet and the encouragement he gave to patrons to buy Impressionist paintings. He died in London, April 18 1925.

Seurat, Georges

Born in Paris, December 2 1859, of a family belonging to the 'petite bourgeoisie', Seurat studied for four years at the Ecole des Beaux-Arts in the studio of Lehmann, a pupil of Ingres, showing an early proficiency in figure drawing. The masters he admired were Piero della Francesca, with whom he is often compared in formal design, and Delacroix whose ideas of colour prompted further study of the writings on colour from a scientific viewpoint by M. E. Chevreul, C. Blanc, O. N. Rood and C. Henry. Conté crayon drawings mainly occupied him from 1881 to 1883. His first big painting, *Une Baignade*, rejected at the Salon, was exhibited at the Société des Indépendants which he helped to found in 1884. It was followed two years later by his great *A Sunday Afternoon at the Grande Jatte*, for which he made numerous oil sketches and drawings, exhibited at

the eighth and last Impressionist exhibition in 1886. The method, variously known as Division-ism (term favoured by Seurat), Neo-Impression-ism and Pointillism was controversially debated either as the logical conclusion of Impressionism in its methodical arrangement of spectrum colours or as a break with Impressionism in its abandon-ment of free, open-air execution. Seurat intro-duced the non-Impressionist element of formal design though this is beautifully combined with atmospheric delicacy in a series of small landscapes. The later figure compositions of Seurat's short life show his effort to make linear design as expressive of his theme as colour, examples being *The Powder-Puff*, 1889–90, *Le Chahut*, 1890 and *Le Cirque*. Seurat died suddenly in Paris, March 29 1891.

Sickert, Walter Richard

Born at Munich, May 31 1860, Sickert was the eldest son of the Danish painter Oswald Adalbert Sickert and became a naturalized Englishman. The family moved to London in 1868. He first trained to be an actor, 1877–81, but gave up the stage to study art for a brief space at the Slade School, 1881, and also with Whistler. He visited Paris in 1883 and met Degas who had considerable influence on his methods and outlook, Sickert following him in the practice of giving an air of spontaneity to compositions carefully prepared and enlarged from sketches. He painted often at Dieppe where he lived from 1899 to 1905, was a member of the Impressionist-orientated New English Art Club, 1888, and organized the 'London Impressionists' exhibition in 1889. He was instrumental in founding the Camden Town Group of English Post-Impressionists in 1911. His work had diverse phases—from the rich, dark tones of his music-hall scenes, town views and squalid interiors to the later works in brighter colours, compositions often adapted from photo-graphs or Victorian engravings. He died at Bathampton, January 22 1942.

Signac, Paul

Born in Paris, November 11 1863, Signac left the Lycée to paint on the quais in 1882 and worked at Asnières, 1882–84 at the same time as Seurat. Two works by him, *Les Modistes* and *Marine*, reflected the Divisionism of Seurat in the eighth Im-pressionist exhibition of 1886. He painted with separate mosaic-like blocks of pure colour and remained loyal to the method throughout his life. His book *D'Eugène Delacroix au Néo-Impression-nisme*, 1899, represented it as the most significant development in art of the nineteenth century. He travelled extensively and especially by sea. Ships and harbour scenes, in watercolour as well as oils, are a major feature of his work. He died at Mar-seilles, August 15 1935.

Sisley, Alfred

Born in Paris, October 30 1839, Sisley was of English parentage (though he had a French grand-mother), his father being a prosperous business-man in Paris. Alfred was sent to England at eighteen to prepare for a commercial career but after some years turned to painting and entered the atelier of Gleyre in 1862, there becoming acquainted with Monet, Renoir and Bazille. He worked with Monet and Renoir in the 1860s in the region of Fontainebleau and also along the Seine, coming near to Monet in style and concep-tion of landscape. He contributed to the first Impressionist exhibition in 1874 and again in 1876, 1877 and 1882. He worked in England for short intervals—London 1871, Hampton Court 1874, Isle of Wight 1881, coast near Cardiff 1897—but otherwise in northern France and the Seine area. Argenteuil, Louveciennes, Bougival, Marly, Sèvres and Moret provided his themes. He settled at Moret-sur-Loing in 1880. His father's business failed in the war of 1870 and he was never out of financial difficulty. It was not until after his death that the tide turned in favour of his painting. He died at Moret, January 29 1899.

Steer, Philip Wilson

Born at Birkenhead, December 28 1860, the son of a portrait painter, Steer first studied at the Gloucester School of Art, 1878–81 and in Paris under Bouguereau at the Académie Julian, 1882–83 and under Cabanel at the Ecole des Beaux-Arts, 1883–84. Influenced in some degree by French Impressionism and Neo-Impressionism he developed an original style in the pictures painted between 1884, when he returned to England from Paris, and the late 1890s, outstanding works being the landscapes with figures that mark his sojourns at Walberswick in Suffolk. Steer's early attachment to Impressionism is also signalized by his being a founder-member of the Impressionistic New English Art Club in 1885 and a contributor to the exhibition of London Impressionists, 1889. Later he painted in various regions of England and on the coast in a more conventional style in which he sought to bring together qualities derived from Constable and Turner. As swift impressions (though with no special relevance to Impressionism) the watercolours of his later years were among his best productions. He died in London, March 21 1942.

Toulouse-Lautrec, Henri Marie Raymond de

Born at Albi, November 24 1864, Toulouse-Lautrec was the descendant of the ancient Counts of Toulouse, the son of Comte Alphonse and the Comtesse Adèle (the Comte's first cousin, Adèle Tapié de Celeyran). Henri went to school in Paris, meeting Maurice Joyant, who was long to be his loyal friend, at the Lycée Fontanes. He returned to Albi in 1878 and the following year some flaw of bone structure led to his breaking left and right leg successively with the result of stunting his growth and causing him to give up his favourite outdoor sports of riding and shooting. He took to art in compensation and after some lessons with the painter of sporting subjects, René Princeteau, enrolled in Bonnat's studio in 1882, continuing his studies with Cormon when Bonnat gave up teaching. Emile Bernard and Vincent van Gogh were fellow-students there. In 1884 he took his own studio in Montmartre and between 1885 and 1895 produced his best work, brilliantly portraying the performers and frequenters of the Moulin Rouge and other gay haunts and the melancholy world of the *maisons closes*. Though not addicted to theoretic method he made some use of Impressionist and Neo-Impressionist ways of using colour but Degas as the interpreter *par excellence* of the Parisian world was a main inspiration in his paintings. In his lithographs he adapted Japanese modes of print design with wonderful effect. Excess had ruined his health by 1898 when he underwent treatment in a sanatorium then producing his drawings *Au Cirque* from memory. He died September 9 1901 at the Château de Malromé, Gironde.

Turner, Joseph Mallord William

Born in London, April 23 1775, the son of a barber, Turner was vast in range as a landscape painter but his art is far from being as closely related to Impressionism as that of Constable and a brief summary of his career shows in how many ways his art lies outside the scope of the movement. The non-Impressionist Turner was firstly the young topographical draughtsman in watercolour, 1793–1801; secondly the exhibitor of oil paintings, 1800–20 based on and intended to rival Old Masters, e.g. Van de Velde and Claude Lorrain; thirdly the Romantic inspired by the forces of storm, fire and flood and finally the poetic visionary of the 1830s with his dreams of Venice. Where a certain affinity appears is in the oil paintings made direct from nature from a boat on the River Thames, 1805–10. There is some affinity also in the final efforts of Monet and Turner that dissolve light and substance in dynamic abstraction of colour. Turner died on December 19 1851, the year in which Courbet's *Burial at Ornans* was a herald of Realism and a scandal of the Salon.

Van Gogh, Vincent Willem

Born March 30 1853 at Groot-Zundert, north Brabant, Van Gogh was the elder son of a protestant clergyman, Theodorus van Gogh. As three of the minister's brothers were art dealers it is not surprising that Vincent and his brother Theo went into the art-dealing business; Vincent to Goupil & Co at The Hague, 1869; in transfer to the London branch, 1873; and to Paris in 1875. Unsuited for business he was dismissed in 1876. After other failures, including his effort to become a preacher, he began to draw in earnest in 1880, much influenced by the 'social realism' of working-class life as depicted by the English illustrators of the time. He worked at Brussels, The Hague, Nuenen and Antwerp and was encouraged to paint by Anton Mauve, 1882. Theo, director of a Parisian branch of Goupil from 1873 (where he was one of the Impressionists' supporters) was now making the financial allowance that enabled Vincent to live and work. Vincent went to Paris in 1886 to join his brother. The sight of Impressionist and Neo-Impressionist works and of the Japanese prints, then so much a Parisian vogue, effected a great change in his work, previously sombre in tone. Seeking warmth and colour in the south he went to Arles in 1888 where Impressionist and Neo-Impressionist influence more especially had its fruition in many splendid and now world-famous works. In the tragic period that followed his quarrel with Gauguin at the end of the year—his entry into the asylum at St Rémy, 1889 and his stay at Auvers under Dr Gachet's care, the violence of personal feeling became interwoven with his subjects in painting in a way that would now be described in art-history terms as 'Expressionist'. He died at Auvers by his own hand in July 1890.

Vuillard, Edouard

Born November 11 1868 at Cuiseaux, Saone-et-Loire, Vuillard studied at the Ecole des Beaux-Arts and from 1888 at the Académie Julian, where he met Bonnard—who was to become his closest friend—and members of the Nabi movement in which both took part. Vuillard for a time shared a studio with Bonnard, and like him made drawings for *La Revue Blanche* and programmes and scenery for the Théâtre de l'Art. He produced a superb series of colour lithographs, *Paysages et Intérieurs*, 1899. Domestic interior views, which earned for both him and Bonnard the title of *Intimiste*, had an Impressionist element of style but Vuillard's lamp-lit interiors grew more academic than Impressionist in his later years. He died at La Baule, June 21 1940.

Whistler, James Abbot McNeill

Born at Lowell, Massachusetts, July 11 1834, Whistler was taken at the age of nine to St Petersburg where his father was consultant engineer for the St Petersburg-Moscow railway. At West Point, 1851–54, he failed to qualify for the U.S. Army and after a brief period of map-making on the coastal survey went to Paris in 1855 to study art in the studio of Gleyre (seven years before Monet and his friends met there). Courbet was an early influence on his work though later he expressed antipathy towards Courbet's realism. In the 1860s he was in Rossetti's Pre-Raphaelite circle in London though his *White Girl* appeared in the Salon des Refusés in 1863. Whistler did not paint outdoors, relying on memory. He valued tone more than colour and gave punctilious attention to design in the sense of carefully planned arrangements of line and silhouette. In these respects he differed from the Impressionists though the Nocturnes of the 1870s were atmospheric in their dim evening visions of the Thames when Nature for once, he said, had 'sung in tune'. The atmosphere of the Thames establishes a certain kinship between his *Old Battersea Bridge* and Monet's *Houses of Parliament*, 1871. Whistler died in London, July 17 1903.

BIBLIOGRAPHIES

GENERAL ACCOUNTS

LOUIS LEROY, 'L'Exposition des Impressionnistes', *Charivari*, April 25 1874

EDMOND DURANTY, *La Nouvelle Peinture. A propos du Groupe d'Artistes qui Expose dans les Galeries Durand-Ruel*, Paris 1876; new edn 1945

GEORGES RIVIERE (ed.), *L'Impressionniste, Journal d'Art*, (5 issues in 1877)

THEODORE DURET, *Les Peintres Impressionnistes*, Paris 1878; 1923

FELIX FENEON, *Les Impressionnistes en 1886*, Paris 1886

GEORGES LECOMTE, *L'Art Impressionniste d'apres la Collection Privée de M. Durand-Ruel*, Paris 1892

GUSTAVE GEFFROY, *Histoire de l'Impressionnisme*, Paris 1894

PAUL SIGNAC *D'Eugène Delacroix au Néo-Impressionnisme*, Paris 1899

RICHARD MUTHER, *The History of Modern Painting*, (4 vols) London 1907

CAMILLE MAUCLAIR, *L'Impressionnisme*, Paris 1904; Eng. version 1903

WYNFORD DEWHURST, *Impressionist Painting. Its Genesis and Development*, London 1904

LIONELLO VENTURI, *Les Archives de l'Impressionnisme*, (2 vols) Paris, New York 1939

JOHN REWALD, *The History of Impressionism*, New York 1946

GERMAIN BAZIN, *L'Epoque Impressionniste*, Paris 1947

MAURICE RAYNAL, *Histoire de la Peinture Moderne de Baudelaire à Bonnard*, Geneva 1949

RAYMOND COGNIAT, *Au Temps des Impressionnistes*, Paris 1950

DOUGLAS COOPER, *The Courtauld Collection*, London 1954

PHOEBE POOL, *Impressionism*, London 1967

OCCASIONAL REFERENCE, CRITICAL OR REMINISCENT

CHARLES BAUDELAIRE, *Curiosités Esthétiques: L'Art Romantique*, 1868

JORIS KARL HUYSMANS, *L'Art Moderne*, Paris 1883 *Certains*, Paris 1889

EMILE ZOLA, 'Mon Salon' (1866), 'Edouard Manet' (1867), *Mes Haines*, Paris 1880 *L'Oeuvre*, Paris 1886 (with fictional character based on Cézanne)

GEORGE MOORE, *Modern Painting*, London 1893

DE GONCOURT BROTHERS, *Journal des Goncourt*, Paris 1891

MAURICE DENIS, *Théories*, Paris 1912

JACQUES-EMILE BLANCHE, *Essais et Portraits*, Paris 1912 *Propos de Peintre: de David à Degas*, Paris 1919

AMBROISE VOLLARD, *Souvenirs d'un Marchand de Tableaux: en écoutant Cézanne, Degas, Renoir*, Paris 1938

KENNETH CLARK, *Landscape into Art*, London 1949

AARON SCHARF, *Art and Photography*, London 1968

BIOGRAPHIES AND STUDIES OF INDIVIDUAL ARTISTS

Bazille　GASTON POULAIN, *Bazille et ses Amis*, Paris 1932

Bonnard　CHARLES TERRASSE, *Bonnard*, Paris 1927

GEORGES BESSON, *Bonnard*, Paris 1934

PIERRE COURTHION, *Bonnard*, Lausanne 1945

DENYS SUTTON, Catalogue of Bonnard exhibition, Royal Academy, 1966

Boudin　GUSTAVE CAHEN, *Boudin, sa Vie et son Oeuvre*, Paris 1900

G. JEAN-AUBRY, *Eugène Boudin*, London 1969

Cassatt　F. WATSON, *Mary Cassatt*, New York 1932

A. SEGARD, *Mary Cassatt, un Peintre des Enfants et des Mères*, Paris 1913

Cézanne　ROGER FRY, *Cézanne, a Study of his Development*, London, New York 1927

GERSTLE MACK, *Paul Cézanne*, New York, 1935

LIONELLO VENTURI, *Cézanne, son Art, son Oeuvre*, (2 vols) Paris 1936

JOHN REWALD, *Cézanne, sa Vie, son Oeuvre, son Amitié pour Zola*, Paris 1939

JOHN REWALD (ed.), *Letters of Cézanne*, (Eng. trans.) London 1941

There are various literary portrayals of Cézanne by Emile Bernard, Ambroise Vollard, Gustave Coquiot and others.

Corot　GERMAIN BAZIN, *Corot*, Paris 1942

Corot raconté par lui-même, ses Contemporains, sa Postérité, Geneva 1946

Courbet　C. LEGER, *Courbet et son Temps*, Paris 1948

GERSTLE MACK, *Gustave Courbet*, London, New York 1951

Degas　P. LAFOND, *Degas*, Paris 1918–19

J. B. MANSON, *The Life and Work of Edgar Degas*, London 1927

JULIUS MEIER-GRAEFE, *Degas*, (Eng. trans.) London 1927

DENIS ROUART, *Degas à la Recherche de sa Technique*, Paris 1945

Gauguin　C. MORICE, *Gauguin*, Paris 1920

J. DE ROTONCHAMP, *Paul Gauguin*, Paris 1906; 1925

The Intimate Journals of Paul Gauguin, (Eng. trans.) London 1930

JOHN REWALD, *Gauguin*, London, New York 1938

BENGT DANIELSSON, *Gauguin in the South Seas*, London 1964

Jongkind　ETIENNE MOREAU-NELATON, *Jongkind raconté par lui-même*, Paris 1918

PAUL COLIN, *Jongkind*, Paris 1931

Manet　ANTONIN PROUST, *Edouard Manet*, Paris 1913

ETIENNE MOREAU-NELATON, *Manet raconté par lui-même*, (2 vols) Paris 1926

P. JAMOT, G. WILDENSTEIN, G. BATAILLE, *Manet*, (2 vols) Paris 1932

PIERRE COURTHION, *Manet*, London 1962

Monet　GUSTAVE GEFFROY, *Claude Monet, sa Vie, son Temps, son Oeuvre*, Paris 1922

FLORENT FELS, *La Vie de Claude Monet*, Paris 1929

DOUGLAS COOPER, Catalogue of the Arts Council Monet exhibition, 1957

DENIS ROUART, *Claude Monet*, Paris 1958

RAYMOND COGNIAT, *Monet and his World*, London 1966

Morisot A. FOURREAU, *Berthe Morisot*, Paris, London 1925

DENIS ROUART (ed.), *Berthe Morisot's Correspondence with Family and Friends*, London 1957; 1959

Pissarro ADOLPHE TABARANT, *Pissarro*, (Eng. trans.) London 1925

L. R. PISSARRO, L. VENTURI, *Camille Pissarro, son Art, son Oeuvre*, (2 vols) Paris 1939

JOHN REWALD (ed.), *Pissarro's Letters to his Son*, New York 1943

Renoir GEORGES RIVIERE, *Renoir et ses Amis*, Paris 1921

ALBERT ANDRE, *Renoir*, Paris 1928

A. C. BARNES, V. DE MAZIA, *The Art of Renoir*, New York 1935

WILLIAM GAUNT, *Renoir*, London 1952

JEAN RENOIR, *My Father*, London 1962

Seurat J. CHRISTOPHE, *Seurat*, Paris 1890

ANDRE SALMON, *Seurat*, Brussels 1921

JOHN REWALD, *Seurat*, Paris 1950

PIERRE COURTHION, *Seurat*, London 1969

FRANCOIS DAULTE, *Catalogue Raisonné of Sisley's Paintings*, Paris 1959

Sisley AARON SCHARF, *Alfred Sisley*, London 1966

Toulouse-Lautrec MAURICE JOYANT, *Henri de Toulouse-Lautrec*, Paris 1926–27

J. LASSAIGNE, *Toulouse-Lautrec*, Paris 1939; 1946

DOUGLAS COOPER, *Toulouse-Lautrec*, London 1956

HENRI PERRUCHOT, *Toulouse-Lautrec*, Paris 1958

Van Gogh J. B. DE LA FAILLE, *L'Oeuvre de Van Gogh*, Paris 1927

L'Epoque Française de Van Gogh, Paris 1927

Les Faux Van Gogh, Paris 1930

JULIUS MEIER-GRAEFE, *Vincent*, (2 vols) London 1936

A. M. HAMMACHER, *Vincent van Gogh*, Amsterdam 1948

The Complete Letters of Vincent van Gogh, (3 vols) London 1958

MARK ROSKILL, *Van Gogh, Gauguin and the Impressionist Circle*, London 1970

Vuillard CLAUDE ROGER-MARX, *Vuillard et son Temps*, Paris 1945

ANDRE CHASTEL, *Vuillard*, Paris 1946

LIST OF ILLUSTRATIONS

Measurements are given in inches and centimetres. Height precedes width.

Oil on canvas. $20\frac{1}{4} \times 27$ (51×69)
National Gallery of Scotland, Edinburgh

24 SISLEY, Alfred
Misty Morning. 1874
Oil on canvas. $19\frac{5}{8} \times 24$ (50×61)
Louvre, Paris

25 MANET, Edouard
River at Argenteuil. 1874
Oil on canvas. $24\frac{1}{2} \times 40\frac{1}{2}$ (62.3×103)
Collection The Dowager Lady
Aberconway, London

26 MONET, Claude
The Bridge at Argenteuil. 1874
Oil on canvas. $23\frac{1}{2} \times 31\frac{1}{2}$ (60×80)
Louvre, Paris

27 MONET, Claude
Regatta at Argenteuil. 1874
Oil on canvas. $23\frac{5}{8} \times 39\frac{3}{8}$ (60×100)
Louvre, Paris

28 SISLEY, Alfred
Floods at Port-Marly. 1876
Oil on canvas. $23\frac{5}{8} \times 32$ (60×81)
Louvre, Paris

29 PISSARRO, Camille
*Orchard with Flowering Fruit Trees,
Springtime Pontoise.* 1877
Oil on canvas. $25\frac{5}{8} \times 31\frac{7}{8}$ (65×81)
Louvre, Paris

30 PISSARRO, Camille
The Red Roofs. 1877
Oil on canvas. $21\frac{1}{4} \times 26$ (54×66)
Louvre, Paris

31 MONET, Claude
Gare Saint-Lazare. 1877
Oil on canvas. $29\frac{1}{2} \times 39\frac{1}{2}$ (75×100)
Louvre, Paris

32 MANET, Edouard
The Roadmenders in the Rue de Berne.
1877–78
Oil on canvas. $25 \times 31\frac{1}{2}$ (64×80)
Collection Lord Butler

33 MONET, Claude
Snow Effect at Vétheuil. c. 1878–79
Oil on canvas. $20\frac{1}{2} \times 27\frac{1}{2}$ (52×70)
Louvre, Paris

34 SISLEY, Alfred
The Small Meadows in Spring. 1882–85
(*Les Petits Prés au Printemps*)
Oil on canvas. $21\frac{3}{8} \times 28\frac{3}{4}$ (54×73)
Trustees of the Tate Gallery, London

35 CEZANNE, Paul
L'Estaque. 1885
Oil on canvas. $28 \times 22\frac{3}{4}$ (71×56.5)
Collection Lord Butler

36 CEZANNE, Paul
Mont Sainte-Victoire. 1885–87
Oil on canvas. $26 \times 35\frac{3}{8}$ (66×90)
Courtauld Institute Galleries,
University of London

37 VAN GOGH, Vincent
Le Moulin de la Galette, Montmartre. 1886
Oil on canvas. 18×15 (46×38)
Glasgow Art Gallery and Museum

38 VAN GOGH, Vincent
Montmartre. 1886
Oil on canvas. $17\frac{1}{8} \times 13$ (43.5×33)
Courtesy of the Art Institute of Chicago

39 SEURAT, Georges
Shore at Bas Butin, Honfleur. 1886
Oil on canvas. $26\frac{3}{8} \times 30\frac{1}{4}$ (67×77)
Musée des Beaux-Arts, Tournai

40 SEURAT, Georges
Bridge at Courbevoie. 1886–87
Oil on canvas. $18 \times 21\frac{1}{2}$ (46×54.5)
Courtauld Institute Galleries,
University of London

41 PISSARRO, Camille
Woman in a Field. 1887
Oil on canvas. $21 \times 25\frac{1}{2}$ (54×65)
Louvre, Paris

42 SARGENT, John Singer
*Claude Monet Painting at the Edge of a
Wood.* 1888
Oil on canvas. $21 \times 25\frac{1}{2}$ (53×65)
Trustees of the Tate Gallery, London

43 VAN GOGH, Vincent
Wheatfield with Cypresses. 1889
Oil on canvas. $28\frac{1}{2} \times 36$ (72.5×91)
Trustees of the National Gallery, London

44 VAN GOGH, Vincent
The Roadmenders. 1889
Oil on canvas. $29\frac{1}{8} \times 36\frac{5}{8}$ (74×93)
Cleveland Museum of Art,
(Gift of Hanna Fund)

45 SEURAT, Georges
*Le Chenal de Gravelines: Petit Fort-
Philippe.* 1890
Oil on canvas. $29 \times 36\frac{3}{4}$ (73.5×93.5)
Courtesy of the Indianapolis Museum of
Art (Gift of Mrs James W. Fesler in
memory of Daniel W. and Elizabeth C.
Marmon)

46 MONET, Claude
Poplars on the Epte. 1891
Oil on canvas. $39\frac{1}{2} \times 25\frac{3}{4}$ (101×66)
Philadelphia Museum of Art
(Photo A. J. Wyatt)

47 MONET, Claude
Rouen Cathedral: Full Sunlight. 1894
Oil on canvas. $36 \times 24\frac{3}{4}$ (91×63)
Louvre, Paris

48 PISSARRO, Camille
Place du Théâtre Français. 1898
Oil on canvas. $28\frac{1}{2} \times 36\frac{1}{2}$ (72.5×93)
County Museum of Art, Los Angeles
(Mr and Mrs G. Gard de Sylva
Collection)

49 SICKERT, Walter Richard
Café des Tribunaux, Dieppe, c. 1900
Oil on canvas. $24 \times 28\frac{3}{4}$ (61×73)
Trustees of the Tate Gallery, London

50 PISSARRO, Camille
Le Pont Neuf. 1901
Oil on canvas. $28\frac{3}{4} \times 34\frac{3}{4}$ (73×88)
Collection Mr and Mrs W. Coxe Wright

51 PISSARRO, Camille
The Church of Saint-Jacques at Dieppe.
1901
Oil on canvas. $21\frac{1}{2} \times 26$ (55×66)
Louvre, Paris

52 MONET, Claude
Water-garden at Giverny. 1904
Oil on canvas. $35\frac{3}{8} \times 36\frac{1}{4}$ (90×92)
Louvre, Paris

53 MONET, Claude
Water-lilies: Sunset (detail). 1914–18
Oil on panel. 77½ × 234 (197 × 594)
Musée de l'Orangerie, Paris

54 MANET, Edouard
Peonies. 1864–65
Oil on canvas. 22 × 18 (56 × 46)
Louvre, Paris

55 CEZANNE, Paul
Blue Vase. c. 1885—87
Oil on canvas. 24 × 19⅝ (61 × 50)
Louvre, Paris

56 CEZANNE, Paul
Still-life with Peppermint Bottle. 1890–94
Oil on canvas. 25⅝ × 31⅞ (65 × 76)
National Gallery of Art, Washington
(Chester Dale Collection)

57 MANET, Edouard
Music in the Tuileries. 1862
(La Musique aux Tuileries)
Oil on canvas. 30 × 46½ (76 × 118)
Trustees of the National Gallery, London

58 DEGAS, Edgar
At the Race Course. 1869–72
Spirit medium on canvas. 18⅛ × 24
(46 × 61)
Louvre, Paris

59 RENOIR, Auguste
La Grenouillère. 1869
Oil on canvas. 26 × 31⅞ (66 × 81)
National Museum, Stockholm

60 RENOIR, Auguste
Le Moulin de la Galette. 1876
Oil on canvas. 51⅝ × 68⅞ (131 × 175)
Louvre, Paris

61 RENOIR, Auguste
Muslim Festival at Algiers. 1881
Oil on canvas. 28¾ × 36¼ (73.5 × 92)
Louvre, Paris

62 RENOIR, Auguste
Umbrellas (Les Parapluies). c. 1884
Oil on canvas. 71 × 45¼ (180 × 115)
Trustees of the National Gallery, London

63 SEURAT, Georges
A Sunday Afternoon at the Grande Jatte.
1884–86
Courtesy of the Art Institute of Chicago
(Helen Birch Bartlett Memorial
Collection)

64 CEZANNE, Paul
Three Bathers. 1879–82
Oil on canvas. 19⅝ × 19⅝ (50 × 50)
Musée du Petit Palais, Paris

65 RENOIR, Auguste
The Bathers. 1884–87
(Les Grandes Baigneuses)
Oil on canvas. 45½ × 67 (116 × 170)
Philadelphia Museum of Art

66 DEGAS, Edgar
Woman Combing her Hair. c. 1887–90
Pastel. 32¼ × 22½ (82 × 57)
Louvre, Paris

67 DEGAS, Edgar
Woman Drying Herself. 1903
Pastel on paper. 28½ × 29½ (73 × 75)
Courtesy of the Art Institute of Chicago
(Mr and Mrs Martin A. Ryerson
Collection)

68 RENOIR, Auguste
Alfred Sisley and his Wife. 1868
Oil on canvas. 42¼ × 30 (105 × 75)
Wallraf-Richartz Museum, Cologne

69 MONET, Claude
Madame Gaudibert. 1868
Oil on canvas. 85 × 54½ (216 × 138)
Louvre, Paris

70 PISSARRO, Camille
Self-portrait. 1873
Oil on canvas. 22 × 18⅜ (56 × 46.7)
Louvre, Paris

71 RENOIR, Auguste
The Box (La Loge). 1874
Oil on canvas. 31½ × 23⅝ (80 × 64)
Courtauld Institute Galleries,
University of London

72 MANET, Edouard
*Waitress Serving Bocks (La Serveuse de
Bocks). c.* 1878–79

Oil on canvas. 30¼ × 25½ (77 × 65)
Louvre, Paris

73 DEGAS, Edgar
Diego Martelli. 1879
Oil on canvas. 43¼ × 39⅜ (110 × 100)
National Gallery of Scotland, Edinburgh

74 RENOIR, Auguste
The First Outing. c. 1875–76
(La Première Sortie)
Oil on canvas. 25½ × 19¾ (65 × 50)
Trustees of the Tate Gallery, London

75 MORISOT, Berthe
In the Dining Room. 1886
Oil on canvas. 24¼ × 19¾ (61.6 × 50.2)
National Gallery of Art, Washington
(Chester Dale Collection)

76 CASSATT, Mary
Girl Arranging her Hair. 1886
Oil on canvas. 29½ × 24½ (75 × 62)
National Gallery of Art, Washington
(Chester Dale Collection)

77 TOULOUSE-LAUTREC, Henri de
*Comtesse Adèle de Toulouse-Lautrec in the
Salon at Malromé.* 1887
Oil on canvas. 23¼ × 21¼ (59 × 54)
Museum of Albi

78 GAUGUIN, Paul
Mme Angèle Satre (La Belle Angèle).
1889
Oil on canvas. 36¼ × 28½ (92 × 72)
Louvre, Paris

79 VAN GOGH, Vincent
Portrait of the Artist. May 1890
Oil on canvas. 25½ × 21½ (65 × 54.5)
Louvre, Paris

80 TOULOUSE-LAUTREC, Henri de
Englishwoman at The Star, Le Havre. 1899
Oil on wood. 16⅛ × 12⅞ (40 × 32.5)
Museum of Albi

81 RENOIR, Auguste
Gabrielle with Roses. 1911
Oil on canvas. 21⅞ × 18½ (55.5 × 47)
Louvre, Paris

82 DEGAS, Edgar
The Dance Foyer at the Opera. 1872

Oil on canvas. $12\frac{1}{2} \times 18$ (32×46)
Louvre, Paris

83 DEGAS, Edgar
The Dancing Class. 1874
Oil on canvas. $33\frac{1}{2} \times 29\frac{1}{2}$ (85×75)
Louvre, Paris

84 DEGAS, Edgar
Dancer with Bouquet, Curtseying. 1878
(*Danseuse au Bouquet, Saluant*)
Pastel on paper transferred on to canvas.
$28\frac{3}{8} \times 30\frac{1}{4}$ (72×77.5)
Louvre, Paris

85 DEGAS, Edgar
Dancers Preparing for the Ballet. c. 1878–80
Oil on canvas. $29\frac{3}{4} \times 23\frac{3}{4}$ (76×60)
Courtesy of the Art Institute of Chicago
(Gift of Mr and Mrs Gordon Palmer,
Mr and Mrs Arthur M. Wood and
Mrs Bertha P. Thorne)

86 MONET, Claude
Women in the Garden. 1866–67
Oil on canvas. $100\frac{1}{2} \times 80\frac{3}{4}$ (255×205)
Louvre, Paris

87 MONET, Claude
On the Beach, Trouville. 1870
Oil on canvas. 15×18 (38×46)
Trustees of the National Gallery, London

88 DEGAS, Edgar
Absinthe. 1876
Oil on canvas. $36\frac{1}{4} \times 26\frac{3}{4}$ (92×68)
Louvre, Paris

89 DEGAS, Edgar
Women on a Café Terrace. 1877
Pastel. $15\frac{3}{4} \times 23\frac{5}{8}$ (40×60)
Louvre, Paris

90 DEGAS, Edgar
Miss Lala at the Cirque Fernando. 1879
Oil on canvas. $46 \times 30\frac{1}{2}$ (117×77.5)
Trustees of the National Gallery, London

91 RENOIR, Auguste
The Rowers' Lunch. 1879–80
Courtesy of The Art Institute of Chicago
(Potter Palmer Collection)

92 RENOIR, Auguste
La Place Pigalle. c. 1880
Oil on canvas. $25\frac{1}{2} \times 21\frac{1}{2}$ (64.5×54.5)
Collection Lord Butler

93 MANET, Edouard
*Young Girl on the Threshold of the Garden
at Bellevue.* 1880
Oil on canvas. $59\frac{1}{2} \times 45\frac{1}{4}$ (151×115)
Private Collection

94 RENOIR, Auguste
Luncheon of the Boating Party. 1881
Oil on canvas. 51×68 (130×173)
Phillips Memorial Gallery, Washington
D.C.

95 DEGAS, Edgar
The Millinery Shop. c. 1882
Oil on canvas. $38\frac{7}{8} \times 42\frac{7}{8}$ (99×109)
Courtesy of the Art Institute of Chicago
(Mr and Mrs L. L. Coburn Collection)

96 PISSARRO, Camille
The Little Country Maid. 1882
Oil on canvas. $25 \times 20\frac{7}{8}$ (63.5×53)
Trustees of the Tate Gallery, London

97 PISSARRO, Camille
The Pork Butcher. 1883
Oil on canvas. $25\frac{5}{8} \times 21\frac{3}{8}$ (65×54.5)
Trustees of the Tate Gallery, London

98 SEURAT, Georges
Bathing at Asnières. 1883–84
(*Une Baignade, Asnières*)
Oil on canvas. $79 \times 118\frac{1}{2}$ (201×301)
Trustees of the National Gallery, London

99 DEGAS, Edgar
Woman in her Bath, Sponging her Leg. 1883
Pastel. $7\frac{7}{8} \times 16\frac{1}{8}$ (19.7×41)
Louvre, Paris

100 DEGAS, Edgar
The Laundresses. c. 1884
Pastel. $29\frac{7}{8} \times 31\frac{7}{8}$ (76×81)
Louvre, Paris

101 CEZANNE, Paul
The Card Players. c. 1885–90
Oil on canvas. $18\frac{3}{4} \times 22\frac{1}{2}$ (47.5×57)
Louvre, Paris

102 GAUGUIN, Paul
Jacob Wrestling with an Angel. 1888
Oil on canvas. $28\frac{3}{4} \times 36\frac{1}{2}$ (73×92)
National Gallery of Scotland, Edinburgh

103 TOULOUSE-LAUTREC, Henri de
At the Moulin Rouge. 1892
Oil on canvas. $48\frac{3}{8} \times 55\frac{1}{4}$ (120×141)
Courtesy of the Art Institute of Chicago
(Helen Birch Bartlett Memorial
Collection)

104 STEER, Philip Wilson
Girls Running, Walberswick Pier. 1894
Oil on canvas. $24\frac{1}{2} \times 36\frac{1}{2}$ (62×93)
Trustees of the Tate Gallery, London

105 GAUGUIN, Paul
Nevermore. 1897
Oil on canvas. $23\frac{3}{8} \times 45\frac{5}{8}$ (59×116)
Courtauld Institute Galleries,
University of London

106 GAUGUIN, Paul
The White Horse. 1898
Oil on canvas. $55\frac{1}{2} \times 36$ (141×91)
Louvre, Paris

107 BONNARD, Pierre
Dining Room in the Country. 1913
Oil on canvas. 63×80 (160×203)
Minneapolis Institute of Arts

108 BONNARD, Pierre
Nude in the Bath. 1937
Oil on canvas. $36\frac{5}{8} \times 57\frac{7}{8}$ (93×147)
Musée du Petit Palais, Paris

INDEX